Xiaoxue Gao
Thinking of Space Relationally

D1082070

Urban Studies

To all serious cosmopolites

Xiaoxue Gao (Dr. phil.), born in 1987, works as a project manager and post-doctoral researcher at the Institute of Architecture at Technical University of Berlin. Prior to that, she researched and studied in urban planning, human geography and sociology of space. She is interested in researching spatial transformation with a focus on counterculture space in China, and in exploring the cross-cultural social-spatial research methodologies.

Xiaoxue Gao

Thinking of Space Relationally

Critical Realism Beyond Relativism –
A Manifold Study of the Artworld in Beijing

[transcript]

Thesis: Technical University of Berlin, Institute of Sociology
Examiners: Prof. Dr. Martina Löw, Prof. Dr. Bettina Gransow-van Treeck,
Prof. Dr. Mitsuhiro Tada

The PhD research on which this book is based was funded by the China Scholar-
ship Council (CSC).

The publication of this book was funded by the Open Access Publication Fund of
the Technische Universität Berlin

Bibliographic information published by the Deutsche Nationalbibliothek
The Deutsche Nationalbibliothek lists this publication in the Deutsche National-
bibliografie; detailed bibliographic data are available in the Internet at http://
dnb.d-nb.de

First published in 2021 by transcript Verlag, Bielefeld
© Xiaoxue Gao

Cover layout: Maria Arndt, Bielefeld
Cover illustration: Xiaoxue Gao
Printed by Majuskel Medienproduktion GmbH, Wetzlar
Print-ISBN 978-3-8376-5587-2
PDF-ISBN 978-3-8394-5587-6
https://doi.org/10.14361/9783839455876

Printed on permanent acid-free text paper.

Contents

Section One: Thinking of space relationally: traveling epistemic frames and local context of knowing and doing

Section Two: The retroductive empirical research on the spatial constitution of Beijing's artworld

List of Figures and Tables

Acknowledgment

This project began from my naïve expectations of learning from an exciting pool of theoretical knowledge developed in Europe, and bringing them back to understand how the urban phenomena form and transform in where I grew up in China. I was born in the late 1980 and the Chinese cities I know have always been fast-growing. They not only grow incessantly in size but introduce new pieces of material, and technological infrastructures, building forms, symbols, rules, textures, flavors, sounds into their urban fabric. These elements seem to be drawn from disparate times and places with or without a shared vision, superimposed into existing so-cial-spatial systems, or imposed in tabula rasa territories. In the latter cases, old material fabrics, along with the underpinning social organization and meaning systems, are discarded suddenly, disappear from people's sights. Yet, the inherent and familiar would reclaim their visibility in people's memories and practices, clash with the new in unexpected ways. How to take account of and explain the urban transformations in the condition of 'compressed modernity'? I found no ready an-swer to this question. Hence, the endeavors in this work are dedicated to answering it.

As many researchers from the sociology of knowledge, science and technology study disciplines have revealed, all forms of scientific knowledge are, to a certain extent, rooted in particular social-material conditions at particular times. Facing the ongoing processes and varigated manefestations under compressed moder-nity, researchers from late-developing regions are generally challenged with evalu-ating and recontextualizing the traveling scientific knowledge. Leaving the entan-gled power relations aside, epistemic gaps can be uncovered between the original and learned scientific knowledge, between the academically legitimated scientific knowledge, the local institutional norms, and common senses lived by the research subjects in concrete cases. In this work, I position myself as a late-learner research-ing social-spatial change embedded in late-developing societal contexts. This book is thus to demonstrate the ways in which traveling social-spatial theories (scien-tific knowledge) could be learned and employed constructively in describing and understanding particular and complex spatial phenomenon (e.g., the artworld in Beijing) of our time.

Apart from my naïve-ness, I have opened many doors in this research but was able to close very few tightly, if at all. My research topic is very profound, and I genuinely know, it is far from being systematically answered. Regardless, this research has taken enormous amounts of time and energy from me and many people from different places. I want to acknowledge my deepest debt of gratitudes to these individuals and the places that made it possible.

In all my thinking on my chosen field, I owe an immense debt of gratitude to my supervisor Martina Löw. It has been a genuine piece of pleasure and privilege for me to have her as my mentor. I can count on her invaluable insights into social-spatial theoretical reflections and research experiences. While reviewing my drafts, I suspect that my problematic formulations, unsystematic analysis, and weak arguments make her raise eyebrows. However, as a dedicated holistic educator, she patiently allows me to explore freely, to fail, to reflect and grow from my own mistakes. When I get lost, she miraculously offers me the most relatable and elegant guidances. She empowers everyone around her not only through conferring knowledge needed. Most importantly, I learn that such persons exist to be looked up to, who has an enormous capacity for thinking and taking delight in other people's progress. Equally, I sincerely thank my second supervisor, Bettina Gransow, who kindly agreed to instruct my dissertation when it was still in raw shape and when her scholastic engagements were especially busy. Her supervision and remarks are amazingly wholehearted, sharp, and thought-provoking. They allow and encourage me to ruminate on, for more than the scale of this book. I am inspired by her courage and approach of being a sinologist, pursuing real inter-cultural understanding.

I have benefited enormously from the inspiring, supportive, and encouraging research environment from the chairs at the Institute of Sociology, TU Berlin. My dearest colleagues and friends, Lea Rothmann, Emily Kelling, Martin Fuller, Gunter Weidenhaus, Mitsuhiro Tada, Rim Aouini, and many others, you are heroes and role models to me in one way or another. Thank you for your generosity, inspiration, and care in our day-to-day encounters. I am also very grateful for the critical comments and feedback from Lisa Melcher and Kimiko Sudan – my working group companions – whose ideas are partly integrated into the fabric of this research. I'd also like to thank Ava Lynam and Ziwei Li for their meticulous proofreading, fixing the ambiguity in my thinking and words.

Furthermore, I am very grateful to the old and new friends I met in the field, including Zhang Sirui, Li Jia, Wu Jianru, Lv Jingjing, Sang Tian, He Chi, Zeng Jiahui, Huang Jingyuan, Chen Wei, Guo Junjun, Liu Guannan, Liu Yu, Bai Xiaohui, and many others. You have supported me significantly in one way or another during my field trips in the past years. For all my interviewees, without your generous sharing about your experience at your home, in your offices, studios, dinner ta-

bles; tagging me along in your professional trips in Beijing, Shanghai, Guangzhou, Kassel, Lion, Berlin… there will not be this book.

Finally, I would like to thank my parents for being exceptionally open-minded and supportive to my unusual choices at all times. My dear friend Chompunuch Vanichayanguranon, thanks for always cheering me when I have shattering souls. Marvin Bartels, thanks for being there with me, offering me care, encouragements, warmth, humor, and daily dose of sweetness.

1 Introduction

1.1 Research background

It is probably true for researchers and practitioners everywhere in architecture, urban design, and planning fields: the term 'space' has become *the* keyword in their thinking and professional operations. Despite they may associate entirely different sets of concepts with 'space' to inform their practices. My acquaintance with this notion began when I got enrolled in the urban planning program at the school of architecture at Tianjin University. Our faculty was known for its pragmatic pedagogical model: design ideas, techniques, and representations from both imperial, communist eras of China and from Western societies since the time of modernism were taught to us without alluding much to their cultural, political context and implications of today's applications. I understood 'space' as merely material, in reference to bounded material entities (a room, an architecture, or an urban neighborhood). The post-modernist, modernist, and traditional-imperial prefixes of space seemed to me, represent objectively the technical and material constitutional principles of purely *historical* interests, the functional and aesthetic evaluation criteria coined at *specific times*. When doing internships in China, I observed practitioners deciding on the forms of spatial constitutions mostly by referring to *objective* indicators like temporal or financial efficiency or the architects' and users' subjective aesthetic preferences. I was convinced that the substantive significances of those spatial defining notions are deflated in our time.

For a long time, I treat my positivist universalistic understanding of space with no skepticism. In my limited planning and design experiences, I was encouraged to draw on ideas, styles, and forms from various times and places and make eclectic use of them. In everyday life, I use 'concrete' spatial names (e.g., Beijing, outer ring, my office) denotatively to refer to particular locations, directions, objects, and material arrangements. No confusion arises as my interlocutors also acquaint with these empirical references. The 'abstract' spatial terms only become problematic when I try to communicate them to an epistemic other. For instance, Shenzhen is undoubtedly a young and energetic 'city' to me, planned, and built up a little over 40 years. Despite Shenzhen has a nominal GDP and is inhabited by more than 12

million people (mostly migrants), calling it a 'city' is strange to my European colleagues. For them, 'economic zone' is a better fit to grasp Shenzhen's spacing mechanism and spatial attributes. In their conceptual system, such a term corresponds better to Shenzhen: a functionally planned area unassociated with historicity, cultural diversity, and shared identity among its inhabitants.

Unequivocally, for researchers in urban sociology, human geography, and other social-spatial disciplines who aim to explain spatial formation and transformation in particular social contexts, the conceptual framework of *space* shall relate to social practices, relations, and meanings to be understood in empirical events. This advocacy has, of course, already been generally called forth by pioneering scholars since the 1960s. It is famously coined by Henri Lefebvre that "(social) space is a *social* production" (1991 [1974], 30). However, how to relate a general conceptual form to the particularities is not yet thoroughly discussed. In my reading, philosophers and social scientists have also spent a lot of energy and effort conceiving and disputing over variegated conceptual definitions but too little on reflecting on the methodological approaches for engaging them meaningfully in understanding and transforming particular local realities.

Suppose our *raison d'etre* is to produce context-sensitive knowledge of space constitution and thereby inform the local transformative processes. In that case, some critical methodological questions are left poorly answered. Then, given the causal agents and boundary-setting criteria proposed in diverse spatial conceptualizations, how shall a researcher select the one(s) that is most revealing for a particular research subject? Secondly, when we depart from one particular (social) spatial conceptualization, what counts as *context-specific knowledge*? Thirdly, what constitutes a good explanation? This book aims to do justice to these concerns.

1.1.1 Traveling spatial conceptualizations and philosophical vigilance

In today's global academia, the dominant majority of sociological and geographical studies on urban China have either discarded theory-guided analysis or adapted western social-spatial models and theories to Chinese reality in pragmatic yet ambiguous manners. Both methodological approaches induce risks of producing context-insensitive, inconsistent, and unsystematic knowledge. The causes are generally attributed to the domination of specific hegemonic epistemic norms, including the north-, male-, market-, and state centrism, which hinders the production and validation of particular/local/subaltern knowledge in the domestic or global fields of knowledge production. Meanwhile, individual researchers are blamed for their succumb or commitment to reproducing such unequal knowledge-producing structures (see, e.g., Ma and Wu 2005b; Chen 2018; Wang and Liu 2015; Roulleau-Berger and Li 2016, 38–43). Nevertheless, few studies have addressed this problem from an *epistemic* point of view, elucidating the patterned epistemic gaps mani-

fested in the selection, misinterpretation, and appropriation of specific conceptual knowledge of space. The philosophical, among other things, epistemic vigilance, is vital in explaining how traveling theories are comprehended and excised by researchers from one social and cultural context to another. Just as Hammersley puts it:

> There is no escape from philosophical assumptions for researchers. Whether we like it or not, and whether we are aware of them or not, we cannot avoid such assumptions. And, sometimes, the assumptions that we make lead us into error. (Hammersley 1992, 43)

The first section of this book (chapter one to four) aims to expound on how attending to distinct Sino-Euro epistemic frames of space would help us understand the prevailing practices of comprehending, selecting, and applying space conceptualizations in researching urban China. It also aims to uncover the implications such underlying assumptions have on the resultant knowledge being produced. Therefore, it will start by revisiting and elucidating various conceptualizations of (social) space in their historical-philosophical contexts. To gain a critical distance from these traveling conceptualizations – to reveal how underlying epistemic assumptions legitimate certain widely influential explanations – I will elucidate them according to their constituting epistemic forms, causal agents, and level of analysis. In the subsequent chapter, I will compare the necessary epistemic assumptions derived from European spatial conceptualizations with those from traditional Chinese thinking. Here, a quick overview shall show why I start the methodological explorations by addressing the distinct epistemic (philosophical) presuppositions/prepositions underlying space conceptualizations in Europe and China.

In Europe, a conceptual genealogy of 'space' is well documented. Bertrand Russell once asserted that some of the problems and paradoxes associated with the ideas around space were set out by Zeno of Elea (fl. 450 BC). He argued, "in some form, (Zeno's ideas) have afforded grounds for almost all the theories of space and time and infinity which have been constructed from his day to our own." (2009 [1914], 143) If Russell were correct, then all trials of conceptualizing space after Zeno until his time are driven by the inquiries about how 'movement' or 'geometrical and physical change' is possible. In one of Zeno's most famous paradoxes – of Achilles – space is characterized as a composition of 'infinitely divisible points,' and time as 'instants,' both exhibiting a structure of mathematical continuum. The paradox occurred as Zeno applied rational deductive logic to add up the sequences, concluding thereby that the fleet-footed Achilles shall never be able to surpass the slow-paced tortoise. A vital proposition is drawn to endorse the inferences: the nature of space is permanent and unchanging, whereas changes occur only in the sensible world. Space and materiality are endorsed with different ontological status and, consequently, represent an epistemic divide. By following the coherent principle of

truth, Zeno presupposed 'space' to be static and infinitely divisible, 'materiality' is thereby movable, plural, and discrete. 'Motion' and 'division' – in their engagements with the material, can only exist phenomenologically in perception.

Following this thread, one notices how a presumed *epistemological dualism* between the 'real' and the 'perceptual' is carried on in later created spatial notions. Such a divide has variegated manifestations when combined with different ontological assumptions of reality. To illustrate, Democritus and Lucretius held a classical materialist conception of space by decoupling perception of motion with the reality constituted by atom – some independent and unchanging units. Plato presumed the distinct mechanisms in the world of 'Form (non-substantial, permanent)' and 'bodies (sensible, changing)' world. Such an epistemic divide ascertain sensible bodies can, at best, *represent (copy)* the transcendental substances. In correspondence with 'form' and 'matter,' Aristotle introduced the dualistic notions of 'potentiality' and 'actuality' to mitigate the presumed friction between the 'real' and 'phenomenal.' We can thereby infer, long before Descartes, Newton, and Leibniz, various version of dualistic epistemic presupposition regarding the mental and physical dimensions of the world were established in European philosophies. In line with these presuppositions, various conceptual dyads – such as 'appearances and essence,' 'sense and rationality' – were developed to resolve the problem of "change." They give accounts of and reconcile the contradiction between the eternal, static, and immutable and the sensible, changing world dimensions.

In light of such philosophical grounding, the commonality and distinction between the three fundamental concepts of space – absolute, relative, and relational space – commonly used by scholars in social and geographical sciences can be better illuminated. They are adopted and accommodated into different social theoretical paradigms to describe and explain the spatial configuration and re-configuration of social-spatial events. Usually, different conceptual lens gets chosen according to the extent of mobility and plurality these events manifest. Many claims that the idea of 'absolute space' seems so basic that it still widely shapes people's shared understanding of build-up space, i.e., as a container-like material backdrop for societal changes to occur. The build-up environment is deemed a homogenous and isotropic territory, which can be measured by classical (Euclidean/Cartesian) mathematics. The geometrical measurement is deemed universally valid, irrespective of the forms of associated societal activities. Such a static idea of build-up space is challenged by the arrival of the information and global trade era: more and more situated material entities, social bodies, and their movements are perceived in connection with each other. Like countries' physical borders, some fixed boundaries become meaningless and fade out of people's perceptions. Space is conceived increasingly complex and *relative*, more as constructed than given. Typological notions of space such as "space of flows" (see Castells 1999, 294), conjoining the social practices of shared meaning or functions arise. In this context, space

is demarcated and measured by the perceived dynamics and intensity of cohering activities. Most recently, thinking of space relationally (this book's subject matter) becomes scholars' new mantra of thinking. It is conceived to capture the multiplicity, juxtaposition, and unceasing change of space (see, e.g., Yeung 2005; Merriman et al. 2012; Massey 2005). The trends seem to be, new conceptual lenses of space are more accommodating to new cross-boundary social-spatial events and their manifestations. Chapter two of this book would demonstrate how dualistic epistemological presuppositions shape the causal agents and level of analysis entailed in relational spatial conceptualizations traveling from Europe.

On the other side of the globe, a cosmological view originated from Chinese antiquity seems to start from an opposite stance: the leading Chinese philosophers regard 'change' to be the fundamental nature of reality. As the title of the first Chinese classic Yi Jing[1] (Book of Changes) implies, "production and reproduction mean Yi (Change)[2]" ("Xi Ci" n.d.). In this book, two distinct yet dependent generative forces were conceptualized as *yin* and *yang*. Their interactions were deemed to give rise to further variations of *yin-yang* (patterns of changes) –the underlying mechanisms that give rise to a myriad of things and social beings. These propositions seem to have shaped the analytical lens that Chinese philosophers have utilized ever since. The *yin-yang* causal account stands in contrast to a single generative force identified by the early European philosophers mentioned previously. It includes the *'unmoved mover'* famously put by Aristotle, who gives a linear account of how things become – actualize one's potential. Works of ancient Chinese philosophy (here I refer only to Taoism and Confucianism) conceive *being* to be structured under binary (*yin-yang*) forces than inherent qualities or transcendental essences. The patterns of changes emerge from and demonstrate in interactions, imply an ontology of change and process[3] (see Graham 1986; Hall and Ames 1987; Chen 2005).

Concerning knowledge, comparative philosophers also argue that, instead of an ideal form or true meaning, 'knowledge' in ancient Chinese philosophy is closely tied to experience gained and warranted in context. To *know* means "generating an emergent world contingent upon the conditions and capacities of the specific persons engaged in the dynamics of enacting reality" (Hall and Ames 1987, 195). The validity of knowledge is deemed contextual-dependent, finite, and negotiable

1 Yijing (易经).

2 In Chinese: 生生之谓易.

3 I have chosen to isolate the temporal and spatial dimensions in my comparative discussions. In traditional Chinese thought, change is usually perceived as circular changes, occurring repetitively in a circular structure of time rather than an evolving linear structure of time. I admit such a reduction can be a critical oversight for this work, and a pending question to be answered for future works.

than *a priori*. For Chinese philosophers, a presupposed dualistic differentiation be-
tween the knowledge acquired by a God-like impartial observer and a partial and
biased mundane person does not exist. Nevertheless, a divide is often associated
with the social-political legitimation held by the knowledge producer. Concerning
such distinct philosophical tradition, Lewis argues that 'space' in early China is not
conceived as naturally given, but as a whole united in the practice of perceiving
subjects, more specifically, "united in the one person who rules it" (2006, 4).

Nevertheless, the conceptual genealogy of space in Europe and China shows
some ostensible signs of confluence at a relational framework. To illustrate, I will
cite a paragraph from *Tao De Jing*, which was muralled on the facade of my old
faculty of architecture at Tianjin University. The quote goes:

> [...] Clay is thrown to shape a vase, and make of void and form a pair, and a vessel's
> put to use. Door and window vent a room, and make of void and form a pair, and
> a room is put to use. Thus, the value of what depends for use on what is not[4] (Lao
> Zi 2001 [n.d.], 51)

When I was a student, I see it as a mere recount of common sense and fail to grasp
this excerpt's conceptual significance. Many years later, only when I put it in juxta-
position with relational spatial concepts I read and learn in Europe, have I realized
their resemblances and deep-rooted divergences to be a critical topic for further
investigation. As we can see, space conceived by Lao Tsu is constituted by material
entities, the immaterial *in-betweenness*, and the meaning (utility, value) assigned by
engaging subjects. Through operating and assigning meaning to the material and
immaterial constituents of space as a whole, people construct conceptual form to
name it. It echoes with Leibniz's conception of space, which goes that:

> (space is) something merely relative, as time is. Time is an order of successions.
> Space denotes, in terms of possibility, an order to things which exist at the same
> time. . . . I do not say that matter and space are the same things. I only say, there
> is no space where there is no matter, and that space in itself is not an absolute
> reality. (G. VII. 363 (D. 243), cite in Russell 2005 [1900], 301)

Leibniz and Lao Tsu's excerpts suggest: they have both addressed the interdepen-
dence and relational constitution of material and immaterial entities in their def-
inition of space. One can also detect, Leibniz's thesis is more analytically and ob-
jectively formulated, indicating no sensitivity to particular subjects nor contexts.
Lao Tsu did not mobilize any abstractions and definitions but illustrated his idea
by referring to everyday objects and general social subjects' shared experiences. A
locus of subject-centric perception is embedded in his definition.

4 In Chinese: 埏埴以为器,其无,有器之用; 凿户牖以为室,当其无,有室之用。
故有之以为利,无之以为用.

Unfortunately, unlike Leibniz, whose relational conception of space gets redis-covered, re-contextualized, and further developed by intellectuals across the globe, Lao Tzu and his followers' ideas of space are subjected to much fewer serious the-oretical discussions and developments by researchers interested in understanding spatial phenomena situated in urban China.

Let me assume a hypothetical situation. If ancient China's spatial thinking re-mained intact, the philosophical preliminaries for conceiving space in the Chinese context today would divert significantly from the substantial ontology and natu-ralistic epistemologies entailed in positivism or Marxist dialectical materialism. Fruitful attempts to theorize would depart from anti-essentialism philosophies (e.g., Whitehead, Deleuze), and locally sensitive conceptual frameworks shall be closer to the relational, dynamic terms. At this point, I would not jump to any hasty claim about the feasibility of such thinking. Especially admitting that, since the 20th century, China's intellectual and political history is marked by cultural meandering and fracturing (Goldman and Li 2012). This brief philosophical exca-vation here, first of all, serves as a reminder for keeping a vigilant attitude towards the epistemic presumptions, the attributed properties of the pre-conceived notions upon which traveling social scientific knowledge is constructed.

Nevertheless, when well elucidated and carefully employed, the relational framework serves as the reference point to distinguish the myriad of spatial concepts. Through comparative deconstruction, discern where their analytical and explanatory powers lie and to what extent they help with analyzing a social-spatial phenomenon in contemporary urban China.

1.1.2 Social theoretical perspectives, methodological implications, and forms of spatiality

To explicate the analytical purchase of traveling social-spatial conceptualizations, another angle is to attend to their underwriting social science traditions or paradigms. It is a commonplace that most researchers succumb to three main paradigms in social science – the positivist, the historical materialistic, and the interpretive – in describing and explaining social-spatial reality. The paradigms prescribe conceptual and technical principles of coding the targeted subject, object, and their relations, affect thereby distinctively how social-spatial phenomenon is cased, analyzed, and explained. Furthermore, the issue of 'perspective,' namely, the cognitive and sub-cognitive gap between the researcher as the 'knowing subject' and that of actors as the 'subject-to-be-known' (as well as the perspectival differences among the various subjects-to-be-known), are addressed varyingly across paradigms. How the issue of perspective is addressed can be different even within one paradigm, i.e., constructionism. The adopted perspective or' criteria of differentiation' would further affect the definition of the valid unit of study.

While reviewing existing studies on spatial (trans)formation in China (in Chapter 4.2 and 4.3), I come to notice an under reflected issue: the role theory plays in informing the research. In these studies, the 'scientific validity' is often achieved by first admitting the prescribed attributes of variables (i.e., an individual's rational agency, or space as territory measured by size), doctrines of causalities unproblematic. The prescribed observables would then be permitted into the analytical framework when observations of their attributes collapsed to the pre-defined ones. Contextual particularities of observable local events often get ruled out as anomalies. In the following paragraphs, I briefly discuss three dominant theoretical perspectives applied in examining social-spatial space formation and transformation in the contemporary Chinese urban context to illustrate the *epistemic fallacy* I wish to address in this book.

The first strand of research addresses the 'mode of production' as the principal structure in arranging social and material bodies. The conceptual models from classical economic geography (e.g., location theory from Walter Christäller and August Lösch), new economic geography (e.g., the economy of scale and agglomeration from Masahisa Fujita and Paul Krugman), among others, are well received by Chinese urban planners and geographers. Scholars mostly embark on such neoclassical economic models or neo-institutional political and economic theories to decode the rapid urban transformations in the post-reform era. They are applied in instructing planning functional zonings in the city and assessing the economic performance of them. The neoclassical perspective presumes the researchers to be impartial and rational. The target social subjects are presumed to hold a substantial-economic rationale and an awareness of Euclidean geometric principles. Despite a collective outlook, it advocates an *individualism* methodology, i.e., regarding social actors to be discrete rational individuals aiming for maximum personal gain. As a result, the valid unit of analysis is derived from the principle of equilibrium *ex-post*, the constraining size for optimized economic activities. When employing the theory deductively, most likely, there is nothing much new that can be found about space from the empirical world beyond identifying an empirical content of the *boundary*.

Alternatively, scholars following neo-institutionalism principles attend institutional economic imperatives and the state's political agency in relation to space production. The ways in which the political-economic agencies are distributed and materialized at various administrative levels are the underlying causes affecting the production and transformation of material spatial structure in China. Consequently, the social-spatial unit is conceived as a 'capital or power container,' which corresponds to the territorialized capital accumulation and jurisdictions (Ma and Wu 2005a; Friedmann 2006, 441). With the emphasis solely on state institutions' agency, neo-institutionalism followers impart a *collective* outlook to define subjects' attributes. They equalize spatial restructuration to the restructuration of the mate-

rialized state-agency. In both cases, the prescribed causal agent in theories is employed to inform coding, formulating predictions, and explanations. The studies endorsing such perspectives are convinced that state-dominant capitalism as the political-ideology and meta-narratives underwrite the formation of multifarious institutional forms and developmental tendencies in post-reform Chinese society. It is not surprising that, in these studies, disanalogies appear between predictions and observable empirical events. The prescribed causal claims thereby often get rectified by necessary patches such as "Capitalism with Chinese characteristics" (Huang, Stein, and Sekula 2010 [2008]), "Capitalism without Democracy" (Tsai 2007), and "Neoliberalism with Chinese characteristics" (Harvey 2005). At stake here is that they fail to elucidate the *bridge-laws* from theory to empirics and the *criteria of adequacy* carried out under such theoretical frameworks in their work.

Among the scholars who choose to turn against strong reductive approaches and embrace a weak pluralist methodological approach, Harvey's perspective is representative. From the onset, he sees the logic of mobilizing power held by urban administrators, the fierce domestic inter-city competition, the act of integration to the global financial system, and the logic of over-accumulation and spatial expansion in China to be in line with that of a global neoliberal framework. Hence, he equalizes social actors' subjectivities to their productive capacities, endorses the dialectic relation between the fixed material form of space on the one hand, and frictionless spaces of flows – accelerating mobilities of liquid forms of capital on the other. The cities and regions are taken as legitimate units in understanding spatial formation in China. On that level of reduction, the capital accumulating agency can be calibrated by each municipality's productive power. Like many other supporters of a *globalism* outlook, Harvey is not hesitant to admit that the neoliberal framework does not work as a pristine doctrine but as a strong program that can substantially absorb inherited institutions and historical particularize. It means that "inside China, it seems a mixture of the old empire, the modern nation-state, and also many other things, you do not know what" (2017, 266). In other words, the 'context' is deemed to cause contingencies, not necessities.

A few scholars have opted for more comprehensive theoretical reconstructions. For example, Ulrich Beck defines the ideal types of Chinese historical-constellation of modernity in mixed terms, including "state-regulated capitalism; post-traditional authoritarian government; truncated institutionalized individualization and plural-religious society" (cite in Hansen and Svarverud 2010, xvi). In *China Construct Capitalism* (2014), Keith et al. have overhauled the sub-concepts under the neo-classical and neo-institutional frameworks. They argue that the Chinese economy stands opposed to neoclassical economics and its notion of dis-embedded actors. Instead, they employ concepts from Chinese philosophy and cultural norms, such as *guanxi*, *wuwei*, relational property ownership, to illuminate the empirical objects overshadowed by concepts in the classical capitalist framework. They ar-

gue that the Chinese development model is characterized as "one country, many systems" (Keith et al. 2014, 109). In contrast to classic modern approaches following a strong integral program, I find descriptions and empirical explanations from these pragmatic, mixed approaches more persuasive. However, one can hardly tell if the hybrid epistemic forms being employed are consistent or coherent enough in a metaphysical and semantic sense.

The third prevailing angle of looking at spatial dynamism in contemporary urban China addresses the role of consumption. The concept of space, in this case, derives from post-modern consumerism theory, where social-spatial reality is often reduced to 'symbolic representation.' The idea is that the emergence of new and fragmented forms of space (representational space) in Chinese cities is caused by globalizing consumers' – the elite class – behavioral preferences. This approach admitted the observable pastiche and assimilation, stylistic diversity, and heterogeneity of materiality and their representations as subject matter. It assumes concepts to have lost their referents in normative subjects' perception. By addressing the normative subject, social actors' perceptions are reduced to that of the urban elites only, as the result of "the death of the subject" (Jameson 2003 [1991], 173). This consumerism reading echoes with Chang's thesis of compressed modernity characterized by the "dynamic co-existence of mutually disparate historical and social elements" (Chang 2010, 444). In this train of thought, the modern architectures, featuring glass, concrete, and steel, in most of the first and second-tier Chinese cities – whose style denies locational differentiation and overrides cultural particularism – are produced by urban administrators' consuming preferences. The "urban image construction" is motivated by "selling the city" (Broudehoux 2004, 38). At a glance, this argument is well purported by the observable changes in Chinese cities'-built environment, especially in those ubiquitous modernism buildings found in real estate and public infrastructure projects in large Chinese cities. Moreover, the phenomenon of architectural projects duplicating exotic European traditional styles (the Dutch town, Thames Town in Shanghai, Small Paris in Hangzhou etc.) or copying traditional Chinese styles from disjoined times and locations (e.g., Xintiandi in Shanghai, and Wangfujing in Beijing), are also widely accommodated by this perspective (see Bao 2008; Gaubatz 2008; Wu 2010). In such interpretations, economic and social value is attributed to particular symbolisms. The European names and styles in the urban landscape, for example, is deemed associated with preferred social and status for globalized consumers. However, how they come about to be preferred by such globalized consumers are often left unexplained. We cannot wait but also notice the thick meaning/values of the symbolism in the original context and that constructed from a new local context are deflated and conflated.

Our glimpse at the commonly applied methodological approaches studying the social-spatial phenomenon in contemporary urban China shows that social-spatial activities are mostly reduced to, and interpreted as, economic activities in most re-

search practices. The accumulation, or realization of economic value, is adopted as *a priori* causal rationale in explanations. Further, these dominant theoretical lenses at work have also presupposed a distinct *unit of analysis* considered valid. They also prescribe the dimension of social-spatial relations (material-geometrical, representational, topological) to be examined as *empirical content*. Most critically, why and how they employ and re-contextualize certain theories into a different empirical context and how specific concepts inform insightful explanations are under-reflected.

1.1.3 A Multi-situated artworld: open system and partial connections

When I first discovered Caochangdi, which later became my focal point for observing space constitution in the artworld, I found it challenging to settle on *one* analytical framework, to employ *one* unit to demarcate the 'relevant' social actors, material entities, symbols, norms at play, and to grasp how they entangle and evolve. Some snapshots of my observations would illuminate this issue. On Baidu maps, Caochangdi sits in Chaoyang district at the intersection of the fifth ring road and the airport expressway. Its location counts as suburban for Beijing as it is barely accessible by public metro. According to the written history, Caochangdi came about as a territorial community' since the Qing dynasty. For a long time, the village members engage in farming on the definite village territory until the artist community started to settle there in the late 1990s. A renowned artist named Ai Weiwei firstly relocated his studio to Caochangdi and set up an art organization called China Art Archives &Warehouse. Gradually, informal housing and services flourish in Caochangdi, and this area became culturally, socially, and materially heterogeneous. Like many ordinary villages, its day-to-day administration is run by a locally elected political body, consisting primarily of representatives from the two local villagers' kinship lineages: the Zhang and Sun family. For art fanatics and dealers, Caochangdi is Beijing's most important locus of galleries and artist studios, secondary only to an art institution agglomeration called 798-art district state – a creative industrial park acknowledged by the state. But, once one enters Caochangdi, going into its shallow, deep lanes and alleys, one realizes immediately that this place cannot be subsumed under the notion of an 'art village.' Otherwise, too easily, readers will associate it with gentrification processes, the creative class, SOHO and so on.

When asking different actors in Caochangdi, they will refer to this area with different names. It is seen as one of the countless un-planned 'villages-in-the-city' (cheng-zhong-cun[5]) in suburban Beijing by urban planners and regulators; as an under-regulated 'creative industrial zone' located on a tiny and unfavorable piece of

5 Cheng-zhong-cun (城中村).

land by municipal governors; as a 'rural village' called Caochangdi by the local vil-
lagers who have their homes and community build up there, and so forth. It is also
one of the few affordable and' liveable places' in the capital city Beijing in which mi-
grant workers – taxi-drivers, restaurant chefs, installation workers, delivery men
– can stay and make a living. It is also known as 'Cao-Cun,' a meeting point for the
local and global art community, where the art insiders extend their professional or
business networks. The names mentioned here hinted at a lack of coherent *norma-
tive system* ruling the social-spatial development of Caochangdi. Across these social
communities, one can observe some normative relations. For instance, the regis-
tered villagers of Caochangdi are also landlords to the art communities due to their
membership in the village collective. The political membership endorses them with
a share of the collectively-owned land and the ownership of their private homes.
However, more transient relations emerge and evaporate in Caochangdi, awaits to
be uncovered and explained.

In Caochangdi, an explicit system of *visual codes* is also absent. The constellation
of architectures in Caochangdi forms a pastiche in the highly compact area of ap-
proximately one square kilometer: the self-built multi-story and low-budget brick
and concrete compounds are close neighbors, extending their volume – through
vertical stories, external staircases, advertising boards, temporary parking, and so
forth – in all possible dimensions, dismissing regulatory norms and unitary aes-
thetic standards. The ground floor shopfronts along the two sides of the lanes are
filled with living places, exhibition places, bistros, DHL offices, bicycle repair sta-
tions, dental clinic extensions and so forth. Social activities such as vending and
shopping, chatting, and commuting takes place both indoors and outdoors. On
the street, the public-private boundary is frayed and continuously being negoti-
ated. The confluence is especially noticeable in the evenings, when various social
bodies flow out of their working or residential places, meet on central business
streets in the north of the village, where the restaurants and shops agglomerate.
It's the time when some (i.e., blue-collar workers) return to their rented homes in
the village from elsewhere, some (i.e., art dealers and managers) leaving for their
homes elsewhere. Some (artists, local villagers, etc.) stay put in the village but move
their social/private lives to indoor/outdoor dinner tables, playgrounds, tea houses,
and so forth.

On regular days, one can regularly witness encounters among different social
bodies embodying distinct lifestyles on the streets, forming a fluctuating village-
scape of the northern Caochangdi. There are two central gallery agglomerations
in the village and a group of grey-bricked studios standing in separation from
the dense self-build housing compounds, designed by artist Ai Weiwei. Other art
spaces scatter around and dovetail tightly with the neighboring self-built hous-
ing in the lanes. Looking from afar, these designed art spaces blend into the back-
ground, as they are made of the same-colored bricks and are of similar engineering

structure and scale. Only on closer inspection can one spot the art spaces' modernist style and tell them apart from their surroundings. In total, I have counted twenty-one galleries, seven off-spaces, over thirty artist studios, and over forty art-related start-ups scattered around the village in the year 2016. Such physical arrangements of Caochangdi exhibit a hybrid, filiated, mixing and crossing of ideas and forms from diverse times and distant places.

Meanwhile, the social, material bodies constituting Caochangdi are highly mobile, subject to changes at different rates. According to several long-term residents, rumors of impending destruction have been circulating since Ai Weiwei chose Caochangdi as the site for his studio in 1999. Between 2013 to 2017, I have personally witnessed many openings of new art spaces, exhibitions by artists from all continents, and the renovation of the village police station, many residential buildings, and bistros. Furthermore, turnovers of physical spaces, shop fronts, and signs are also visible. Some art events program took place in Caochangdi and disappeared into obscurity in the next week, month, season, or year.

Figure 1 Street view in Caochangdi. On the left side, the mixed-use residential area; On the right side, the gallery compound named "the red courtyard no.1." (Photo by Xiaoxue Gao, November 2013, Caochangdi, Beijing, China)

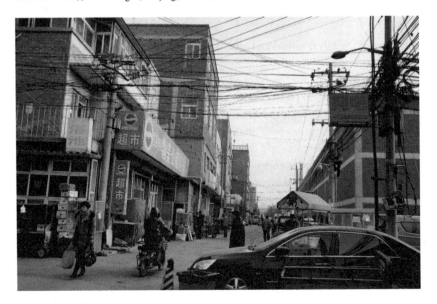

During my field trips, I have communicated the most with the artist community, whom I met in Caochangdi. Some work there, some live there, some have their work exhibited there, some party there. Caochangdi is a hub where many di-

Figure 2 View from within the "the Red Courtyard No.1." (Photo by Xiaoxue Gao, November 2013, Caochangdi, Beijing, China)

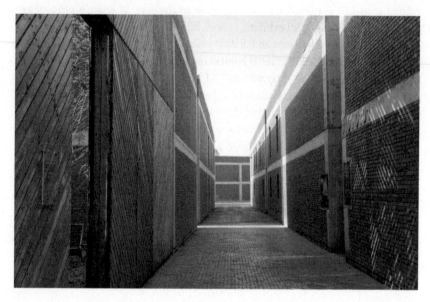

mensions of their lives unfold and extend. Some daily needs of artist communities rely on the village services (laundry, food markets, copy shops, illegal taxi services, etc.) offered by the migrant workers, as well as the local villagers who are landlords and sometimes also art patrons to the art spaces... *Partial connections* take place in regular, accidental, formal, and banal ways. I am convinced that these heterogeneous bodies and their relations shall not be subsumed under the mere notion of 'artworld,' nor does the artworld fully unfold in Caochangdi.

Moreover, having art as a keyword in mind when designing and carrying out my field trips, I have discovered art-related practices beyond particular and fixed institutional boundaries (i.e., museum, gallery, academy, auction house). The generally considered, integral practices of the artworld might include studying and creating art, curating, installing exhibitions, dealing, trading, transporting artworks, documenting, reviewing, and critiquing artworks and the art system. They conjure up heterogeneous social relations among artists, curators, dealers, gallery technicians, landlords, politicians, celebrities, editors, real estate developers, party caters, taxi drivers, delivery men, and so on. Some less frequently occurred events and forms of relations are proved to be of critical significance to the *sustenance* of the artworld. For example, none of my interviewees would refute the importance of having a

reliable landlord (rental relationship) for the sake of materializing an art project, despite their seemingly unrelated role in the artworld.

Having connected with some of the representative and active actors from the artworld, I got linked to many more places: to 798 Art District for numerous exhibition openings, workshops, and artist talks, to Heiqiao village (a nearby artist village further towards Beijing's outskirts) for studio-visits and interviews, to countless restaurants and bars in Wangjing neighborhood, to Chinese Academy of Fine Arts (CAFA) for conferences and workshops, to Chinese Museum of Art (NAMOC) for interviews, to the Guardian auction house, to the K11 shopping mall in Shanghai for social meet-ups, to Kassel Documenta, to Berlin and Cannes for art biennials/fairs/festivals and parties. The art communities I know share overwhelmingly cosmopolitan lifestyles and outlooks. Departing from Caochangdi, following the notion of art, the Artworld-relevant actors, artifacts, and relationality are multi-situated in the world.

My field experiences allude to an artworld driven by multi-linear structural and procedural drivers. As a passionate flaneur who has lived in several large Chinese cities, the 'sense of place' (Relph 1976, 20) I noticed in Caochangdi – amidst material, semantic and aesthetic hybrids, the co-existence of cross-historical and trans-local entities and ways of life, the immediate and transient norms, and the provisional and approximate practices – was nothing but familiar. As a rule, the social phenomenon is rarely unambiguous. In my eyes, Caochangdi precisely exemplifies a typical spatial phenomenon that occurs in post-reform Chinese society, where the fragmented structural changes occur in an extremely condensed manner in respect to both time and space, prompt heterogeneous bodies to adapt and react. Many bodies get carried along in a particular wave and held together in proximity, forming more or less enduring and visible assemblages in urban spaces like Caochangdi. I thus held back from employing hypotheses merely from one conceptual framework of social-space. The epistemological-methodological link principle in the singular form may hinder the discovery of the particular causal mechanisms critical for introducing cross-sectorial changes. Thus, to understand the way in which these particular bodies get held together, the parallel processes of stabilizing or destabilizing, I shall explore approaches for systematic employment of mixed theories and methods.

1.2 Research question

My above-described preliminary reflections lead to further inquiries on the relationship between *epistemic assumptions* about the nature of social-spatial constituents embedded in the *conceptualizations of (social) space* hold by the *knowledge*

producer and *empirical events*. The question of this research is thereby a method-
ological one, which could be summed up as follows:

- How can one best employ a (relational) social-spatial theory to inform a context-
 sensitive study of particular situated social-spatial phenomenon?

When I draw my targeted empirical subject matter (the spatial constitution and
transformation of the artworld in Beijing) into concern, this question can be elab-
orate as:

- How can I gauge and bridge the epistemic distance between the traveling so-
 cial-spatial theories (conceptual tools) and the contextual knowledge held and
 enacted by the situated research subjects?
- What are the methodological steps needed to avoid the epistemic fallacy and
 ensure the finding of generative mechanisms underlying the timed and spaced
 events?

1.3 Preliminary methodological concerns

1.3.1 Post-modern reflections, thinking of space relationally, relativism and the local context

The issue of 'validity challenge' embedded in applying traveling social scientific con-
cepts, models, and theories originated from Anglo Sachsen academia to analyze
or explain the phenomenon in other historical and social contexts or on a global
scale is not novel. So far, many scholars have declared their skepticism against the
claims of universal truth and the cross-cultural validity of applying social theo-
retical tools. Lyotard has famously pointed out that modern scientific knowledge
systems are organized around a particular set of grand narratives, including "the
dialectics of spirit, the hermeneutics of meaning, the emancipation of the ratio-
nal or working subject, or the creation of wealth" (1984, 1). According to Lyotard,
these meta-narratives have referred to enlightenment narratives, which constitute
the historical backdrop against which modern scientific knowledge is legitimated
and promulgated. In other words, the universal claims underpinning the enlight-
enment narratives are taken as undertones in modern scientific practices. Giddens
has also asserted that modernity, along with its affiliated grand narratives, "has its
roots in specific characteristics of European history ... [with] few parallels in prior
periods or other cultural settings" (2013, 174).

In our time, universal claims have, to a great extent, been dismissed. More
specifically, knowledge production within the sociological sphere is also deemed

rooted. As Urry has once noted, "a specific academic practice, was the product of the particular moment, of emergent industrial capitalism in western Europe and North America" (2012, 10). Regardless, the social-political impact of the very concept of modernity, and the widespread deployment of the social theories building on its particular conceptual frame, endure (see Bhambra 2007; Wallerstein 2006). Especially in the globalized media and academic arena, Eurocentric or Western-centric political perspectives or the so-called sociological gaze from Global North are still widely deployed in interpreting the occurrences of social-spatial formation in the Global South. As a result, such scientific or public knowledge referencing Global South reality further contribute to reproducing the north-south power structure (Connell 2007).

One rectification plan presented by 'northern' intellectual communities is to introduce comparative perspectives and advocate for the pluralism of voices. The discourse of "multiple modernities" (Eisenstadt 2003), for instance, has made major attempts to recognize and justify the differences between civilizations. It encourages scholars to rethink the embedded character of social-spatial events and be sensitive to the overt and covert differences in the frames of meaning that prevailed in the global periphery. Such reflections have inextricably prompted the emergence of various forms of *relativism-localism* (i.e., nationalism, regionalism, place-localism). These forms of "judgmental relativism" have thereby generated paradoxes. According to Giddens, "each makes the circle in which all knowledge moves – always involving presuppositions but being able to illuminate such presuppositions through knowledge built upon them – into a vicious rather a fruitful one." (2001, 152). The knowledge produced along this *relativism-localism* line is self-referencing or even self-petrified.

The other proposal to overcome epistemological universalism is to take a realistic view of the empirical *interconnectedness* – the relations, the movements, and the transnational structures – of social reality. Ulrich Beck, for instance, has reified such an orientation through coining a 'cosmopolitanization vision.' It rests on an understanding of reality as "a non-linear, dialectical process in which the universal and the particular, the similar and the dissimilar, the global and the local are to be conceived, not as cultural polarities, but as interconnected and reciprocally interpenetrating principles" (2006, 72–73). Methodologically speaking, this cosmopolitanism orientation has been reified into several concrete approaches. They include replacing the *either/or* oppositional typology between 'nations,' 'streams,' 'networks' and 'scapes' with *both/and*, applying multiple perspectives to read and interpret every single phenomenon of study; making inquiries into the congruence or lack of congruence between actor and observer perspectives, rather than taking a fixed perspective for granted (ibid., 81). Meanwhile, many scholars from the Asian countries and other late-mover regions have been aware of the shackles in the northern narrative, hence addressing the interconnectedness in the locally observable phe-

nomenon and putting forward multiple (time-space and theoretical) interpretive narratives (see, Chen 2010; Mizoguchi 2011 [1989]; Zhou 2010).

Behind all these efforts in search of post-modern resolutions, a shared acknowledgment is that frames of meaning being employed by actors to-be-known at a given time-space are very likely to be plural and dynamic. Local subjects might deploy incongruent or inconsistent frames of meaning unrelated to the ones researchers have adopted. However, while acknowledging and embracing conceptual multiplicity and empirical connections, most approaches fail to offer a criterion for rational evaluating or comparing different explanations' validity. It is logically evident that a Sino-centric perspective is by no means better/worse than a Euro-centric perspective in analyzing and understanding this interconnected, continually transforming social-spatial occurrences. Regardless, a full-fledged Sino-centric social scientific realm[6] does not exist. Thus, questions remain: how can researchers who aim to conduct context-sensitive studies in a post-plural world work with theories that offer the most accurate analytical purchase to their subject matter? How can they get there, methodologically? This book undertakes such methodological questions, particularly engaging with the 'conceptualizations of space (theoretical),' and 'the formation of the artworld in Beijing (empirical).'

The concept of space in the social sense is, of course, extremely polyvalent. Notably, from the 1960s onwards, through the incessant efforts made by French philosophers and subsequent sociologists, the analytical constituents of 'space' extend from static representation, materiality, and geometry to social entities, relations practices in the process. The shift to 'thinking (space) relationally,' for many scholars, is already a logical answer to the post-modern challenge. It insists upon "an overarching theoretical approach and ontology that emphasizes the interactional constitution of social units, processes, and practices across space" (Go 2013, 31). However, the relational turn in the social scientific realm concerning the conceptualization of 'space' is not yet theoretically coherent, i.e., the analytical frames are constructed upon various ontological-epistemological assumptions genuinely alternative and incompatible with each other. Some scholars (e.g., Jessop, Brenner) have opted for mixing one relational framework with epistemically 'othered' ones in virtue of grasping the multidimensional nature of social-spatial relations. They find such a pragmatic approach justified as it avoids "ontologically privilege a single dimension, presenting it as the essential feature of a (current or historical) socio-spatial landscape" (Jessop, Brenner, and Jones 2008, 391). In other cases, conceptual collage takes place on the epistemological level. For instance, Yeung advocates

6 Regarding the (lack of) sinicization of sociology in China, Chen's (2018) book has offered a thorough chronological documentation on relevant historical incidences and discussions addressing the evolution of the sociological discipline in China from early 20th century.

integrating a 'relational concept of power' into the neo-institutional economic, geographical analytical frame. In doing so, he hopes to reconcile the institutionalism analytical framework by selectively embracing relationality, particularly in "power relations and actor-specific practice" (Yeung 2005, 37).

On the other hand, scholars such as Jeff Malpas and Martina Löw propose to build the concept of relational space on coherent epistemic foundations. They hope to ensure the empirical data is gathered coherently and interpretations hold together on all analytical levels and perspectives. For example, Malpas holds that common multi-perspective approaches or eclectic approaches (i.e., one employs varying terms like territory, place, scale, and network in the study) committing to different ontologies (realism-substantial and idealism-relational) to be problematic. He states that "many spatial concepts simply give accounts of various phenomena of space only rather than conceptualizing space as such, lacking concerns for other spatial concepts rooted in philosophical topology" (Malpas 2012, 226). By pointing out that a spatial concept is based on "phenomena of boundedness, openness, emergence and relational to place and time," he proposes re-embed geographical thinking into the domain of philosophical topography.

Having this divergent modus operandi in mind, I will briefly introduce Critical Realism in the following section. I find the distinct meta philosophical topology it offers will shed light on a new methodological path, upon which we can resolve the conflicts between the plurality of (Northern) concepts, post-plural social reality, and context-sensitive research without sacrificing the ontological-methodological coherency.

1.3.2 Critical realism and research strategy

As described above, in the post-modern era, awareness is widely shared among social scientists to avoid making totalizing claims on the level of meaning. It is also clear that relational thinking, although representing a core feature in the intellectual movement against totalizing theories, is not yet coherently theorized. They rest on different epistemic programs. Meanwhile, methodologists argue that if a consistent connection between ontology and methodology is missing, the employment of methods will be, "if not wrong, less fruitful" (Danermark, Ekström, and Karlsson Jan Ch. 2005 [1997], 175). Besides, when taking a trans-locally configured social field as subject matter (i.e., the artworld, whose material and symbolic constituents crisscross several social fields, situated only partially in China's social-institutional context), I am aware that it would be partial, if not arbitrary, to recourse to one theoretical program for explanations. Thanks to the insights entailed in the Critical Realism framework, I am convinced that it is both possible and necessary to employ multiple spatial theoretical frames with methodological rigor. Which ones to employ and how they are applied shall not be an *ad hoc* decision but the central

concern of the research. My goal is that, through employing theory(s), I give consistent and manifold accounts of the partially related social-spatial occurrences and explanations for the inconsistencies observed from the social-spatial phenomenon.

To answer my research question, the first barrier is to clarify the epidemic constituents and assumptions underlying the traveling theories of space. Straightaway, the sociology of knowledge (SK) approach has offered methods for teasing out epistemic entities and inherent inferential relations. It also leads to examine social (institutional and communicative) rules and resources regulating knowledge production, circulation and legitimation, and epistemic positionality subjects. Thus, I will draw on the sociology of knowledge toolkit to deconstruct and elucidate the given relational conceptualizations of space with relation to their underlying epistemic assumptions and attributed causal mechanisms. The meta-philosophical framework in Critical Realism (CR) is insightful in overcoming the second barrier: to locate the competing relational-causal claims on different analytical levels and link them effectively to my empirical analyses. The Critical realism ontology offers strong arguments on the nature of social reality and social scientific knowledge. It introduces abduction and retroduction as warranted inferencing modalities and a mechanism-based and effect-driven notion of causality. They are necessary for evaluating the strength and validity of the selected theoretical thesis in interpreting the targeted empirical phenomenon. I will explain why I engage critical realism as the metaphysical base, and how retroduction, generative mechanism, and effect-driven causality fulfill the goal of this research.

1.3.3 Critical realism and its metaphysical assumptions

Critical realism is constructed to solve the epistemic fallacy, which is at issue in inducing cross-cultural theoretical-empirical inconsistencies. The 'epistemic fallacy' refers to the problematic reduction of ontology-statements about being (i.e., what exists) to epistemology, or the limitation of reducing "reality" to what can be empirically known or experienced (Archer et al. 1998, 27). To be more specific, in light of CR, both constructivist and positivist research approaches are victims of this fallacy. Despite the ostensibly oppositional truth conditions these two approaches entail, both have reduced reality to empirically accessible human knowledge: the former reduces reality to experiment results. At the same time, the latter diminishes it to the meaning entailed in commonsensical discourses. In other words, CR is against both the naive realist view prevalent in natural sciences and against the soft epistemological-interpretive view of reality, insisting that the human consciousness constructs meanings but has no direct access to reality. It also criticizes social scientists following empiricist epistemology. It is when one researcher (the knowing subject) perceives oneself to be "an impartial observer and the other to be subject to the observer's gaze" (Savage 2000, 328). In this circumstance, the

real mechanisms and dynamics of the phenomenon are dictated by and reduced to the knowing subject's epistemic frame. In sum, CR is against reducing reality to a matter of different perspectives dictated by corresponding epistemic frames: presupposed conceptual categories and causal mechanisms.

Figure 3 An Iceberg Metaphor for CR ontology. (Adapted from Amber J. Fletcher (2016), Applying critical realism in qualitative research: methodology meets method, International Journal of Social Research Methodology, 20:2, 181-194, fig. 1)

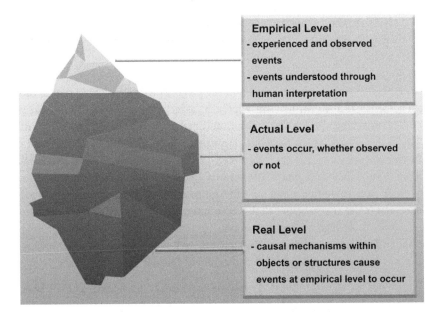

Then, what is CR's account of social reality? The account Bhaskar proposes is to categorically distinguish between the "transitive" and the "intransitive objects of science" (1978 [1975], 36–38), between our categories, theories, and conceptual frameworks on the one hand, and the real entities, mechanisms, structures, and relations that make up the natural and the social world on the other. Hence, CR treats (social) reality as theory-laden but not theory-determined. For Bhaskar, the reality is both 'intransitive' (exists independently of humans) and 'stratified,' i.e., hierarchically ordered – known as the domains of the 'real,' the 'actual,' and the 'empirical' (fig.3). Such an account of reality is commonly illustrated in the form of an iceberg. The real domain contains mechanisms and structures with enduring properties. The actual domain consists of events that occur, although they are not necessarily observable to the perceiving subjects. The empirical domain contains those events that are observed, experienced, or understood by human interpre-

tations. The stratified and differentiated understanding of reality in CR provides an ontology that accommodates plural epistemologies for researching the targeted social subject.

According to Bhaskar (2005 [1979]), such a stratified ontology commits to the particular nature of the social world in terms of:

1. Social structures, unlike natural structures, do not exist independently of the activities they govern.
2. Social structures, unlike natural structures, do not exist independently of the agents' conceptions of what they are doing in their activity.
3. Social structures, unlike natural structures, may be only relatively enduring (so that the tendencies they are grounded in may not be universal in the sense of space-time invariant)[7] (ibid., 42).

Here, the first claim about the nature of the social structure is close to that in the phenomenological-constructivism approach, associating social structure closely with experiencing subjects' perceptions and practices. The second and the third claims, plus Bhaskar's claim about intransitive objects, demonstrate their core differences: the social structure is deemed a result, not a cause of social practices, being both spaced and timed. CR regards social beings not reducible to their symbolic dimension (meaning), and meanings as an effect resulting from social activities. It also suggests that all theorizations of reality can be treated as fallible, but some knowledge is closer to capturing reality than others. The following example from philosopher Ian Hacking can well-illustrate such a relationship between concept (theory), social structure and observable empirical events:

> I do not necessarily mean that *hyperactive children*, as individuals, on their own, become aware of how they are classified and thus react to the classification. Of course, they may, but the interaction occurs in the larger matrix of institutions and practices surrounding this classification. There was a time when children described as hyperactive were placed in 'stimuli-free' classrooms: classrooms in which stimuli were minimized so that children would have no occasion for excess

7 The meaning of space and time is not clearly defined in Bhaskar's theory. At times, Bhaskar's formulation comes close to a Leibnizian idealist relational concept of spacetime, describing it as "set of relations" and a "potentially emergent property either of new relata of an existing system of material things, or relata of a new emergent system of material things" (Bhaskar 2008 [1993], 68).The relative space-time locations in materiality, or in his own words, the "site or space-time duration of certain geo-historically specific and internally related ensembles of structures, powers and tendencies," are also drawn upon as spacetime (Bhaskar 2005 [1979], 193). The main difference that I identify is that, for Bhaskar, it is the new relations (sui generis) induce possible causal powers rather than the pre-existing law-like social structure.

activity. Desks were far apart. The walls had no decoration. The windows were curtained. The teacher wore a plain black dress with no ornaments. The walls were designed for minimum noise reflection. The classification hyperactive did not interact with the children simply because individual children had heard the word and changed accordingly. It interacted with those who were so described in institutions and practices that were predicated upon classifying children that way! (Hacking 1999, 103)

In this example, Hacking has demonstrated, when one departs from the norm-related event of 'hyperactive children,' can one reveal a few stratified layers of social realities and how they interact. Children's *hyperactive practices* towards stimuli are observable in the empirical domain. The generalization of such observations has resulted in a *scientific notion* of 'hyperactive children.' The *scientific notion* is deployed as a *social structure* and manifested in the laying out the classroom and the dressing codes for the relevant teachers. It becomes one layer of social reality, subsists even in the absence of any noticeably 'hyperactive practices.' The effects of this social structure are timed and spaced. It does not apply to arranging 'normal' classrooms. It will be replaced when Children continue reacting hyperactive. It is also evident that children's *hyperactive properties* are neither fully triggered nor manifested in such a school environment when the 'hyperactive children' *social structure* is at play. Thus, it has also illustrated another aspect of CR social ontology that social entities' existence is partly independent of the conceptions we have of them.

According to Mingers, CR epistemology entails four characteristics, which include: "1) social systems are inherently interactive and open; 2) the possibilities of measurement are minimal since intrinsically the phenomena are meaningful, and meanings cannot properly be measured and compared, only understood and described; 3) social science is itself a social practice and is, therefore, inherently self-referential; 4) social theories must be self-consistent in not contradicting their own premises since they are part of their own domain" (Mingers 2014, 2.3.3).

These four insights are crucial for re-envisioning how context-sensitive research could be done. The first point suggests that the constituents and their relations in social reality are conceived as constantly interacting, evolving, and knowledge-laden, opposing the controllable, close, and passive lab environment. Social knowledge (generalized from describing and explaining certain social phenomena) is the transitive objects evolving from the social reality, which can affect other constituents in the social reality and perhaps change them. This point resonates with Giddens's concern about the 'double hermeneutics.' Giddens argues that in comparison to nature scientific domains, where conceptualization represents a "single hermeneutic," social science conceptualization involves a "double hermeneutic": the social conceptual schema "enter and grasp the frames of meaning involved in the production of social life by lay actors, and reconstitute these

within the new frames of meaning involved in technical, conceptual schemes" (Giddens 2001, 86). The second point has addressed the distinct attributes of social meaning, which can hardly be measured by a unitary scalar. The third and fourth points suggest that social scientific theories and concepts are deemed in themselves products of social practice. The timed and spaced epistemic structures from one's domain condition their production.

Regarding the origin of knowledge, CR shares with SK tradition (see, e.g., Berger and Luckmann; Schutz), in that they both acknowledge commonsensical knowledge to have a social origin. They are socially distributed and legitimated. Even more so, it echoes with the Science and Technology Studies (STS) tradition on acknowledging the mutual influence between scientific knowledge and their social rootedness (see Cetina 2009 [1999]). They both regard natural scientific knowledge production to be a process of selection, translation, and construction of information through 'epistemic machinery' validated in the epistemic culture. They also both emphasize the plurality of epistemic frames, which are socially embedded and constructed. Distinctively, CR epistemology holds that entities in social reality (e.g., observable social practice) interact with our conceptual knowledge of them and other intransitive social structures, which are not necessarily determined by them. Social structure and practices do not relate dialectically because they "do not constitute two moments of the same process" (Bhaskar 2005 [1979], 36). The below-illustrated model from Bhaskar showcases such a core difference.

Figure 4 Bhaskar's illustration on the distinction between constructivism and the transformational models of Society/Person Connection. (Bhaskar, Roy. The possibility of naturalism: A philosophical critique of the contemporary human sciences. Routledge, 2014., 35-40)

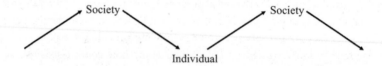

Model III: The 'Dialectical' conception 'Illicit Identification'

Model IV: The Transformational Model of the Society/Person Connection

Furthermore, CR epistemology does not argue that the theories, models, and classifications we use to study social reality are 'objectively' wrong for any targeted research subjects. Instead, it argues, the way they reduce the real to the conceptual may accommodate only the manifested discursive order of reality. It is then unlikely to reveal the intransitive real and the underlying generative mechanisms that induce events to occur. For this reason, according to Bhaskar, one must "avoid any commitment to the content of specific theories and recognize the conditional nature of all its results" (ibid., 5). He also proposed, presumed causal laws must be analyzed as "tendencies," and initial theories must be treated only as "initial theories" (ibid., 50).

It occurs to me that, for conducting context-sensitive research, one shall 1) capture the plural, interacting generative mechanism underlying the locally observable empirical events; 2) engage with interpretive research methods to excavate subjective meanings; 3) avoiding reproducing the linear causality prescribed in given theories; 4) engage with plural interpretive frameworks systematically by conforming to the ontological, methodological link.

Thinking of space: epistemic frames and the social context of knowing

It is a commonplace that spatial concepts (e.g., place, network, territory, space) developed in the social science domain in the European context are directly or indirectly built from the absolute, relative, and relational conceptualizations of space embedded in modern philosophy-physics. It is to say that the epistemic entities and rules from particular modern science-philosophy traditions are employed in reconstructing the concept of (social) space when it is reasserted in the social domain. In this process, some epistemic forms are refashioned to embrace a wide variety of social entities. Following CR, I take several methodologically sound and widely influential relational conceptualizations of space as initial theories. I dissect and elucidate their inherent epistemic frame and rules in Chapter 2. By *epistemic frame*, I mean, the necessary knowledge elements, structures, and strategies that guide knowledge production and scientific inquiry, as a combination of *epistemic forms* (abstract forms of knowledge or schemata appropriate to the discipline) and *epistemic games* (rules for the manipulation of these forms) (Collins and Ferguson 1993). In the scientific domain, non-convergent epistemic schemes are separated by the well-discussed concepts of 'knowing that' and 'knowing how' – the declarative and procedural knowledge, or what Wittgenstein calls 'bedrock' and 'hinge' propositions:

...the questions that we raise, and our doubts depend upon the fact that some propositions are exempt from doubt, are as it were like hinges on which those turn. That is to say, it belongs to the logic of our scientific investigations that certain things are indeed not doubted... But it isn't that the situation is like this: We just cannot investigate everything, and for that reason, we are forced to rest content with assumptions. If I want the door to turn, the hinges must stay put. (Wittgenstein 1969, 341–43)

Moreover, I stress the role of manipulating rules like communicative rules in shaping the knowledge produced. I thereby look at the "(argumentative) legitimating elements (for example, scientific, moralistic, and voluntarist patterns of legitimization), subject positions, and discourse generated model practices as components of phenomenal structures" (Keller 2005, 57).

Conceptual thinking of space is at once epistemic, personal, and social. I do not want to endorse the argument that, *empirically*, the way social actors *think and sense* are pre-structured by an existing palette of epistemic schemes. This is partly because the contextual epistemic environment in which social actors are situated is increasingly dynamic and condensed than linear, static, and highly institutionalized. I find van Dijk's concept of 'mental context' cogent in identifying the *epistemic frames actors actively employed* in a particular concrete context. Van Dijk argues that social situations do not directly condition knowledge. Neither can a researcher tell a priori-ly which aspects of the situation are relevant in explaining the produced knowledge-discourse. He proposes to address the interface at the cognitive level, the "mental constructs of relevant aspects of social situations," to reveal the way participants understand, select and represent the social situation that constitutes their actual knowledge structures (van Dijk 2006, 165). Besides, the *emergent properties* arise on the interface of one's interaction with the contextual factors, shape how people feel, think and act. Both only become observable when they cause *consequences* on discourse and practice.

The scope of epistemic frames in the theoretical knowledge of space, correspond more closely with that of the scientific paradigm (cf. Kuhn 2012 [1962]). The term paradigm refers also to the set of presuppositions about the nature of beings and what is knowable and legitimating modalities of generalization and inference (deduction, induction, abduction, and re-troduction), the criteria for true knowledge (consistency, correspondence). Many methodologists have addressed that most scientific questions have different answers depending on which theoretical paradigm is presupposed. Nevertheless, I opt for the epistemic frame as the analytical tool for this research. It addresses the constituents of epistemic schemata more lucidly and connotes less inexorable self-containment and thorough coherency. The epistemic frames can be appropriated, always subject to change in cross-disciplinary or trans-contextual knowledge transfer. It can

also be unsystematic, like the scheme social actors use to understand events in everyday life. It reflects the context-specific and domain-specific practices. For example, when traveling conceptualizations of space are learned and deployed to explain empirical phenomena situated in the Chinese context, likely, the original epistemic frame does not stay as epistemically and hermetically sealed. From the perspective of a non-Western social scientist, focusing on the epistemic frame enables me to address the creative interaction between 'here' and 'there,' an aspect that is less addressed, or black-boxed, by the sociology of knowledge approach.

The abduction, retroduction, and generative causality: research strategy under Critical Realism

As I have indicated earlier, meta social theoretical paradigms originating from Chinese discursive field – in line with traditional Chinese epistemic assumptions – do not yet exist. Theoretical knowledge developed through in-depth, systematic, and grounded empirical approaches is also rare. The traveling conceptualization of social space originating in the West is often applied in the Chinese context in under-reflective, deductive, or *de facto* abductive manners. As I will show in chapter four, studies often reproduce the presupposed theoretical claims without thoroughly examining the correspondence between the concepts and the observable empirical data they intend to represent. On the other hand, many scholars have admitted an epistemic distance between the West and China on core ideas such as truth, liberty, equality (Peng and Nisbett 1999). Regarding the epistemic rules for truth, Smith (1980) claims that the Chinese focus on what is appropriate in the situation rather than what is objectively true. Julien (2000) asserts that the Chinese language is known to be indirect and context-dependent. Based on these insights, I am alerted that relating the traveling theoretical frames to the particular empirical phenomenon is challenging. Also, in doing so, the risk of reproducing the theoretical hypothesis's prediction is high.

As indicated, following the CR principles, the social reality is deemed an open system. People's experience of the real world is deemed theory-laden, and that social scientific practices are deemed self-referential in nature. To me, conducting context-sensitive analyses on situated social-spatial phenomenon shall involve sampling transitive data sources in the empirical domain and revealing the intransitive knowledge at the actual and real ontological domains of reality. It is thereby necessary to excavate the prototypical modes of contextual thinking and treat them as potential initial theories. In Chapter three, I put the discourses referring to the conceptual constituents of space in traditional Chinese normative thoughts under scrutiny, as they yield potentially to the prototypical epistemic forms and rules deployed by Chinese scholars, administrators, and subjects in the artworld, in constituting the social reality. Then, in chapter four, I attend to the main 'traveling

spatial conceptualizations' being employed by urban planners and geographers in studying spatial phenomena in contemporary urban China. These materials help to triangulate the epistemic frames at work in studying and constituting the urban spatial phenomenon in China. My focus lies not in discussing the empirical content of these pieces of knowledge *per se* but uncovering the underlying epistemic and social structures that allow them to be learned and re-contextualized, i.e., selected, anchored, adapted, and transformed.

In this research, following the principle of the ontological-methodological link under CR, I recourse to *retroduction* as the guiding methodological strategy to analyze the data mentioned above. The term 'retroduction' is often used interchangeably with 'abduction.' Both processes allow researchers to engage with theories on creative and imaginative bases than fully committing to linear inferring orders. Suppose the direction of inferential movement in 'deduction' moves from hypothetical premises to empirics and finally validation. To 'induce' is to move from empirical observables to theoretical hypotheses and examine if the hypothesized mechanisms correspond with further observable data. Retroduction is then a strategy designed to avoid naive reproduction of predications and allow the act of moving from something to arrive at something else. As a methodological strategy, it is more than just methods.

For those who differentiate abduction from retroduction, the former begins with theoretical frameworks but does not present logical rigor like deduction, nor does it forge empirical generalization like induction (Collins 1984). In the book *Explaining Society* (2005 [1997]), Danermark et al. have clarified, the initial objects of inquiry for abduction are theories, i.e., rules describing a general pattern, and differing from deduction in that the conclusion is not intended to be logically given in the premise. Through empirical observations, one does through abduction to re-describe or re-contextualize the theory, i.e., using a set of concepts from an existing theory to describe, interpret, and explain something in a new context, yet remain skeptical towards the predicated causalities between the concepts. On the other hand, retroduction begins with unexpected empirical observations, then moves to the possible cause to arrive at an explanatory hypothesis. The notion of the unexpected, however, is relative to the existing theoretical claims that one plans to use as a reference. The core of retroduction, according to Danermark et al., is transcendental argumentation, which seeks to clarify "the basic prerequisites or conditions," i.e., the circumstances without which an event cannot occur, in social relationships, people's actions, reasoning, and knowledge (ibid., 96). The relationship between the retroduction and induction modalities lies in that induction does not rely on existing theory as a conceptual reference. In contrast, retroduction relies on a conceptualization as a reference to construct and test its explanations.

Table 1 Deduction, Induction and Abduction – the informal structures of inference (Adapted from Danermark, Berth, Mats Ekström, and Karlsson Jan Ch. 2005 [1997]. Explaining Society: Critical Realism in the Social Sciences. Critical realism: interventions. London, New York: Routledge, 90, table 3)

Deduction	Induction	Abduction
Rule: All beans from this sack are white	Case: These beans are from this sack	Rule: All beans from this sack are white
Case: These beans are from this sack	Result: These beans are white	Result: These beans are white
Result: These beans are white	Rule: All beans from this sack are white	Case: These beans are from this sack

Furthermore, in CR, a distinction is drawn between *real* and *actual* causation. Real causation concerns the powers and tendencies that complex systems have to *affect* the world, regardless of whether they are actually realized on any particular occasion or observed by anyone. The mechanisms do not necessarily manifest as the experience or as the entire visible aspects of events. Therefore, the empirical regularities are deemed pieces in the jigsaw puzzle leading to uncovering generative mechanisms, than arbiters *per se*. Both the abduction and the retroduction strategy reinforce CR's principle of the ontology-methodology link. They enable the researcher to perceive social reality as a stratified and open system, where the experiences, events, and generative mechanisms are mutually interactive but not reducible to one another.

Both inferential strategies support researchers to employ theory as tendencies and dismiss absolute logical rigor. They enable the researchers to leap from manifested phenomena to generative mechanisms. This leap is endorsed by the CR ontology, as mechanisms, not the empirical regularities, is the base of the social scientific research. Thus, I do not differentiate the two strategies and deem both particularly suited for uncovering plural deep structures from the empirics in the context of compressed modernity. If the hypothesized theoretical claim (in form of causal agent) is valid, it will help code the tendencies observed in the empirical domain (Alvesson and Sköldberg 2000).

Finally, how can one make sure that one mechanism (presumed in one conceptualization of space) is more suitable to explain the targeted phenomenon than the others? One solution lies in Bhaskar's definition of *generative causality* – as contingently effective, ontologically deep, and generative mechanisms or powers. I

repeat, here again, CR holds that reality is stratified, events occur (despite their observability) on the actual domain, and the real is the domain of mechanisms that generate the events through their interactions. It contrasts with positivism or empiricism approaches, where causation is defined based on regular successions of events or a correlational assessment of event regularities. The CR causality is, "contra Hume, that causal relations are relations of natural or metaphysical necessity, rather than of contingent sequences" (Groff 2007, 2). Thus, one may take any hypothesized causal agents to code the tendencies of events and compare them with what is observed in an open world, to determine their effectivity.

Concretely, Bhaskar has proposed a set of methods to identify and validify the structure that generates the events, abbreviated as DREIC. It includes procedures of description, retroduction, elimination, identification, and correction (DREIC):

> Description of some patterns of events or phenomenon; Retroduction is applied – putative causal mechanism(s) are hypothesized which, if they were real, would account for the phenomenon or pattern in question; Elimination of those which do not apply in this case; The causally efficacious generative mechanism or structure is Identified; iterative Correction are made to existing theories in light of this identification. (Bhaskar 2016, 2.4)

In line with CR principles, manifold re-descriptions and interpretations of a situated social-spatial phenomenon can be made. If any epistemic frame applied is not casually effective, the outcome of this examination would still contribute to the elimination or change of the chosen hypothesized causal agent. Nevertheless, following retroduction to a full account – examine the explanatory powers and liabilities of various epistemic frames possibly confer to the empirical phenomenon – may prove to be extremely complex, if even possible. One may also encounter transcending levels of explanations in this process.

CR and its ontology and epistemological principles are in line with seeing theorizations in social science as a product of social practice, which is inherently self-referential to the pre-existent epistemic frames. Thus, as previously stated, I start with deconstructing the variegated conceptualizations of space and revealing their underlying epistemic frames. Conceptual deconstruction and elucidation constitute a necessary step for pre-selecting epistemically relevant 'initial theories.' These operations can be found in the first section of this book, from chapter two to four. The spatial conceptualizations that commit to a relational epistemology, addressing different analytical levels are taken as initial theories for empirical examinations in the second part of this book, in chapter five. By following DREIC procedures, the shackles from disciplinary boundaries and conceptual incommensurability become irrelevant. The initial theories are then eliminated or reworked according to empirical tendencies found in Beijing's artworld

1.4 Research map and chapter contours

I draw the constitutive parts of this book in the chart below. The texts on the side will illuminate the inferential relations between these parts following CR principles.

Section One: Thinking of space relationally: epistemic frames and local context of knowing and doing	
Chapter 2	How to differentiate the traveling theories of space? i.e., What epistemic forms, rules, and causality-mechanisms are postulated in the conceptualizations?
Chapter 3	How are the corresponding epistemic forms, causal agents, inferential relations and level of analysis conceived in traditional Chinese thoughts? What epistemic forms and causal agents about space constitution can be derived from traditional Chinese thought? What unique features regarding thinking of space relationally can be found?
Chapter 4	What are the features of the spatial turn in the Chinese discursive field? What epistemic, communicative and normative rules are at play in the Chinese discursive field, shaping the spatial knowledge produced?
Section Two: The retrodictive empirical research on the spatial constitution of Beijing's artworld	
Chapter 5	To apply three initial theories to case, code/redescribe and interpret the empirical phenomenon in the artworld; identify the demi-regularities from the empirical reality. To examine how the prescribed causal agents correspond to the demi-regular tendencies found in the artworld. To summarize empirical findings and evaluate causal efficacy of the particular theory of selection and propose modified/complementary causes.
Conclusion	The role of critical realism in informing the context-sensitive studies of complex social-spatial phenomenon in contemporary Chinese urban context. Reflections on 'thinking of space relationally' in the local context, with regard to spatial phenomena in China under compressed modernity.

Section One: Thinking of space relationally: traveling epistemic frames and local context of knowing and doing

2 Conceptual elucidations
The epistemic frames and causality in relational spatial theories in the European context

2.1 Introduction

It is pointed out by Sayer that "while it is common to argue that social phenomena are historically-specific, and that method should take account of this, little interest has been shown outside geography in their geographically variable character; indeed most social scientists ignore space" (2010 [1984], 99). There is no doubt that the particular intellectual tendency of *thinking space relationally* or the *relational theory of space*, admits space to be all about relations, reflects the intellectuals' efforts in the post-modern social science domain to rectify such methodological negligence. More than ever, social scientists endorse the concept of space (in terms of place, location, territory, etc.) to describe and explain the local and global social formations and transformations. The meaning of 'relational space' is yet to be directly addressed nor given enough analytical rigor in most of the applications. Malpas lamented that "one may develop frameworks to organize forms of spatial description and analysis, those frameworks will be, at best heuristic, whereas what is needed is a more careful analysis of the ontological underpinnings of the very concepts at issue" (2012, 230).

As I have indicated in the introduction, in line with the sociology of knowledge (SK) and critical realism (CR) approaches, I deem conceptual knowledge of space socially produced. The underlying epistemic frame of a conceptualization or theory might, to a great extent, shape scientists' accounts and explanations of the social-spatial phenomenon of interest. It imposes significant challenges for scientists who want to embrace analytical rigor yet remain sensitive to the context in which the empirical phenomenon is situated. In this chapter, in order to elucidate the epistemic underpinnings of the relational thinking(s) of space, I will first excavate the 'epistemic frames' and 'causal agents' embedded in the 'absolute,' 'relative,' and 'relational' notion of space within the physics and philosophical domain. These conceptualizations represent some of the most prototypical epistemic as-

sumptions, which are later appropriated. Then, I pay particular attention to three relational conceptualizations of space within social science. It is necessary to clarify from the roots that *relational* bridges a multitude of theoretical traditions and research approaches (see Powell and Dépelteau 2013), far from forming a unifying paradigm.

Aligning with the stratified ontology from CR and the understanding of knowledge production in SK, I will do the following. Firstly, in sections 2.2 and 2.3, I delve into the ideas of space in modern physics and philosophy to explore the prototypical epistemic foundations. I will revisit the ontological 'substantial-relational controversy' between Newton and Leibniz to elucidate the epistemic frames (forms and rules) underpinning the absolute, relative, and relational concepts of space. Secondly, in 2.4, I examine how the constellations of epistemic forms and rules in the conceptualization of space (A) are transferred from the modern physics and philosophy domain and get recontextualized in the social science domain (A'). The underlying 'connect-ability assumptions' will be excavated and outlined. I search for the empirical content of the epistemic forms and causal agents presupposed in the physically and philosophically defined space (A), which are explicitly or implicitly employed by social science scholars in shaping their ideas of social space (A'). By connecting or bridging, I do not mean a one-to-one transference from A to A' regarding epistemic forms and their properties. The epistemic forms in A' are likely to be modified in light of social events without displaying formal contradictions.

For me, to differentiate the plural forms of the relational conceptualizations of space in social science on a fundamental level, it is necessary to trace the epistemic origin of space in the physics and philosophical domain and to discern the interdisciplinary epistemic connectivity and disparity. More specifically, the discussions in this chapter help to clarify the ambiguity in 'thinking of space relationally,' as listed by Anderson and Harrison:

> There are many emerging questions and unresolved tensions in geography's treatment of 'relations' and 'relationality,' including, how to bear witness to the plurality of relations? How to understand the 'reality' (felt or otherwise) of relations?; are relations internal or external to their terms?; can relations change without the terms also changing?; are actual entities exhausted by their relations?; and how to think what could be termed the 'non-relational'? (Anderson and Harrison 2010, 15)

At the end of this chapter, I will clarify the methodological implications when three selected relational space conceptualizations get deductively employed.

2.2 The absolute-relational divergence and epistemic frames

Space, as Max Jammer notes, is "the subject, especially in modern philosophy, of an extensive metaphysical and epistemological literature. From Descartes to Alexander and Whitehead, almost every philosopher has made his theory of space one of the cornerstones of his system" (1993 [1954], 1). In the modern philosophical and natural scientific domain, the 'absolute,' 'relative,' and 'relational' conceptualizations of space are disputably associated with the theory of space of Isaac Newton, René Descartes and Gottfried Leibniz. For scholars from social-spatial domains, the difference between these notions is often reduced to a matter of semantics, leaving their distinct yet tightly bound epistemic forms and rules overlooked.

Geographer David Harvey asserts that, from his understanding, "absolute space refers both to the kind of *Newtonian space* that 'in its own nature, without relation to anything external, always remains similar and immovable' and to Descartes' *res extensa*, the discrete and bounded physical space." For Harvey, the relative notion of space is mainly associated with "*Einstein and the non-Euclidean geometries*." Relational space, is ultimately associated with the name of Leibniz, which "can embrace the relative and the absolute." The relative space "can embrace the absolute, but absolute space is just absolute, and that is that" (2006b, 272–76). From these discussions, I infer, Harvey deems the three concepts of space as differed merely in representing space of different properties and scope. The depth of conceptual incommensurability, underlined by incompatible ontological and epistemological stances, is clearly underestimated.

Following Lawrence Sklar, on 'ground zero,' the divergence between the Newtonian and Leibnizian theories of space can be captured by the 'substantivalist-relationist controversy' (1977, 225). This term is a bit misleading, as Leibniz's conceptual scheme of space is not free from the substance. However, the properties of substance conceived by Leibniz are entirely different from those by Newton. To further clarify, I first recontextualize these concepts back under 17th century philosophical and scientific realms, examining what and how meaning is given to the constellation of epistemic forms (substance, body, force, time, place) and how legitimacy is given to certain causal inference logically jointing the epistemic forms. The constitutive entities would be thought *about* along the multi-staged conceptualizing process, rather than just thought *with*.

To begin with, the most straightforward statements comparing 'absolute space' and 'relative space' can be found in Newton's writing at the beginning of the *Principa*:

> Absolute space is in its own nature, without relation to anything external, remains always similar and immovable. Relative space is some movable dimension or measure of the absolute spaces; which our senses determine by its position to bodies;

and which is commonly taken for immovable space; such is the dimension of a sub-
terraneous, an aerial, or celestial space, determined by its position in respect to
the earth. Absolute and relative space are the same in figure and magnitude, but
they do not remain always numerically the same... Absolute motion is the trans-
lation of a body from one absolute place into another: and relative motion, the
translation from one relative place into another ... (cite in Jammer 1993 [1954], 99)

When reading this paragraph, we cannot yet tell the meta-epistemic ground taken
by Newton nor the source of his mode of reasoning. Recalling how Newton's law
of motion is taught and demonstrated in the physics classroom might help un-
cover that. In high school, I was taught that Newton wanted to give a systematic
account of motion patterns, which he deemed real. However, in the well-designed
experiments, I would never *observe* or *document* an absolute motion nor an absolute
acceleration from the object used for demonstration (e.g., a running cart). What
can be observed and measured includes a running cart *represented* and *measured* by
its body mass. It *tends* to maintain its speed on smoother surfaces. When it sub-
jects to an external force, the cart's speed *tends* to decrease when its mass increases.
The acceleration is *represented* and *measured* by the increased or decreased running
distance per unit of time (e.g., m/s^2).

Now it because more vivid that Newton's arguments, i.e., laws of motion and
acceleration, can be taken as true only when we accept a set of assumptions. It
includes his 'realistic' assumptions about substance realized and represented in
terms of the quantity of matter, force, absolute durations of time; quantified dis-
tance between real, discrete locational points as measures of absolute time-space.
One shall also warrant an 'inductive leap' – bridging observable tendencies to hy-
pothetical laws as a legitimate way of making generalizations. Thus, what makes
Newton's theorization of motion *true* is the correspondence between 1) recurring
and consistently observable patterns of movements; 2) predictions of movements
derived from hypothetical laws; and 3) the moving bodies' properties attributed by
philosophical presuppositions. Regarding bodies, he has postulated on a 'substan-
tial nature,' which presupposes mass, time, distance, and velocity as the *real* aspects
to be seen and measured through empirical examination. The substantial assump-
tion of bodies is also drawn to justify a reduction in the scientific formulation.
In this context, we have revealed hypothetical and deductive logic aspects, which
subject to purely philosophical debates and immune to empirical verification.

Sklar reminds us that "to go from one's account of absolute motion to the adop-
tion or rejection of either a substantial or relational account of spacetime again re-
quires the invocation of methodological or metaphysical principles whose defense
and criticism seem more a matter for philosophical resolution than for scientific
decision" (1977, 225). Following this thread, I have noticed that Newton's spatial
schema has invoked the epistemic divide between 'movable' and 'unmovable bodies'

as a necessary clause to deduce the difference between relative and absolute motion. The postulation that the body's relative motion is induced solely by external forces hints also at such an epistemic commitment. Consequently, the motion-related properties of things: their position, velocity, and acceleration are all ascribed as relative. Therefore, logically, absolute space must exist to serve as a reference for absolute motion. Alternatively, as Sklar has noted, if Newton claimed motion and acceleration as absolute rather than a relative property of things, the claim of absolute substantial space free of things would no longer be necessary (for more discussion on this point, see Sklar 1977,185-188). Newton's ontological concern in defining absolute space, according to Jammer, is not only logical but also theological. The postulated ontology acknowledges something besides God – as an absolute, immutable, eternal, and real being – to exist independently of how it is measured (Jammer 1993 [1954], 110).

Newton's notion of absolute and relative space, as shown in the analysis above, is constructed based on his sensible observations and philosophical-epistemic postulations. What can be sensed and known rests on the properties of bodies assumed real, measurable, and enduring in relation to absolute space. In Newton's scheme, absolute space has a Euclidean (three-dimensional, homogeneous) structure, whose features can be accessed and measured by following the Euclidean geometric principles. Newton has differentiated two ways that absolute space can be grasped: its real and holistic structure exists only in the divine perception, whereas its parts – the relative dimensions – are comprehensible and perceptible to human senses (see Casey 1997, 142–43; Sklar 1977, 161–62; Jammer 1993 [1954], 96–97). The relative positions and distances are revealed when observers apply the measurements using their bodies as reference points. These epistemic rules constitute the condition in which spatial knowledge is generated and validated as true.

To sum up, Newton's notion of absolute space is, in the first instance, built upon a realist ontological stance. In each subsequent stage, Newton invokes various additional premises and principles to formulate his arguments. These postulations include the dichotomy between movable and unmovable entities and the existence of God. The conceptualization of absolute space emerges both as the necessary medium and the outcome in his deductions. It loses all meaning if we leave the propositions above out. Newton's conception of the relative space rests on the realist epistemology of geometry. It emerges both as the holistic structure of absolute space in the divine perspective and as the *means*[1] for measuring the movable and perceivable dimensions of space by non-divine observers.

1 Newton assumes the Euclidean geometry to be known by the perceiver via internal cognitive structures. He does not explain why, nor how perceivers acquire it as the means for understanding relative space.

As I have cited in the introduction, Leibniz's notion of space is defined by relations – among the coexistent bodies, including not only those which are concurrent and observable but also those that are possible. My focus here is not to repeat all Leibniz's arguments against Newton but only to explicate the core premises and principles embedded in his conceptualization. According to Russell, Leibniz's has followed such a logical order in conceptualizing: "first comes the notion of substance, secondly the existence of many substances, thirdly extension, resulting from their repetition, and fourthly space, depending on extension, but adding the further notion of order, and taking away the dependence upon actual substances" (2005 [1900], 118–19). In this order, 'relational space' is coined as the sum of the substances and relations, whose mobilization or stabilization is explained by the interacting mechanisms (extension and order).

To paraphrase Russel, we can also recount the logical order deployed by Newton in his conceptualization practice. As opposed to an order of discovery, it begins firstly with absolute space, secondly with the movable and discrete substance, thirdly with the relative motion resulting from the external force, and fourthly with relative space, depending on the position of the situated non-divine perceiver. To further reveal the core difference between Newtonian and Leibnizian spatial conceptualizations, it is necessary to situate it back to its historical context. Judging by the Leibniz-Clarke correspondence, Leibniz accepted Newton's claims of absolute and relative motion and acceleration but rejected the claim that viewed absolute space as neither a necessary medium nor an outcome for absolute motion and acceleration. To make his own theorization logically coherent, Leibniz introduced complex definitions for the 'organic' and 'intelligent' substance, as well as the 'law of identity' and 'order of the possible world' as two generative mechanisms to explain the primary and secondary motions of the substances and their interactions. In his own words, the constituents of space include:

> (1) the primitive entelechy, i.e., the soul; (2) matter, namely primary matter, i.e., primitive passive power; (3) the monad completed by these two things; (4) the mass, i.e., the secondary matter, i.e., the organic machine, for which innumerable subordinate monads come together; and (5) the animal, i.e., the corporeal substance, which the monad dominating in the machine makes one. (20 June 1703, PL: 264–265, cite in Antognazza 2018, 351)

There are different readings of the Leibnizian ontological stance[2]. Here, I agree with many interpreters who read Leibniz as an idealist. Thus I summarize his inferences from 'monad' and 'substance' to 'relational space' as follows. As the first step, the monad is conceived as the smallest unit of substance, consisting of soul and primary matter. It subjects to two types of force: one is passive, induced by its soul, the inherent and extensive attribute – *materia prima*; the other is active and external, as the result of the indistinctness of representation – *materia secunda*. The secondary 'organic machine' consists of monads and their dynamic confluences. Leibniz defined a substance's passive attributes by drawing on the presupposed 'subject-predicate principle' and 'law of identity.' The former presupposes that one part of the monad (the soul) is real and unchanging, which relates to the primitive powers that predicates and impels its extensive bodily-material change. Such change might not be observable to sensible perceivers. The latter principle of 'identity of indiscernibles,' along with the existence of God, are also invoked to justify the heterogeneity and irreducibility of the monads among one another. This law premises that "monads must differ, but since they have no parts, they can only differ in their internal states; and internal states, as far as experience goes, are either perceptions or appetitions" (D. 210; L. 409; G. vi. 599, cite in Russell 2005 [1900], 154). In this context, absolute motion is defined as appeared passive extension, explained by the indiscernible identities of the monads.

Drawing on the definition of substances (monads), Leibniz made secondary arguments to explain the formation of mass, or the 'organic machine' – the whole constituted by the dynamic interrelations of interacting monads. According to Leibniz, the mass or the organic machine as the cluster of secondary matter forms a body. It is conceived as an aggregate of monads, whose material body existing only as a phenomenon in the monads' perception, as an accidental unity (G. ii., 252; N.E., 722 and G. vii., 501, cite in ibid., 90). For 'the animal' (as the tertiary matter), monads are conceived to sympathize with one another and cohere into an extended compound with one dominant monad, which in this relationship acquires a certain unity. This unity is made up of heterogeneous compounds.

2 Due to the lack of a magnum opus, some arguments appear inconsistent in Leibniz's earlier and later texts (charges made by e.g., H.G. Alexander 1956, 105; Russell 2005 [1900], 91). The commentators disagree on the ontological stance Leibniz took in conceptualizing the substance, and its relation to change and time. The commentators have also developed different theories justifying their interpretations and explaining the inconsistencies that have occurred. In this section, I opt for an idealist reading of Leibniz on the matter of defining the substance, as in addition to the soul, the material bodies existing and constituting the logical unity in monads are to a great extent predicated by the soul. It is different from the Platonian (idealist) conception of substance which constituted only by immaterial minds. I would not attend to the inconsistencies in the Leibnizian conceptualizations, but purely aim to adumbrate the

The derivative active forces associated with relative bodily motion, and derivative passive forces associated with substantial resistance and impenetrability, occur at the highest-level aggregates. The interrelations between the two forces are interpreted by Pasini as, "the animal force is entirely in the whole, and entirely in any of its parts" (1996, 223).

In one crucial passage in *Monadology*, Leibniz described the indispensable mediating function of the situated body (position), drawing on a second postulated principle: "since every monad is a mirror of the universe in its way, and since the universe is regulated in a perfect order, there must also be an order in the representing being, that is, in the perceptions of the soul, and consequently, in the body in accordance with which the universe is represented therein" (cite in Casey 1997, 177). This quote demonstrates that Leibniz postulated on the existence of an *external and constant temporal and spatial ordering force* (a third one, in addition to substance and mass) on the real level, which partly coordinates with the monads' relative bodily change and movements through the mediation of secondary force. It is also attributed to maintaining the infinite diversity of substances in the universe.

Thus, for each (perceivable) possible world that monads aggregate in, there exists an order that determines the causal relations between monads and how the relative changes occur. For Leibniz, the possible worlds have general laws analogous to the laws of motion; what these laws are is contingent, but the existence of such laws is logically and theologically necessary. This assumption is followed by the inference that each monad has a different 'point of view' with respect to its bodily position. It is particular and biased, as every monad mirrors the world from a particular location and spatial point. We could infer, the boundary of a perceivable possible world for a particular monad is conceived, on the one hand, in relation to the bodily position and soul induced 'intelligibility' of the perceiving subject (the monad). On the other hand, it corresponds with the efficacy of the law of a possible world. Both constraints are postulated to affect the perceptions of coexistent and constitutive monads *in bilateral and symmetrical manners*. For each monad, the sensible ideal order and the bodily position conditioned particular point of view co-shape the 'confused partial' perception of the monads and their relative movements. Finally, the sum states and their connections constitute the aggregate (animal) order and its relative motion as a whole.

In conceiving the epistemic rules, Leibniz has introduced a God's perspective, which sees the order of the possible worlds as being embodied by the monads' bodily relations in the course of passive and active bodily changes. Moreover, resultant spatial relations and the relative motions on the collective level are deemed *external* to the monads' perceptions. Their forms are conceived as constant in the *current-actual* and *forthcoming-potential* terms. In his book, *History of Western Philosophy*, Russell accredits the milestone contribution to the Leibnizian conceptualization of the two worlds: "what I, for my part, think best in his theory of monads is his two kinds

of space, one subjective, in the perceptions of each monad, and one objective, consisting of the assemblage of points of view of the various monads. This, I believe, is still useful in relating perception to physics" (2005 [1900], xi). These assumptions have also enabled him to justify the plurality and diversity of individual substances and their perceptions of space. Leibniz has come up with alternative causal agents to explain the perceived relative motion without referring to absolute motion nor space through conceiving these epistemic entities and rules.

To sum up, Newton's and Leibniz's theorizations of space, have although attended to the same empirical phenomenon (motion), are conceived with vastly different epistemic forms and built upon very different epistemic rules. These presumed principles are not immediately reducible to empirical patterns accessible to impartial observers. I summarize the epistemic frames in three spatial notions as follows:

Table 2 *The Epistemic Frames of Absolute, Relative and Relational Space*

Concept of Space	Absolute Space (Real)	Relative space (Ideal)	Relational Space (Ideal)	
Empirical phenomenon	None	Event: perceived movement of physical objects	Event: conceived primary and perceived body-agglomeration and secondary motion agglomeration	
Ontological Principles	The dichotomy of movable and immovable beings		Law of subject-predicates The identity of Indiscernibles	
Epistemic Object	Material bodies with the substantial attribute: quantity of matter force; points of space-place; pieces of time		Intelligible substance Substantial attribute: soul, material prima Phenomenal attribute: embedded body, point of view; material secunda	
Epistemic Subject	God perspective-holistic and consistent	Sensible observer- logical but partial	God perspective-holistic and consistent	Embedded monads as the sensible perceivers
Knowledge Situation (the hinge propositions that guide the process of knowing)	Whole-a priori knowledge -Euclidean geometry as ordering principle	Partial-a priori knowledge -Euclidean geometry as an ordering principle, applied to perceptible movable dimensions of space-Reflection and Correspondence	Objective–perfect order: maintain and maximize the variety of Substances	Subjective – possible and symmetrically perceivable relations: the result of intelligence and point of view
Explanatory Mechanism for Motion (derived)	Law of motion		Perfect universal order, Contingent general law of the possible world	

After retrieving the three underlying epistemic frames, the flaw of engaging mixed conceptual frames 'pragmatically' in one analysis becomes clear. For instance, in the following narrative, Harvey dismisses the thick difference underlying the constituents of two theories of space:

> The view of relative space proposes that it be understood as a relationship *between* objects which exists only because objects exist and relate to each other. There is another sense in which space can be viewed as relative, and I choose to call this relational space – space regarded in the manner of Leibniz, as being contained *in*

objects in the sense that an object can be said to exist only insofar as it contains and represents within itself relationships to other objects. (Harvey 2009, 13, italics original)

Based on my extensive discussions earlier, we can see that the 'object' embedded in the two conceptual frameworks are conceived with very different properties, thereby far from equivalent. Moreover, in the Leibnizian framework, the *relation* is conceived on two different levels (real and phenomenal) relating to two different causal mechanisms.

Furthermore, Newton and Leibniz's conceptualizations of space encompass four sets of epistemic rules, rather than of two. They both admit the epistemic divide between a God-like figure and a sensible perceiver. Thus, the first epistemology takes God as the epistemic subject, generating and justifying the real existence of the a priori order of space (the absolute Euclidean order in Newton's case and the order of possible worlds in Leibniz's case). The true knowledge of space is then only comprehensible to God. The second epistemology in the Newtonian theory of space takes a view of knowledge characterized by reflection and correspondence. The epistemic subjects (mundane social beings) are conceived to have acquired *a partial reflection* of such true knowledge in reference to their relative bodily positions. On the other hand, the Leibnizian second epistemology deems the (plural and diverse) monads to be epistemic subjects, whose intelligibility and bodily positionality are admitted in shaping their *distorted knowledge* formed in perceptions.

2.3 Newtonian space and its implications for modern social theory

The sociologist, then, is someone concerned with understanding society in a *disciplined* way. The nature of this discipline is scientific. This means that what the sociologist finds and says about the social phenomena he studies occurs within a certain rather strictly defined *frame of reference*. One of the main characteristics of this scientific frame of reference is that operations are bound by certain *rules of evidence*. (Berger 2004, 16, italics added)

My examinations of the prototypical absolute, relative and relational conceptualizations of space have revealed the distinct ontological premises, epistemological principles endorsed by Newton and Leibniz. They are indispensable for justifying the analytical purchase of these conceptualizations. Now, I will move on to examine the theoretical knowledge of space of a more particular kind – in the European social science discipline. In this section, I present the frames of reference that prevailed in the European sociological domain and the rules of evidence for justifying spatial knowledge.

The Newtonian epistemic rules, especially his ontological postulation on real-istic substance (eternal, consist of matter) and epistemological commitment to the existence of true knowledge, has a wider impact on many later conceptualizations of space. According to Schemmel, Newton's concept of space, in its concern with the movable things in space, has enabled Kant to put forward an epistemic separa-tion between space and matter (2016, 84). Kant has famously conceived space and time as an *a priori cognitive conditions* – the pure form of intuition – under which social subjects' sense perceptions operate. In contrast, *matter* is conceived to be an 'empirical concept,' i.e., it needs perceptual instances in order to attain objec-tive reality. The social subjects in the Kantian scheme, in Crowell's words, "live in the truth," wherein their positive cognition "experiences" categorial clarity without "knowing" it (2001, 62). Kant did not assume a God figure nor a dual epistemology but simply regarded it logically unnecessary to assume space to be real. Therefore, his 'hinge proposition' assumes that the social actors know the structure of absolute space prior to, and independent of, his or her experiences in any particular tem-poral or spatial context. Actors are conceived to be capable of acquiring knowledge deductively through pure reasoning based on their pure intuition. The Euclidean geometric ordering principle and the primacy of space are simply given for the existence of synthetic a priori judgments (Kant 2009 [1781], 69–71). Along this line of theoretical derivations, the premised epistemic principle of 'dichotomy between movable and immovable' remains intact.

In a similar vein, one can find Newtonian premises mobilized in Husserl's ide-alistic conceptualization of space. The statement that the "spatial shape, motion, sense-quality and notions of 'spatio-temporality, body and causality' as examples of universal, general structure" – that is "a priori" in being unconditionally valid for all subjects – corresponds to such an epistemic divide (Husserl 1989, 139). Sim-ilarly, space is conceived as an ideal a priori cognitive category, independent of empirical content and experiences of the perceiving subjects. Husserl contended thereby that, regarding the above-mentioned spatial-temporal attributes, "normal Europeans, normal Hindus, Chinese, etc., agree in spite of all relativity" (ibid, 139).

More concretely for the sociologists, the social-scientific paradigms entail cor-responding sets of epistemic rules. It is pointed out by many that in comparison to philosophy, theoretical developments in social science concern primarily with *the way of knowing* in the social setting, or the *"primacy of epistemology"* (Connolly 1987, 116–26). As a well-known element in philosophy, epistemology concerns the con-dition of knowledge and justification rules for truth. Somers and Gibson argue that the sociological field exhibits "ellipsing of discovery an ontology by the con-text of justification" (1993, 3). It means, the postulations about the "way of knowing" determine where the best place is to search for the social-spatial mechanisms: in the material/symbolic structure of social reality itself, in the rational/reflective/re-flexive structure of the mind, or the pre-reflective behavioral structure of the social

actors? Somers and Gibson have also highlighted consequences of sociologists' limited effort in constructing epistemic rules: 1) "issues of social being, identity, and ontology are excluded from the legitimate mainstream of sociological investigation; and 2) the social sciences focus their research on action and agency by studying primarily observable social behavior – measured variously by social interests, rational preferences, or social norms and values – rather than by exploring expressions of social being and identity" (ibid., 4). In other words, they evade admitting the role of ontological postulations that attribute varying answers to the same question. In adopting a realist social ontology, social structures are revealed as quasi-materialized driving forces, external to the individual's perceiption and practice. When opting for an idealist reading of reality, social structures are symbolic or affective dimensions placed inside the social actors' perception.

The relational debates have, to a great extent, responded to the missing ontological debates in sociology. According to Emirbayer's manifesto, written in 1997, sociologists possess an ontological dilemma between substantivalism and relationalism. It means "whether to conceive of the social world as consisting primarily in substances or processes, in static 'things' or in dynamic, unfolding relations" (1997, 281). Emirbayer differentiates the 'interaction' and 'transaction' modes of relational thinking. He regards the latter to be the genuine relational thinking, as "the very terms or units involved in a transaction derive their meaning, significance, and identity from the (changing) functional roles they play within that transaction" (ibid., 287). Both ontological substantialism and relationalism, according to Emirbayer, are ideal types that locate on two ends of the ontological spectrum. Social scientists often alternate their stand between the two when developing analytical categories in a complex conceptual matrix. Emirbayer has also clarified how several fundamental sociological concepts subject to reformulation under transactional-relationalism, including 'power,' 'equality,' 'agency,' 'individual.' However, he lists issues like boundary specification, network dynamics, and causality as unsolved. Noticeably, to reformulate these terms call for reevaluating epistemological principles, too.

As we have just discussed, the absolute, relative and relational conceptions of space in the modern physical and philosophical domains are generated to explain the phenomenon of motion that appeared in one's perception. When these conceptual claims are made, distinct epistemic postulations about the nature of things and identity are drawn, function as the first order yet unverifiable causal agents. These postulations might be necessary for achieving logical coherence and completion in a premise-conclusion structure. The resulting conceptual claims may also correspond with empirical observables, yet the theoretical adequacy will not justify if the postulations stand true in themselves. When the concept of space is reinserted into social theories, the epistemic frames accommodate not only natural beings but also social beings. Inevitably, we can witness systematic conceptual reconstruc-

tion. Sommers has indicated how Newton's first-order epistemic postulation of the agency is widely redescribed in classic sociology, which shaped the conceptualization of social subject:

> Social science's modern actor was thus conceived through a blending of philosophy with Newton. At a stroke, a philosophy of moral autonomy was refashioned to accommodate the progressive naturalism of modernization theory. This new revolutionary idiom of agency raised to a priori status an abstracted fiction of the social subject. Agency and social action became theoretically embedded in the historical fiction of the individuating social actor whose natural state was moving toward freedom from the past and separation from the symbolic association, "tradition," and above all, the constraint of "others." (ibid., 15)

I have noticed another epistemic continuity from the Newtonian 'absolute and relative space' to the modern social theory of space. In particular, Newtown's postulation about 'God and sensible being's dichotomic perspectives' is transposed on to two classic sociological strands. When the researcher admits a God-like external epistemology, along with a prescribed *a priori* knowledge condition, 'structure' is thus conceived to signify an ontologically and empirically real and holistic causal agent that maneuvers social actors' practices. It is deemed external to the observable objects and observing subject – the researcher, imposing causal powers that are independent of the individuals' actions and state of mind. Such an understanding of structure is exemplified by Durkheim's (1982) objective, external, and constraining social rules, coupled with the methodological demand to study social facts *sui generis*. Social structure, therefore, is obtained through accounting for fact-like relations between social beings. In this context, social beings are inferred as passive entities, as parts of an objective whole.

Following a God-like perspective, space in modern sociology is deemed primarily as an inert backdrop that resonates with the concept of absolute space. In this context, 'boundary' is not conceived as a necessary epistemic form, but often addressed as an empirical notion in reference to the nation-state's territorial borders. As pointed out by Elias, "many twentieth-century sociologists, when speaking of 'society,' no longer have in mind (as their predecessors) a 'bourgeois society' or a 'human society' beyond the state, but increasingly the somewhat diluted ideal image of a nation-state" (2001 [1987], 241). Here, we can also detect a strong influence from Newtonian spatial views, where 'external forces' and 'Euclidean geometrical structures' are embedded into the 'social' and 'spatial structure,' referencing empirical contents in the nation-state system.

One can also easily detect the close affinity between the Newtonian 'relative space' epistemic frame and that from the semantic school of spatial analysis. According to Gottdiener et al., "material structure of the built environment, the image of its inhabitants, the codes of meaning found articulating with space, and

the discourse of urban planners, analysts, and academicians" characterize objects of urban semiotic inquiry (1986, 101). Early urban semiotics studies regarded the 'grammars of design' conceived and deployed by planners and other experts – externalized through semiotic expressions – the structuring principle of space. The material dimension of the architecture and urban landscape was then conflated with codes and text-like representations conceived and deployed by architects and planners. Accordingly, the modalities of such language – the 'syntax' – are deemed surrogate of Euclidean geometry as a structuring principle and causal agent. At this point, the designer's denotive meaning is taken as a social fact, while the connotative meaning – the varying subjective articulations in public discourses – are dismissed. The later urban semioticians, following the inspiration of Barthes (1967 [1964]), have picked up the connotation within a society's value system. They have further distinguished between first-order signifying systems (which are termed denotative) and second-order systems (which are connotative). Yet, their conceptual inferences depend essentially on the god-like epistemic perspective and postulations of discrete, passive and indifferentiable individuals. Just like what Rapoport has once pointed out, the semioticians have focused overwhelmingly upon syntactic and semantics, devoting little attention to "pragmatics – the relation of the system of signs to the behavioral context" (1990, 38–39).

The above-discussed theoretical approaches allude to and can be seen as, a derivative of the Newtonian relative notion of space. Diverse entities in the social domain (social actors, social activities, social structure, semantic or visual representations) are embedded into the form of 'things' and 'law of motion' in Newtonian frames, keeping their ontological premises intact. The Newtonian epistemological principle under God's perspective (objective, holistic, static and external) is also bridged with some empirically observable principles, such as syntax, institutional rules of the nation-state. The redescription of the Newtonian epistemic frame into the social domain results in many logically coherent ways of describing and explaining the spatial form. They are deemed as a result of certain dominant social structures. However, space is left unremittingly inert and passive.

These analyzed approaches are inadequate to explicate the development of social-spatial reality of our time for two reasons. Firstly, the epistemic forms and the sense-relations are derived from a closed, physical model common in physics-natural sciences. They are a-historical and a-spatial. The social-spatial reality, especially in compressed modernity, is open and entails learning processes that produce continual innovations, epistemic uncertainties and qualitative changes. Secondly, the Newtonian epistemic frame reduces space as a passive variable irrelevant to the change's explanation, giving no justice to the spatial particularities. It leads to the *cul-de-sac* argument that there is nothing new about space that can be discovered. This is precisely why I need to conduct 'epistemic reading' on these spatial notions, uncovering their thick epistemic postulations. I aim to show how they might

be valid logically but not necessarily useful and relevant for us to understand the world changes of our time.

2.4 When relational space is re-inserted into the post-modern social science

In *for Space*, Doreen Massey makes explicit three affirmative and universal propositions to approach space through a post-modernist lens. For the first proposition – space is the product of interrelations – one must recognize space "as constituted through interactions, from the immensity of the global to the intimately tiny" (2005, 9). The second – space is the sphere of the possibility of the existence of multiplicity – perceives space "as the sphere in which distinct trajectories coexist, as the sphere therefore of coexisting heterogeneity" (ibid., 9). For the third – space is always under construction – "it is always in the process of being made. It is never finished, never closed" (ibid., 9). For Massey and many post-modern scholars, the reassertion of space within the post-modern social theory is entangled with the intellectual movement against meta-modern discourses, the strong collective and objective ordering principle. Instead, they aim to embrace the heterogeneous and fragmented cultural, political, and material landscape (see works from Foucault, Soja). In Massey's words, the goal is to pursue "a relational politics of relational space," attending to the heterogeneous make-up of spatial formations (ibid., 147).

The ethical ground of such a conceptual redirection is comprehensible and convincing. However, the lack of elucidations on its epistemic frames makes most conceptualizations chaotic or short in the analytical purchase. For example, in the lines cited from Massey above, it is impossible to detect the distinctions between relations that are conceptually *substantial* and those that are *formal, necessary* and *accidental, durable* and *transient, symmetrical* and *asymmetrical*. It allows all or none of these relations a valid place. Moreover, in Massey's book, the term 'place' is conceived to represent consolidated self-identifiable and historically coherent spatial formations, which are "articulate[d] in the physical form both the social spatiality of knowledge production and an imagined spatiality of the knowledge relation" (2005,145). Nevertheless, without elucidating the definitions of epistemic forms (subjects, things [physical entities], knowledge, etc.) that are conceived in sense relation with the notion of place, it is impossible to differentiate the analytical purchases between 'space' and 'place.'

Since no philosophical school holds exclusive rights to *the* relational thinking in general and thinking of space relationally in particular, there is no single nor coherent theoretical turn in conceptualizing relational space. In the following section, I will expound on three post-modern social theories of space that register *relationality* to the core of their conceptualizations. They have all set themselves apart from the

static, container-like notion of space while embrace conceptualizing social-spatial formations in process, interconnectedness, and change. The three theories come from David Harvey, Martina Löw, and Nigel Thrift. In the following, I attempt to 1) identify the explicit or implicit epistemic premises that underlie and characterize each relational thinking; 2) elucidate the empirical references assumed by each concept of relational space; and 3) clarify the corresponding methodological implications, i.e., the difference such conceptions make on thinking of space.

2.4.1 The (Neo-)Marxism and relational space

The first strand of the relational theory of space focuses primarily on the political-economic dimension of social-spatial change in the capitalist societies, as discussed in the works of Henri Lefebvre and David Harvey. Both scholars have explicitly referred to the Marxist historical materialism tradition as a basis to develop a relational concept of space. Harvey, Lefebvre and many sociologists (e.g., Emirbayer) have considered Karl Marx to be a relational thinker, for he has taken 'social relation' as the central object of analysis. As just mentioned, the term relational thinking is not bound to any philosophical perspective, hence, they may mean very different things according to the referential epistemic frame. I would elucidate how *relations* and *their terms* are explicitly conceived and how Marxist epistemic postulations are bridged into Lefebvre and Harvey's spatial concepts.

Regarding the nature of social entities (social actors and material entities), their relations, and the causal agent generating these relations, the Marxist doctrine has prescribed a set of straightforward theses:

> In the social production of their existence, men inevitably enter into *definite relations*, which are independent of their will, namely [the] relations of production appropriate to a given stage in the development of their material forces of production. The *totality* of these relations of production constitutes the economic structure of society, the *real* foundation, on which arises a legal and political superstructure, and to which correspond definite forms of social consciousness. (cite in Giddens and Held 1982, 37, italics added)

To put this into formal terms, the core propositions in the Marxist doctrine have placed social actors and material entities dialectically in an epistemic divide whose distinctive agency subject to different conditions of justification. It is to say, materials are conceived to be the fundamental substance. Their objective attributes condition the mode of production. The social actors possess although mental and conscious capacity, are structured by the material conditions they get with. This dialectic material-social relation is conceived to apply to society as a whole and afford explanations to all social phenomena.

In his epistemic frame, 'material condition' is defined by the way in which things are socially distributed or possessed by actors from certain social classes within historical contexts. Tools, land, and technology are characterized as distinct in their innate productive forces, thus enable different forms of production and ways of life. 'Mode of production' is thereby understood as the way in which social actors are organized to own and engage with productive forces created by tools, technology, machines, and land. Consequently, the social relation between actors is subsumed under the class relation characterized by their corresponding mode of production. Thus, the class relationships in society are defined in the first instance as an enduring structuring principle, which characterizes the form of praxis (social action) in the second instance. The agency of social actors may only be understood as a necessary relational attribute, i.e., the agency of capitalist class actors is defined by their possession of certain material entities and the dispossession of the working class. Furthermore, the class-specific social attributes are conceived to be fully internalized by these actors embodied by the labor they engage in. In other words, there is a postulated symmetry between the objective material structure and social actors' agency. The parts (social actors, their class attributes, and material goods) are conceived to add to an organic whole known as society.

In *The Production of Space* (1991 [1974]), Lefebvre takes the 'forms of space' produced in the capitalist social system as the core object of inquiry. He forges his conceptualizing practice in a frank dialogue with Marx, accepting Marx's theoretical propositions underlined by the historical materialist social ontology and dialectic epistemology. In his conceptualization, the social relation in capitalist societies is meticulously bridged with the dialectic relationship between the social-cognitive and the spatial-material in the Marxist epistemic frame. To contend with the dynamics of a dialectic constitution between the *material* and the *social* on the level of social agency, Lefebvre sketches out a spatial triad of architectonics as his analytical framework, comprised of "representations of space (conceived space – ideal)," "spatial practices (perceived space – ideal)," and "representational space (lived space – material, bodily experienced)" (ibid., 38–39). As for epistemic subjects or social actors situated in various class positionalities, Lefebvre has postulated three respective ways of knowing, i.e., the cognitive, the imaginative, and the bodily, as well as four types of knowledge produced from their primary form of spatial practices, i.e., the savior, the scientific, the practical, and the informal knowledge. Through associating distinct forms of agency (cognitive, perceptual, and practical faculty) to actors occupying varying social positions, the linkages between the three forms of produced space are forged in a logical manner. Thus, the production of the three forms of space and their interrelations are also explained following such formal dialectics.

According to Lefebvre, the perceptual, conceptual, and practical aspects of the agency are ideally unified in social actors' daily practices within social space, so that

"the 'subject,' the individual member of a given social group, may move from one to another without confusion – so much is a logical necessity." (ibid., 41). Lefebvre criticizes the semiology approach, for it tackles only the incomplete body of knowledge, "bound to transfer onto the level of discourse, of the language per se, i.e., the level of mental space" (ibid., 7). Instead, Lefebvre acknowledges a wide range of knowledge into his spatial analysis, from the coded to the embodied, the formally institutionalized to the informally tacit and unknown. To explain how the specific form of space in a capitalist society comes into being, Lefebvre introduces a core idea from Marx – alienation. According to Marx, 'alienation' is both the medium and the result of the enduring social(labor) relations in a capitalist society. Lefebvre then asserts that actors' spatial perception is socially legitimated in relation to the type of labor they engage in. Lefebvre has also argued that no single form of spatial knowledge would hold true on its own. Yet knowledge conceived by the dominant social class becomes collectively understood, as their production is legitimized, and they circulate in the frames of social class division and control. More specifically, Lefebvre has deemed represented knowledge of space in 'savoir' and 'science' as an immediate productive force in the capitalist mode of production. They are legitimized by the dominant social class and objectified in forms of regulative social norms, which further allow corresponding spatial practices to reproduce. As a result, working-class actors in a capitalist society experience a rupture between the imaginary perception of space, the imposed conceptualized spatial knowledge, and the everyday operation of 'spacing.'

Take the social-spatial reality in capitalist society as a whole, Lefebvre has also explicated how architects and urban planners – in alliance with administrators and capitalists, with the aid of technical codes and drawings – produce 'material space' based on their conceptual plans. Conversely, the working class produces space through their practice and senses, subjugated by plans of the mass production of space. Thus, their embodied intelligence manifests merely as 'lived space.' Whereas although artists possess the agency to produce 'space of representation' through imagination, they are unable to materialize or subvert the dominant conception of space due to their disenfranchised social position. The holistically defined social space concept is as follows:

> (Social) space is not a thing among other things, nor a product among other products: rather, it subsumes things produced and encompasses their interrelationships in their coexistence and simultaneity – their (relative) order and/or (relative) disorder. (ibid., 73)

In line with Marxist postulations, Lefebvre has conceived social structure, the social positions and their interrelations, as a holistic causal agent. New forms of space can only be produced when holistic change occurs in society. Thus, Lefebvre has attributed the production of 'absolute space' to the social structure in imperial so-

cieties where religious authority dominates farmers. He has also attributed the production of 'abstract space' – the homogeneous, fragmented, and hierarchical space – to the capitalist mode of production. Both forms of space are conceived to encompass materiality, social actors, and their relations. As a result, though Lefebvre postulated no *a priori* attributes to social-spatial boundaries, the nation-state is still taken as the *de facto* empirical content to the boundary, taking as the demarcation of the unit of analysis on the empirical level. We can notice a methodological consequence here: to follow the Lefebvre approach, an empirical social-spatial boundary must be identified as a quasi-holistic social structure.

In a similar vein, David Harvey follows the ontological postulations from historical materialism. Harvey attributes the causal agent of material distribution to political-economic structures (modes of production and their interrelations). These political-economic structures are deemed objective, determining the social ideology and culture that further shapes social actors' perceptions and productive practices. Harvey has also taken the class-specific attributes of spatial practices as an analytical dimension, but he differs from Lefebvre in his predominant heed on economic activities (monetization, commodification, exchange production etc.). The latter attends to the full spectrum of social activities and their causal relation to 'spatial structure.' Harvey has proposed a two-level conception of social-spatial structure (of economic systems vs. experience) to amend the limitation of his analytical framework. Yet, the inferences made on these two levels lack conceptual coherence.

Harvey builds his conceptualization of 'spatial structure' by reconstructing Marx's 'law of accumulation.' He claims that the different spatial structures that inhabit social reality are "glued together by flows of such items as money, commodities, information, cultural artifacts, and symbolic systems" (Harvey and Braun 1996, 286). For Harvey, spatial structure in the capitalist society manifest, on the one hand, in the interaction between the production of *fixed and immobile* territorial organizations including urban built environments, industrial agglomerations, regional production complexes, large-scale transportation infrastructures, and long-distance communication networks, regulated by state institutions; and on the other, in the production of relative space-time of *accelerated and expanded* capital circulations (2001, 237–66). He distinguishes the processes of "monetization, commodification, the exchange" and the process of "valorization and devalorization," emphasizing the speed of different modes of circulation (ibid., 23). Both are deemed to be steered by the law of accumulation. Here, an epistemological postulation is deployed at work: the dichotomy between movable and immovable beings. It means firstly that the material infrastructure and capital are deemed distinct in their circulative-mobile attributes. Then, the modes of circulation (motion) are conceived as caused by distinct forms of mobile forces.

I would argue that Harvey's inquiry lies in identifying the empirical content of the 'spatial structure,' the structuring principle that organizes the distribution and circulation of various forms of materiality than that of space. His concept of space is derived directly from Marx's realist concept of materiality. Thus, in Harvey's analysis, social-spatial structure corresponds with the sum of rules regulating two forms of capital circulation and accumulation in a capitalist society. Under Fordism, he argues, the social-spatial structures are realized primarily in fixed and immovable material forms, such as transport facilities.

While recognizing that the organization of accumulation under the post-Fordist economy (late capitalism) to be different from that of the Fordist-economy (capitalism), in the *Condition of Postmodernity* (1989), Harvey re-embeds his notion of space and social-spatial structure into a new social, historical context. It is called the late capitalist or postmodern society. In this context, flexible accumulation, according to Harvey, "rests on flexibility with respect to labor processes, labor markets, products, and patterns of consumption." This mode of production is also deemed deeply affective to class structures and political-economic possibilities to modify the processes of community production (ibid., 147). As other means of production and consumption cannot be moved without being destroyed, these structures themselves act as a barrier to further accumulation. Harvey has famously characterized such structural change as the 'time-space compression':

> It has also entailed a new round of what I shall call 'time-space compression' (see Part III) in the capitalist world – the time horizons of both private and public decision-making have shrunk, while satellite communication and declining transport costs have made it increasingly possible to spread those decisions immediately over an ever wider and variegated space. (ibid., 147)

Furthermore, in the book *A Brief History of Neoliberalism* (2005), Harvey seeks to identify the empirical content of organizational structures of accumulation and capital circulation and the manifestation of the temporal-spatial structure resulting from the interactions of the two in neo-liberalism societies. In Harvey's eyes, neoliberalism is gradually becoming the central guiding principle of economic practices on a global scale. In the non-western context, i.e., the Chinese context, Harvey perceives the economic system as a whole falls under this category. However, empirical data from China has often contradicted what the grand material-ideal dialectic premise predict, assuming a state (political-cultural) reconfiguration subsequent changes in the economic production system. Facing the incoherence between his theoretical prediction and phenomenon, Harvey proposes a 'creative destruction' argument:

> The process of neo-liberalization has, however, entailed much 'creative destruction,' not only of prior institutional frameworks and powers (even challenging tra-

ditional forms of state sovereignty) but also of divisions of labour, social relations, welfare provisions, technological mixes, ways of life and thought, reproductive activities, attachments to the land and habits of the heart. (Harvey 2006a, 147)

So far, we can affirm, in Harvey's model, *space* is deployed heuristically to refer to the observable, material and symbolic, movable and immovable entities subject to accumulation. Spatial structure is conceived to represent the dominant political-economic rules organizing spatial constituents, which may or may not correlate with other social structures in a given society as a whole. In Harvey's epistemic frame, he separates the space of the economic system from that of experience. The concrete agencies of social actors are thereby deemed determined by the economic structure. At this point, Harvey's conceptualization of space correspond closely with the Newtonian relative space conceptualization, as 1) the social-economic entities are conceived as passive, discrete and material, characterized by their attributed movable or immovable bodies; 2) the ordering principle of space is deemed objective and encompassing, irrespective of the local context; 3) the 'law of accumulation' is deployed to *replace* the Euclidean geometry as the overarching measuring and ordering principle.

This affinity between the Newtonian relative epistemic frame and Harvey's spatial notion can be further affirmed by his own conceptual clarification in later writing (2006b):

Space is relative in the double sense: that there are multiple geometries from which to choose and that the spatial frame depends crucially upon what it is that is being relativized and by whom. ... The relational notion of space-time implies the idea of internal relations; external influences get internalized in specific processes or things through time (much as my mind absorbs all manner of external information and stimuli to yield strange patterns of thought including dreams and fantasies as well as attempts at rational calculation) (ibid., 272-274).

It is evident, Harvey fails to clarify whether or which of the relations (internal or external) are (conceived as) real or phenomenal. He has conflated the observable formal and substantial relations and has dismissed an epistemic distinction between relationalism and relativism. Harvey also holds that researchers could employ the absolute, relative, and relational conceptualizations of space at different intersections, integrate "different modalities of understanding the meanings of space and space-time" (ibid., 281). Harvey has thus characterized various entries according to their (assigned) relative attributes of mobility and associate them with the three spatial concepts. For instance, mountains, water, and energy flows are categorized under the row of material space in a native realism manner, overlapping with the lines of the absolute, relative, and relational categories. As indicated earlier, as the epistemic rule at Harvey's work is Newtonian, such 'mixed concepts' renders

each spatial term's analytical dimensions ontologically flat and epistemologically chaotic.

2.4.2 The structuration and (relational) space of everyday experience

The second conceptualization of relational space addresses the space of everyday experience, represented by Martina Löw's theory of space. Löw has developed a systematic conceptualization of space in the book *Sociology of Space: Materiality, Social Structure, and Actions (2016 [2001])*. As a theoretical project, her theorization aims at bringing space as a fundamental concept into sociological theory, enabling its analytical purchase to explore the 'phenomena of space' on all theoretical levels. Diverging from Harvey and Lefebvre, who aim to embed the concept of space into dialectic materialism tradition in a logically coherent manner (through following epistemic rules prescribed by Marx), Löw has clarified from the outset that she would depart from the Leibnizian relativist stance. In other words, Löw rejects a deflated realist ontology and the postulated epistemic divide between the movable and immovable entities. As I have discussed in 2.2 in detail, Leibniz conceptualizes space, on the collective level, as an order to things exists at the same time, emerging from the accumulation of the biased perspectives of 'situated monads.' Monads are understood as substantial agents. Their absolute manner of change and movement is caused by their substantial internal attributes. Their relative motion occurs in the process of negotiating their contingent 'point of view' with other compossible monads in realizing the particular law of their 'possible world.' Löw argues that the Leibnizian epistemic prepositions about the nature of entities and thereby the causal agents of their absolute and relative change allow her to attend to the process of change and the co-existence of plural subjective spaces. This integration is possible as Leibniz conceives "the 'bodies' (actions) to be always in motion" in both absolute and relative senses. The 'bodies' are conceived situated, which allows them to possess and actualize a different 'point of view' (ibid.,10). As a result, in her conceptualization of social space, Löw put "the coming-to-be of space" on the perceptual level, and "the arranging of the bodies in action" on the material level in causal relations to "the constructions and perceptions of the 'observers'" (ibid., 51).

In reference to the Leibnizian relational space conceptualization, we notice that the conceptual building blocks in Löw's conceptualization of space are syntactically parallel and analogous with that from the Leibnizian epistemic frame. The afore-discussed Leibnizian epistemic forms get systematically embedded and extended into a pool of concepts in sociology. Its epistemic rule – the premises and sense relations prescribed by Leibniz – get retained. Most prominently, the conceptualization of 'unit of intelligent substance,' or the 'monad,' has been embedded into both the notion of 'social being' predicated by pre-reflective perceptual and practical attributes, and the 'social good' predicated by perceivable (symbolic) and sen-

sible (material) attributes. On a secondary (*materia seconda*) level, Löw includes and connects the 'patterned perceptions,' 'actions,' and 'bodily positions' of the monads with the social actor' pre-reflective, internalized perceptions and social practices, and their positions in the social world. Furthermore, the ways in which these predicated attributes are related to social structure resembles how 'perception,' 'relative motion,' and 'point of view' are causally connected to 'the order of the possible world' in the Leibnizian schemata.

In line with the principle of epistemic coherency, Löw recourses to Giddens and Bourdieu's general social theories to further shape the epistemic building constituents of social space. In the Leibnizian epistemic framework, the orders of 'the possible world' is deemed contingent in substance, but absolute in form, as they are pre-established by God. Thus, Löw has also admitted an idea of collective social structure to account for the spatial constitution and transformation on the collective level. In contrast, she does not have a pre-established spatial order nor an absolute law attributor in mind but locates the source of collective order in the context of everyday social structures. On this point, Löw has drawn on Giddens' structuration theory. Social structure is conceived to have both the potential for enabling action and constraining repetitive social actions, resolving the dichotomy between social structure and action. Giddens presumes that a social actor reproduces one's core sense of meaning through 'repetitive actions and routines' in a social context. In his words, "routine is integral both to the continuity of the personality of the agent, as he or she moves along the paths of daily activities, and to the institutions of society, which are such only through their continued reproduction" (1984, 60). This mutual constitutive relation between agency and structure is compatible with that in the Leibnizian epistemic frame. The monads, in relation to the clearness of their perceptions, act in response to the intelligible law perceived from their point of view. Löw is thus inspired by Giddens, who takes 'routinization' as a key causal category to mitigate action and social structure. Following Giddens, she defines human beings' substantial attribute in terms of 'repetitive human action, which is deemed as social actors' inherent ability to affect change.' The social actor's 'absolute motion' is thereby caused by their routine actions.

Aligned with the Leibnizian differentiation between a 'general law' and a 'point of view' relevant to point in time and space, and with Giddens, Löw differentiates between 'structure' and 'structures': "structures are isolable sets of rules and resources, while structure means the totality of different structures" (2008, 31). More specifically, regarding 'structure,' Löw diverges from Leibniz and Giddens' conception in that she does not regard it as a 'general law' nor 'universal ordering force.' For Giddens, social reality is structured by mechanisms *out of* time and space. More specifically, structure(s) entail recursive rules of a normative nature (legal, economic, political structures) and resources (material or social) embedded in institutions. This implies that the validity of the term 'structure(s)' is deemed

irrelevant to the concrete and particular social contexts one investigates. Löw re-
fuses the concept of structure to be "independent of space and time and beyond
materiality" (2016 [2001], 142). Instead, she perceives that structure – like the di-
vision of public and private, and gender and class – "materializes itself in all so-
cial entities of whatever dimensions, including human bodies" (2008, 31). Then,
there is still a risk that 'routinization' is re-embedded into Leibniz's both notions
of repetitive passive (absolute) activity and active (relative) activity, conceived as
the primary and secondary attributes of the monads. In other words, the two-fold
causal agents Leibniz has postulated to explain the relation between substantive
and relative motions, might be conflated in 'routinization.' To clarify the differ-
ence, and understand how Löw resolves the problem of conflation, let's have a look
at the source of such a divergence. In the Leibnizian frame, the basic intelligent
subject (the monad) is firstly defined on the primary level *(material prima)*, as a sit-
uated subject with substantial attributes. For Giddens, the modern social subject
is primarily and explicitly defined as a 'reflexive' and 'knowledgeable' agent. Thus,
his concept of structure(s) is constructed only on the ideal level, offering universal
analytical purchase (1984, 3). Löw diverts from this line of thought, considers the
social beings as having not only the 'social minds' but also as 'social bodies.' She
conceives the social subject to have pre-cognitive faculties (often embodied) and
pre-reflective perceptions (often cultivated from concrete social contexts, situated
position). Therefore, she finds it necessary to extend the analytical dimension of
structure to the materiality of things and social bodies, including the spatial and
temporal structure.

Like Leibniz, Löw conceives each social subject to have its own capacity of 'per-
ception,' but unlike *materia prima*, which is merely an innate quality. Löw regards
the structured cognitions of social actors, their pre-structured perceptual patterns
and bodily sensations to be formed in a 'temporal continuum.' On this primary
level, Löw draws on the concept of 'habitus' in Pierre Bourdieu's sociology of cul-
ture to ground the causal relations between the concepts of substance, perception,
bodily motion (practices) in the social field. The *habitus* is defined by Bourdieu as
social actors' set of bodily and cognitive dispositions, generating their social prac-
tices and perceptions. It is conceived to be the result of a long inculcation pro-
cess, beginning in early childhood, which becomes a 'second sense' or a second
nature. According to Bourdieu, dispositions represented by habitus are durable, in
that they last throughout an agent's lifetime, and transposable, in that they may
generate practices in multiple and diverse fields of activity. They are "structuring
structures" as social actors would inevitably incorporate the objective social con-
ditions into their inculcation (1977, 72). Following these assumptions embedded in
habitus, Löw conceives perception to be pre-structured by an actor's education and
socialization, imprinting itself as orientations and pre-reflective repetitive social
practices.

In addition to introducing Bourdieu's habitus concept into her analytical framework, Löw has embedded the subjects' social positionality into the notion of 'point of view,' introducing the perceived social structure(s) as a secondary causal agent. The notion of structures(s), in its plural form, is similar to the 'general law of the possible world' in the Leibnizian epistemic frame. For Bourdieu, social actors in a particular social world "mutually relativize each other," so that the way the world appears to and is understood by individuals is correlated to the sense of place they have developed in relation to the *whole* compossible field (2006 [1995], 193). For an actor situated in a particular social world, a sense of one's place refers to "a sense of what one can or cannot 'permit oneself,' implies a tacit acceptance of one's place, a sense of limits (sense like, that's not for the person likes of us etc.), or, which amounts to the same thing, a sense of distances, to be marked and kept, respected or expected" (Bourdieu 1993, 19). In other words, an actor orients themself in relation to their sense of position in a lived social world. The sense of place of all social actors (*doxa*) in a particular social world amounts to the "law of the field," which corresponds with the 'order of the possible world' in the Leibnizian frame (Bourdieu 1993, 39).

In line with Bourdieu, in Löw's conception, an actor's perception is pre-structured by education and socialization. It imprints itself as pre-reflective orientations in social actions. Löw follows the principle of 'subject-predicate-substance,' seeing reflexivity as a 'transcendental attribute,' and setting the condition of truth in socially cultivated and embodied subjectivity. As such, she connects the internalized, pre-structured perceptual schema to an actor's routine actions, which further contribute to the reproduction of social structures and space of everyday life. This causal connection also enables her to include distinct biographical perspectives explaining social actors' perceptions of space in co-existence. When 'structure' is embedded in the 'universal ordering force,' it is deemed "unrelated to place and point in time" (2008, 38). In her book, Löw illustrates the nominated reference of 'structure' interwoven with 'space,' using the structural notions of 'class' and 'gender.' The epistemic divide between 'structure' and 'structures' correlates perfectly with that between the twofold, substantial and phenomenal laws in the Leibnizian epistemic scheme.

Different from the Leibnizian notion of relational space, Löw has taken the bodies and materiality seriously. Materiality enters the social-spatial phenomenon's constitution when perceived or sensed by the social actors and placed by their actions. The former process is termed as 'synthesis,' and the latter as 'placing.' By *synthesis*, she refers to the process in which "goods and people are amalgamated to spaces by way of processes of perception, imagination, and memory." By *placing* (*Anordnung*), Löw refers to the process in which "space is constituted through the placing of social goods and people or by the positioning of markings that are primarily symbolic of identifying ensembles of goods and people as such (e.g., street

signs on entering or leaving communities)" (ibid., 134). For Löw, operations of synthesis and spacing can occur simultaneously and coherently in social actors' everyday practices. However, unlike the Leibnizian epistemic frame, she addresses the possibility in which "the operation of synthesis as an operation of abstracting without associated spacings" (Löw 2016 [2001], 135). Such detachment is illustrated by designers' software-based design and drawing. Correspondingly, she differentiates two types of knowledge needed for the constitution of space: the 'knowledge of the symbolic attributions' for the meaning constitution and the 'knowledge about how to deal with the material components of spaces' for the material arrangement. The knowledge about materiality is thus intricately linked with an actor's habits and internal characteristics. It demystifies what Leibniz has coined as the contingent association between monad' intelligence, the clearness of perception and the extent of activity. In this way, Löw has offered a systematic analytical framework to examine and explain how space is routinely constituted in repetitive social actions and interactions. Space pre-structures social actors' perceptions and practices also presuppose the existence of social structures. Her thesis of space goes as follows:

> Space is a relational arrangement of living beings and social goods. Space is constituted by two processes that must be analytically distinguished: spacing and the operation of synthesis. The latter makes it possible to unite the ensembles of goods and people to one element. (ibid., 135)

As a result, Löw's relational notion of social space enables one to acknowledge the two empirically concurrent processes as analytically distinguished. By delinking the causal necessity of these two processes, the methodological implications are, researchers are encouraged to attend to a plurality of space constituting processes on the symbolic and material levels, attend to their interactions and resultant material manifestations. One can also analyze the forms of detachment between the two levels of spatial constitution.

To clarify the meaning of relational in Löw's conceptualization of space, two crucial propositions and their inferential order need to be addressed. Firstly, two processes of constituting space (the operation of spacing and synthesis) are conceived to be permeated in the perceptual aspect of individual actions. Secondly, in the process of placing, the perceptual-symbolic and meaningful dimensions of social bodies are taken as the primary ordering principle. Furthermore, Löw has introduced 'atmosphere' to describe social goods and human beings' external effect, being realized perceptually in their spatial ordering. Atmospheres arise as the *perception of relationality* between people and/or the external effects of social goods in their arrangement (ibid. 172). This mode of inference implies that the *relationality* formed in the pre-cognitive *perceptual process* (synthesis) has the causal primacy in explaining the deployment and arrangements of material bodies.

As this chapter aims to elucidate and compare the methodological implications among distinct forms of relational conceptualizations of space, I cite Löw's own reflection and conclusion on this point first:

> Based on Sturm, four levels of procedure for scientific study can be derived from this classification: (i) the study of social goods and people in their arrangements, (ii) the analysis of operations of synthesis, (iii) the treatment of processes of spacing, and (iv) the exploration of spatial structures. (ibid.,187)

I have identified a few additional methodological implications after closely examining the relevance and difference between the epistemic frames underlying Löw's and the Leibnizian notion of relational space. As previously indicated, Löw constructs the concept of relational space on the level of the phenomenon, i.e., space emerges in subjective perception, constituting one's meaningful experience. It enables the analysis of movement and changes as the imminent factors in sensorial perceptions (as indicated in [i], [ii] in the above quotation). She also presumes social actors to be endowed with differing pre-cognitive knowledge required for spatial practice, which is not necessarily in line with, or legitimated by, the normative social structures in a social context. As a result, Löw's relational notion of space enables analyzing the co-existing 'multiple possible spaces' synthesized by different social individuals or groups, in relation to their spacing practices and materialization. In doing so, we can avoid the simple judgments of the 'true' or 'real' causes but incorporate those that come laden with a plurality of social actors and their situated perspectival limitations. Furthermore, 'boundary,' in the principle of making an empirical halt (as described by Löw that "movement has to be artificially halted in empirical analysis in order to be able to determine a configuration" [ibid.,188]) is not admitted as a formal concept in Löw's relational space.

2.4.3 Relational materialism and assemblage

The third approach for thinking of (social) space relationally can be broadly described as the assemblage approach. Most directly, the assemblage approach draws on epistemic premises from the 'actor-network theory' (Latour 2005), attends to the event of 'agencement' developed by Deleuze, Guattari, and their followers (see Thrift 2008; Anderson and Harrison 2010). As a general currency, the assemblage approach is developed to address the indeterminacy, emergence, becoming, processuality, and turbulence of social-spatial events. Such events are deemed to be composed of human and non-human, organic and inorganic, and technical and natural elements. According to Delanda (2006), the assemblage is part of a more general conceptualization of the social that seeks to blur divisions of social and material, near and far, structure and agency. Thus, we can also deem it a re-conceptualization of space.

As there is no all-encompassing systematic conceptual formulation of space under this approach, nor are its epistemic forms and rules defined in an agreed-upon manner. I examine here primarily the spatial notion conceptualized in non-representational theory (NP) by Nigel Thrift. I consider it to be the most elaborated work following this tradition. The non-representational theory was firstly developed in the volume *Spatial Formations* (1996), in which Thrift pieces together several concepts that came central to his thinking: 'time-space,' 'practice,' 'subject' and 'agency'. Later, the logical relations between these key concepts were formulated in a more detailed manner in *Non-Representational Theory: Space/Politics/Affect* (2008). For Thrift, he deemed the subject matter of his theory to be the 'onflow of everyday life': the superfluous, hybrid consciousness which is constantly destabilizing and changing content, present in 'experience' (2008, 2). In NP, Thrift does not offer a clear definition or conceptualization of space, nor is the meaning of the term deployed in a unitary way. Judging by the interchange of discourse, I infer that a notion of space as such is used by Thrift to refer to the represented arrangement of things and their interrelation in social actors' senses and consciousness, as a subjective cognitive and pre-cognitive condition under which experience and practice arise (see ibid., 97-98). However, as Thrift has integrated notions of social reality and subjects underlined by epistemic premises different from that in Marxist and Leibnizian traditions. Thus, we shall attend to another important relational spatial notion, the *assemblage*, distinct to the relational materialism tradition.

Firstly, regarding the postulations of social subjects' agency, the non-representational theory is aligned with the social constructivism tradition, primarily in its rejection of deeming human subject as autonomous, rational, and reflective. However, Thrift regards the human subject's pre-cognitive capacity to be more than an addendum to the cognitive capacity, so much so that he values the 'emergent' component more than the cognitive and entrenched pre-cognitive components of subjectivity in constructing social reality. To be more exact, Thrift has traced his postulation of *relational subjectivity* to that from Deleuze: "I take Deleuze's work on topics like the gap between sensation and perception, the difference between possibility and virtuality, the heterogenies of both material density and subjective action from a pre-individual field, and the different time images of repetition and recurrence, to be important" (ibid., 18). In Deleuze's differential ontology, the subjectivity of any given being is formed on the basis of the ever-changing nexus of relations in which it is found. In other words, the source of such relational subjectivity is attributed more to the responses to the external – the emerging sensation and perception occurring in nowness.

The NP theory contends to be "resolutely anti-biographical and pre-individual" (ibid., 7). By anti-biography, Thrift holds that the autobiography "provides a spurious sense of oneness," while biography offers a "suspect intimacy with the dead." Regarding the issue of pre-individuality, Thrift explains that "the flow of

dialogical action is a fundamental determinant of the intelligibility of social life: understanding comes from the betweenness of the 'we,' not the solitary 'I.'" Instead, he emphasizes the "flow of practice in everyday life" and the "on-going creation of effects through encounters," rather than "consciously planned coding and symbols" (Thrift and Dewsbury 2000, 415). From my reading, Thrift's conception of a relational social agency addresses less the relational representation formed via willpower or cognitive deliberation but more the sensible social-material relationality in the embodied and situated practices, dispositions, and habits, cultivated amidst environmental affordances. Having practiced in the center of the theory, 'agency' in NP is not conceived as being "localized in individuals but is understood as a relational structure" (2004, 87). It is then defined to entail ontologically heterogeneous modes of subjectivity (internal and external), embodied by "joint actions – action as always a reaction to other action –in a concrete context" (ibid., 14). Following Deleuze, Thrift has ruled out the 'subject-predicate-substance' as a principle, defining the social beings' agency as a complex relational structure.

We can move on to discussing the underlying epistemic rules regarding the definition of the 'thing' in non-representational theory. In NP theory, it is clearly expressed that the premises on which the nature of objects and thereby the necessary subject-object relation are primarily borrowed from actor-network theory's relational materialism tradition. It presumes 'things' to possess 'technological ante-conscious,' and conceives thereby the world to be made up of actors or actants (Latour 2005, 54). In other words, it abandons the differentiation between subjects and objects at both ontological and epistemological levels. Following Latour's flat ontological principle, Thrift grants the social being's body and the thing with the same ontological footing, both as real and inseparable entities. Things are deemed to have the capacity to act, to the extent that they are endorsed with a practical and processual role in accounting space formation. The result is that the material context against which space emerges is no longer conceived as a dormant or an ordering background but an active and productive entity. Things appear and assume significance in the "manifold of actions and interactions" – a mobile but more or less stable ensemble of practices, involvements, relations, capacities, tendencies, and affordances.

Nevertheless, Thrift contends that the agency of things and social actors are not the same, in that the human body "is what it is because of its unparalleled ability to co-evolve with things" (Thrift 2008, 10). Thrift also diverts from ANT in that Thrift perceives human's 'expressive powers' to be of especial importance in understanding "what is possible to associate," which is neglected in the ANT framework. Thrift sees "the power of imagination, the capacity to posit that which is not, to see in something that which is not there" to be the cohering force, structure the transformation of the assemblage (ibid.,111). The notion of space is coined on the individual level to capture what social subjects have sensed in the course of interacting with

heterogeneous actants of different natures. It is formulated in a non-conceptual style, as Thrift strives for "deflating methodology and replac[ing] it with style, self-exemplification rather than self-referencing" (1996, xii). It is described as follows:

> space is not a metaphoric, nor is it a transcendental principle of space in general (the phenomenological idea of consciousness as the fount of all space, produced by a finite being who constitutes 'his' world), nor is it simply a series of local determinations of a repeating theme. In each of these cases, we can see that the very style of thought is 'oriented by spatial relations, the way in which we imagine what to think' (Colebrook 2005a:190). Rather, it is three different qualities in one. First, it is a *practical set of configurations* that mix in a variety of assemblages thereby producing new senses of space and... Second, it also forms, therefore, *a poetics of the unthought*, of what Vesely (2004) calls the latent world, a well-structured pre-reflective world which, just because it lacks explicit articulation, is not therefore without grip. Third, it is *indicative of the substance* of the new era of the inhabitable map in which space has more active qualities designed into its becoming – a tracery of cognitive and pre-cognitive assists threading their way through each and every moment of the being-at-work of presentation – which makes it into a very different ground from the one that Heidegger imagined as presence. (Thrift 2008, 16, italics added)

As previously indicated, two notions are core to capture and explain social-spatial formations in NP: one is 'space,' the other is 'assemblage.' My reading of this is that 'space' is conceived to encompass both social beings' mental and sensual structures – how they see and feel about the world around them, as well as the representation of such engagements in the world. Space arises from, and gives rise to, practices, embodied exteriorities, and joint-actions – associative processes through sympathy. Subsequently, under the backdrop of space, 'assemblage' emerges, which is considered real, yet cannot be accessed fully by the researcher or observer directly. The term assemblage refers to a compositional unity of the social and material entities, relations of the historical and the potential, and materially mediated arrays of human activity and performance, centrally organized around shared practical understandings of its emergent properties. To my understanding, the concept of assemblage is built on the ontological 'empirical' and 'actual' domain, consisting of manifested entities whose come-into-being could be captured in various ways, according to the temporal, spatial position and the perspectives held by the experiencing subject and the observer. As Olds and Thrift assert when examining global schoolhouses in Singapore, "assemblages will function quite differently across different contexts, not because they are an overarching structure adapting its rules for the particular situation, but because these manifestations are what the assemblage consists of" (2005, 202). In particular, the term assemblage also suggests that NP is built on a weak (situated) epistemology – it sets little pre-defined limits on

what and how would be known by the observer as constituents of assemblage (1996, 32–33). Vannini, a follower of NP, clarifies that:

> But what truly distinguishes the non-representational research from others is a different orientation to the temporality of knowledge, for non-representationalists are much less interested in representing an empirical reality that has taken place *before* the act of representation than they are in enacting multiple and diverse potentials of what knowledge can become *afterwards*. (Vannini 2015, 12)

With regard to the *structuring forces* of assemblage, building on a flat ontology as in Latourian sociology (2005), the descriptions of 'social mechanisms' in the NP are 'associative,' whereby the concept of society and social structure are dropped altogether from his conceptualization practice. The social does not refer to any type of collective representation that exists in itself, but a certain sort of circulation in which movement is constant; it is not characterized as a special or specific realm but "a very peculiar movement of re-association and reassembling" (ibid., 7). We can draw a reference to the 'contingent general law of the possible world' in the Leibnizian epistemic frame, where its form is deemed given, and the substance is actualized by the monads in their constant negotiation and conflicts. Thrift has admitted its form but addressed the construction and actualization of the empirical content of 'the contingent law' on the level of the assemblage. Without a mechanism proposed on the collective level, how can one describe and explain the stabilizing or destabilizing processes of these co-existent heterogeneous components in assemblages?

One causal agent proposed by NP theory is also 'routinized practices.' In Thrift's earlier writing, he has quoted directly from Vendler (1995)'s definition: "practices, understood as material bodies of work or styles that have gained enough stability over time, though, for example, the establishment of corporeal routines and specialized devices, to reproduce themselves" (ibid., 5). This quote has foregrounded the trans-actional, relational nature of the practice again and deems repetition to achieve stability measured by *temporal endurance and materialization*. Secondly, Thrift makes it explicit that stabilization and destabilization are both a *consensual and contested* process: "consensual because relations are usually made out of agreements or alignments between two or more entities, contested because the construction of one set of relations may involve both the exclusion of some entities (and their relations) as well as the forcible enrolment of others" (Thrift 2004, 91). The stabilizing process is also conceived as 'power-filled,' in which relations run through meeting places over different spatial scales, and "some alignments come to dominate, at least for a period of time, while others come to be dominated" (ibid., 91). The second causal agent is thus referred to the active derivative forces associated with social and natural entities' resistance, interpenetration, and movement of association and re-association at the level of assemblage. This implies that although a

contingent law or structuring force is conceived as a concrete analytical category and a causal agent within the NP epistemic framework, its form is not derived from the Leibnizian but Deleuzian epistemic premises, which get substantiated in the empirical realm, upon effectuality.

As I have previously indicated, instead of proceeding from subjects and objects predicated with *a priori* substantial attributes or prescribing singular forms of structuring force to the assemblage on the collective level, NP theory accentuates a third element: the emergent-external relational structure between subjects and between subject and object. The NP epistemic frame is aligned with that from a set of diverse but cognate anti-substantial philosophies of becoming, vitalist intuition perspectives, and Latour's relational materialism. The emergent capacity is conceived to exist in the real domain, not solely as a representation of the formal relations (institutional norms, frames, etc.) on the empirical domain. Furthermore, it's empirical manifestation is conceptually refers to an 'embodiment' representing elements such as affects, virtual memories, and hauntings. It resonates with what Löw defines as the atmosphere. Just, instead of addressing the more stabilized relation between embodiment and the resultant patterned perception of social actors, Thrift focuses more on those "which are ephemeral and possible" (Radley 1996, 560, cite in Thrift 2005, 115).

The methodological implications of NP include: one can trace the existence of absent entities from the way present entities are assembled, through looking for the unexpected qualities of events and ways of knowing in the movement of the practices in context (see Thrift 2008, 114–24). The focal point, as argued by Dewsbury et al., "is to redirect attention from the posited meaning towards the material compositions and conduct of representations" (2002, 438). If this clarification still appears obscure, my understanding is that the presented interpretations in the empirical domain can be considered plausible when they correspond with your observation of the way in which material components are configured and moved, and/or with the knowledge learned by experiencing subjects. The temporality of the events halted artificially by the researcher is crucial for identifying generative mechanisms. The associative mechanism between the social actors, materials, and other entities can only be derived *after* the completion of the processes, not *before*. And, by no means is one mechanism to be deemed as the only plausible one.

Let me summarize the necessary epistemic forms and causal agents that constitute these two forms of spatiality in NP theory. Firstly, in NP, both *social actors* and *social goods* are conceived to have contingent properties (e.g., affect) emerging from their interactions. In other words, the *non-cognitive properties* of social actors are (also) employed in explaining their social practices. The practices are conceived as embodied actions, ranging from perceptual, pre-reflexive, and conscious discursive, to controlled and coerced actions. These actions are more or less enduring and more or less mediated, but all conceived as relational. In contrast to Lefebvre and

Harvey, the assemblage approach deliberately avoids *a priori* reduction of social-spatial relations and processes to one or a set of fixed, necessary forms. Therefore, the routinary social practices (as conceived by Löw) is attributed to both social and natural entities in NP as causal agents to explain the spatial formation. They are conceived either immediately regulated or mediately generated and organized by rules bundled with the positionality of the individual. Thrift has attended more to the *responsive* effect of practice to the *ever-changing* context. The concept of *space* is thus conceived as the sensible backdrop against which actual practical manifestations unfold. It shapes and is shaped by the relational senses and practices of experiencing and expressing subjects. The *relational space* in perceptions here are not merely pre-structured by the law of inner identity, nor external norms (codes, rules, and laws), but also shaped by the constant, contingent mode of exchange with others in the context.

How do the weak epistemological principles (rules) characterize the logical relations between different epistemic forms in the assemblage theory is much discussed by Delanda. He states that, "unlike wholes in which parts are linked by relations of interiority, assemblages are made up of parts which are self-subsistent and articulated by relations of exteriority, characterized along two dimensions: along the first dimension are specified roles which parts may play, from a purely material role to a purely expressive one; along the second dimension, components come together in the process of stabilizing or destabilizing" (DeLanda 2006, 9). In comparison to the relational conceptualization of space coined by Löw, the assemblage has given both the sense of space, and the emergent relations between entities as parts and as a whole, a realistic epistemic status of their own.

Overall, the assemblage approach offers no unifying analytical framework due to its take on weak epistemology and the multiplicity of impulses, issues, and oppositions it tries to tackle. Methodologically, the two analytical dimensions in NP are in line with Löw's epistemic divide between synthesis and spacing. Both have stressed the distinction between the process of cohering the parts and their interrelations as a whole in one's subjective perception and senses; the process of spacing the parts in practices across scales. The difference lies in that, in the assemblage approach, time is not conceived as linear nor homogenous. Researchers are required to detect the *angle* or *moment* to capture the formation of synthesis and associative practices.

2.5 Summary

In this chapter, I have made the first step towards understanding the ways in which divergent relational conceptualizations of space come into being and the grounds on which one can tell their analytical purchase apart. These aspects are of crucial

importance to preselect relevant traveling conceptualizations for conducting context-sensitive spatial research. In 2.2 and 2.3, I have *deconstructed* the prototypical notions of the absolute, relative, and relational space embedded in the modern philosophical and scientific contexts, as elaborated by Newton and Leibniz. My deconstruction focuses on 1) addressing the epistemic premises which make certain events a target problem for scientific investigation and explanation; 2) explicating the fundamental epistemic forms and their attributes introduced in spatial conceptualization; 3) explicating the causal or inferential relations conceived between them, and 4) clarifying the criteria conceived for validating such inferences. Although both Newton and Leibniz's spatial conceptualizations aim to explain the event of motion, they diverge firstly on how the attributes of things are conceived on the individual and collective levels. They also differ greatly on the sensible subject's capacity to capture motion, and the rule they follow to justify their knowledge. In short, due to the depth of epistemic frames, the distinction between the absolute, relative and relational conceptualizations of space cannot be reduced to a mere matter of semantics.

Subsequently, in section 2.4, I have analyzed how the epistemic frame entailed in Newton's absolute and relative concept of space, in Leibniz's relational space is re-contextualized into the domain of social science, shaping the conceptualizations of social space and our reading of the empirical phenomenon. Particularly, I have focused on elucidating three distinctive approaches of thinking of space relationally in the social domain (represented by David Harvey, Martina Löw, and Nigel Thrift's theories of space), in relation to the prototypical Newtonian and Leibnizian notions. At stake here is to identify the explicit and implicit epistemic presuppositions deployed in the conceptualizations, which conferred distinct causal agents, mode of inference, and level of analysis, affecting the way in which a social-spatial phenomenon can be read 'relationally.' In extremely broad terms, the philosophical strands the three theorists take – Newtonian (mechanics) and historical materialism, Leibnizian idealist-relationalism, and phenomenology and relational materialist traditions – rest on vastly different epistemic rules. The three theorists have systematically resorted to – the (post-)structuralism, the structuration-ism, and the relational materialism – distinct and non-convergent epistemic grounds for conceptualizing their notion of relational space. Equipped with a cross-cultural sensibilities, a philosophical-epistemic vigilance enables me to trace the source of their controversies over nature and mechanisms of space constitution back to its underlying philosophical controversies that cannot be settled on empirical grounds.

As I have indicated in my analysis, I perceive Harvey's concept of space (the space of the economic system) to be derived mainly from a Newtonian epistemic framework. Harvey has bridged the Marxist social-material dialectic to rebuild a dialectic inferential relationship between movable and immovable bodies rather

than a dualistic one. The 'material entities' are bridged to the capital of different forms, endorsed with varying capacity to move or produce the built environment from the perception of 'impartial observers,' with their driving forces linked to the law of accumulation, internal to these social actors.

Lefebvre, Löw, and Thrift share the same insights to conceptualize the *process* of producing, constituting and assembling space, including its symbolic, material, and imaginative or atmospheric dimensions. Lefebvre's forms of space – the material, representational, and the perceived – are immediately derived from, and in correspondence to, the Marxist material-social dialect and the principle of alienation. Löw's theorization links the structuration approach to the Leibnizian framework. She bridges the epistemic form of the 'social actor' to the 'monad,' the social actors' *habitus* to *materia prima* and *materia secunda*. Following a structuration epistemology, Löw presumes that social actors learn about and reproduce social structures through processes of internalization and objectification. Löw introduces the epistemic form of social objects, conceived to entail symbolic and material dimensions. The agency of the social object is defined through its interlinking with social actors' two dimensions of the habitualized practices. The primary analytical dimension is perception (the operation of synthesizing) of the symbolisms, and the secondary one is practice (operation of building and placing out the material bodies). Furthermore, Löw connects the 'spatial structure' to the 'order of the possible world,' while acknowledging potential dislocations between one actor's synthesis and material placements. Both orders are conceived relative to the situated bodies.'

In Thrift's conceptualization of space, social bodies and objects are forged within multitudinous actions and interactions, conceived as more contextual than structural. Despite their similar commitments to constructionism principles, Thrift's and Löw conceptualizations are not convergent. They address distinct subject matters. Thrift addresses the 'space of flow,' or the interactive and transient spatial constitution in contingent practical contexts (e.g., dance). Moreover, Thrift addresses the spontaneous, responsive, and emergent aspects of social actors' relational agency, *more* than ritualized or repetitive. The primary level of analysis is put on the affective, pre-cognitive level. He has also advocated a flat ontology between the social and material and a weak epistemology. Therefore, movements and change are assumed to be caused by factors that are both immanent and external to the subjects who experience them. It requires the researcher to be both interpretive and objective in identifying the mechanisms behind social-spatial phenomenon. One also has to take both an artificial temporal and spatial halt in determining the range and processes of stabilization or destabilization.

3 Accounts of social space in traditional Chinese thought

3.1 Introduction

In the last chapter, I have firstly elucidated the epistemic frameworks which underwrite the absolute, relative, and relational conceptualizations of space in the European philosophical field, showing how they make distinct spatial analysis and explanation possible and deemed valid. I have then shown how they are transposed into the social domain, laying the partial groundwork for three types of relational social-spatial conceptualizations, granting them unique analytical purchases. I have concluded on the methodological implications of employing each of the spatial notions. In this chapter, my intended subject matter is 'social space' conceived in traditional Chinese thought. Ideally, it would be most convincing to analyze the representative 'conceptual equivalents' and the epistemic genealogy of such spatial concepts in the Chinese scientific realm in the same way as I did in the last chapter. However, as indicated earlier, it is impossible to identify conceptual counterparts for the absolute space, relative space, and relational space from traditional Chinese philosophical and scientific discourses. The examinations (section 3.3 and 3.4), thus, could only be carried out on various fundamental epistemic 'building blocks' and 'causal agents' concerning the social space constitution. The building blocks and causal agents were made explicit in the previous chapter: the social-being, the natural-being and the forms of their interrelations.

This chapter's concrete subject matter is not the conceptualization of 'social space,' but the epistemic building blocks and causal agents of (relational) social space – the constellation of epistemic forms and principles that allow thinkers to attend to and express the meaning of social space. The ways in which their attributes are conceived and the attributed epistemic rules could shed light on the possible conceptual account of relationality in traditional Chinese thinking. In 3.5, I arrive at various *claims* regarding the accounts of social space in traditional Chinese thought, which may be seen as potential, complementary conceptual tools for understanding common spatial phenomena occurring in contemporary urban China.

3.2 The scope of Chinese literature and abductive reconstruction

Before commencing the analysis, it is worth explaining what I mean by 'Chinese thought' and what I have chosen to derive the building blocks that constitute 'the Chinese' spatial imaginaries, experiences and conceptions. I am aware that there is a great danger of being called an essentialist when using terms like 'the Chinese,' 'the European' or 'the Western' tradition. By employing these notions, I do not mean that specific ideas or ways of thinking grow solely out of national heredity without exchanges with the other, nor do I see China or Europe as a bounded territory for homogenous culture. Despite the danger, I find it necessary to explain the *differentiations* deployed by particular subjects in today's globalized and post-plural world at a given time and place. I often hear comments like "the Europeans are on strike again" either on the Chinese media or from my Chinese friends in everyday life. It is not very likely that 'the European' in these comments refers concretely to European nations' overall population. Instead, it stresses the differences perceived by the knowing subject in relation to what they know at 'home.' Depending on the context and the kind of differentiation one aims to make, 'the European' might represent anyone 'non-Asian,' 'non-Chinese,' or simply 'not me.' It is a practice of *Auseinandersetzung*, which sets the ideas and ways of thinking in relation (from my standing point). This perceived relation manifests as a sense of *difference and distance* between the 'other' and 'me.' Therefore, I use these notions in a relative than substantive sense to address the Sino-European differences in thinking of space relationally from my point of view.

To justify which literature and discourses I deem as Chinese, I shall clarify my own positionality a bit further. To start with, I do not equate Chinese literature with that written by scholars living in China or with Chinese nationality. As I will show in Chapter 4, now more than ever, scholars practicing in Chinese academia are situated in knowledge discontinuities, unpredictable epistemologies, and plural conceptualizations. Considering particularly, since the May Fourth Movement in1919, generations of Chinese thinkers have advocated for wholesale westernization regarding social-political ideas and technology. Thus, much quasi-sociological knowledge is not generated from examining the particular subjects nor from critically reconstructing classic Chinese philosophical threads. In this context, to me, Chinese literature shall be the ones addressing social-spatial phenomena situated primarily in a *Chinese discursive world*. At stake is the epistemic than normative attributes (such as the nationality of examined social actor, the locale), for the following reasons. Firstly, language is the primary carrier and transmitter of meaning, especially the culturally rooted ones. Secondly, discourse encompassed epistemic entities, stabilized by specific institutional-organizational contexts. Thirdly, practices, material bodies can be highly trans-local and mobile in our time. Their mean-

ing can be interpreted differently depending on the epistemic framework hold by the interpreter.

Then, the epistemic tools and approaches deployed in Chinese literature should not be directly adapted from western epistemic frames nor purely deductive. In that case, most likely, studies reproduce given epistemic presuppositions rather than uncover situated knowledge. Negative examples include literature such as *Capitalism Without Democracy* (Tsai 2007), *Neoliberalism with Chinese Characteristics* (Harvey 2005). These studies engage with epistemic frames as universally valid while ascribing the incompatibility between theoretical predictions and the observational terms acquired from immediate experience to the Chinese exceptionalism (discussion on this point, see, e.g., Fukuyama 1997). I refer to anthropological studies *grounded* in Chinese epistemic context to be Chinese literature, i.e., those that derive their theoretical claims inductively from situated narratives and social-spatial practices. Such examples include *From the Soil* (Fei 1992 [1947]), *A History of Chinese Civilization* (Gernet 2008 [1982]), *The Construction of Space in Early China* (Lewis 2006), *The Cultural Gene of Ancient Chinese Space* (Zhang 2012). I consider the knowledge produced by these authors to be quintessential Chinese. For me, at stake for being taken as Chinese literatures, are their admission of data and frames of meaning from the local context, openness to revise presupposed epistemic forms and rules. The 'Chinese' here is irrelevant to an authors' nationality and institutional affiliations.

Furthermore, although some works have intricately integrated or belong to so-called Chinese classics – such as ancient philosophical cosmology – I reckon only those that register a connectedness on the level of meaning, to discourse and practices entailed in a social-spatial phenomenon under study. I find *relevancy* to be core in defining Chinese thoughts. From the 1990s onwards, along with the rise of the Chinese state as an economic and political player in the global arena, more and more contemporary scholars have started picking up and advancing their knowledge production from traditional Chinese thinking, especially from that embedded in Confucianism tradition[1] (see, e.g., Yan et al. 2013; Fan and Yu 2011; Jiang 2018). Yet, it does not mean that all Confucian norms are once again relevant to construct Chinese people's everyday experiences. Instead, this trend is largely propelled by the sensible strikingly change in the social life in China and many East Asian countries. Scholars resort to Confucianism to account for the particular version of modernity observed (see Bell 2010; Du 1997). These practices are undoubtedly driven by the state-building aspirations imposed by the political authorities.

1 One illustration could be, "Learning to be Human", an important topic in Confucian philosophy, is deployed as the theme for the 24th World Congress of Philosophy, held in Beijing in 2018.

The socialist core values designated by Xi Jinping echo with the core moral values prescribed in Confucianism. Intellectual practices funded by state money are inevitably instrumentalized for constructing a new state ideology espousing political sovereignty and social coherence. In this context, the Confucianism classics are relevant in explaining the rationale under the state-building project and the professional practice of the involving intellectuals, but not necessarily the everyday experiences from Chinese social actors.

The subject matters, style, and the sheer number of Chinese philosophical texts make epistemic exploration and reconstruction challenging. There is a plethora of philosophical schools that take on very different intellectual stances, metaphysical claims, and topics of focus that are subject to transformations in Chinese history. Therefore, in the discussion that follows, I have carefully selected the theoretical discourse whose frames of meaning are relevant to explain my own experience and observations in my field study. This selection may be partial, biased, but grounded and relatable. To serve the purpose of this chapter – how the epistemic forms (the subject, object, and the forms of their relation) are formulated differently in traditional Chinese thought than in previously discussed European ones – I draw on normative discourses about being from Confucianism and Daoism.

I am aware that such a selection would induce much skepticism. The first one might be, the Confucian and Daoist discourses are known to be difficult to translate into ontological and epistemological terms, then, how can one carry out comparisons? To solve this problem, I resort to many works from comparative philosophers who have well translated the classics into analytical terms. The second question might be, "Chinese philosophy.... is directly or indirectly concerned with government and ethics... All [its branches] are connected with political thought in one way or another", which do not separate the natural from the social world (Fung and Bodde 1997, 7), how can one derive the separate epistemic forms regarding social and natural entities? To put my solution simply, I consciously choose Daoism writing, as it has laid the ground for natural and cosmological views of the world among all the ruling philosophical schools. Confucianism is the humanist school of philosophy, contributing mostly to ideas around the ethical, social, and political order of social reality in traditional Chinese society. Thus, I deem them legitimate to excavate the spatial building blocks concerning social and natural entities. Besides, as both epistemic views are built upon cosmic principles set in the *Book of Changes*, emphasizing humans as an integral part of nature[2] and that substance and activity have the same origin[3], no fundamental epistemic collision exists between the discourses from these two traditions. The third question that might arise is how I can prove these epistemic premises have empirical relevance to studying

2 Tian Ren He Yi (天人合一).
3 Ti Yong Yi Yuan (体用一源).

contemporary urban China? To navigate that, I would not stop presenting a-temporal differences but develop claims on the accounts of space concealed in traditional Chinese thought. At the end of the discussion, I would employ my account to explain a common social-spatial phenomenon that occurs in contemporary Chinese society. I will also employ these claims in my empirical analysis of the artworld in chapter 5, show thereby their analytical relevance to the empirical phenomenon of our time.

3.3 The social subject, self-hood and self-other relations

3.3.1 Relationality as postulation and priority

As previously indicated, in the European social-science domain, scholars often take the 'individual subject' or the 'homogeneous social group' as the basic unit of study, addressing their rational or rule-abiding agencies. More explicitly, the transition from positivism to hermeneutic traditions has re-associated the individual back with 'sociality' and 'social relations.' Moreover, the symbolic interactionist and constructionist traditions require one not to attribute agency to agnostic individuals but socialized subjects, whose perceptions and practices are deeply embedded in and shaped by socially and materially intertwined domains. These epistemic forms, the *'social subject' and 'subjectivity,' 'social relations,' and 'sociality'* become ineluctably interdependent. As shown in chapter 2, the relational epistemic frameworks differ, not only in how they define these necessary entities and at particular analytical levels, but also (though not always) which attribute is given the causal primacy to explain the change. In this section, I look at the narratives[4] about 'personhood' in Confucian classics and commentaries regarding its postulated attributes about the social subject. I will elucidate how 'social subject' is logically related to other epistemic entities like social relation in explaining social change.

 To delve into the definition of 'social subject,' I take *ren* (仁), a polemical concept often translated as 'human-heartedness,' 'benevolence,' and 'authoritative humanity' as my departure point. Scholars generally agree that the concept of *ren* is a central, if not the most fundamental concept regarding the fundamental understanding of human existence in Confucianism (see Tu 1968, 29). The fact that it appears 105 times in 58 out of 499 passages in the book *Analects (Lunyu)* implies both the profundity of its meaning and the difficulty in interpreting it. A coherent

4 Here I use sayings and concepts rather than definitions, because: 1) ancient Chinese scholars use a metaphorical style of drawing definitions, 2) the Confucian classic is written not in an analytical way, but in ordinary language. It is explained in the form of dialogues between Confucius' explanations and his followers' inquiries in the Analects.

and rigorous definition of *ren* is absent in Analects. The interpretations of *ren* fall primarily under three categories: as an inner virtue of a subject, as outward and extended consciousness, and as a dynamic process of self-cultivation. The three interpretations allude to three different conceptions of 'social subject' or 'subjectivity.' How social subject come about to be 'social' are also divergently conceived. I will briefly compare them and argue why I find the third interpretation most convincing. From there, I would arrive at my claims on the Confucianist conception of the social subject, and how different forms of social relations are derived from subjectivity.

In most contemporary interpretive works, *ren* has been interpreted as a psychological notion – *ren* representing 'human-heartedness,' 'benevolence,' 'love,' 'agape,' 'compassion,' 'magnanimity,' 'perfect virtue,' 'goodness,' etc. – as a kind of virtue or a subjective inner state of mind, feelings and attitudes. Such interpretations are primarily drawn based on the sayings from *Zi Zhang, who asked Confucius about authoritative humanity*. Confucius replied, "a person who is able to promote the five attitudes in the world can be considered *ren*." When Zi Zhang asked what they are, Confucius replied, "Courtesy, tolerance, trustworthiness, diligence, and kindness"[5] (2007 [1983], 17.6). Follow the idea in this narrative, Tu Wei-Ming has developed his interpretation:

> Ren is not primarily a concept of human relations, although they are extremely crucial to it. It is rather a principle of inwardness. By in-wardress, it is meant that ren is not a quality acquired from outside; it is not a product of biological, social or political forces... Hence, ren as an inner morality is not caused by the li (ritual act) from outside. it is a higher-order concept which gives meaning to li. Ren in this sense, is basically linked with the self-receiving, self-perfecting, and self-fulfilling process of an individual. (Tu 1968, 33–34)

Tu's reading of *ren* clearly shows that he favors a substantial-individualistic understanding of subjectivity. For him, *ren* represents the source of virtue feelings in one's psyche, from where the ritual conduct (*li*) arises. It precedes and explains the formation of social values and norms. This subject-predicate interpretation is criticized by many. Fingarette, for one, contends that there is a tendency for scholars from the west to 'psychologize' *ren* as a 'natural move' from the substantial ontology that they are familiar with. To revoke this argument, Fingarette highlights the lack of reference to any inner psyche-related language such as in the original text of the Analects 'will,' 'freedom,' and 'inner states' (2004 [1972], 45).

5 In Chinese: 子张问仁。孔子曰: 能行五者于天下,为仁矣。请问之。曰: 恭, 宽, 信, 敏, 惠。恭则不侮, 宽则得众,信则人任焉,敏则有功,惠则足以使人。

Instead, Fingarette argues for an 'outer' or a 'normative principle of conduct' reading of *ren*. He conceives *ren* as a particular, individual form of moral practice. He argues, "*li* and *ren* are two aspects of the same thing. *Ren* is the aspect of conduct that directs our attention to the particular person and his behavioral orientation as the actor" (ibid.,14). Fingarette further explains:

> It is not simply abandoning one's own person in assuming the persona of another; rather, it is projecting oneself personally into the circumstances of another, responding to those circumstances as one deems most appropriate. One acts by extending the parameters of one's own person to embrace the defining conditions, perceived attitudes, and the background of the other person in order to effectively become 'two' perspectives grounded in one judgment. Further, this one judgment is continually conditioned and refined by the relationship between it and the changing circumstances with which it is engaged. (ibid., 16)

This perspective draws mainly from the sayings of *Fan Chi asking about ren*. The master replied, "in private life, be courteous; in handling affairs, respectful; in dealings with others, loyal. Even if you go among the *Yi* or *Di* tribes, these rules can never be put aside." (ibid., 13.19). Nevertheless, this behavioral reading of *ren* underscores an implicit claim – in the process of extending oneself into the circumstances of another, one's cultivated principles are retained as a coherent whole. This echoes with the assumptions underpinning Nietzsche's master morality theory, in the sense that *ren* is seen as the superior consciousness that can be extended outwards by the practice of the masters. Whoever has 'slave consciousness' is disproportionately affected by the master's practice and is subordinate to it. The problem of this interpretation lies in its one-directional outward extension, which cannot be better criticized than using Deleuze's arguments, "consciousness is always the consciousness of an inferior *in relation to* the superior to which it is subordinated or 'incorporated.' Consciousness is never self-consciousness, but the consciousness of ego in relation to the self that is not conscious. It is not the master's consciousness, but the slave's consciousness in relation to a master who does not have to be conscious himself" (2006, 39). Following this line of argumentation, the second interpretation equates *ren* as a form of particular normative practice. It fails to explain why 'the inferior actor' has not internalized *ren* in the first place, nor how can such a consciousness-practice be kept intact through transactions in such asymmetrical relations.

The two interpretations above share the idea that there is a virtue aspect in *ren*. They both have difficulties in giving such a love-based and 'un-selfish' virtue proposition a plausible, logical ground from an individualistic point of view. This proposition is logical in Christian tradition because unselfish love (agape) is conceived to originate from God. Taking God's existence and virtual as given, individuals can approximate and express such love in their behaviors simply because they are seen

as the vehicles for God's love. After all, there are *two* figures involved. As there is no God-like transcendental figure presumed in Confucianism, it is only logical to argue for an ontological ground for *ren* from communal living.

The third interpretation of *ren* suggests this virtual consciousness could only be deemed valid when admitting a premise of '*transcendent relationality*'. The arguments begin from an etymological explanation of the sign *ren* (仁). It consists of (人) (*ren*, meaning man[6]) on the left side, and 二 (*er*, meaning 'twoness') on the right side. Considering the virtue connotation on the level of meaning, the third group of scholars (e.g., Boodberg; Hall and Ames) insists that *ren* as the human-virtue state can emerge only from the intended aspect of affect, presuming the co-existence of social beings in subject's perception. Supporting discourse from Confucian classics include: "*ren* is the character of the man, and it is foremost to love family. The moral character of benevolence is inborn, and it is essential to love one's own family" (Zi Si 1980, Chapter 20). This saying has made an explicit inference from a perceived, affect-bound social relation to *ren*, specifically from familial relations to *ren*. Relation within the family is conceived as the necessary social ground from and through which social actors develop and exert *ren*. This is affirmed by Confucius' illustration of the utmost interdependent interactions between an infant and his/her parents – the most emotionally charged human interaction.

So far, we can see that the disputes among various forms of interpretations arise from different postulations regarding human subjectivity, and subsequently, the logical order between subjectivity and intersubjectivity. The first interpretive approach attributes a transcendental status to the individual subjectivity as a conscious and moral state, assuming inherent subjectivity to be a social actor's source of knowledge and meaning. From apodictic subjectivity, sensible, representational and normative relations or sociability are conceived to arise. This approach presupposes a knowledge condition close to that of the Newtonian and Kantian synthetic *a priori* discussed in 2.3. The second perspective evades the source of subjectivity and reads *ren* as a normative principle of conduct embodied by individual social subjects, which echoes with the postulations of the social subject in the Marxist dialectic social structure discussed in chapter 2.4. We can now have a quick review of this line of thinking before returning to discuss the third interpretive approach. As stated previously, the mundane knowing subject in the absolute-relative space conceptualization is conceived as an impartial rational observer, however, Newton did not justify the source of such intelligence. Along this line of thinking, Kant has later clearly stated that the 'proper self' is located in the pure and rational will, or the 'noumenal self' of an agent, rather than in one's feelings, natural impulses, or inclinations. In contrast to Confucianism, the Kantian discussion of marriage

6 According to Nisbett and Peng (1999, 52), there is a lack of comparable vocabulary of "I" in the traditional Chinese, Japanese and Korean thoughts.

and family comes in the form of property relations, contractual and formal. The difference lies in that Kant defines autonomy principally as "the property of the will by which it is a law to itself (independently of any property of the objects of volition)" (cite in Wood 2007, 106). The subjective autonomy is central in Kant's and many later scholars' ethics, for it is in one's membership in the intelligible world that Kant locates freedom. Therefore, even in his practical philosophy in which he conducts a pragmatic, impure, and empirical study of human behaviors, Kant perceives interpersonal relationships as guided by independent, rational, teleological intentions.

We can identify the premise of a 'subject-predicate principle' also in the later European conceptual paradigms of space. Phenomenologists (upon which Löw's and partly Thrift's relational conceptualizations are grounded) admit that space is not only *pre*-constituted in cognition and senses as an intentional object but also *post*-structured by one's habitus and practical knowledge – one's experience in the lifeworld. Husserl argues that subjectivity, "understood as that which naively pregives the being of the world and then rationalizes or objectifies it" (1989, 69). It means, in plainer words, subjectivity should be deemed a transcendental condition for the possibility of objectivity and the world as such. Thus, Husserl's investigation of the lifeworld starts from a straightforward '*first-person perspective*' toa sensible '*shared lifeworld*' and bridging the two with the principle of 'empathy' and 'inter-subjectivity.' The later phenomenologist Heidegger created the new term of being, '*Dasein*' – conflating the subject and object in explaining the mode of human existence. Dasein (being-in-the-world) is still conceived singular. No differentiation is drawn between '*the self*' and '*the other*' in Dasein's lifeworld. Thus, the 'thrown-ness' and the 'projection' of the Dasein's past conditions how Dasein encounters the world of the future. In both lines of thought, the conceptual self and his/her subjectivity are re-embedded in the social condition. The singular subjectivity constitutes and is thereby constituted by the social rules and shared cultural normativity (as a form of collective subjectivity) from a given lifeworld.

Returning to Confucianist discourse, I would argue, Confucius has ascribed the locus of meaning creation to 'relationality' in the family, especially between the father and the son. The primordial epistemic status of normative social relations is made more explicit by some disciples of Confucius. The first person to register relationships as the basis of social order was Dong Zhongshu[7], who coined them as *Three Cardinal Guides or Bonds* (san-gang[8]). Dong believed that the three cardinal bonds are not just constructions of social norms but real in the sense of embodying and actualizing the cosmological principles of *yin* and *yang*. In *the History of the*

7 Dong Zhongshu (董仲舒) (197–104 BCE), the great Han dynasty Confucian philosopher and statesman.
8 San-gang (三纲).

Han he wrote: "The lord is *yang*, the retainer is *yin*; the father is *yang*, the son is *yin*; the husband is *yang*, the wife is *yin*. The way of *yin* cannot proceed anywhere on its own[9] [...] The retainer depends on his lord to gain merit; the son depends on his father; the wife on her husband, *yin* on *yang*, and the Earth on Heaven [...] The Three (fundamental Bonds) of the kingly way can be sought in Heaven" (Han Shu, Ch. 53). Later, in *Mencius*, one can find five rather than three social relationships deemed real and primal. Some ethical norms are further attributed to these proto relationships "between father and son; there should be affection; between sovereign and subordinate, righteousness; between husband and wife, attention to their separate functions; between elder brother and younger, a proper order; and between friends, friendship" (Mencius, 3A.4).

I find these ancient and contemporary Confucian philosophers' emphasis on the dyadic relationality insufficient to ascertain a *relational social ontology* in classic Confucianism. It is not easy to read Confucian discourses analytically, as they were not formulated in analytical terms. Moreover, no immediate equivalent terms such as subjectivity, consciousness, perception, or social structure can be directly identified in the narratives. It can be noted that the aforementioned proto relationalities are composed not in abstract terms, like 'subject and the other,' but in the form of normative categories, i.e., social roles. One can thus only re-read the conversations *abductively* between Confucius and others to shed light on this issue.

I find it worthwhile to elucidate the logical relations between these categories further. In the example of a father-son relationship, it is logical and self-evident that there can be no son without a father. Furthermore, by definition, either father's or son's awareness of their relational self is developed by virtue of perceiving the presence of the other and the normative relation between them. We can also find that such interpersonal relationalities are *legitimated* through drawing analogies to the polarized epistemic terms in classical Chinese cosmologies, i.e., the *yin* and *yang* or heaven and earth. Interestingly, these epistemic pairs are also not conceived as mutually exclusive but rather as constitutive to each other, indicating their mutual dependence. Chang's interesting discussion on the east-west definition could also support my hypothesis of a relational ontology:

> In western logical definition, it is necessary to make the sign of equation between the "definiendum" and the "definiens." For example, "a triangle is a portion of a plane bounded by three straight lines." However, in Chinese thought, the problem

9 In general, Confucian ideas were shaped for the purpose of consolidating a society that has been ordered by patriarchal principles. In this dissertation, I would certainly not espouse the substances of such patriarchal norms, nor arbitrarily justify its relevancy to the social norms in China of today. The citations are made for the purpose of deriving the possible epistemic forms and rules that may linger in many people's minds today, shaping the way they think and behave.

of the equation between the two is never thought of. For example, 'wife' is denoted as 'a woman who has a husband.' (Chang 1952, 213)

In addition, the discussions on human emotions in Confucianism could also be read as supporting evidence to a hypothesized relational account of subjectivity. The strong association between personhood, a moral and affectionate self, the prioritization of affect as a primary attribute of personhood is made clear in the volume of *Nature Coming Out Of Fate*[10]. It is shown in the narrative "Dao originates from affection (feeling, emotion), and affection comes from nature. The beginning is close to affection, and the end is close to righteousness" (Guodian Chumu Zhujian, n.d.). The epistemic and causal primacy of 'affect' in defining 'personhood' is also justified in the phonetical identicality between *ren* (仁, partly meaning human kindness) and *ren* (人, meaning human) in later Confucian classics such as *Mencius* and the *Zhong Yong* (*The Doctrine of Mean*[11]). They state explicitly that *ren* (仁) means personhood. To bring focus on the presumed first-order relationality in *ren*, Boodberg argues that "one could employ *ren* as a Latin synonym of "manship" a term such as "homininity" (with "hominine" and "hominate," as corresponding adjective and verb), that is, a derivative from homines, rather than one from the singular homo" to interpret *ren* (Boodberg 1953, 329–30). Among others, Hall and Ames further argue that *ren* reflects a degree of qualitative achievement of *ren* (man), 'two' is attached to the notion of 'human being' which would indicate, such an achievement is attainable only in a communal context through an interpersonal exchange (1987, 116). These arguments constitute the third interpretive approach of *ren*.

By tentatively accepting *ren* as an affective attribute of subjectivity built on a relational ontology, I move on to hypothesize, in the Confucian tradition, *the spatial dimension is prioritized as the structuring principle of experience*. As my analyses in chapter 2 have shown, relationality can be admitted on the epistemological level (like in the Leibnizian), or on the ontological level (like in the hypotheses Confucian frame). I would argue, in these two contexts, time and space are conceived to play different roles in structuring people's life experiences. When one starts from a first-person perspective (as in constructionism) and equips with a relational epistemology, the experience is conceived to arise from the individual's consciousness, in the form of constant creative activity. As discussed briefly before, in line with the logic of identity, *time* is attributed as a subjective and dynamic structure in the idealist (e.g., the Leibnizian) and phenomenological traditions. They both postulate individual temporal consciousness structure subsequent (possible) displacement of bodies from the current (actual) ones. In the former cases, temporality is deemed the primary structure of experience.

10 Xing Ming Zi Chu (性自命出).
11 Zhongyong (中庸).

Let me elaborate further on this point. In the European context, before the phenomenology tradition, individual consciousness was conceived to be structured by rationality, detached from a social context. The surrounding world is taken as static and passive (the Newtonian absolute and relative space). In the epistemic tradition of phenomenology, a social subject's perceptual experience is conceived to entail a phenomenologically deep micro-structure constituted by time-consciousness (see Miller 1984). Provided with such a structure of temporal-consciousness, the social subject is conceived to experience time as a flow due to the momentary structures of 'retentions,' 'original impressions,' and 'protentions.' Moments are conceived as continuously constituted (and reconstituted) in the form of past, present, and future. When an experiencing subject is conceived to rely on the structure of consciousness (horizon of meaning) as such, his/her experience of the real world is gained incrementally, following a principle of coherence and correspondence, i.e., the same representations are perceived the same *over time*. In this tradition, only time is admitted as a dynamic structure, according to which social subjects' perceptual experience *form*. For a subject, his/her experiences shall reinforce the sense of his/her identity consistently. Thus, time is premised on the dispositional 'higher-order sense' or something akin to the 'constant inner perception' of *the subject*, which cannot be doubted.

The primacy of a temporal structure applies even to Heidegger's conception of *Dasein*, a notion that integrates 'subjectivity' and 'objectivity-to-be-known,' which is conceived as always already being-in-the-world. Dasein's world is primarily conceived as the locus for historical facticity and is hence convened into time. Alfred Schutz made an even more radical claim along this line of thought: "the problem of meaning is a time problem" (1967, 12). However, for Schutz, it is not time that is a "given to consciousness," it is "consciousness that unfolds time" (cite in Muzzetto 2016, 6).

On the other hand, I would claim, space, over time, is taken as a primary structuring force of experience in Confucian thought. Evidence can be found in the discourse illustrating the normative meaning of *xiao* (filial piety). For instance, in Analects 2.8, "the master said: 'xiao[12] lies in showing the proper countenance, as for the young, contributing their energies when there is work to be done and deferring to their elders when there are wine and food to be had. How can merely doing these things be considered *xiao*?" (cite in Hershock and Ames 2006, 70). *Xiao* (filial piety) is often referred to as a key virtue and the origin of the absolute character of submission in Chinese culture. Here, again, such an intended moral virtue strikes social relations at its core of constitution, over self-sustenance. In Analects 1.11, Confucius stated: "While his father is alive, observe his intentions. After his

12 Xiao (孝).

father is dead, observe his actions. If after three years he has not changed his father's way of doing things, then you can call him filial." (ibid.) Here, we can notice more explicitly that, a consciousness of social relation (with one's father), even in the imaginary form – without the physical presence of a father, is necessary for actualizing *xiao*.

The other evidence that supports my argument for spatialized social relationality as a primordial structure of consciousness is that, the Confucian proto relationalities are conceived as *asymmetrical*. We can assume that, when social actors are embedded in the three-principal relationship, their social interactions s are most likely to induce 'emotional resonance,' 'simultaneity among the consciousness,' 'expressive movements and acts' and 'the shared context of meaning-sign systems.' In these prototypical social relations, the level of experienced physical intimacy seems to be comparable with Schutz's formulation of a face-to-face scenario. I have noticed, by definition, the father is *different* from the son, the husband *different* from the wife and, and the sovereign *different* from the subordinate. Aside from three or five defined principal bonds, following a directive of asymmetrical relationality, the Chinese never seem to tire of further differentiating roles and norms. As Chang describes below, the Chinese language has excessive categories of consociates, contemporaries, and predecessors, providing ample intentional indexes to anchor one's subject experiences.

> It is interesting to note that the most numerous terms in China come from two realms; the one, kinship, illustrated by *po* (father's elder brother), *shu* (father's younger brother), *fang* (paternal cousin), *piao* and *yi* (other forms of cousins); the other from the realm of ethics, illustrated by *chung* (loyalty), *xiao* (filial piety), *lien* (frugality in taking) and *chien* (frugality in spending). All the fine shadings in Chinese terminology in these two fields may be lumped together in such English terms as brothers, uncles, cousins, frugality. (Chang 1952, 222)

I see the attribute of *asymmetry* as a crucial aspect for clarifying the distinctive inferential orders between subjectivity and sociality in classic Chinese and European thought. Despite 'inter-subjectivity' is introduced as a crucial epistemic form by phenomenologists, elucidated especially by scholars such as Schutz. It is nevertheless conceived as a *derivative* of subjectivity. For example, from a first-person perspective, Husserl conceived intersubjectivity to emerge from 'empathic acts' – when one perceives the other as a subject, rather than a mere body or a material extension. Here, Husserl and later phenomenologists' fundamental premise is that 'the other' appears, behaves, thinks, and feels more or less *like* 'me.' In other words, 'we' are equal. Under this implicit premise, the way in which the 'other' perceive the world is assumed to be *similar to* my own. However, we are positioned differently, thus having different egocentric viewpoints. Regardless I experience the world in the same way as you do by making the analogy with one's own past experiences.

It is exactly upon this epistemic premise of equal/indistinct beings, could the social subject be conceived to attribute intentional acts to others immediately or 'a-presentatively,' i.e., analogous with one's own case, with no necessity of drawing any further forms of reference. Heidegger's *Mit-sein* (being in the social relationality) is conceived to be positioned among the *same* beings in their lifeworld. Even for Schutz, a steadfast advocate for intersubjectivity as the ground for meaning construction, who famously writes, "the world of daily life is by no means my private world but is from the outset an intersubjective one," share the 'same' postulation with his predecessors (1982, 312). Schultz and Luckmann write with clarity that "all experience of social reality is founded on the fundamental axiom positing the existence of other beings 'like me'"(1995, 62). In other words, my subjectivity and that of the other are conceived as the same in form. The social relation is taken as 'symmetrical' in our reciprocal perceptions. It is thereby logical that my perception of a co-existing other would not necessarily affect how my own perceptual experience is constituted and the meaning I generate to interpret this experience. In this train of thought, Schutz has proposed a two-dimensional 'structure of the lifeworld' scheme: one spatial dimension in terms of the increasing zones of anonymity that radiate out from the ego to the spatial zones of the world within 'actual' or 'obtainable' reach. The other is temporal, in terms of 'predecessors' (Vorwelt) and 'successors' (Folgewelt) (ibid.). According to this scheme, my *own* identity construes my consciousness of the world in the now, as the locus of my meaning production towards the future. The spatial dimension unfolds in two quadrants (as with the temporal dimension) of physical immediacy and intimacy. It subordinates to the temporal dimension in structuring meaning.

At stake here for drawing the difference – the betweenness of spatial dimension – is highlighted by Japanese philosopher Watsuji. He (1989) argues that the phenomenologists have missed one essential aspect of consciousness: "the fact that consciousness of the other is simultaneously the consciousness of me by the other". To act *upon* a relational consciousness where 'the other' or the 'represented self' is perceived as different from myself is more than 'ap-presentation.' It is to act within a context in which some basic evaluations and differentiation are constructed based on the sense of other's immediate reactions. Thus, the perceiving subjects act on a perceived relationality between a self and a represented self, which is interpreted as how the other is relating to me. This relation could even be 'not relating,' Which is well illustrated in the following example:

> When friends come upon each other, they remark on the weather. This is the common sense of Ningen- betweenness. They do not reflect on the reason why they speak of the weather. When they speak of it, they know that they do not concern themselves with knowledge of the weather but only the mutual relationship thereby expressed. (Watsuji, Seisaku, and Carter 1996, 39)

I can now finalize my claim regarding the form of (spatial) relational subjectivity, the inferential relation between subjectivity and social relations in the Confucian tradition. When social relations are presumed primordial and asymmetrical – if 'the other' were perceived as intrinsically and dynamically (not only normatively) *different* from me, manifested in terms of seniority, gender, and other prescribed social roles – 'the other' will not simply appear passively as 'ap-presentation' in my perceptual experience. In this case, the temporal consciousness will also cease to be the primary structuring force of one's experience and subjectivity. Instead, when my senses of the other's immediate sense of me were dynamic, the other will be constantly differentiated in my reflective projected act (in spatial terms, with regard to the extent of immediacy and intimacy). When 'the other' exhibit multiple roles in the course of our continuous encounter, one can never stop reaffirming or re-actualizing the reciprocal perceptions. Such perceptions and senses will affect and re-direct social interaction forms, hence structure and participate in constituting one's experiences and subjectivity.

Provided the sensible social relationality was interpreted varyingly from moment to moment in one's consciousness, and the meaning of it does not grow incrementally, the relational and spatial consciousness can thus be seen as the primary structuring forces of meaning-making activity. The interpreting and re-interpreting processes end only when a sense of relationality ends in perception, expectation and memories, which will affect not only a face-to-face encounter but potential future encounters. Chang's example regarding the notions of *lien* (frugality in taking, virtuous) and *chien* (frugality in spending, flawed) shows that the Chinese language is especially rich in addressing directed value judgments regarding the same practice. These categories help one to materialize the spatialized experiences constituted by asymmetrical (spatial) relational perceptions.

I would argue that a relational subjectivity is embedded implicitly in Confucianism, presuming that one can and shall *react* in the now. The senses of '*asymmetrical relationality*' constitute the subjective experiences. It differs from what Schutz has argued that "the whole present, therefore, and the vivid present of our self, is inaccessible for the reflective attitude. We can only turn to the stream of our thought as if it had stopped with the last grasped experience. In other words, self-consciousness can only be experienced *modo praeteritio*, in the past tense" (1962, 173). Furthermore, it also counters the statement "meaning is seen as the product of the intentionality inherent in the reflective projected act," embedding meaning to a more outward, directed intentionality. In contrast, my proposal stresses that subjective meaning can be derived from one's senses in the moment and in the context. One can sense such an experience while occurring or while we are living in it.

Now, I would like to make my first claim more clearly. In the context of Confucian thinking, the spatial is conceived as a prioritized structure ordering the social subject's perceptual experience (the sense of asymmetric relationality). Social ac-

tors are predicated as *different* from one another. The difference materializes as social status, gender, age and so on, which are sensible. When defined as ontologically real and asymmetric, the sensible social relationality is actively employed (consciously or subconsciously) by social subjects, informing their meaning-making perceptions and experiences.

Guanxi and social relationality

The concept of *guanxi* (social ties) from Chinese cultural studies affirms my first claim about relational subjectivity strongly. Literarily, *guanxi* means 'connections,' 'social ties,' or simply 'relations. It implies the subjects' deep embeddedness in inter-personal relationalities and the constitutive role such relational perceptual patterns play in meaning-making.

Chiao (1982) has once listed a range of social practices in Chinese society in which *guanxi* is employed: matchmaking; receiving a quota to have a baby; entering a school; moving residential registration (from rural to urban, from small town to big town); getting a job or changing jobs, and so on. Although not all these practices remain common in today's Chinese society, studies continually demonstrate the prevalent employment of *guanxi* in social actors' everyday practices.

As a sociological concept, scholars generally agree that *guanxi* refers to the kind of enduring asymmetric relationships perceived by two parties. It incurs through reciprocal social obligations and the solicitation of special favors in each interaction between the participating parties. What has been transacted entails both material (gifts), economic (money and information resources), and symbolic capitals (reputation and face) (see Yang 1994). According to Lin et al., *guanxi*'s most crucial feature is that it contains at least two parties in asymmetrical and unbalanced positions. There is always a seeker (petitioner) and a giver (allocator) favoring each *guanxi*-driven transaction. It also implies an actor's agency in a social encounter is affected by their sense of positionality in *guanxi*. The practice of *guanxi* corresponds with my previous claim of relational, asymmetrical subjectivity.

Furthermore, what gives *guanxi* transactions an asymmetrical nature is not necessarily the amount of capital that each party possesses and transacts but its sentimental basis. 'Qing[13]' (sentiments or emotion), or *ren-qing* (human feelings), is a central element of *guanxi* (So, Lin, and Poston 2001, 157). The sentimental basis of relations hinders any symmetric exchange in each transaction. Namely, a favor given is not met with favor in return right away. Thus, the primary causes of inequality do not lie in the individual or group possession of the capital of whatever forms, but rather in their position in the unfolding relations, in the enactment of affect. In Charles Tilly's words, the "bonds, not essences, provides the basis of durable inequality" (1999, 136).

13 Qing (情).

Lin et al. argue that economic, social, and affective entities are evoked in each *guanxi*-driven transaction. But the efficacy of a transaction is more dependent on one's position in social relationality in which transactions occur. On the normative level, scholars stress that *guanxi* takes on significance in a society where social standing (e.g., social relations and social recognition of one's placement in the web of social networks) is deemed valuable for actions and that individuals and institutions share the same dominant *exchange* ideology (ibid., 159-162) grounded in asymmetrical social categories. Instrumental transactions are considered a means to maintain *guanxi*-relationships, with decision making based primarily on the gain of relational social capital (credit, reputation, face). The social interactions associated with *guanxi*, rather than formal and contractual relationships, are believed to have led to the emergence of social structures with the increasing complexity of positions, authority, rules, and agency in Chinese society (ibid., 165). In short, the asymmetrical and affect-laden feature of *guanxi practice* and the processual and reciprocal feature of *guanxi* transactions derived by the cultural scholars, are congruent with my proposal of the relational subjectivity.

3.3.2 Two sensual coordinates and relationalities

In my own inference, two sets of questions arise from my first claim about a relational social ontology hence a relational subjectivity. The first one is: when the instantaneous affection emergent between the subjects are conceived as the driving force for developing relational consciousness and establishing intimate social relations, how would a person develop a constant sense of self in the Confucius tradition, if at all? Secondly, if the meaning of wider social relationalities can be generated by drawing an analogy to family relations – the basic units of social relations? What inferential modality justifies such analogy? How are social parts assumed to be associated as a whole in Confucianism? Would a hierarchical normative social ordering system allow a common ground for a shared meaningful social world (Sozialzusammenhang)?

I begin with analyzing the second set of questions, as there are already straightforward answers to them in the Confucianist philosophical scheme. His followers have repeatedly confronted Confucius with such inquiry regarding if the guiding principles in the proto-social relations apply to an ideal social whole. In that social-historical context, the primordial relational principles are conceived to reinforce the power relations in an aristocratic society. First, Confucius denied that, laws – the external legislative norms could cultivate the ultimate good, hens establishing ideal social order. The supporting discourses can be found in "in hearing lawsuits, I'm no different from other people. What we need is for there to be no lawsuits!" (ibid., 12.13). The Confucian solution was to integrate the intricate social interrelatedness within a simple scheme of three (and later five) principal bonds. On one

occasion, Confucius answered about the principle of 'governscraft,' "let the ruler be a ruler, the ministers minister, the fathers father, and the sons son" (ibid., 7.11.).

In the previous sector, I have already introduced the normative content of three or five principal bonds. In this section, I would like to walk you through my second claim that, the social subject is conceived to have a 'two-dimensional,' 'affect-based' sensible-consciousness structure that orders their experience and process of 'meaning-making.' I arrive at this claim by deriving their distinct affective principles, and by refering to the five cardinal relationships in parallel with the 'we-relationship' concept proposed by Schutz. Both Confucius and Schutz have conceived the form of primordial social relations in which all other social relationships are rooted and to which all relations can be referred. When I draw on the affective principle of intimacy and anonymity from Schutz to characterize the form of primordial relations in Confucianism, it is evident that three out of five relationships are located within the family (intimate sphere), one 'friend-friend' relation is located in the semi-mediated sphere, and one relation "between sovereign and subordinate" is located in the anonymous sphere. Yet, I find these one-dimensional affective measures not adequate to describe the concatenations among these cardinal relationships. Inspired by Chang and Shun's interpretation of Li[14], I find it possible to identify two distinct affective and cognitive structures that underwrite the meaning constitution of these relationships. The first one is *ren (affection and intimacy)*, and the second one is *li (reverence and hierarchy)*. The two coordinates are positively correlated because they can both be evaluated by 'closeness and distance' and 'center and periphery' in the affective dimension. If it were the case, we could further legitimate the inter-relatedness of these seemingly normative social relations. It then allows me to explain how one's primordial social experiences can be extended into other social scenarios.

I will first justify how 'affect' can be conceived as a joint base in these two structural axes. Manifested as both intimate 'affect' and 'reverence,' the affect-based relational subjectivity enables the social actor to infer their experiences from the familial sphere to the social sphere. Concerning the differential and relational interpretation of *ren*, and its embeddedness in the prescribed familial relationships, it appears logical to align the senses of *ren* in the dimension of *affection and intimacy*. A broad body of commentaries supports such an argument. According to Ames and Hall's interpretations, in the text of *Shuo-wen*, *ren* is defined more explicitly by the character *qin*[15], which carries the underlying meaning of extending affection to those close at hand (ibid., 119). This argument corresponds with the humanity-making perspective – the third interpretation of *ren*, which infers from subjectivity to a moral endeavor among fellow men. There, *ren* is interpreted as an act of

14 Li (礼).

15 Qin (亲).

extending affection from the self to the other. Furthermore, this claim can be affirmed as the term *qin* can refer not only to affection that is extended to others, but also to the *person* extending the affection (themselves[16]) and the *recipients* of that affection (parents, kin, intimates[17]).

According to Confucius, affections could be extended from the core relationship outwards, following a naturally descending gradation. When asked why he conceives *ren* love to be biased rather than universal, beginning with family members and extending outwards into one's society, Confucius answers: "The gentleman [exemplary person] operates at the root. When the root is firm, then the Way may proceed. Filial and brotherly conduct – these are the root of humaneness, are they not?" (ibid., 1.2). However, one shall also not neglect that, the Confucianism schemata is conceived for supporting the social cohesion in the imperial society. Thus, the *ren-affection-intimacy* coordinate axis is by definition, extends primarily within the consanguineous domain.

Then, by analyzing the concept of *li*[18], I have concealed a second reverence-based sensible-cognitive axis embedded in the Confucianism schemata. *Li* is usually translated as rites, rituals, ceremonies, propriety, etiquette, and so on. Most often, it is interpreted as the representations of institutionalized social norms that regulate social behaviors. As Benjamin Schwartz explains:

> The word *li* on the most concrete level refers to all those 'objective' prescriptions of behavior, whether involving rite, ceremony, manners, or general deportment, acting roles within the family, within human society and with the numinous realm beyond... What makes *li* the cement of the entire normative sociopolitical order is that it largely involves the behavior of persons related to each other in terms of role, status, rank, and position within a structured society. (Schwartz 1985, 67)

As the interpretation above indicates, *Li* is often interpreted as external structures of praxis than an internal structure of the sense and consciousness. In Confucian thinking, *li*'s conceptual significance is comparable to *ren*. In the Analects, *li* is conceived to result from *zheng-ming*[19] (rectifying [ordering] of names). I thus examine *zheng-ming* as a logical predecessor and examine the meaning it confers to understand *li*. In the Analects, when a disciple asks Confucius what his first action would be if he were to rule a state, Confucius replies, "if I had to name my first action, I would rectify names [*zheng-ming*]" (ibid., 13.3). The doctrine of *zheng-ming* has appeared several times in the Analects, deployed by Confucius to justify a first step of establishing the social order. Most frequently, *names* refer to the social positions

16 Qin-zi (亲自).
17 Qin-ren (亲人).
18 Li (礼).
19 Zheng-ming (正名).

in society, including 'father,' 'minister,' 'son,'...and so forth. As Kuan Tzu describes, names are crucial to administrative practices, which are "the means whereby the sages organize the myriad phenomena." The two seemingly mutually constructive notions, *"ming* and *li"* (names and ritual practices), represent the normative and embodied social conventions sanctioned by the authority. However, Hall and Ames argue that one cannot separate the idea from the action when interpreting the concept of *zheng-ming*. They assert that "not only are names used to name the order, they are also used for effecting order in what is to be named, to name is a prompting to 'actualize' it, similar to ritual action (*li*)" (1987, 272–73). The interpretation of *li* from Schwartz is congruent with this view, which subsumes *li* under a set of formal-external rules, corresponding to the names. By this reading, the normative orders are assumed to be fully internalized by social actors from diverse social hierarchies and embodied in their day-to-day practice.

In support of such interpretation, we can find narratives include Confucius' account of his own personal development "by thirty I had found my footing (*li*[20])" (ibid., 2.4). Here, the notion *footing* (*li*) is also related to the concept of 'rank' or 'position' the general posture that one strikes and pursues as a person, and the 'names'(*wei*[21]). It means that, for social actors to enact these ritual activities, one shall have a sense of proper place. It also means that if one did not understand the ritual procedures, he would not know where to stand (*li*). Thus, a mutual reinforcement between *zheng-ming*[22] (ordering of names) and *li* is expected to be found in the practices of social actors, whereby *li* is conceived to be conjoined with and inferred from of *zheng-ming* by the governors. Normatively speaking, after the ordering of names, the society consists not only of social roles bond to differentiated ranks (*wei*) but roles assigned with performative rituals (*li*). So far, these two concepts appear to be analogous to 'social position' and '*doxa*' from Bourdieu's field theory, but one logical caveat remains. How did Confucius justify the claim that the prescribed *li* are to be fully internalized by mundane social actors and reproduced through their social practices?

Chang has once adeptly discovered a *hierarchical* element entailed in *ordering names*. To me, it alludes to a new affective-epistemic principle underlying the definition of primordial social relations. Chang writes that "the aim of *zheng-ming* lies in the discernment between what is above and what is below, the determination of the superior and the inferior and the distinction between good and evil. Its aim lies in human affairs rather than logic" (1952, 221). Moreover, in paper *Ren and li in the Analects*, while clarifying the difference between *li* and *yi* (good form), Shun points out that "norms governing polite behavior such as ways of presenting a gift

20 Li (立).
21 Wei (位).
22 Zheng-Ming (正名).

are described as a matter of *yi* (good form) but not *li*. *Li* relates to norms of conduct governing those in a higher and those in a lower position, to proper ways of governing a state, and to the proper relation between rulers and ministers, fathers and sons, older and younger brothers, husbands and wives, and mothers and daughters-in-law. Proper observance of *li* is supposed to be the basis for an orderly society and the ideal basis for government" (1993, 457–58). These discourses suggest that, in the normative framework, *li* is logically associated with hierarchy. I would argue, hierarchy – more than a static representation of the arrangement of social roles and norms – is deemed a 'structuring structures' bridging the prescribed normative rules and social actors' distinct and distinctive practices.

Hierarchy as a prevalent value orientation can be easily identified in the Chinese language's common expressions, which is often mistakenly understood as normative or transcendental. The examples abound. In the case of describing motions from place to place, to go from the local districts to the central government is "to go up[23]" as in the expression "to go up west" and "to go up north" and to go from the central government to the local regions is to "to go down[24]," such as to "go down south," to "go down east." More implicitly, the same motion is expressed in different words according to the enacting actor's social status. Chang noticed that "to kill a king is called murder or *shi*[25], implying a violation of the superior by the inferior. The killing of an inferior by a superior is called execution or *zhan*[26], implying a justifiable punishment according to law" (ibid, 221). When reading hierarchy as a fixed norm, the logical caveat remains, how can the designated differentiation, materialized by the names and ritual rules, get diffused, received and reproduced in the broader social sphere? What ensures people's following and voluntary adaptations of these norms in various real-life situations?

In *Hsun Tzu*, Confucius recourses to the principle of *dao* to legitimate the social order he constructed. *Li*, the essence of rites, good customs, traditional observances are exalted into the cosmic principle.

> *Li* is that whereby heaven and earth unite, whereby the sun and moon are brilliant, whereby the four seasons are ordered, whereby the stars move in their courses, whereby rivers flow, whereby all things prosper [...]. It causes the lower orders to obey, and the upper classes to be illustrious; through a myriad change, it prevents going astray. If one departs from it, one will be destroyed. Is not *li* the greatest of all principles? (Hsun Tzu 1966, 223)

23 Shang (上).
24 Xia (下).
25 Shi (弑).
26 Zhan (斩).

A correlative logic (rather than a causal one) is employed to validate the associa-
tion between the cosmological principles and the orders conceived for regulating
human society[27]. This argument is confirmed by Schwartz, who saw *dao* as a le-
gitimate principle to justify the familial relationship between the king and heaven,
thus the social orders prescribed by the king, as it is commonly shared *belief* among
the ancient Chinese. By conforming to the *li* in worshiping the royal ancestor, the
king has also worshipped heaven. As the son of heaven (*tianzi*), he shows the citi-
zens his qualification through getting the mandate from Heaven (*tianming*) to rule
over the kingdom (Hsun Tzu 1966 [n.d.], 114). When following a correlative logic,
the symbolic representation and thereby the material manifestation of *li* are legit-
imated due to the postulated linkage between kinship and kingship, family and
state, the social and political pillars of traditional imperial China.

I do not mean to discuss the validity of such arguments but to reveal the hidden
causal propositions deployed and the modality of justifying such an argument. I
would then try to fill the logical gap uncovered. Again, the epistemic gap lies in
that *li* – norms that the royal family prescribes and performs – differ not only in
content but also in form with that followed by laypeople. The prescribed meaning
of such rules will inevitably transcend the actual and potential reach of everyday
people's experiences. Thus, the question regarding a knowledge condition where
li get voluntarily received and enacted by everyday people has not yet been fully
answered. Against a nominative understanding of hierarchy, I would claim, a two-
fold affect-based cognitive and perceptual structure is embedded in the father-son
relationality. In this structure, there is a perfect positive correlation between the
ren-affection-intimacy and *li-reverence-hierarchy* principles. It is crucial to recognize
such a structure in order to fill the logical gap we have noted so far.

To argue for such a two-fold affect-based cognitive and perceptual structure,
we need to examine the principal familial relations with an eye for reverence. As
narrated, the family is constantly addressed by Confucius as 'roots.' It can be seen
as a basic social realm where the participants have the fullest access to each other's
cognitive, affective and bodily symptoms. Following Shun's (1993) argument of rev-
erence as a cognitive structuring principle, namely, "what gives unity to the various
things that have come to be included in the scope of *li*[28] is presumably *jing*[29] (rev-
erence)," one can infer a proposition of such affect-cognitive structure can serve
to justify the sensible inferior-superior relation rooted in the father-son, husband-

27 The constituent dyads Hsun Tzu referred, are derived from *yin* and *yang*. They are the most
 basic conceptual category that is well known and applied in ancient Chinese society. It implies
 a pair of unequal but complementary forces that drive to further generating subcategories
 in a system of correlated arrangements.

28 The character *li* originally refer to the rites of sacrifice.

29 Jing (敬).

wife, elder and younger brother relationship within the family. *When one is conceived to acquire both the ren-intimacy and li-hierarchy sensible-perception principles from family relationships during primary socialization, it is logical that such 'structuring structures' enables one to give meaning to the extended relationships along each axis.*

The three principal 'we-relationships' exhibit the attributes of *ren* and *li* with different degrees of intensity, which can be deemed three proto-schemas. If my claim were true, one could logically anchor the other two social relations, relations between friends and sovereign-subordinate, in relation to the family realm in the actor's perception. The analogy is possible, as social actor deeply believes, thereafter could 'space them out' in perceptual practices following the two-dimensional spatial coordinates. In other words, these two hierarchical sensible-cognitive cardinals enable one to position an unknown other on an analogous category. One could thereby relate to any social 'other' from symbolic to potential reach. Other forms of empirical social relations, in addition to or despite their substantive content (age, gender, class, etc.), can always be ordered in subjects' perceptions and practices.

3.3.3 Spacing and synthesis as divided agencies

I have just made two claims about relational subjectivity and how social subject relates to social others in the Confucianism normative. The first one is relational subjectivity, whereby a spatial sense of relationality is prioritized on the first order in structuring human experiences. The second one is a more specific claim about how such subjectivity is related to social relations. I argue that, when a two-dimensional spatial consciousness is conceived, in identifying the hierarchical magnitude of intimacy and reverence, one can make sense of and position oneself appropriately in each and every asymmetrical social relation. The inference from principal social relation to forming relational subjectivity and social relation is then logically possible. However, the questions about how the self-hood is conceived in classic Confucianism thinking remain underexamined.

As discussed in 2.4, scholars following historical materialism like Lefebvre assume the social subject's agency to correspond with one's position in the class-based stratified social structure. In contrast, scholars following constructionism or structuration tradition like Löw see an individual's agency to arise from the reflexive and pre-cognitive structures cultivated in a situated, enduring socialization process. In the latter case, a social actor's practice is deemed as the manifestation of the internalized social structure. As social actors perceive and internalize social structures only partially, conflicts arise among social actors at the interface of embodied individual habitus. In other words, in both epistemic frames, a sense of self or a consistent internal orientation (given or cultivated) is assumed to pre-structure the social actor's continuous behavioral stream daily, shaping what one receives from and constructs to the 'external world.'

When discussing the meaning association between *ren* (man) and *ren* (human-ity), I suggest that the Chinese *men* are primarily conceived to fall into a social world constituted by a wealth of relationships and social transactions with one's fellow men and women. However, notions expressing the sense of personal self (*wo*[30]) and reflective self (*ji*[31]) also exist in Chinese discourses since antiquity. In an attempt to explain the Confucian meaning of 'self,' Tu Wei-Ming maintains that in Confucian thought, the self is a "dynamic, holistic, open system, just the oppo-site of the privatized ego" (1985, 8). Drawing on Löw's epistemic divide between the spacing and synthesis, I further explore Confucianism discourses to see if and how this ever-present, dynamic, open, spatial consciousness is logically coherent with a sense of coherent self, and continuous experiences?

Having these two questions in mind, I have identified two revealing categories[32] of personhood in Confucianism, i.e., the *exemplary man* (*junzi*[33]) and the *sage man* (*sheng-ren*[34]), as the relevant epistemic forms for my examinations. When reading at its face value, the discourses about and the definitions of 'exemplary person' and 'sage man' constructed by the Confucianism scholars involve supernatural mysti-cism. I am not intended to give value or normative judgments on these discourses here, but to explore the idea of selfhood embedded in the 'exemplary person' and 'sage man.'

Briefly speaking, the 'exemplary man' is ascribed by the Confucian scholars to represent the subject, endorsed with the capacity to comprehend, actualize and reproduce meanings of the existing social-space normative orders. The 'sage man' is coined to address the kind of social subject, who is able to *name*, i.e., to synthesis the *potential* and possible arrangement and utility between the social and material entities and construct the form anew. Here, I draw on two analytical terms devel-oped by Löw. It is 'spacing' – coined to describe the process of erecting, deploying, or positioning practices, and 'synthesis' – describe how goods and people are amal-gamated to spaces by way of processes of perception, imagination, and memory. According to Löw, in the everyday act of space constitution, operations of synthe-sis and spacing are simultaneous because an action is always processual. She also

30 Wo (我).

31 Ji (己).

32 Confucius has developed a meticulous system of categorizing social actors by their moral, wisdom capacity and performances. The examples from the Analects include sage (*sheng ren*), exemplary person (*jun zi*), good/adept person (*shan ren*), person of superior quality (*shang ren*), complete person (*cheng ren*), scholar-official (*shi*), great person (*da ren*) and small person (*xiao ren*). Both 'exemplary person' and 'sage' are conceived as the elite social class, in contrast to the mass (*min*).

33 Jun-zi (君子).

34 Sheng-ren (圣人).

points out how such operations could also be carried out by different social actors, considering the distribution of labor in society:

> However, the operation of synthesis is also possible as an operation of abstracting without associated spacings, that is, spacings directly subsequent to it; examples can be found in scientific work, but also in art, planning, and architecture. In these fields, objects are linked to spaces on the drawing board, in a computer simulation, or on paper. Though these links can guide further action, they do not directly lead to resultant spacings. (ibid., 135)

Inspired by such a separation, I put forward my *third claim* regarding the types of social agency and their casual relation to normative social-spatial order derived from the Confucian discourses. I contend the *spacing and relational synthesis are conceived enacted by different parties situated in an asymmetrical relation*. Also, in the ideal social order, *only the superior figures are entitled to materialize ones' spatial synthesis after their negotiations and attunement with the inferior figures*.

One can find many supporting arguments from the discourses in the Analects. For example, Confucius' famous statement, "to discipline oneself and practice *li* (ritual action) is to become an exemplary person[35]"(The Analects 12.1). According to Hall and Ames, this process shall be more accurately interpreted as "the process of dissolving the barrier between the self and its social environment involves discipline the ego-self and becoming a person-in-context" (1987, 93). Leaving this generalization aside, in the following analysis, I would unravel the tangible aspects in the conceived self-developing process by teasing out the discussions on the necessary achievements of an exemplary person. The three conceived forms of agency to be discussed are *ren* (becoming humane/benevolent), *zhi* (to know/being wise), and *yi* (to appropriate/being appropriate).

Departing from the discourses of *zhi* (to know/being wise), I would argue, an 'exemplary person' is conceived to be able to internalize, act in accordance with, and reproduce the norms in the society. The norms are expected to be so deeply internalized (*zhi*) in one's psychology that (s)he never 'stop and think,' 'leaving the stream of durée' when practicing them. When (s)he encounters novel situations, (s)he is able to adapt the known rules properly to the context. In this way, his(her) *ren*-moral value is manifested in maintaining and reproducing the social norms. Departing from *yi* (to appropriate/being appropriate, proprietary), I notice that an exemplary social actor is also expected to constantly adjust one's synthesis in harmony to that of others in the context, to achieve a condition of being *yi* (proprietary). As I have elaborated enough on the epistemic dimensions of *ren*- in the previous part, I would now focus only on de-construct *zhi* (to know/being wise) and

35 Keli-fuji-jiwei-ren (克己复礼即为仁).

yi (to appropriate/being appropriate), in order to reveal the underlying premises about 'self' or 'selfhood.'

The concept of *zhi* (to know) is characterized as an intentional act. It is written in *Chung-yung* that "completing oneself is 'person-making' (*ren*); completing things and events are '*zhi*' (realizing)." According to Hall and Ames' interpretation, "*zhi* refers to a propensity for forecasting or predicting the outcome of a coherent set of circumstances of which the forecaster himself is a constituent and participatory factor" (ibid., 51). When we read *zhi* as "to know and to realize the meaning in a context," we are implying that *zhi* entails a non-differentiable continuous process from subjectively intended action (action; Handeln) to the completed act (actum; Handlung), similar to the social action defined by Weber. I cite as follows:

> Social action is the action which by virtue of the subjective meaning attached to it by the acting individual (or individuals), takes account of the behavior of others, and is thereby oriented in its course.... In "action" is included all human behavior when and in so far as the acting individual attaches a subjective meaning to it. Action in this sense may be either overt or purely inward or subjective; it may consist of positive intervention in a situation, or of deliberately refraining from such intervention, or passively acquiescing in the situation. (Weber [1972] 2013, 88)

In Weber's definition of social action and Hall and Ames' reading of *zhi*, an *other-oriented-ness* is addressed. The social-spatial relation remains static and intact in the subjects' inner consciousness. When taking my previous claim into concern, namely, 'the other (subject or object)' is conceived as immanently dynamic, changing, organism different from me (whose emotional and cognitive activity remains ever active in my sensation-consciousness), then we come to tell *zhi* and Weber's 'social action' far apart. Famously, Weber's conceptualization of social action is criticized for not distinguishing the 'projected act' from the 'completed act,' the confusion and conflation between the meaning of an action with its motives, i.e. "the meaning-complex which he takes to be the meaningful ground of his behavior" (Schutz, Walsh, and Lehnert 1972, 28). I see *zhi* – a type of subjective other-oriented action elicits toward a changing or dynamic other. *Zhi* shall then be understood as *trans-active* than *subjective-intentional* or *inter-subjective* action. It entails a process when the acting subject's motive gets continuously modified in response to the momentaneous affect and symbolic intercourses emergent from the context.

We can find supporting shreds of evidence when reading the meaning of *zhi* from other parts of the Analects. *Zhi* is frequently characterized as a process of dispelling doubts (*huo*[36]). It is illustrated in sayings like "a person with *zhi* is not of two minds" (The Analects 9.29), "to *zhi* is to influence the process of existence within the range of one's viable possibilities" (ibid., 12.22). I find the emphasis on

36 Huo (惑).

'non-distinguishing' and 'deciding over possible alternatives' implies that *zhi* requires to take all the perceived contextual elements and the emergent attributes in the context into concern, ordering them by adapting learned rules-*li*. Regardless of the empirical content of *zhi*, whether it consists of positive intervention in a situation, or deliberate refraining from such intervention, the 'exemplary man' here, is conceived to resume the order through enacting *zhi*.

Complementarily, the concept of *yi*[37] (appropriate, be appropriate) alludes to the sensible-affective dimension of the conceived agency of *junzi*. In *Mencius*, it is written that "the heart-and-mind of shame (*xiu*[38]) and disgrace (*wu*[39]) is the starting point of *yi*." Although emotions like shame (*xiu*) and disgrace (*wu*) are context-dependent in the sense that they presuppose someone else's presence and resonance, their affect can only be known by the experiencing self. Due to the non-fixed, multivalent nature of the consciousness-in-context, the person's sense of *yi* (appropriateness) cannot be derived solely from referring to the external norm. To achieve *yi*, the exemplary person figure is not supposed to surrender to prescribed principles but to *evoke* one's *internal* moral standard (*ren*) creatively to comprehend and gauge each encounter's uniqueness in Confucianism. One would then be able to implement the entire process of the *zhi*- know the pre-given ritual rules (*li*) while also taking the immediate emergences from the context into concern.

Plenty of empirical studies show that, in imperial China, the name 'exemplary person' exists not just as a constructed ideal figure, but often reified by actual local gentries[40], who are well-educated and respected senior people from the family of major lineage in a place. According to Hu (2015)'s historical studies on local administrations in imperial China, the local gentries have long complemented the central government's inactive performance on the local level, which accounts for the core position ensuring social and political stability. They are also deemed crucial figures who contribute to the reproduction of cultural values and rituals in traditional Chinese society where both physical and social mobility is slow. In a similar vein, Fei Xiaotong (1946) argued that the gentry is an important social class between the state and the peasants, responsible for reproducing social structure in traditional Chinese society. The gentry's role in acculturation affirms our discussions about the *reproductive effect* of practicing as exemplary men (*junzi*):

> The gentry differs from the aristocracy in the West in that the former does not form a political party with the responsibility of running a government. ...owing to their pivotal position in the power structure, the gentry has through long history acquired a set of codes of professional ethics. They preach the doctrine of

37 Yi (宜).
38 Xiu (羞).
39 E (恶).
40 Shi-shen (士绅).

order: everyone should behave according to and be satisfied by the position one occupies in the social structure...The gentry's interest is not in possessing political power but in maintaining order irrespective of who the monarch is. They will serve him as long as he behaves as a benevolent ruler, but if he becomes despotic and suppresses the peasants too hard, the gentry will exert their pressure against him. On the other hand, if peasants revolt against the ruler and disturb the social order, they will fight on the side of the monarch. This is their social responsibility. Being a privileged class themselves, they are never revolutionary. Order and security are their sole interests. (Fei 1946, 9–10)

The notion of *sagehood* in Confucianism refers to one's capacity of integrating all the moral achievements, and above all, of being innovative and creative. In contrast to the narratives about the exemplary man, "the practice of *li* and to the notion that mastery of *li* was the path to *sagehood*" and the ones Confucius used to reject a credential of *sagehood* was that he regarded himself to be "someone who transmits but does not create" (The Analects 7.1). In Chinese historical text, the *sagehood* title is often used to address the achieved imperials like in the 'sage-kings' or intellectuals who work for the state – 'sage-counselor.' Sage, the symbol for the utmost elites, is conceived to have extra-ordinary intelligence and endorsed with exclusive authority and power, i.e., the right to *zhengming* (ordering the names). Noticing that, in these empirical applications, the notion is strongly associated with political status, privilege, and power, apart from personal achievements. The stories from *Sun Zi* suggest that sages are the ones who can observe and communicate, rearrange the situation by changing the ordering of the existing elements and give new definitions accordingly. Sage is also conceived to make the most use of the temporal-spatial momentum and achieve one's goals effortlessly. The sage attunes oneself into the context so much that "the sage has no (disclosed) self[41]."

As we have just discussed, to *know (zhi)* in Confucianism refers to the actors-exemplary persons' compacity to consciously perceive the emergent compacity of social and material beings in the trans-active context, than the static essence of them. It is followed by actualizing the figuration of the contextual constituents according to the learned normative order-li. To *create (be the sage)*, assumes the compacity of figuring out the meaningful coherency among the selected heterogeneous constituents and their relationalities, based on the knowledge of the emergent attributes of things and social subjects alike, and the scheme of relevance the sage figure holds to be true. It is not creation *ex nihilo*, namely, creating something new with no connection to the existing things and social beings, but recognizing the

41 The phrase, Shengren-Wuji (圣人无己), originates from the article Xiaoyaoyou (逍遥游), by Zhuangzhi.

mutual resonances among people of different understandings and things of different names. The sage man is also expected to re-associate things, establish new sense relations between then, and assign new name. At the end of the chapter, I would draw briefly on a contemporary phenomenon to show how such epistemic divide regarding social agencies offer explanations to contemporary events.

3.4 Things, names and truth-conditions

We have already discussed, the transcendental-substantial epistemic traditions in antique Europe gives rise to an understanding of the 'thing' as 'substance' whose nature lies in its unchanging form. The substantial view is so profound that it shapes how 'things' are represented and categorized in the commonsensical domain. This section examines *'things'* in traditional Chinese thoughts, with particular attention paid to the following issues: how is the nature of things conceived? How are things known and named?

3.4.1 Things and a correlative system of classification

To elucidate the conceptualization of 'things' and how 'things' relate to the social-spatial order in traditional Chinese thought, I take the ancient Chinese book *Yi Jing (The Book of Changes)* as a departure point. It is commonly deemed as the beginning of all Chinese metaphysical discussions. The discourses about two systems of categorization – *yin-yang*[42] and *wuxing*[43] *(the five phases)* – build on metaphysical propositions from *Yi Jing*, serve as the base material for my analysis. In *Yi Jing*, the cosmos of things – including heavens, earth, men, animals, and myriads – originate from one unitary source, a chaotic state (*taiji*[44]). In this context, as contemporary philosopher Tang Junyi has once asserted, the cosmos "is only flow, a dynamism," all things "can only be in process, beyond which there's no fixed reality as substratum" (Tang 1988, 9-10, cite in Li and Perkins 2015, 4). If Tang were right, the epistemic postulations upon which this conception of things is built has differed from that in the classic Newtonian and Leibnizian ones (as discussed in 2.2 and 2.3 in this book).

To foreground how things are conceived in Chinese philosophy, my comparative analysis draws on Aristotle's definition as the epistemic reference. Aristotle has

42 The concept originats from the *Book of Changes*, which estimately dates back to 1000-750 BCE. It is further developed by the Yin-Yang School, Daoist and Confucian traditions.

43 Wuxing (五行). It is believed to be founded by Tsou Yen, who lived approximately between 350 and 270 BCE.

44 Tai-ji (太极).

famously formed the line 'things are beings.' He has proposed a system of ten categories in defining things, among which the 'substance' (the eternal and immutable 'form') – represents the 'principle and a cause of being' – is the primary category (see Studtmann 2018). Perkins claims a Sino-European meta-epistemic difference is as follows: "European metaphysics has tended to center on problems of *reconciliation* (how ontologically distinct things can interact), Chinese metaphysics has been more concerned with problems of *distinction*" (Perkins, 1, italics original).

Within *Yi Jing*'s most influential and interpretational book, *Xi Ci*[45], yin and *yang* are identified as two primary 'generative forces.' Upon interaction, they give firstly rise to four, then eight subtypes. Overall, eight 'patterns of motion' are conceived and represented by trigrams (Qian, Kun, Zhen, Xun, Kan, Li, Gen, and Dui[46]). In the book called *Shou Gua (Discussion of the Trigrams)*[47], a list of such 'patterns of motion' is presented, among which, "the creative [Qian] is strong; the receptive [Kun] is yielding; the arousing [Zhen] means movement; the gentle [Xun] is penetrating; the abysmal [Kan] is dangerous; the clinging [Li] means dependence; keeping still [Gen] means standstill; the joyous [Dui] means pleasure" (Tang 2015, 43). To demonstrate such emergent properties or property-like items, tangible 'things' from the natural world are deployed as *instantiations*. For instance, the 'south side of a mountain,' which receives the sun is employed as a typical 'thing' to instantiate *yang*. The 'north side of a mountain' instantiates *yin*. In a similar vein, the eight sub-*patterns of motion* are often instantiated by the sky, earth, thunder, wind, water, fire, mountain, and marsh.

At first glance, the 'patterns of motion' in *Yijing* is easily confused with Aristotle's 'acting category,' or Leibniz's *prima materia* discussed in Chapter 2.3. For Aristotle, 'acting' is the *inherent* property of things that cannot stand apart from their substance. He assigned essential locations and modes of motion to the five fundamental elements identified in the universe: earth, air, fire, water, and aether. Air and fire naturally move upwards, while the earth moves downwards, and so on. To clarify, the particular 'patterns of motion' are not fixed to things as subject-predicate (substantial) attributes derived from a transcendental source. A plurality of things can be deployed to instantiate one pattern of motion, *yang*. One particular thing (e.g., a mountain) can be deployed to demonstrate different patterns of motion at different points of circles (e.g., *yin* or *yang*).

In the Aristotelian framework, 'things' can be distinguished by their *material boundary* and *location*. A *'movement'* is understood as the change of location in an absolute, homogeneous space in the Newtonian sense. 'Things' in *Yijing*, I would claim, do not predicate a fully actualized material (bodily) boundary against the others or

45 Xi-Ci (系辞).
46 Qian (乾), Kun (坤), Kan (坎), Li (离), Zhen (震), Xun (巽), Gen (艮), Dui(兑).
47 Shuo-Gua (说卦).

an absolute background. How can one draw a fixed line between the sunny and the shady south side of the mountain? When one 'pattern of motion' is instantiated by a thing, it is a thing in a relationship with a counter-acting other(s).

When motion is deemed relational and ontologically real, an abstract, absolute, and static notion of space play no role. No such a notion of space is necessary, as an 'unmoved mover,' to account for how things move. Nevertheless, Chang has noted, in ancient China: "the conception of space is not homogenous, entailing regions-orientations different in status (the east-south-west-north-middle sides are defined with different relational status). Time is neither conceived in terms of era, like from ancient to now nor in terms of cycles like in spring-autumn. It ignores the eternal progressive sense of time" (1946, 30). These coordinates – mark how things move in relation to the sun and the earth.

Before diving into abstract metaphysics any further, I will draw on some examples to demonstrate how ideas of things and space are embodied in the everyday practices and material figurations in ancient China. *Ming Tang*[48] is a well-documented example. Needham has once depicted such a bedroom of a Chinese emperor: "in the proper pavilion of the *Ming Tang* or the Bright House, no less his dwelling-place than the temple of the universe, the emperor, the clad in the robes of color appropriate to the season, faced the proper direction, caused the musical notes appropriate to the time to be sounded, and carried out all the other ritual acts which signified the unity of heaven and earth in the cosmic pattern" (Needham 2005 [1956], 287). Drawing on a particular *Ming Tang* built by Wang Mang (fig. 5), Wang has described how its architectural layout embodies *wuxing* categorization principles: "the central hall and four side chambers represent the five phases (*wuxing*), with each side chamber symbolizing one phase and one season, and the central room symbolizing the phase of earth and the middle of the year.... Wang Mang's ritual complex, therefore, submitted the hall of the five phases and the emperor occupying it to the authority of heaven (symbolized by a circle) and earth[49] (symbolized by a square), materializing the moral cosmology represented in the textual structure of '*wuxing zhi*'" (2006, 171).

Similarly, Bodde observed how a sense of relational coordinates underwrite the trivial details in the Chinese way of life: "it is to be found all the way from the formal arrangement of the furniture in a Chinese room to that rigid layout of city streets along north-to-south and east-to-west axes" (Bodde 1939, 201). He also believed that "the Chinese possess an amazingly acute sense of direction. When in China,

48 Ming-Tang (明堂).

49 According to Zhu (2016), until the end of 19th century, the Chinese scholars still withhold the inherited cosmological conception of the earth, seeing it as square rather than sphere. Such a conception of earth is shaped by and has consolidated the ritualistic practices and material arrangements of state in longue durée.

Figure 5 Plan of the site of the ritual complex built by Wang Mang as a reconstruction of 'Ming Tang' from antiquity. (Illustration from Wang, Aihe. 2000. Cosmology and Political Culture in Early China. Cambridge studies in Chinese history, literature, and institutions. Cambridge: Cambridge University Press, 170, fig. 4.1)

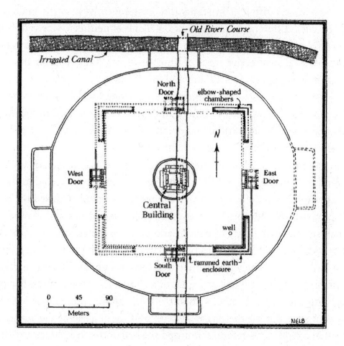

for example, one wishes to have a table moved to a different part of one's room, one does not tell the servant to shift it to his right m to his left, but to 'move it a little east' or west, or whatever the direction may be, even if it is a matter of only two or three inches" (ibid.).

The alignment between the 'bedroom's orientation,' the 'color of the robe from the emperor,' the orientation of 'a dining table' and 'street,' suggest the common categorization structures followed by a Chinese person in imperial times: *the yin-yang or five phases (wuxing[50])*. In both systems, 'things' are categorized according to their ways of acting and reacting. Meanwhile, 'things' under the same category are

50 Wu-xing (五行). More on the conceptual constitution, it's cultural and political implications, and historical developments of *wuxing* system, see Cosmology and Political Culture in Early China, by Aihe Wang (2000).

deemed to share the same tendency of change and have a positive mutual response (enhancing resonance[51]) with one another. Those under opposite categories are deemed to neutralize each other's generative forces and momentum when placed together. By following these principles, social actors can ensure the enactment of favored spatial configurations and the transformation of the unfavored ones. *Feng Shui*, the famous ancient Chinese geomancy strategy,[52] represents the culmination of such principles.

Regarding these categorization systems, Comparative philosophers like Needham (2005 [1956]), Chang (1952), Graham (1986), and many others have argued that, instead of subsuming one concept under another, the Chinese display their conceptions through 'side by side' relations. They argue, a *correlative way of thinking* is embedded in constructing "the symbolic correlations or correspondences all formed part of one colossal pattern" (Needham 2005 [1956], 281). The *wuxing system*, a derivation of the early *yin-yang* system, result from the same epistemic rules, which categorizes things (e.g., east, wood, green, wind, wheat) into a certain class, based on the assumed ways in which they interact and affect things in the other class. According to Needham, the five elements (*wuxing*) gradually came to be associated with every conceivable category of things in the universe, classify everything in fives (2005 [1956], 261). Table 4 shows only the tip of the iceberg of such an all-encompassing system. It differs drastically from the objective 'genius-species' logic in Aristotelian categories, as well as that from a social constructivist point of view. It is also worth noting that the sense relations between categories are legitimated by a particular type of experiencing subject (e.g., the sages), suggesting weak anthropocentric views[53].

To reiterate, I do not intend to verify if such systems are plausible by any criteria. For me, it materializes an (orthodox) correlative way of thinking about things by a myriad of 'symbolic ap-presentations' of things. To compare with the law of order in the Newtonian epistemic frame, Needham argued, in the Newtonian worldview, "if a particle of matter occupied a particular location in space-time, it was because another particle had pushed it there" (ibid., 285). In *wuxing* worldview, it was taking up because of "its place in a field of force alongside other particles similarly responsive. Causation was not particulate but circumambient" (ibid.). It resembles the Leibnizian *material seconda*, whereby *dao* is conceived as the universally valid general law.

51 Gan-Ying (感应).

52 Feng-Shui (风水).

53 I draw on the thesis of 'weak anthropocentric' from Fan (2005). Fan argues, the Confucianism thinking entail primarily human-centered value, attend to human phenomenon. This anthropocentrism is 'weak' insofar that it is oriented toward cosmic principles.

Table 3 The five elements/phases (wuxing) categorization system, entailing symbolic correlations among both social and natural things. (Needham, Joseph. 2005 [1956]. Science and Civilisation in China: History of Scientific Thought 2. Cambridge: Cambridge University Press, 263, table 12)

Elements hsing 行	Rulers tí 帝	Yin-Yang 陰陽	Human psycho-physical functions shih 事	Styles of government cheng 政	Minist ries pu 部	Colous seu 色	Instruments chihi 器
WOOD	Yü the Great [Hsia]	Yin in Yang or lesser Yang	demenaour	Relaxed	Agricul	green	Compasses
FIRE	Wen Wang [Chou]	Yang or	vision	Enlightened	ture	red	Weights&
EARTH	Huang Ti[pre-dyn]	greater Yang	thought	Careful	War	yellow	measures
METAL	Thang the	Equal balance	speech	Energetic	The	white	Plumblines
WATER	Victorious [Shang]	Yang in Yin or	hearing	Quiet	capital	black	T-squares
	Chihin Shih Huang	lesser Yin			Justice		balances
	Ti [Chhin]	Yin or greaterYin			Works		

The *wuxing* system has integrated the logic in *yin-yang* categorization system, which has profoundly informed how symbolic and material things are known and ordered in Chinese history. Hence, from my perspective, such a *correlative logic* is a crucial epistemic rule to explain studying the constitution of space in ancient China. Furtheremore, the entrenched ways of knowing about 'things' and correlative categorizing and arranging principles *might* remain in the current-day practices.

3.4.2 Naming as a mode of differentiating and cohering

In the above discussion, we have compared the epistemic rules applied in categorizing things by Aristotle with that in *yin-yang* and *wuxing* system from traditional Chinese thoughts. Categories are deemed universal when the designator entrusts a substantial-realist ontology and provides an inventory of every object that is actually and possibly exists. This speaks to the 'categorial realism' in Aristotle's primary and secondary substance (i.e., quantity, quality, relation, place) (see Studtmann 2018). They are also deemed conceptually universal also when the nature of the mind and their 'cognitive objects' is conceived to be the same. It applies to the 'categorial conceptualism,' such as Kant's twelve pure concepts (see Carr 1987, 6).

Yet, the later scholars, subscribing to either realist or idealist spirits, realize the necessity to develop two separate systems of categories for characterizing things' two different but correlated *dimensions*: the dimension of meaning and objects. The realist philosopher John Stuart Mill once differentiated the 'concrete name' from the 'abstract name' by their association to the 'singular' or 'general' category of things. A concrete name is a name that stands for a thing (as an object, having material bodies), while an abstract name is *qua* 'ideal object' which stands for an attribute of a thing (meaning). Thus, John, the sea, this table are names of things. White, also, is a name of a thing, or rather of things" (see Mill 2009 [1875], 16–17). Langer, from the

idealist tradition, introduced the particular perceiving subject in the equation. For Langer, on a concrete level, 'signs' indicate the existence – past, present, or future – of a thing, event, or condition. Signs are deployed as proxies for their objects, which are announced to the 'subjects.' Thus, the sign-thing relation is a triadic one: subject, sign, and object (2007 [1942], 42–68).

When it comes to the Chinese language, the taken-for-granted epistemic divide between the general and the particular, abstract and concrete, run into question. For example, Hansen noticed the 'count noun' and the 'principle of identity' were nowhere to be found in the Chinese language:

> Western languages mark this intuitive distinction with different kinds of nouns – count nouns and mass nouns. The river is a count noun. Water is a mass noun. A count noun has a principle of individuality built in. To understand the noun is to know how to count the objects it refers to. The principle of identity for a count noun allows it to gain and lose matter and still remain the same individual. (Hansen 1983, 46–47)

According to Ziporyn, to understand sign-things relations in Chinese philosophical thought, only two categories are needed: 'names' and 'stuff.' He states that "Chinese epistemology functions based on only names and stuff, no other entities, such as properties, attributes, essences, ideas, universals, or particulars, are necessary" (2012, 51). I would further argue that the fundamental categories in *yin-yang* and *wuxing* – based on the assumed *patterns of motion* and conferred to the *dynamic tendencies* of things exhibiting in a particular context – are incongruent to the count and mass noun system. Such categorical systems do not speak for the constant, inherent attributes of thing(s) independent from time and space but for the relational property of things that emerged in context and the subject's perceptions. To be more specific, it assumes types of mutual resonance, feelings, and responses between human beings and things, which is essentially anthropocentric. Such systems also offer immediate information on the way in which things can be controlled, influenced, or disrupted by purposeful human beings. Human beings' socialized perceptions subject to such relational categorization (as indicated in table 3) and constitute the categorizations. The legal definition of the neighborhood from the Qin Dynasty can be used to highlight this point:

> What does 'neighborhood' (silin[54]) mean?
> 'Neighborhood' means the members of one's mutual responsibility group

54 Si-Lin (四邻).

(wuren[55]).

(Shui Hu Di Qin Mu Zhu Jian[56], 194, cite in Harbsmeier and Needham 1998, 55)

Similarly, neither *yin/yang* nor green/yellow/red/white are categories of things in-dependent of the existence of perceiving subjects. The significance of human per-ceptual and expressive capacity in drawing the categorical system is explicitly ad-dressed by Confucian philosopher Xunzi, in that: "When different forms make con-tact with the heart, they make each other understood as different things. If the names and their corresponding objects are tied together in a confused fashion, then the distinction between noble and base will not be clear, and the like and the unlike will not be differentiated." (Xunzi 2016 [n.a], 237)

A secondary question remains, how does the sign-thing association become consolidated and legitimated in ancient Chinese society? A common understand-ing is that the ancient Chinese denies the univocal correlation between 'names' and 'things.' It is also clearly stated in *Xunzi* that "names have no predetermined appro-priateness. One seeks agreements in order to name things. Once the agreement is set and has become custom, then they are called appropriate, and what differs from the agreed usage is called inappropriate. Names have no predetermined objects." (ibid., 239). It acknowledges the arbitrariness regarding the association between the conceived name and the actual objects being referred to, as well as stresses the role of convention in consolidating such associations, suggesting an epistemolog-ical normativism.

Hansen's insight into the Chinese language has affirmed and exemplified Xunzi's statement as above. He noticed that Chinese nouns are not pluralized and thereby argue, this is both the cause and the consequence of the non-substantial ontology. He proposed a semantic and epistemological hypothesis in which "count nouns represent stable and unchanging objects in the Indo-European language, yet Chinese use mass nouns to refer to constantly changing *stuff* out of which objects are made" (Hansen 2000, 48, italic added). Furthermore, after conducting thorough anatomy of several schools of Chinese linguistic theory, Hansen pro-poses the 'mass-noun syntax' and a 'part-whole model' for explaining the logic underlying the name-thing relation. He elaborates further that "the world is a collection of overlapping and interpenetrating stuff or substances. A name ... denotes ... some substance. The mind is regarded not as an internal picturing mechanism that represents the individual objects in the world. Instead, it is seen as a faculty that discriminates the boundaries of the substances or stuff referred to by the names." (ibid., 243)

55 Wu-Ren (伍人).
56 Shui Hu Di Qin Mu Zhu Jian (睡虎地秦墓竹简)

The idea that to name is the act of 'discrimination and distinguishment' for the experiencing subject resonates with other Chinese classics narratives. It is also consistent with the anthropocentric understanding of perception and conception. For instance, as Xunzi puts it, "what makes humans is that they can make distinctions . . . birds and beasts have fathers and sons among them but not the intimacy of father and son; they have male and female but not the division of male and female. Thus, the essence of being a man involves making distinctions." (ibid, 35). What remains to be discussed in Hansen's linguistic theory, however, are the more specific rules followed in the act of naming and how truth is recognized despite the inconsistent names.

To bring more lucidity to the weak anthropocentric epistemic rules, we still need to ask, i.e., who names and how? As I have indicated in section 3.3.3, 'naming' is conceived by Confucius scholars as a privileged capacity and exclusive right for 'the sages.' Normatively speaking, the sages are deemed entitled to 'order the names', i.e., setting socio-political rules for other inferior members. In empirical reality, 'the sage' usually refers to the authoritative figures in a community, the elder in the family, the gentry in a village, or the emperor of a kingdom[57]. According to the earliest classic Chinese literature, the origin of names of natural things, as well as names of human-invented artifacts, is attributed by the sage-like figures. The yellow emperor[58] is one of them, who assigned the correct designations to the various things[59]. Throughout history, the validity of names is dominantly legitimated by the sage's credentials and the incumbent political system (Hall and Ames 1987; Hansen 2009 [1992]). In this context, 'names' are not justified by 'logical acts' (analytic judgments), reflection, abstraction, or democratic public consensus. The sage-centered view explains why the most drastic name system changes correlate with the overturn of political regimes in Chinese history.

In addition to the principle of conventionality and coherence, Hansen's argument also brings non-correspondence, non-representational, and affective and contextual principles into understanding traditional Chinese thought's knowledge conditions. He argues, in short, despite the Chinese language's pictographic nature, signs are not conceived to *represent* objects or events. It calls for a designator's active mental context and convention to tie language to the world (ibid., 38). By comparing the rules according to which poems were written in Chinese and Greek tradition, Jullien (2000) has made this point especially clear. He argues that the Greeks conceive poetry in terms of *representation*, whereas the Chinese relate

57 The living elder in the family, not the parents of the new-born have to right to name the newborn baby.

58 The yellow emperor (黄帝).

59 Zhengming-Baiwu (正名百物).

it to *incitement*. He further elaborates that the act of representing is to "put be-fore the eyes," "create a tableau," and to "give a convincing impression of its truth" (2000, 162-163). To incite is to "borrow from external reality to introduce what one feels to unburden oneself" and to "stir up the readers' emotions" (ibid. 142). This calls for an "external co-anesthesia" arise "on the level of subjective emotional re-sponse." It is more "immediate than analogical" because the analogical "entrust[s] it to the external realities, the incitatory veritably stirs an interiority reacting to the stimulation of the world." (ibid., 152-153). Jullien's thesis coincides with my claims in 3.3 regarding the affect-based relational subjectivity. These theses have also af-firmed that normative epistemic standards for validifying knowledge in traditional Chinese society are anthropocentric. Truth is partly constituted by the legislator's perception of the attributor's social position, the emotional response or resonance from perceiving subjects and trading off among all these elements.

In the previous section, I have discussed naming's regulative social function, particularly regarding the naming of social positions. According to Hansen, the act of naming and the names of things always engender and express actors' motiva-tion, with implications for action. He argues that the Chinese are more concerned with the practical *effects* of language in behavioral terms than *representations* as – the ground for truth or fallacy of propositions. He proposes a *behavioral nominal-ist* perspective to account for how ideas, and the enforcement of such ideas, are integrated into names. The performative dimension of naming or names and the relationship to meaning is demonstrated in the fact that name (*min*[60]) is frequently considered "to cause certain possibilities to be realized (*ming*[61])."

Lastly, I arrive at my claims regarding the conceptualization of 'things,' how 'things' relate to the social-spatial order, and knowledge conditions in traditional Chinese thought. *Firstly*, a 'thing' is not considered to be fully actualized and pred-icated with fixed properties. Things are conceived to entail emergent capacity in a relational and interactive context. *Secondly*, subjects, particularly entitled and priv-ileged social actors, are conceived as indispensable designators, to name things. Names are designated to discern forms of emergent relations among things and re-establish a correlative and hierarchical order.

3.4.3 Names, social bodies, and the city

I will now use a short anecdote about the re-naming of a city to illustrate how my claimed epistemic rules and truth conditions may be deployed in explaining the spatial phenomenon of our time: the renaming of a city. In 1988, a town-level city

60 Ming (名).
61 Ming (命).

called Dayong[62] was upgraded into a prefecture-level city by the central government. The previous town center was designated as the location for the central administrative office of three adjacent townships. In 1994, the then little-known city of Dayong (from 1321-1994) was renamed after Zhangjiajie[63] – originally the name of a national park located in its jurisdiction. The park was enlisted as a UNESCO natural heritage site in 1992 and has become a well-known and popular destination for tourists ever since. According to a published interview, the urban administrators' intention to renaming the city from Dayong to Zhangjiajie is to extend the city's positive reputation as a UNESCO heritage site to the entire jurisdiction may attract the hotel and service industry to these areas (see Chinanews, January 24, 2011). The practice of renaming a city after its newly uncover potentiality – an emergent attribute – was perceived by Zhangjiajie's urban administrators as "a practical strategy for city branding, a strategy of consensus and common sense" (ibid., translation added).

In the post-reform era, Chinese cities' names often get altered. In Zhangjiajie's story, renaming is enacted by urban administrators and accepted by the local citizens without many opposing concerns. It reveals the notion 'city' refers neither to a place with a fixed territorial boundary nor inherent identity/form, prescribing a structuring force for future development. A particular name (e.g., Dayong) is also not conceived as the representation of such material or symbolic entities. The report mentions that older locals would still prefer to address themselves as a Dayong-er rather than Zhangjiajie-er, indicating this name has constituted part of the local citizens' identity. However, both the administrators and the citizens are pleased to expect that the 'outsiders' such as tourists will associate the newly extended area (including the old Dayong area) with the name Zhangjiajie. In renaming, the new name addresses mainly an emergent possibility, i.e., how the area would be perceived by future visitors. Meanwhile, along with the new name, the urban administrators also initiated a new orientation for the local development plan – to relocate the administrative center and redirect the city's future development model (pattern of motion) towards tourism. The new name suggests the new movement which the name designator hopes to enact: to be part of the UNESCO heritage and its tourism program. It indicates that a city's name plays less of a role in representing a material form, a location, or a perceived historical identity (corresponding to and preserving a substantial unchanging attribute). Its major role is to address the change to be propelled.

In ancient Chinese cities, the name-territory-social bodies also always do not 'match.' Max Weber declared that traditional China was an empire without true cities, without what he called 'complete communities.' His normative standpoint

62 Dayong (大庸).
63 Zhangjiajie (张家界).

reflects the self-governing Western European city model, with its name, local citi-
zenry, and material boundary extending back to the sixteenth century (1959 [1951],
13). The work of Skinner et al. on Chinese cities in the late imperial period has
clearly demonstrated a disjoint name-territory relation has its historical roots:

> A capital city had no corporate existence apart from the total administrative ter-
> ritory of which it was the node and the symbol. Capitals were known by the name
> of their administrative units, the generic included, no distinction is made in ei-
> ther written or spoken Chinese. The word for the province, *Sheng*[64] was also used
> to mean the provincial capital city. It is entirely in keeping with Chinese cognition
> in general that the geomantic (*feng shui*) fate of a county was held to derive from
> the sitting of its capital city (taking the surrounding into consideration). (Skinner
> et al. 1995 [1977], 262)

The asymmetrical agency between the urban administrator and the citizens is also
addressed:

> Social organization in the city are vastly distinct from that in the western cities.
> Citizens don't have urban identities, administrative center Yamen, or the court is
> seen as quintessential of urbanity, normally located in the central place of the city,
> was supposed to be the central institution of administration, the most immedi-
> ate and frequent encountered form of imperial authority for the residents in its
> jurisdiction. In fact, 'towns and counties were alike governed.' (ibid., 275)

The contemporary anecdote and the two historical narratives imply a city-coun-
try continuum model in traditional Chinese society that stands in direct contrast
to the autarkic, homogenous, and bounded city-state model in ancient Europe. In
this case, the part-whole principle illuminates how such a reality is associated with
a name. The *name* of the central part (the capital city) is deemed a driving force for
developing the whole province at a territorial scale. Undoubtedly, only the subjects
who hold the highest political position are entitled to name and demarcate. Au-
thorities dominant the agency to name, make rules and mobilize resources, i.e., to
actualize its envisioned mode of change.

3.5 Summary

In this chapter, I have elucidated how the 'social subject,' 'things,' and their sense
relations on a collective level are conceived in traditional Chinese philosophy. In
3.2, I have focused on the postulations about the nature of the 'social subject' and
the formation of subject-subject relations. I argue that the Confucian thinking has

64 Sheng (省).

prescribed a causal primacy to relational, sensual subjectivity than individual, reflective subjectivity. More concretely, my *first* claim is that: in defining subjectivity, a spatial-relational property is prioritized, in terms of affective and cognitive structures to account for the constitution of social practice and experience. *Secondly*, I identified *two-fold* spatial-relational properties prescribed in the prototype social relations prescribed in Confucianism. One is *ren-affection-intimacy*, and the other is *li-reverence-hierarchy*. The two coordinates correlate positively in the sensible magnitude of *closeness-distance*. It legitimates the logical relatedness across the primordial normative social relations, as well as the possibilities for extensionality. Thirdly, a sense of social *relationality* is conceived *asymmetrical and affect-laden*, which actively emerges from and get re-defined by the mind-senses of the participating social actors in the course of their social interactions. As a causal agent, relationality is firstly conceived real on the level of affect, which is then inferred to explain the relationality in perception, social practice, and normative orders.

My analysis of 'things' and 'names' in chapter 3.4 suggests that, firstly, *thing(s)* is assumed to possess emergent capacity, which exhibits in relational, interactive contexts than substantial attributes independent of the others and the perceiver. The *yin-yang* or *wu-xing* categorical system demonstrates a correlative epistemic logic of ordering things. Hence, the placement of the things according to/reversing such epistemic order is believed to either enhance or interrupt the mutual resonances between the things, enable administrating or maneuvering the motion of things. Secondly, the names of things fall between the abstract and concrete, or the purely conceptual and actual representational categories. Names are constructed in accordance with the conceived emergent properties of the things. Naming is normatively defined as a privileged agency entitled to the social elites. To name, for the 'exemplary' and the 'sage man,' means to reproduce a certain social order and to enforce a starter of a new process of reordering.

4 Recontextualizing theoretical knowledge of space and the local context of knowing

Objects of reference are at once more particular and more general than the expressions used to designate them. (Sahlins 1985, 148)

4.1 Introduction

In the second chapter, I have deconstructed prevalent relational spatial theories developed from the European context, revealed the epistemic frames they build on, i.e., the fundamental premises for defining basic entities and their inferential relations. Each theory informs and affects our analysis and understanding of social reality in distinct ways. In the third chapter, I have delved into the classic discourses in Chinese philosophy to uncover the epistemic forms, rules and causal agents essential to the Chinese way of thinking of space relationally. Following the principles of CR, I see such features only as hypotheses or initial theory, which could be tested at specific analytical strata.

In this chapter, I attend to the theoretical spatial knowledge at the crossroads: traveling western spatial theories circulated and reproduced in China. Trans-local knowledge circulation and recontextualization is a defining figure of our time, as famously portrayed by Clifford, "the roots of traditions are forever cut and retied" (1988, 15). Marilyn Strathern contends that "the pluralist vision of a world of distinctive, total societies has dissolved into a post-pluralism one" (1992, 77), in which a sustained interchange and borrowing process takes place, whereby "elements cut from diverse times and place can be combined, though they cannot fit together as a whole" (ibid., 95). To examine the differentiated meaning constellation of the 'same' knowledge piece, one has to attend to the meeting points between knowledge of self and others, between competing representations, practices, and views of the world. It is especially true for understanding the concepts like 'space,' which transit between natural and social sciences and form part of the everyday language at different times and places. However, uneven relations – economic, social, cultural, technological, academic – and variations of their entanglements have inevitably

shaped conditions for knowledge circulation and recontextualization. Thus, the exploration of the re-contextual process of traveling spatial knowledge is necessary. It is not just to focus on the roots of the whole but also to "listen, then, to how the images of recombination and cutting work" (ibid., 95).

In this chapter, I examine the ways in which traveling knowledge of *space* is learned and recontextualized in the Chinese academic context, with the aim of revealing how *epistemic context* affects meaning construction locally. In particular, I attempt to uncover the types of traveling knowledge of space circulated in Chinese academia and the communicative conditions under which they are legitimated. In 4.2, I start with a summary of the 'spatial turn' in the Chinese context, fleshing out its prevalent thematic, conceptual, and methodological features. In 4.3, I examine how certain traveling knowledge of space is selectively adopted, mixed, and redescribed into Chinese empirical realities. In 4.3.1, the overt epistemic conditions in which recontextualization of *scale theory* occur are interrogated, i.e., the epistemic rules scholars employ to 'translate' and 'anchor' the traveling theories' original frameworks. In 4.3.2, I analyze the conditions of knowledge justification that have affected the construction and legitimation of selected pieces of normative spatial knowledge among scientists and politicians at the national level. Finally, in 4.4, I focus on the studies that describe and analyze social-spatial knowledge embodied by marginal social actors and those situated in structurally weak social sectors, following a more constructivist approach. These studies are examined as the 'most different cases' to reveal the covert or overt contextual epistemic rules that scholars apply in knowledge production.

4.2 The 'spatial turn' in Chinese academia

To discuss the distinct features of 'spatial turn' in Chinese academia, I draw on that of the western European version as a reference. The features are discussed in relation to the meaning constellations and the particular social, cultural, and political context in the 1960s. As elaborated in the last chapter, in western academia, the conceptual abstraction of *space* has been subjected to philosophical and natural scientific contemplations long before it entered the domain of social science. The term 'spatial turn' describes a transition of basic spatial understanding from territorial and static towards social and procedural. It also marks the reinsertion of 'space' and 'place' back into European social, cultural, and humanities scientific domains (see Löw 2015; Warf and Arias 2009).

It is necessary to split my discussion into two stratums: the empirical and the epistemic. On the empirical level, the territorial fixations of colonialism and imperialism have collapsed. Moreover, accelerated global mobilities and intensified connectivity – in communication and transportation systems, globalizing produc-

tion and consumption of commodities, emerging environmental and ecological issues, the proliferation of digital technology, and cyberspace – render container-like spatial concepts inadequate. Such tendencies have led to inter and intra-national social-material transformations, including uneven economic developments and diversification of spatial representations. These observable changes drive scholars to integrate social and spatial processes in their analysis. On the epistemic level, the spatial turn is scholars' logical response to the long-standing ontological and epistemological bias toward time within the realm of social science. According to Edward Soja, the spatial turn is "fundamentally an attempt to develop a more creative and critically effective balancing of the spatial/geographical and the temporal/historical imaginations" (2009, 12).

New spatial conceptualizations have thereby been developed to reform the prevalent conceptual model of absolute space (Euclidean, Cartesian, and Newtonian) – the dimensioned container or measures of extension – out of the modern era. Spatial research is unrooted from the positivist and universal epistemic ground. Spatiality is gradually conceived as manifold and socially constructed. Moreover, methodological challenges are upgraded. More dimensions (material, typological, representational, experiential, and so on) manifesting the diverse markings of social are unleashed, awaited to be integrated into the 'spatial.' These conceptual dimensions need to be bridged logically with existing categories in multi-paradigm social science.

Unlike in western Europe or North America, endogenic inquiries and debates regarding conceptualizing space remain underdeveloped in the Chinese scientific realm. Studies on spatial phenomena in China resume after the economic reform of 1978. The number of studies increased vastly since the 1990s when unprecedented social-material transformations arose due to nationwide economic reforms. No double, rapid spatial developments in China are interconnected with and, to a great extent, resemble the broader global occurrences. However, local particularities cannot be fully grasped by the imported traveling conceptual lenses. The following two quotes capture the widespread importation of traveling western theories and the lack of endogenous theorization within the Chinese social science realm.

> In the context of China's social development, which from the middle of the nineteenth century was marked by the confrontation of its civilisation with the attractions and dangers of a modernisation process approaching from abroad, Chinese scholars have reproduced constituent parts of Western sociology. This has been and still is unlike western sociology, which itself was part of its endogenic modernisation development the basic collective situation of Chinese sociologists, which they share with other Chinese intellectuals (Gransow 1993, 101).
>
> From the 1990s onward, however, the development of sociological theory came to a standstill. According to a content analysis of Shehuixue Yanjiu (Sociological

Studies), the top journal in Chinese sociology edited by the CASS Institute of Sociology, from 1990 to 2000, there were altogether 7 articles on sociological theory, research method and the history of sociology, making up only 2% of all 341 articles. Only 18 articles were empirical studies with a theorising intent, whereas 247 articles did not even have any theoretically derived hypothesis (Lin and Wang 2000, 43). This finding seemed to contradict the optimistic judgment in another review, which posited an effervescence of sociological theory in the same period (Liu 2002a). But the contradiction was more apparent than real, as "sociological theory" in the latter review encompassed the then-burgeoning field of economic sociology. The underdevelopment of sociological theory seemed to continue into the first decade of the twenty-first century, as less than 1% of paper submissions to the annual conferences of the Chinese Sociological Association directly addressed social theory. (Chen 2018, 56)

Drawing on my observations in lectures, book releases, conferences, workshops, and casual conversations, I see the knowledge-making conditions described above as still valid. Most domestically funded spatial studies are commissioned and endorsed by state representatives of different ranks, thematizing policy guidelines about spatial planning and governance. Each discursive turn in the central and provincial government's policy agenda has tremendous and immediate impacts on scholars' thematic and analytical focuses. Scholars are often expected to offer technological solutions or legitimations to existing policies or evaluate the impact of policy-led development initiated by state representatives. In recent decades, such discourses abound. They include the 'construction of ecological civilization[1]' launched in the 18th national congress of the communist party of China in Nov 2012; the 'urban-rural integrative development[2]' launched in the third plenum of the 18th Chinese communist party congress in November 2013; the 'national new-type urbanization[3],' launched in the central conference on urban-related issues in March 2014, as well as political rhetoric like the 'Chinese dream.[4]'

One widely shared and obvious fallacy is that scientific concepts are often conflated and confused with political semantics and discourses. Political concepts are often deployed as keywords in subsequent research projects. To illustrate this, I count the number of research projects sponsored by the Chinese National Natural Science Fund[5], which entails the term 'national new-type urbanization' in their titles from 2008 to 2018. The chart below shows (fig.6) the number of funded projects

1 Shengtai-Wenming-Jianshe (生态文明建设).
2 Chengxiang-Yitihua (城乡一体化).
3 Xinxing-Chengzhenhua (新型城镇化).
4 China Dream (中国梦).
5 The grant is issued by the National Natural Science Foundation of China (NSFC), an organization directly affiliated with the State Council.

in semantic affinity with such political discourse. It peaked in 2015, one year after the policy release.

Figure 6 The number of funded research projects entailing 'national new-type urbanization' sponsored by NSFC, 2008-2018. (calculated by Xiaoxue Gao)

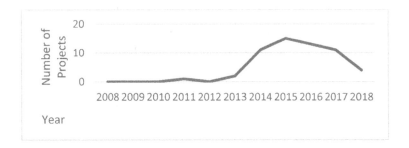

I would argue that the 'spatial turn' in the Chinese discursive context is more a *thematic turn* than a conceptual turn. This thematic turn addresses scholars' interests in the newly emerging spatial phenomena – like land-use, urban administrative system restructuration, and urban agglomeration. In the meantime, on the conceptual level, Chinese scholars have made unremitting efforts in importing diverse concepts, theories, methodologies from western intellectual realms. These analytical tools are further recontextualized into examining the empirical cases found in the Chinese context. This general tendency is summarized as 'western theories and Chinese realities' (Zhang 1992, 105). In practice, this imported knowledge is not always applied in a manner of 'conceptualization' or 'ordering framework.' To deploy a theory as conceptualization means to accept the prescribed way of forming ideas and notions about the phenomena studied. Instead, adopting theory as an ordering framework permits observational data to be used for predicting and explaining the empirical phenomenon, or seeing theories as "a way of ordering the relationship between observations (or data) whose meaning is taken as unproblematic" (Sayer 2010 [1984], 50). More often, they are deployed as a descriptor or a mere heuristic tool. Space – regardless of what it means – remains primarily the subject matter of positivistic disciplines like economic geography and urban planning. Theories and methods, particularly the qualitative methods from disciplines such as cultural and human geography, sociology, and anthropology, are greatly dismissed.

In the following, I explore the representative conceptual orientations, focus on the imported spatial theories that are well circulated and received. For an up-to-date and representative sample, I use *'urban' and/or 'space'* (in Chinese) as keywords in the most well used academic database, CNKI (Chinese National Knowledge In-

frastructure), whose indexed scientific literature stretches across a wide array of publishing formats and disciplines in the Mandarin language. For space-oriented research written in English and addressing cases situated in China, I recourse to state-of-art review articles. I have ruled out the papers that fall into natural scientific disciplines (such as geology and ecology). It results in as many as 30,435 scientific items. The time frame of publications was set from 01-01-2010 to 01-01-2018. After the initial scan, I set the sample's scale to 200 items, the top 200 most cited articles, due to the upper limit for the amount of the papers one may analyze using the website's tools. There is a lag in citation date. The selected samples entail articles published mostly from 2010 to 2013. On average, the sampled items were cited 130.28 times. Thus, I consider it a valid pool for examining the dominant conceptual orientations of space deployed in the Chinese language scientific realm. The analysis results are organized and presented under 'thematic commitments,' 'theoretical tools,' and 'research methodologies.'

Regarding 'thematic focus,' my sampled studies agglomerate around a few key topics. The five most frequently employed keywords are urban scale[6], urban space[7], spatial structure[8], urban economy[9], and urban agglomeration[10]. In terms of the discipline, the samples fall predominantly into urban planning and geography. 67.5% of the papers and thesis are published in seven academic journals, among which two journals are from the planning discipline, and five journals are from geography. There are merely twelve items that fall into social and cultural science categories, consisting of only 5.7 % of the papers. The thematic tendencies I derive resonate with that from English language geographical studies, as remarked on by Fan et. al:

> Despite the growing numbers of English-language geographical studies on China in the 21st century, much of the work on China since the 1980s (by Anglo-American geographers) has been on China's economic geography (namely, regional development and foreign investment-induced growth); urbanisation and migration; economic reform-induced environmental change; and food and resource security. (C. Cindy Fan, Laurence J. C. Ma, Clifton W. Pannell, and K. C. Tan 2008, 673)

My sampled studies' research approaches are exclusively empirical and positivistic, short in theoretical and methodological reflections. A few articles draw on discourses from state policy to derive from their analytical categories. In this first group, scholars try to describe, measure and map out the geographical ordering

6 Chengshi-Guimo (城市规模).

7 Chengshi-Kongjian (城市空间).

8 Kongjian-Jiegou (空间结构).

9 Chengshi-Jingji (城市经济).

10 Chengshi-Jiqun (城市集群).

of economic activities (i.e., finance, manufacturing industry, real estate, tourism) in a specific administratively defined territorial unit (a city, a province, an urban agglomeration or the entire state). In almost all the selected studies, the notion of space is deployed in territorial and normative terms. The performance of certain economic activities is measured quantitively within the bounded study area. Space is described by its territorial (quantity, size, and location) and normative-functional (residential, commercial, industrial etc.) features. Their correlations are described and measured through sophisticated metric models, through the aid of geo-computational powers of GIS, more so in geography than in the urban planning discipline. The study area's boundary, the land's classification, is retrieved from urban legislative demarcation and codes without exception. The spatial analysis serves as an instrumental tool for governance. Moreover, the studies typically conclude with policy recommendations. The evaluations, guidelines, and optimization plans are carried out to fulfill the objectives of germane policies in the designated study region.

Ten (5%) articles out of two hundred have attended to diachronic and dynamic interactions between social-economic variables, employing various quantitative spatial econometric modeling approaches. Favorable models include the geographically weighted regression model (see Lu and Zhen 2010), PSR regression model (Zhu and Cao 2011), systematic-dynamics mode, gravity model (see Zhu et al. 2011; Guo, Hu, and Jin 2012, 2012; Li and Li 2011), multi-agent system model (see Liu et al. 2010; Xue and Yang 2003) and so forth. Along with the 'big data fever' in spatial research, the social actors' – who inhabit and construct the city and villages – multidimensional subjectivities, are omitted. The urban ecology approach is employed in seven articles (3.5%), addressing the phenomenon of social-demographic and territorial segregation. It means the uneven distribution of the population contained in certain areas, measured by their social-economic attributes (i.e., income or migrant status), are captured. Administrative jurisdictions are adopted as the territorial unit of analysis (see Li, Wu, and Lu 2004; Lu 2004; Yang and Wang 2006; Feng and Zhou 2008). None of the authors questioned the Chicago school's ecological premises regarding human agency and the reductions of space to a socially homogeneous black box with a geographical location. These methodological measures, although underwritten by a Newtonian relative space concept, are fruitful. They came closer to describe the dynamic entanglements between the material dimension of space and plural social factors, reveal more complex autocorrelations between material space and systems of meaning.

Relative space vs. the urban-rural flux

A particular relative spatial perspective is widely employed in studies analyzing the relations between institutional restructuration and social and territorial change.

Three papers (1.5%) implicitly employ a neo-institutionalist perspective, perceiving urban spaces' configuration to be caused by changing distribution of governmental agencies and their relations (see Chai, Chen, and Zhang 2007; Zhang, Wu, and Ma 2008). The state administrative structure is not only employed to represent the institutional apparatus of the state but also a system of positioned agencies regarding implementing policies, regulations and undertaking spatial strategies, plans, and other social-spatial interventions. In a recent review on theoretical perspectives on China's urbanization in Anglophone literature, named *How Unique is 'China Model,'* Wang and Liu (2015) summarize the typical ways in which scholars relate social-spatial phenomena occurred in urban China to the conceptual framework of neo-institutionalism:

> First, the most salient feature of China's political institution is de-centrali-sation/centralisation and restructuring, which makes *the scale or central-local relation* a rather explanative view of China's urban processes. Second, the economic aspect is mainly characterised by marketisation and growth, which make the theories on neo-liberalisation and capital accumulation prevalent in studies of China's urbanization.... Under the Chinese context, in which urban resources (such as fiscal revenues and grand projects) are allocated proportionally to the level of a city in China (Zhao and Zhang, 1995; Fan, 1999; Chung, 2007; Chan, 2010). (Wang and Liu 2015, 102–3)

I can affirm such a tendency. The neo-classical and neo-liberalism lenses are adopted as prevailing analytical frames chosen to describe and explain dynamic macro and meso level social-space (territorial) reconfigurations. From my sample, I can identify one ostensible tendency: scholars favor the unitary economic or political-economic system over the plural systems of meaning or experience to probe into the restructuration of space. Normatively defined political jurisdictions dictate the definition of the city in scientific studies. Both theoretical perspectives – reduce space as a container or measurable homogenous surface as in the discussion in 2.3 – are, in essence, built on the Newtonian absolute-relative epistemic frame. The ontological premise shared among such scholars is *realism*. They conflate *empirical categories*, i.e., a normatively defined term (such as 'city') with an *abstract category* ('city' as a conceptualization grounded in analytical frames).

In the planning domain, *comparative case studies* on the state or city level are widely employed. Facing the challenge of conceptual incommensurability, some scholars affiliated with overseas academic institutions[11] tend to maintain epistemic forms and concepts, their sense relations, and the causal agent from the deployed theory. They extend the meaning of certain concepts (i.e., housing property rights) to the observable qualities of empirical referents in a Chinese context (i.e., housing

11 Not affiliated with mainland Chinese institution.

ownership detached from land property rights), then extend the conceptual framework as "XXX with Chinese characters" (see Harvey, 2005; Lim, 2010; Peck and Zhang, 2013; Zhang and Peck, 2014). Scholars affiliated with Chinese institutions tend to de-ideologize the theories deployed, disregard the causal agents postulated in frameworks such as capitalism or neoliberalism, as the very use of the term may create its own references[12]. Instead, they employ theories in a heuristic manner, replacing some original epistemic forms (such as property rights, citizenship, or scale) and their corresponding causal agents intuitively with relevant Chinese concepts (such as house ownership, *Hukou*, or hierarchy).

Furthermore, a cultural turn remains marginal in social-spatial studies in China. In the field of sociology, Chen has recorded the vicissitudes of a broad cultural turn along with methodological reflections in the post-reform era:

> It was not until the 1980s that a group of Taiwanese and Hong Kong scholars initiated a more sustained and systematic reflection on the issues of indigenization. Here the major impetus came from Taiwanese social psychologists, whose studies in face (mianzi[13]), social relationships (guanxi[14]), affinity and destiny (yuanfen[15]) and other indigenous idioms and notions led them to question the applicability of Western categories, measurements and assumptions to the psychology of the Chinese people (Yang Guoshu 1982; Huang 1995; Yang Zhongfang 1996). In the 2000s, however, these cross-cultural and meta-theoretical reflections were largely abandoned. ... An obverse trend, however, could be observed in mainland China. While playing a somewhat marginal role in the previous indigenization discourse, mainland Chinese sociologists came to assume a more prominent position after the century's turn (Qiao 1998; Qiao et al. 2001). (Chen 2018, 120–21)

Overall, my sample shows that there has yet to be any social theorizations that have translated traditional Chinese ontology or epistemological frames into well-grounded analytical frameworks. Those that do exist are not systematic enough to accommodate and be validated by concrete empirical analysis. In 2.1, I mention briefly that since the 1990s, along with the rise of the Chinese state as an economic and political player in the global arena, official political discourses are becoming more nationalist than globalist[16]. Against such a backdrop, more and more con-

12 Adopting neo-liberalism or neo-institutionalism perspective in analyzing spatial transformation in China was also initiated by Chinese scholars from overseas.

13 Mianzi (面子).

14 Guanxi (关系).

15 Yuanfen (缘分).

16 More discussion on the nationalistic turn in state-led cultural construction since 2008 can be found in Soziologische Chinastudien und chinesische Soziologie im globalen Kontext: Geteiltes Wissen – unterschiedliche Forschungsperspektiven by Gransow (2017, 126-27).

temporary Chinese scholars pick up the thread advancing theoretical development from ancient indigenous philosophical thought, especially Confucianism. I want to stress here again that my point of departure in this research is *not* political but methodological. To paraphrase Ulrich Beck's comment on post-modernist theory, political discourses and arguments are eager to persuade us what is *not* the case but fail to say what *is* the case. A meta-argument about the dominant social ideology in China, 'Confucianism' and 'neo-liberalism' can be equally valid or invalid. What matters is how useful the set of concepts, epistemic forms, and causal agents are in helping us develop an insightful understanding of the formation of local social space under the condition of compressed modernity.

4.3 Spatial knowledge recontextualized and the social context of knowing

In this book, I take an epistemic approach, which means, I understand the methodological challenges researchers face to have emerged (at least partly) from the *epistemic distance* between traveling 'theory (conceived by the attributor)' and the '*empirie* (perceived and understood by the researcher).' It means, the gap between the epistemic frames initially conceived by the attributor in one time-space, and that understood and invoked by scholars in examining empirical cases in a different context. It is an enduring and prevalent challenge for researchers who engage in cross-cultural and comparative research. These researchers face more difficulty when their subject matter's characteristics are unprecedented or if they cannot be, registered, observed, or understood (in part or as a whole) by existing theories and concepts. Here, I have broadly followed the sociology of knowledge tradition (already introduced in chapter 2), which has delved deeply into explicating why and how the *symbolic content* appearing in the mental context is social. I also refer to the social psychology of knowledge theories, which offers conceptual tools to detect the represented *social forms* that constitute the mental context.

According to social psychologist Moscovici (1988, 237), the adoption and application of a piece of distance and abstract knowledge – take the concept of scale as an example – would be achieved first through anchoring it to an existing social representation. In a similar vein, Valsiner argues that: "the social representation system of society at some historical period may selectively guide the researcher to seek general knowledge, or, through denying the possibility of general knowledge, let the researcher be satisfied by descriptions of 'local knowledge' (2006, 601)." It implies that the interpretation of learned knowledge is relative to the receiving subject's socialized mind, which can be detected as the knowledge encounters interface. The 'knowledge attributor' and the 'putative subject of knowledge' can be distinguished in the communicative process of knowledge (re)production. For the

analysis in this section, the concepts of 'anchorage,' 'misinterpretations,' and 'reconstructions' are especially useful for identifying extra-evidential features (cognitive principles or implicit communicative rules) deployed by the participating subjects as the active (socialized) mental context of knowing.

Following the discussions in chapter 3.3, I adopt an epistemic reading to the processes in which traveling knowledge is received by scholars dealing with Chinese cases. I refer to 'context' in the sense of mental (cognitive) and affective models held and actively mobilized by the assumed subjects of knowledge. According to van Dijk (2008), such mental and sensible models offer researchers the orientation in selecting and interpreting the knowledge. We researchers have tacitly defined our 'mental models' rather than certain objective features of the subjects' surroundings as *a priori*.

4.3.1 Hierarchy as epistemic context: scale theory re-contextualized

The previous discussion regarding the divergent ways in which 'spatial turn' unfold in the European and Chinese intellectual contexts suggest, knowledge does not diffuse evenly. Some pieces of knowledge travel fast and wide, get anchored into various local frames of knowing. Due to their epistemic distance, maybe translated or reviewed, their further application and development do not follow. In the following, I take the *'scale theory'* as a 'boundary object' traveling from Europe or the West to the Chinese discursive field. The concept of *'scale'* in scale theory (among others like location theory and growth machine theory) has gained prevalence in studies of the post-reform social-spatial transformation of Chinese cities. However, the meaning and analytical purchase of 'scale' have gone through a notable change in scholars' empirical applications, rarely noticed and discussed. A close-up comparative examination of original and recontextualized versions of scale theory will reveal the covert epistemic context and overt epistemic gaps at work. The analysis aims to shed light on the epistemic rules (as generative mechanisms) applied in the local context of knowing space.

Briefly speaking, in its original context, the concept of 'scale' was coined and developed by geographers since the 1990s (see, e.g., Agnew 1997; Cox 1996; Swyngedouw 1997) in an attempt to decipher how inherited local, regional, national, and global strata relations among territorial units change through economic restructuring and state recalibration under the condition of global capitalism. Wang and Liu assert that when scale theory is deployed to explain the post-reform Chinese phenomena, "scale is generally conceptualized as the administrative structure or political hierarchy" (ibid., 103). When deploying it as an analytical framework, Li and Wu, like many, have dis-embed it from a neo-liberalist rooting. Due to the ostensible fact that "the economy is administered under persistent state intervention, which is a far cry from the orthodox theory of neoliberalism that suggests a

retreat of the state to make room for the market" (2018, 2). The scale is still deemed a critical causal agent in their works, it structures social actors' agency, and territorial change explains some emerging spatial phenomena. For instance, new territorialized governance units (e.g., the city-region) are conceived to be caused by the interactions between scaled (leveled) state entrepreneurs. Similarly, a sizable number of scholars opt for the concept of scale, to represent state administrative hierarchies in an absolute or relative sense, to explain the differentiated urbanization processes (see Smith 2014; Hsing 2010; Cartier 2005; Ma 2005).

In the following analysis, I focus on three selected works that have deployed and recontextualized the scale theory to study China's urban system's restructuration. In their applications, I trace and examine their operations of selection, reception, anchorage, interpretation, and (re)construction.

The conceptualization of scale in western academia emerged from the debate about the social construction of order since the early 1990s. Contested debates occurred regarding the politics of *re-scaling, scale jumping, scalar fix*, and their impact on (re)differentiation among various intertwined forms of socio-spatial organizations such as urban systems, citizenship regimes, state institutions, and capitalist economies (Collinge 1999). Against this background, 'scale' is primarily conceived as a predicate of 'territorialized social systems' and has extensive powers. 'Scaling' is then conceived as a territorial medium and an outcome of processes associated with capital, labor, and state institutional change (Peck and Tickell 1994). In a secondary analytical dimension, most studies associate the property of 'positionality' or 'network' with scale. For instance, the scale (relative positioning) of a 'territorialized social system' within a network can be differentiated and measured by the quantity of the dominant form of activity identified in this system. Economic activity is deemed a particularly important form for evaluating the 'scale' of post-capitalist societies in the time of globalization (see, e.g., Delaney and Leitner 1997). Under neo-liberalist epistemic rules, although the conceptual scope and causal power of scale are deemed varyingly across studies, by and large, it is conceived as "a foundational hierarchy – a verticality that structures the nesting, and with it, the local-to-global paradigm" (Marston, Jones III, and Woodward 2005, 419). Here, I cite one of the most well-accepted definitions of scale from Brenner:

> [A] 'vertical' differentiation in which social relations are embedded within a hierarchical scaffolding of nested territorial units stretching from the global, the supranational, and the national downwards to the regional, the metropolitan, the urban, the local, and the body. (Brenner 2004, 9)

Following this definition, the concept of scale represents *in the first order* to the extensive property of a bounded territorial unit in which social activities unfold. It most likely refers to the sized notions like 'state,' 'city,' 'body,' and so on in empirics. Under global capitalism, *following the second-order logic*, the social and territo-

rial significance of homogenous political and economic activities is evaluated and re-evaluated in the process of economic restructuring. From there, the researcher identifies certain political, economic, or social relations – like capital mobility, state regulation, production, and consumption – as a transversal variable to give the territorial units a vertical order. As the social activities are conceived isomorphic within a fixed territory, their magnitude subjects to a vertically differentiated calibration. Scale refers simultaneously to the relative positions and the *sum* of these scalar relations across differentiated magnitudes. In Brenner's definition, these relative positions are instantiated by the body, the local, the regional, and beyond, which offer little clues to the concrete objects they refer to in reality.

In this context, the hierarchical relations implied in 'scale' *as a whole* can only be defined from a 'top-down' standpoint. In other words, it presupposes a God-like methodological perspective (see Amin 2004). Marston (2005) has challenged the impartial observer assumption, i.e., the sense of scale is socially or scientifically constructed 'out there.' It leaves the perspectives and experiences of actual subjects on the ground to be dismissed or disguised:

> For once hierarchies are assumed, agency and its 'others' – whether the structural imperatives of accumulation theory or the more dynamic and open-ended sets of relations associated with transnationalism and globalization – are assigned a spatial register in the scaffold imaginary. Invariably, social practice takes a lower rung on the hierarchy, while 'broader forces,' such as the juggernaut of globalization, are assigned a greater degree of social and territorial significance. Such globe talk plays into the hands of neoliberal commentators, like Thomas Friedman. In his popular account of outsourcing (e.g., Friedman 2004, 2005), the standard trope – at least 'at home' – is to shift blame 'up there' and somewhere else (the 'global economy'), rather than on to the corporate managers who sign pink slips. In this fashion, 'the global' and its discursive derivatives can underwrite situations in which victims of outsourcing have no one to blame, a situation possibly worse than blaming oneself. (Marston, Jones III, and Woodward 2005, 427)

I now examine the conceptual form of scale and its associated spatiality when it is redescribed in explaining Chinese social realities. My goal is to unravel the epistemic models perceived as necessary in the scholar's (as the putative subjects of knowledge) mental context. This mental context is constituted by social representations, epistemic frames, communicative structure. I conduct this examination along two lines of inquiries. First, what transitive epistemic entities are admitted as referents in the conceptual framework of scale? Secondly, what spatiality is conceived to be subjected to re-scaling?

My examination focuses on three pieces of work. They have grounded their research in the political and economic structural imperatives, employ scale theory *systematically* as an analytical framework, take the concept of scale as the essential

causal agent in explaining social-spatial transformations in the context of post-reform China. The three pieces that I choose to examine here have all redescribed a part of scale's empirical content to administrative hierarchy. Their authors do not all have Chinese nationality. However, their empirical subjects are embedded in the Chinese social and discursive fields. They allow the local observables to inform the postulated causal claims [17]. Thus, these works have demonstrated the active involvement of *mental context* in reshaping the prescribed epistemic forms and rules in the original scale theories.

Before delving into each work, I briefly recapitulate the institutional context upon which the three pieces have stated their research problems and examinations. In the most general terms, since 1978, the Chinese central state has initiated a series of top-down reforms that de-centralized, sometimes partially, specific administrative and economic powers from central to local governmental bodies. Earlier studies address the impact of fiscal reforms since the early 1980s, particularly the tax sharing system implemented since 1994, which designated the revenue from land development and sales to the local government. Subsequent studies highlight the role of reform strategies in sectors like housing markets (see, e.g., Qian 2008). It is widely acknowledged that such policy reforms re-activate certain materiality into mobile, deployable resources and restructure the discretion of the local states and private actors in resource deployment (see Zhu 2004; Chien 2013; L. Wang 2014). In the meantime, scholars have observed local governments' increasing endeavors to promote local economies and construct the urban built environment expansively (see Oi 1992; Walder 1995).

The other common denominator is the gradual formation of a Chinese urban system with differentiated political and economic power. As illustrated in figure 7, this urban system comprises three normative categories of 'city[18],' 1) provincial-level cities[19] that are administered directly by the central government, including Beijing, Tianjin, Shanghai, and Chongqing; 2) cities with districts[20], referring largely to cities at and above the prefecture-level[21]; and 3) cities without districts[22], referring mainly to county-level cities[23]. The dynamic changes of such administrative units'

17 I identify the works from Cartier, Ma, and Shen as qualified targets for examination, despite the diverse national affiliations of the authors. My criteria of selecting sampled studies lies in the systematic deployment of the conceptual framework. The studies who engage scale theory as mere heuristic tools and descriptors, are ruled out.

18 Shi (市).

19 Zhixia-shi (直辖市).

20 Shequ-de-shi (设区的市).

21 Diji-shi (地级市).

22 Bushequ-de-shi (不设区的市).

23 Xianji-shi (县级市).

relative positions and territorial forms constitute the selected studies' shared inquiries.

Figure 7 China's territorial administrative system in 2002. (Illustration from Ma, Laurence J.C. 2005. "Urban Administrative Restructuring, Changing Scale Relations and Local Economic Development in China." Political Geography 24 (4): 477–97, 479, fig. 1)

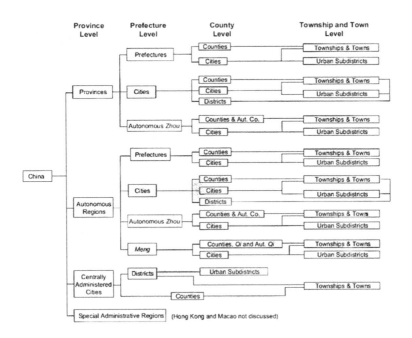

In this context, let me begin with analyzing Cartier's work City-space: scale relations and China's spatial administrative hierarchy (2005), which focuses on analyzing the re-scaling of the Chinese state in the post-reform era. She asserts that "in the normative terms of state administration, we refer to scales in terms of territories defined by political boundaries, i.e., towns, counties, cities, provinces or states, nation-states, and world regions" (ibid., 21). It means that Cartier has conceived scale as an extensive predicate of territory. She argues that, in the western context of the neoliberal capitalist state, the state exhibits minimal practices and hence does not equate to the national level, nor is it specific to one scale, leaving its social-spatial organization unexamined. Drawing on historical research of Chinese state administration, Cartier contends that the state organizational structure in the form of territorialized administrative hierarchy has existed throughout China's history. In her study, the state's overall hierarchical arrangements – an ad-

ministrative system constituted by territorial units as a whole – is admitted as the empirical content of scale. In other words, in the first-order, scale is conceived as a vertical attribute of the state (the sum of many vertically arranged, politically bounded, sized areas).

Cartier has then ascribed scale – vertical arrangement – as the primary drivers of change inside the state. These *scale-level relations* refer to the form and sum of relations between inter-scalar territorial administrative units, described to be formulated inherently and dialectically. By re-scaling, Cartier refers to:

> How actual processes work out through China's territorial administrative hierarchy, from the national capital to provinces, cities, counties, and towns, and, in turn, how such political territories are constructed, mutable and dynamic. (ibid, 19)

According to Cartier, the urban system is perceived as a system of scaled territorial units, whose territories are then subject to change by the principle of hierarchy. The empirical content of territory is understood principally as an administrative practice, separating the area of the unit in question – the cities – from other cities. In Cartier's words, "de-centralized powers are not simply 'fixed' at lower levels of state administration, in cities and counties, but that they exist in vertical and horizontal relations among cities, that is, in constant dialectical formation" (ibid., 26). What triggers the re-scaling of state in the post-reform era for her is that "the state focused on a highly uneven strategy of rapid development in particular zones, cities, and regions, first on the south coast, and then in the coastal region generally." The strategy is deemed as a package of diverse political and economic empowerment measures. As a result of uneven internal reordering, cities' role has been enhanced, taking on a newly adjusted and specified vertical level. This level of governance enables the state to "spur economic development while simultaneously maintaining political control" (ibid., 25).

Laurence Ma (2005)'s work, *Urban administrative restructuring, changing scale relations and local economic development in China,* focuses on the policy-led re-scaling of urban administrative units of different ranks and their political and territorial consequences. In particular, Ma examines how administrative units negotiate their territory and political power by resorting to several state-issued institutional reform strategies regarding re-organizing administrative units. Such strategies include the system of "city administering county[24]," "converting county to the city[25]," and "annexation of suburban counties[26]."

Ma argues that for single local administrative units, the ranking system *as a whole* is a given factuality. The central government "determines the number of

24 Shi-guan-xian (市管县).

25 Xian-gai-shi (县改市).

26 Xian-shi-hebing (县市合并)

government offices it may have, the names of the offices, the number of officials staffing the offices, the ranks of the officials, the amount of fiscal resources and their allocation within the unit, and the decision-making power of the unit to manage and approve local and foreign investment projects" (Ma and Wu 2005b, 485). Yet, one's relative political position in this system, is conceived as the primary causal agent. Hence, the political activities within the city's jurisdictional-territorial boundaries constitute the empirical content of scale, subject to re-scaling. In other words, the political power and territorial resources between physically adjacent or politically adjacent administrative units are up for negotiation. For any urban administrative unit, when employing one of three state-issued strategies from a given position in the hierarchical administrative structure, the possible outcomes are as follows. The one situated in a relatively low position in the political hierarchy could opt for maintaining its administrative rank while subsuming one's territorial resource and political agency to a higher-level administrative unit. It means the city's territorial dimension is deemed an attribute subject to scale, not merely representing the static empirical referent. Due to the annexed territories, the higher administrative unit can promote this overall administrative rank, thereby obtaining more political agency. A given administrative unit could also opt for applying for promotion on its own, but its success rate is much lower. All three reform strategies privilege the higher-ranking administrative units in their negotiations with adjacent lower-ranking administrations. Eventually, due to territorial annexations, the number of administrative units changed, so are their relative political positionality. The hierarchical system as a whole was still reinforced.

The third work to be examined is from Jianfa Shen (2007), entitled *Scale, State and the City: Urban Transformation in Post-reform China*. Shen focuses on the relationship between the re-scaling of urban administrative units and re-organizing urban space in China. Interconnected with the concept of the 'city,' the concept of scale is also used in the first instance to *represent* the administrative rank of a city, which is essentially determined by the state:

> "Such a power structure ensured that the central government had the ultimate power in initiating changes and controlling local governments at various levels. The central government has been influential in the changes of city scales, i.e., the promotion of a city from one level to another in the administrative hierarchy, and urban territorializing, i.e., city boundary change, both before and after 1978." (ibid., 310).

For Shen, re-scaling means that "when a city is promoted in the administrative hierarchy from county level to prefecture level, vice-provincial level or provincial level which are three basic levels of government administration in China below the central government" (ibid., 309). Here, scale (administrative hierarchy) is taken as a relational attribute of 'city,' negotiated between local and central government. In

other words, the city's primary attribute is reduced to its positionality in the state-local institutional structure without pre-established territorial or social attributes. Thus, the city's territorial dimension is perceived as a result of, and also secondary to, its positionality.

In Shen's analysis, the series of state-initiated de-centralization policies – including the fiscal reform, the marketization of land, and the housing sector – are perceived as the triggers and leverages of re-scaling. According to Shen, the central-local relation is constitutive to a city's division and sharing of power on policy, personnel, and fiscal matters. In contrast, the inter-scalar relations involve the division and sharing of territory and fiscal matters. The second type of re-scaling is associated with the group of policies, including the "system of the city governing the county." It is read as "an example of re-scaling of territoriality or re-scaling of cities precisely" (ibid., 305). Similar to Ma's argument, Shen conceives territory as a secondary attribute of the city, result from the inter-scalar governmental negotiations. What marks Shen's analysis from Cartier and Ma is that he incorporates two pairs of relations – the central-local and the inter-local relations – to the concept of scale. They are deployed in explaining a city's positional change in relation to the state and territorial change in relation to adjacent cities, respectively.

Like the previous two studies, Shen also notices the nested territorial relations between cities of different ranks, i.e., lower-rank administrative units, such as villages, townships, counties, county-level cities, and urban districts as part of the territory of a higher-level administrative unit. Alternatively, from the perspective of a prefectural level urban administrative unit, aside from the central city area, other lower-ranking cities are sitting within its jurisdiction, submitted to its daily administration and planning. He introduces territorialization and de-territorialization as the second form of scale's analytical dimensions to explain such inter-scalar negotiation processes.

At this juncture, I can summarize the differentiated theoretical adaptations of 'scale' in terms of their subject and 'spatiality,' following the two lines of questions that I raised previously – 1) what empirical objects are admitted as the referents of scale? 2) what spatiality is conceived to be associated with scale and subjected to re-scaling?

The commonalities these three scholars share in their practice of recontextualizing scale theory can be concluded as follows:

1. The concept of scale has been anchored into an existing concept of hierarchy in the sense of administrative rank (*dengji*[27]). It is anchored either as the predicate of a whole institutional system (the state) or as an inherent attribute of a territorialized administrative unit (a city).

27 Dengji (等级).

2. For a given spatial unit, its relative position in the hierarchical system is re-contextualized as an internal causal attribute associate with its political agency. It is unlike that conceived as an external one in the neo-liberalism model.

3. For a given spatial unit, its territorial attribute (the dimension of size) is re-contextualized as both the subject and result of scaling. In the neoliberal context, it is conceived as a substantial predicate.

4. The primary measure of scale is reduced to the political agency over economic ones.

The common practice of anchoring 'scale' to normative administrative ranks (*dengji* as leveled position or structure) reveals that the scholars naturally perceive 'hierarchy' to be ontologically real. It opposes the definition of scale from its original theorization under neoliberalism, in which ontological primacies are given to the enclosed, homogeneous territorial-social unit or place-like social-spatial units. The vertical dimension of scale (as level) exists on the secondary level of the conception, whose existence is dependent on the perceiver. In the Chinese context, the concrete territorialized administrative unit (e.g., city) subject to re-scaling is conceived primarily as a political agent, whose political power is associated with one's relative *positionality* in the hierarchical system of the state. Its territorial scope (*guimo*[28], size) are caused by one's *relative positionality* to the adjacent administrative units. Furthermore, the 'city' is reduced to a mere administrative unit. The heterogeneous everyday practices occurred in a city, and to a certain extent, the economic activities conducted by non-administrative actors are not admitted as the empirical content of scale. In sum, through my comparative analysis, we can uncover the commonality in these three scholar representatives' approach of anchoring, interpretation (reduction), and reconstruction (changing epistemic orders) 'scale' into the Chinese context. It exposed essential features of their contextual cognitive activities.

4.3.2 Asymmetric communicative forms and consensual truth-conditions: constructing and legitimating spatial terms

Chinese geographers and planners are not the *only* contributors to selecting spatial concepts and redefining their meanings in empirical applications. I would argue that, more often, scholars straddle between the legitimation criteria imposed by the domestic political actors (state-urban administrators) and that from the western scientific world (exhibited primarily in Anglophone scientific journals). To illustrate the truth condition under which spatial notions are defined in the Chinese scientific discursive field, I analyze two renowned scholars' presentation excerpts.

28 Guimo (规模).

They were presented in the Expert Symposium on the 60th Anniversary of China's Planning Association held in Beijing in January 2016.

> The concept of *urban agglomeration* has appeared on several documents issued by the central committee of the communist party of China (the incoherent meaning implied is problematic). I don't mean that we can't just use this notion. [I find] it is not practical to construct another new term. But the problem now is how to make this concept more defined. We shall flesh out the necessary variables for defining the urban agglomeration, including maybe the density of the population, the parameter for measuring the intensity of the connection between cities, the level of economic development of a city. After doing that, (most likely, you would realize) the Beijing-Tianjin-Hebei (area) cannot be called an urban agglomeration. Some administrative bodies use the term to refer to all the physically proximate cities; some examples include even vast grassland and desert (the undeveloped areas) between cities. [Us]in the urban planning practice circle and academic circle should tease out anomic applications as such. The misuse of the concept is already ubiquitous (which creates lots of problems in practice). We shall define this concept more accurately and report it up (to the central party committee) [...] I would suggest the urban planning association be the body to define a fundamental concept. (Hu, 2016, translation added)
>
> China's unique conditions are our concept of the city is only accurate to the extent that it mainly describes an administrative jurisdiction. Such an area is [usually] much bigger than the actual built-up urban area. However, [I think] there is a complicated relationship between the administrative jurisdiction and functional urban area. The further can be equivalent to bigger or smaller than the latter. The problem lies in that we do not have the criteria nor conceptual framework for examing the *actual* urban build-up area; neither do we have any concept referring to the *functional* urban area. Instead, we have a myriad of ambiguous terms like the 'urban agglomeration' encompassing the city's physical and functional dimensions. Now we have around 280 urban administrative units, all of which are bigger than the *actual city*. Therefore, we cannot conduct any valid comparative studies across these 'cities,' nor can we do that with cities in other countries. The perilous consequence of using the extended concept of 'city' as such is that we exaggerate the urban demography, urban land, urban infrastructure, urban investment, and so on.
>
> Only when we draw the conceptual boundary of the city clearly, can we further define concepts like 'urban population,' 'urban land-use,' 'urban infrastructure,' 'urban economy,' 'urban ecology,' 'urban planning,' 'urban management' and so on, on the base of it. We can then understand, respect, follow the law of urban development. I used to propose that "the first and foremost scientific problem in urban studies is to find the correct concept." I [now still] mean that. I fervently hope that our coun-

try's leadership pay enough attention to this most significant and fundamental problem in urban-related issues. (Zhou 2016, translation added)

In both excerpts, the scholar has reflected on the ambiguity of the mainstream spatial terms at work in the Chinese scientific field and made proposals for clarification. When we look at the notions (spatial representations) mentioned in their narrative, we can identify one crucial political context – the 'fourth meeting on urban-related work' held by the central committee of China's communist party in late December 2015. The italicized terms and narratives appeared firstly in the party's conference report, released a month before this expert symposium. We can also identify that such debates on the meaning of urban agglomeration are triggered by the discourse set by Xi Jinping, such that "[the administrative bodies] shall take urban agglomeration as the fundamental spatial unit, scientifically plan and construct the city, in order to achieve compact, efficient and green development[29] (Xinhua.cn 2015)" Both Mr. Hu and Prof. Zhou are among the most-established scholars in geography and planning circles in China, holding top council positions in scientific associations. Neither of the scholars is content with the heuristic devices directly imposed, such as 'urban agglomeration' constructed by the politicians. They call for another round of proposals and verifications from science to politics.

Nevertheless, neither seems to be in favor of overthrowing the term. For Hu, scientists' role is to clarify the notion transferred from politics, in the sense of identifying the real and material object(s) as the referents, designing an analytical framework consisting of a set of coherent, diagnostic criteria following positivistic principles. He proposes a set of parameters representing some quantifiable and measurable attributes exhibited by some urban components to be admitted and legitimated in the scientific realm. One can infer that Zhuo expects the Chinese scholars to point out the caveats in politically constructed spatial terminologies, to find solutions to fill the lacunas. He deems the notions like urban population, urban land, urban infrastructure, urban economy, urban ecology, urban planning, and urban management as adequate regulatory and scientific semantics. They share *sense relations* with, and are secondary to, the concept of 'city.' Thus, Zhou contends the primary problems to lie in the ambiguous relationship between the *empirical referents* and the conceptual notion of *'city,'* which are not defined and legitimated by scientists. Nevertheless, Zhou draws the epistemic premises to help identify and connect the real object with 'city' as positivistic. He endorses the development of diagnostic, quantifiable, and universal measurements, which enables international comparability. He refers to the OECD's analytical angles identifying functional urban areas (OECD. and Organisation 2012). Either way, spatial schemata constructed

29 In Chinese: 要以城市群为主体形态,科学规划城市空间布局,实现紧凑集约, 高效绿色发展.

by Chinese scholars, city makers, and other social actor groups on the ground are neither recognized nor legitimated in such a communicative norm construction process.

The discursive entanglement and asymmetric legitimating power between politics and science are also reflected in a review of the progress of economic geography research in China by Liu et al. (2011). The authors assert that the prominent feature of economic geography research in China is application-oriented and mission-led development. By application-oriented, Liu et al. refer to the tendency that administrators' practical economic-geographic problems determine the thematic research options. Geographers interpret the result of spatial analysis from a classic economic or political-economic perspective to give urban administrators and managers technical instructions in drafting land-relevant policy and plans. By mission-led, Liu et al. refer to the dominance of state-commissioned research projects. Like the notion of urban agglomeration, terms like major 'functional oriented zones' are proposed in the 11th *National five-year development plan* imply a spatial strategy to coordinate and regulate regional developments in terms of land use, economic activities, and ecological carrying capacity. It is also intensively employed, discussed, and developed in the scientific realm.

In sociology, Chen (2018) claims that state-building is one of the leitmotivs shaping sociological knowledge production since its inception in the 1930s. My observations also verify that political discourses are often reproduced in the scientific realm, even when politicians are not present in communicative situations. Attending a recent academic conference entitled *China's new urban agenda* in Manchester in November 2018, I heard several scholars characterize their analysis under the label of *ecological civilization*, a political slogan that the central government has put forward since September 2015. In the meantime, I have witnessed the difficulties such scholars demonstrate in narrowing down concrete and analytical dimensions of this term.

What rationale has been taken by Chinese politicians in constructing spatial concepts in policy discourses and developmental plans? What role does political power play in producing and legitimating spatial knowledge in the scientific realm and beyond? These questions are beyond the range of discussion in this research. I would argue for the salient and pervasive *coupling* of social scientific and political discourses. They are mutually legitimating in the course of conceptualization. Instead of interpreting this phenomenon merely as ideological or political oppression, I would instead read it as manifestations of a tacit epistemic culture.

A question regarding the implicit truth condition at work is then raised. In the context of the *central urban-related work conference*, the spatial concepts proposed in the policies intend to instruct further urban planning, governing, and constructing practices. Thus, they are *instrumental semantics* for making predictions and instructions, coordinating practices in various domains to solve practical problems. The

use of them must ensure practical consensus, as a useful concept's concrete refer-
ents have to be shared by perceiving actors to coordinate practices and bring out
the actual efficacy. However, without a participatory process that allows social ac-
tors to propose, affirm and internalize the designated meaning, coordinated and
consistent transition from idea to practice cannot be ensured, despite semantical
consistency and alliances.

I would argue that – unlike the grand assumptions regarding participatory and
symmetrical communicative form and *correspondence* as truth conditions embedded
in the classic sociology of knowledge tradition (see Berger and Luckmann, 1966)
– the communicative forms in the Chinese political and social scientific contexts
are rarely built on inclusive, symmetrical social relations. Nor is truth legitimated
by adopting the representation and correspondence principles. Here, by commu-
nicative form, I mean the "major 'building blocks' for the construction of reality in
that they allow people to coordinate actions and motives" (Knoblauch 2013, 306),
which gives shape to "styles of communication" (codes, formats), and "as any in-
stitution, are linked to legitimations" (ibid., 307). As indicated, in China, political
and social science discourse is entangled in generating normative-scientific spa-
tial knowledge in China. In this process, the social relations between scientists and
politicians are most likely asymmetrical, as the main (if not the only) sponsor of
spatial science (planning, geography) is the state. The criteria embedded in public
funding shapes the kinds of knowledge being produced. In the meantime, the pub-
lic is exempt from the legitimation process so that feedbacks from non-professional
actors will rarely affect knowledge construction. I see such communicative forms
as institutionalized and constitutive in producing spatial conceptualizations.

This claim exhibits a direct contradiction to the tradition of debates in west-
ern epistemology – that the study of knowledge (episteme) as opposed to mere
belief or opinion (*doxa*). Moreover, although positivist methodology prevails in the
Chinese scientific realm, semantics and their meanings are derived from political
discourse. The practice of *conceptualization* results from a *consensus* between politi-
cians and scientists, with the latter in a subordinative position. The condition is
closer to what Habermas (1979) conceived in the discursive theory of truth. The
difference is noteworthy that the *actual* actors drawing a consensus of truth with
regards to key spatial concepts are not only among the most well-informed scien-
tists in Habermas' sense, but also politicians and city managers. The political power
is continually re-inscribed into scientific theories and conceptualizations through
conventionalized communicative forms, imposing direct impact on the practices of
constructing the city, citizens, and various new forms of spatiality (e.g., the special
economic zones, the smart community).

On the other hand, the consensus on adopting concepts such as 'urban agglom-
eration' and 'ecological civilization' is made primarily on the semantic and discur-
sive level. It is less on the real level regarding the generative mechanisms or on the

empirical level, regarding concrete, observable referents. The result is that concepts and conceptual plans do not coherently *represent* the observable phenomenon nor reflecting a shared understanding of reality.

4.4 Revised social constructivism and relational spatial knowledge on the ground

In the previous sections, I have shown that traveling theories from the positivist or structuralist traditions do not stay hermetically sealed when adapted to the Chinese context. The local context manifested as mental models – entrenched epistemic presumptions and communicative forms-could be revealed by comparing the original and recontextualized forms of knowledge and their inferences' modality. This section looks at studies that recontextualize social-spatial theories into studying the social space constitution in the structurally weak sectors in Chinese society. They attend to particular lifeworlds and/or fields of practice centering around marginal social groups (primarily subculture or subaltern groups). These authors have generally prioritized first-hand, unmediated empirical data in the field, using the methods like, i.e., participatory observation or interview, to capture the processes in which such marginal social groups (such as 'aboriginal' residents in urban centers, lesbian and gay community, rock-n-roll musicians, migrant women, NGOs) manage to construct a lifeworld, community, spaces of practice, or places. In these works, space serves merely as a heuristic tool. By looking at how key notions like 'structure,' 'practice,' 'subjectivity,' and 'space' are anchored and recontextualized, I hope to reveal the tacit forms of space knowledge they uncover on the ground.

The first example is the study of the 'space of housing,' which emerge from the negotiations and conflicts over the right to the housing between old native homeowners living in old city centers, the commerce-driven real estate developers, and administrators. Guo et al. (2014) argue that when looking into the interactions among these homeowners, developers, and administrators, one finds conflicts in the cultural norms they follow and the institutional norms. The tacit rules actors abide by in practice are against the formal norms and even against the legal rules. Thus, an institutionalism perspective renders very little purchase in explaining their practices and thereby the spatial manifestations. Guo et al. have also addressed the urban homeowners' changing perceptions and practices in the course of their resistance against the others. The transformation can be captured as, from "creating grievance narrative against eviction" "appropriating Mandarin discourses" to "learning about property rights," "unifying cultural elites and journalism," "sit-in protests," and "entering judicial proceedings as a defendant" (ibid., 111-119). They demonstrate the ability to reflect on and learn from the scenario, and

an increasing number of new meaning frames, constructing 'space of possibilities' to act and negotiate. In Guo et al.'s interpretations, the homeowners gradually gain awareness that 'the field of housing' – instead of a sphere of private actors and matters – is deeply rooted in the conflictual politics between local and central governance. They become aware of not only their rights and agency within the current legal framework but also the possible agency. They learn to adopt the forms of publicly justifiable discourses to make an effect in the public sphere. By acquiring factual, procedural and tacit knowledge from the political, legal, and media fields, they get to know, particularly the distribution of power, the rule of games in each field, and the conflictual interests among them. As a result, homeowners have gradually extended their agency to much wider fields and constructed a 'space of housing' constituted by an evolving arrangement of social actors, resources, and material entities.

The second example examines the emergent social spaces related to the 'South China Miracle' – a term often deployed to capture both the remarkable economic boom as well as the concurrent unprecedented urban change in south China since the economic reform. Studies adopting neo-liberalist perspectives tend to argue that a series of structural changes – including the de-centralization of the fiscal system – set off this great economic and spatial transformation. In their interpretations, these new structures allow Guangdong provincial administrative to gain the autonomy in setting its own budgetary priorities, or the state-endorsed special economic zone strategy, in which 'special policies, flexible measures,' transformed central-periphery relations. Such structural changes are also conceived to have resulted in the export-oriented economy in south China, home of the 'world factory.' They address the causal power of state agency in a single-sided manner, dismiss the role of the most commonplace form of social organization, tacit social-spatial knowledge embodied by actors situated in south China.

Here, I cite two authors who have engaged studies on the level of practice, analyzed the construction of subject spaces between state-making, trans-local economies, and local identities. Cartier, in her work *Globalizing South China* (2001), presents a challenge to the existing literature of the reform experience by reading the success of social and economic capital accumulation in Guangdong through a lens of diaspora. She contends that South China should be read as a trans-boundary space, in which diasporic identities formed along lifepaths of high mobility are materialized into capital transactions and cooperation.

In her book *Gender and South China Miracle* (2001 [1998]), Lee also shows that normative rules (organizational principles of enterprises) are disjunct from rules perceived, understood and carried out by actors of her study. Lee uses a comparative ethnographic study on women workers rooted in two electro-manufacturing factories located in Hongkong and Shenzhen. The factories adopt the same technologies and are owned and managed by the same enterprise. Lee looks at the form

and principle of ordering 'the productive lifeworld' behind high performance and efficiency. Through examining the organizational structures, the interactions on the assembly lines, and the narratives about the self and others, Lee develops two pairs of synthesizing frames to capture the organizing principles of the two forms of lifeworlds. It is captured from the perspective of the manager and the woman workers: the 'matron worker' vs. familialism and the 'maiden worker' vs. localism. The internalized self-perception as 'matron worker' by Hongkong workers and as 'maiden worker' by Shenzhen workers is inextricably yet variably intertwined with their entrenched understanding of gender and class roles. Lee asserts that it is the "gender identities, grounded in women's lived experiences inside the factory, in their families, and in localistic networks" that have propelled the worker's agency, the associated patterns of social practices. Lee discloses it is the "local rather than national forces play more determining roles in defining the dynamics of production politics" (ibid., 163). In a similar vein to Cartier, Lee also sees the south China region as "made up of shifting institutional relationships among institutional arrangements and cultural practices." Therefore, she contends that "to reduce the layered subjectivities of social actors to their class status obstructs theorizing" (ibid., 163–64). In both cases, the institutional approaches exhibit minimal explanatory powers, as the normative structures (the causal agent inscribed in their epistemic frames) appear detached or are irrelevant in constituting the overt daily practices hence the social space in the structurally weak local context.

Aside from the non-dialectic, non-mutually constituting relations between institutional rules and social perceptions and the volatile and all-encompassing state orders, some ethnographical studies disclose the forms of space constructed by social actors embedded in asymmetrical power relations. In the study of urban spaces constructed by migrant worker NGOs in the Pearl River Delta, Gransow and Zhu have found that the day to day routines of NGO employers are strongly influenced by external regulations launched by powerful urban institutions, which leaves them "barely in a position to 'negotiate' urban spaces" (2016, 196). Instead of compliance or loud resistance, the NGO actors develop informal, innovative, and flexible forms of agency, such as "invisible growth," i.e., "what looks like a decreasing profile and less visible activities in public spaces is the deliberate result of producing small-scale, flexible, transient organizational spaces" (ibid., 191). In this case, the NGO actors' interpretations of the institutional regulations are different from that of the authorities. They are deprived of the agency in supporting migrant workers while expected to reproduce the authorized social rules. They also lose the agency to build a visible name to enable solid growth or allow their practices to be perceived as consistent for outsiders. Consequently, the urban space constructed by such actors is less material but transient and nameless.

Similar processes are also revealed in studies on the spatial practices of gay and lesbian social groups under the conditions of discriminative mainstream cul-

ture in contemporary China. In her book *Gay and Lesbian Subculture in Urban China*, Ho (2011) has depicted how cyberspace has become the main space in which inter-action and representation of the gay and lesbian community take place. The spacing practices online exhibit a "non-confrontational approach" navigating state surveil-lance, such as developing an "a netspeak subculture," "subverting traditional lan-guage use" (ibid., 102). As a form of perceived reality, the practices that occurred in the virtual space has implications for both online and offline social experiences. The shared practical knowledge of spacing among these subculture group mem-bers come from the shared experience of navigating and avoiding institutional and cultural norms. Meanwhile, as general regulation changes in the cyber world, Ho also highlights that the content uploaded on the website is "self-censoring" and "in-creasingly commercialized" (ibid., 142). In this case, the value and meaning lesbian and gay groups ascribe to their social relations are divergent from the authoritative and commonsensical ones. The practical orders shared by this community is also hardly in line with the dominating social structures. The perceptual patterns of this group are also not reducible to class, age and gender determinants. Their practices are tacit, less embodied and transient, and the social space they construct rarely becomes materialized. Thus, the imposed normative rules help them to shape the form of their community space, in a reversed manner. Such forms of space have a rich meaning to those who constitute them and cannot be grasped by reducing its spatiality merely to informal or illegal terms.

In the works cited above, scholars have centered their analysis on the level of practice. Rather than locating social practices dialectically with social struc-tures, socialization with institutionalization, and social positionality with the social agency, the scholars have placed the social subject into multitudinous, volatile, and inconsistent structures. According to Roulleu-berger, such a compromised theo-retical position is placed within a type of "mosaic of situated and contextualized constructivism" (2016, 31). Subjectivity is conceived entirely differently here and is linked to the construction of 'them' and 'us' in a context of social stratification, an increase in social conflicts, and a crisis of confidence in the 'other' (ibid, 33). Although the 'space' is adopted primarily as a heuristic tool in these works – as a proxy for forms of spatiality, such as network, field, territory, or place – these studies revealed the situated social-spatial knowledge, and the less enduring, less materialized, and less visible forms of space.

4.5 Summary

In this chapter, I revisited some traveling spatial theories which are recontextual-ized in studying social-spatial phenomena in China. Following a characterization of the features of 'spatial turn' in Chinese academia, I carry out several focused

examinations on 1) the contextual factors that affect the selection, interpretations, and appropriation of certain spatial knowledge; 2) the communicative forms and truth conditions that affect the production of spatial knowledge in academia; and 3) the features of social-spatial knowledge embedded in structurally weak social sectors.

Taking the scale theory as a representative travelling spatial knowledge, I argue that in all three chosen works, 'scale' is anchored into the local concept of 'hierarchy' in the first order. Depending on the subject of their analysis (the state or the city), hierarchy is conceived as an absolute or relative predicate and causal agent to explain the changes of ranks and territorial boundaries of the territorialized administrative units situated in China. The primary postulation of a bounded territorial unit where homogenous social practices occurs, as well as the secondary postulation of scale as a constructed leveling indicator in the 'original' conceptualization, are flipped when recontextualized into study situated cities in China. Such contextual features are coherent with the second hypothesis I raised in 3.4, a vertical relational structure for thinking of space is deemed real on the ontological level.

Subsequently, by examining several events of knowledge legitimation, I argue that on the level of practice, the communicative structure for knowledge production, legitimation, and circulation in Chinese academia is asymmetric, entangled with the political power. The intersectoral communications are ordered primarily by principles of political hierarchical, clearly different from scientific norms in democratic, neo-liberalist political and economic regimes. To a great extent, the truth conditions for meaning construction and legitimation are aligned with the epistemic preferences of elite social groups. The production of spatial knowledge is affected by the asymmetrically distributed communicative agency between political and scientific fields. It has an immediate impact on the forms of spatial knowledge produced in science. They are often unanalytical, but heuristic tools exhibiting political ethos.

Finally, spatial studies following revised constructionism have shown the gaps between situated social-spatial knowledge and mainstream social norms, i.e., spatial planning codes, legislative regulations, nominative gender definitions, and local embodied knowledge, i.e., the practical understanding that marginal social group shares when orientate and coordinate their practices.

Section Two: The retroductive empirical research on the spatial constitution of Beijing's artworld

5 Critical realism methodology and the study of an artworld

5.1 The polymorphic contemporary artworld in Beijing

In the first session of this book, I have deconstructed various schools of relational spatial conceptualizations, regarding their epistemic forms and postulated properties – based on ontological or epistemological presuppositions, inferential relations and the level of analysis. Subsequently, an a-chronic dialogue is set up between the undercurrents of the European and ancient Chinese relational thinking. From classic Chinese literature and their commentaries, I derive several first-order premises underlying forms of relational thinking, which are different from the Newtonian and Leibnizian ones. The ways in which such premises are mobilized in recontextualizing traveling spatial knowledge in the Chinese discursive field, affecting knowledge circulation and production *in situ*, are discussed in chapter four.

So far, the discussions and analyses have been conducted at a relatively abstract level. Given the elucidated plural conceptualizations of relational space, the remaining core question is how I shall employ them to inform the understanding of a complex empirical phenomenon of my interest – the polymorphic contemporary artword[1] situates in Beijing. I call the artworld polymorphic primarily because, when departing from the notion of *dangdai yishu*[2] (contemporary art), I fail to identify a regular set of institutional rules, social or material bodies being deployed by art community members in *constituting* the events observed. In public discourse,

1 Throughout this work, I call my empirical research subject the 'artworld.' The close compound form of 'artworld' is borrowed from Arther Danto's (1964). Yet, unlike Danto, I do not address the unique value of the art nor deem the artworld as a functional field. For me, the artworld is considered as a relational configuration(s) of actors, objects, rules, joined knowledge, and coordinated practices. Against the background of the artworld, an object can be described as an artwork and an actor as artist. Due to my subscription to CR ontology, I reject the presumed a priori ordering principle (aesthetic, functional, conventional, institutional, nomos etc.) which grants the artworld a transcendental or immanent coherence (see e.g., Becker 1982; Bourdieu 1993).
2 Dangdai-yishu (当代艺术).

the term 'contemporary art' is attributed to a wide range of art forms, programs, practices, and places entailing diverse substantive contents. Nor can I find consistent forms of rules *regulating* the movements and interrelations between the art-related social and material entities. In particular, what the term contemporary art refers to in empirical reality, can overlap with that referred by its counterparts, i.e., *the traditional, tizhi-nei (the orthodoxy* and *official)*, depending on the attributor and the context. In late 2012, soon after I entered the field, I met many actors in Beijing who quote contemporary art as the core source of their social identity but hold disparate political, economic, and aesthetic stakes on many matters. This is inconsistent with the way in which art historians have characterized *contemporary art practices* in Beijing as counterculture activities since the late 1970s, which indicates a shared value among the participants in the artworld. I shall thereby not take the notion '(contemporary) artworld' as a normative or empirical category to begin my research.

Due to its lack of an overt organizational structure and normative coherence, a phenomenon of polymorphic artworld imposes challenges for me in employing a single conceptual framework, i.e., to postulate a fixed boundary for defining and investigating it. To capture its 'complexity,' I chose to apply a plural of lenses on it to reveal the potential multitude of underlying mechanisms. Based on the procedures prescribed in CR (section 1.3.2.3), I further develop the methodological steps for examining each adopted conceptualization of space. Thus, drawing on three notions of space (discussed in chapter 2.4), I depart from three distinct series of 'field constituting events,' which allude to the polysemantic social-spatial representations of the artworld in Beijing. It means that *casing* the phenomenon and describing the demi-regularity of the corresponding observable events, proposing the hypotheses (from the conceptualizations), applying the hypothesis and interpreting the demi-regularities in question, and identifying those that do or do not apply.

With a concrete empirical subject at the center of study, the second section of this book reinforces its three subjects: to discuss the conceptual-empirical relation, to develop an integrated approach of employing the general abstract conceptualizations of space into concrete empirical analysis to identify empirical tendencies, and to reveal effective causal mechanisms. I will put forward a discussion regarding the necessity of having conceptual pluralism and context-sensitive spatial analysis under the condition of 'compress modernity' dynamisms and 'epistemic uncertainty' in the Chinese urban context. Finally, *empirically*, I am interested in knowing how the social-material arrangements of the contemporary artworld in Beijing city transform after the *fin-de- siècle*, and the forms of lived ontologies and epistemologies at work, causing the observable empirical events.

5.2 Threefold research on Beijing's artworld under Critical Realist principles

5.2.1 Critical realism principles and explications of the artworld

In Chapter 2, I have elucidated three main relational spatial perspectives from David Harvey, Martina Löw, and Nigel Thrift, discussed how they differ in postulated causal agents, mode of inference and level of analysis. I have analyzed them in detail, concerning their distinct ontological and epistemological presuppositions, which are the historical materialist and positivistic epistemology; the ontology of repetitive human doing and interpretive epistemology; and the flat material-social ontology and weak (situated) epistemology. I have also explained on the abstract level, how the social and material entity, forms of relationalities are preconceived and associated causally, in line with the premises of their underlying epistemic framework. Altogether they constitute the *conceptual* toolbox from which I draw as *initial theories* to redescribe the empirical tendencies of the events, occurred in Beijing's artworld. Departing from these three theoretical lenses, I collect 'transitive empirical data' from a multitude of sources on Beijing's artworld, 'case' them in the form of 'field constituting events,' and explore the underlying plural forms of generative mechanisms and their interactions in the real domain.

Before mapping out the *methodological steps* developed following CR principles, I find it necessary to briefly and straightforwardly recap the core concepts and causal agents prescribed in the three relational space conceptualizations. For David Harvey, space (the space of political-economic system) is produced by the political-economic structure as a whole. On the ontological level, a wholistic social-economic structure is conceived as given, which orders the social class division – the social actors' possession of material resources and knowledge. Social actors are conceived to be motivated for accumulating capital, while various material resources (land, capital, etc.) are conceived to entail differentiated inherent circulative attributes. As a result, social actors' knowledge and agency are inherent to and congruent with their positions in the social-economic structure. On the epistemological level, the researcher is deemed an impartial observer who can grasp the structure as a whole through detecting the divisions of knowledge, materiality, and productive practices held by the social groups. Therefore, the principle of accumulation and differential material circularity are prescribed as causal agents to explain the forms of space being produced.

For Martina Löw, the form of relational space (the space of everyday life) arises in the social actor's habitual perception of the symbolic whole (synthesis) and manifests materially as an arrangement of moving social bodies and goods. Ontologically, the 'repetitive human doing' is taken of causal primacy. Epistemologically, the symbolic forms in everyday life are deemed known and internalized by social

actors through the 'repetitive human doings.' The socialized 'synthesis' forms the basis for social actors' (re)constructing of social reality in practices. To elaborate on this point, the day-to-day practice is conceived as intrinsically recursive, formed in the enduring processes of internalizing and externalizing social structure – embodying the experienced rules and resources. Relational space is firstly formed in social actors' ingrained perceptions – coalescing the symbolic relationalities between social beings and goods as a whole, and then in a set of actualized constants moving bodies and space and between them. Researchers are assumed to be the targeted social actors' close interpreters who try to disclose the symbolic-social origin, capture the process and materialized result of the everyday constitution of space. The researchers, through employing a deep understanding and various bracketing techniques, shall make their interpretations closely resemble what appears in the social actors' subjective perspectives.

Finally, in non-representational theory[3] (NRT), Nigel Thrift conceives social actors and things to be on the same ontological footing. Epistemologically, Thrift conceives the entities' agencies to lie partly in their predefined or pre-existing capacities, partly arise from the interactions. NRT shares a practical basis with Löw's constitution of relational space in addressing the expressive power of human actors, their understanding of what is possible to associate and enact. It emphasizes the spontaneously formulated relations. Thus, in comparison, NRT builds on a weaker or situated epistemology to explain the constitution of relational space, addresses both the 'repetitive human doings' and the 'emergent properties in the interaction between the perceiver and the perceived.' It deliberately avoids the *a priori* reduction of social-spatial relations and processes to one or a set of fixed forms. In addition, Thrift assumes the experiencing social actors' way of perceiving and knowing to be differently unraveled from that of the researchers, from one particular context to the other. Therefore, 'space (relational-perceptual)' emerges, and 'assemblage (relational-material)' results from the more or less contingent, recursive, yet never-ending interactions between actors and things. Both can manifest differently in the eyes of experiencing social actors and that of the observers.

To conclude: the three spatial conceptual frameworks make very different proposals about the *properties of social and material entities*, *forms of relations* that a researcher should attend to in casing the empirical materials regarding the constitution of space, and *how they can be known*. The causal agents are attributed to the political-economic structure, repetitive practice, and orders emergent from social

3 Nigel Thrift has consciously clarified what he means by 'theory' in *Spatial Formation ?*. He explains that, by adopting 'style' instead of 'theory' as a way of theoretical writing, he wants to avoid "a theory centered style which continually avoids the taint of particularity" as well as to point out the "perpetually inadequate (but not thereby unnecessary) powers of theory" (ibid., 30).

and material interactions, respectively. Overall, I find that the three theoretical perspectives' analytical strength lies respectively in the *material-structural*, *perceptual-practice*, and *interactive-affective levels*. When employing them one by one in a manner of retroduction, the phenomenon of the artworld is 'cased' into very different events. Different empirical transitive knowledge is selected, coded by different 'initial theories,' and provisionally interpreted by presupposed causal agents in the corresponding epistemic frameworks.

Inextricably, each conceptualization has also brought forth claims/patches to enhance the general explanatory purchase in the entangled analytical levels and dimensions. For example, Harvey argues that the neo-liberal structure encounters concrete social realities in a creative-destructive manner (2016 [2006], 23–24). He emphasizes the constraining effect of *pre-existing local institutional and cultural contexts* to explain *away* the divergence between the theoretical prediction and the actualized, empirically observable social-political practices and material arrangements. I exclude such claims in re-describing the empirical materials but follow only the claims coherent with the causal structure of the conceptual framework.

In carrying out empirical investigations in sections 5.3, 5.4 and 5.5 under CR principles, I follow the retroductive logic. Concretely, it means that I firstly sample and organize my empirical data (transitive knowledge gathered in the empirical domain) according to the three analytical levels the three spatial theories instruct me to look at. They are the transitive and institutionalized social-spatial representations – the political-economic norms and rules of the artworld; the recursive everyday practices enacted by actors/actor groups and their narratives about that; the inter-and intra-group social-material interactions observed in Caochangdi village, and the interpretations made by the participating social actors. Two types of data are included and examined at each level: first, the data gathered around the immediately visible and fragmented aspects of the empirical events, and second, additional data I identify through following the selective lenses of the 'initial theories.' The complex social-spatial phenomenon of the artworld, is thereby broken down and extended into three groups of component events in the actual domain. The three groups of 'field configuring events,' are "different but complementary data on the same topic" (Morse 1991, 122).

My data sampling and sorting processes are also entangled with what Bhaskar termed as 're-description.' This is a process of re-describing the events in theoretically meaningful ways, and of "taking some unexplained phenomenon and propose hypothetical mechanisms that, if they existed, would generate or cause that which is to be explained" (Mingers 2014, 20). In this process, I first derive at demi-regularities found in the empirics and then try out the causal agents conceived in the initial theories as potentially legitimate ones which, if they did indeed exist, would account for the observed events. As an indicator for confirming the feasibility and fallibility of a theory, a proposed explanatory mechanism "must survive an empiri-

cal test...where survival is indicated by the observation of evidence consistent with what the theory predicts" (Lee and Hubona 2009, 246).

In section 5.3, I look at the contemporary artworld from the structural level, coding the norm-related events in line with the (relational) space of political economics proposed by Harvey. I look at the *events* that take place with reference to already established *political-economic norms* prevalent in the artworld, redescribe the events through *patterns of relationships between social groups, division of resources and knowledge, modes of production, modes of material circulation* and so forth. Under examination are norm-constituting discourses, the descriptions about how social actors deploy these norms in social practices, the observable material arrangements directly linked to the productive or consumptive practices, from the empirical domain. These norms include *tizhi-nei* (inside-the-institution or the official system) and *tizhi-wai*' (outside-the-institution or the official system); *yishuqu* (art district), *gonggong yishu* (the public art) *and duli-yishu* (independent art). These transitive norms are widely deployed by art critics, artists, art merchants and regulators, and governors in conversations and in print. Finally, I will discuss whether/to what extent the postulated causal agent in Harvey's conceptualization is compatible with the events observed in Beijing's artworld.

In section 5.4, I focus on forms of everyday social practices carried out by the artworld's key insiders. With data collected through participatory observation and interviews in the art community's everyday scenarios, I characterize and redescribe the events under three categories: 'art-making,' 'studio-living,' and 'exhibiting.' I follow the analytical dimensions proposed by Löw in coding them, looking at the forms of 'recursive practices' unfold in concretely timed social-material contexts, the 'entrenched meaning' ascribed by the acting subjects. I derive the forms of cultivated dispositions from sampled artists' biographical experiences. By analyzing how 'rules and resources,' 'habitus,' 'routinary practices' and 'materialization of everyday life spaces' actually unfolds in these events, I will discuss *if or to* what extent some typical social-material configurations in the artworld, such as the 'loft studio,' the 'art village,' and the 'exhibition' can be seen as resultant from actors' habitus and recursive practices.

In section 5.5, I bring the social-spatial transformations of a specific art village called Caochangdi into focus. It has been briefly mentioned in the introduction: Caochangdi accommodates both the most established art organizations, individuals and a wealth of hybrid non-art-related social actors and artifacts. It seems to me, a perfect locus to uncover the condensed ways in which plural mechanisms occur in Beijing's artworld, give forms to its dynamic social-material configurations. Self-understandingly, the plural, co-existent generative mechanisms reject a single, linear explanation. I thereby employ all three conceptual frameworks of space to redescribe the constitutive events of Caochangdi village on different levels

and at different phases. The empirical data are separate to describe processes that occur at 'regular times' and 'disruptive times.'

5.2.2 Multiple qualitative research methods

I gathered the empirical material included in this chapter through books and articles written by art critics and artists themselves, as well as interviews and participatory observations I conducted during my field trips in Beijing. The total period of field trips stretched from September 2013 to February 2017[4]. The focused field trips took place mainly in October 2015 to December 2015 and October 2016 to February 2017, for a total number of seven months. Prior to the dissertation project, I wrote my master thesis (finished in June 2014) on the correlation between the social network structure (indicated by nodal centrality, clustering coefficient, conductance) and the physical geometrical structure (indicated by nodal centrality, edge conductance, and network clustering coefficient) among art institutions in Caochangdi art village. From October 2013 to April 2014, I undertook a part-time position in a local gallery to gather the data needed. I was immersed in the artworld for one to two days per week for six consecutive months. Despite the quantitative method and a different conceptual focus of the previous work, the information I obtained from the previous field trips remains valuable for this work.

Overall, I have conducted and documented 30 formal interviews, many informal interviews (list attached in appendix), and participatory observations on various occasions, such as artist talks, studio visits, art critics and historian conferences, art fairs, biennials, exhibition openings, after-parties, and so on. By formal interview, I mean one-to-one conversations with actors around a list of pre-structured questions. The interview proceedings were either jotted down or recorded on site, and interviewees were informed beforehand that their names are kept anonymous and their answers would contribute to my dissertation research project. The interview typically began from biographical questions, followed by a set of open-ended questions regarding their experiences of career milestones, their everyday routine as an artist/curator/gallerist, and subsequently, a series of 'why' questions. In this setting, interviewees draw on their memories to answer my question. The answers are inevitably refabricated and detached from the original context under which the events and activities occurred.

While working in the field, I gain tacit knowledge about the artworld through informal interviews or casual chats with the acting subjects, amidst the occurrence

4 My last field trip took place actually in December 2018. However, due to the rapid pace of urban change in Beijing, the events noted in the later visits are not thoroughly documented nor analyzed, hence not included into this book. The COVID-19 induced impacts on the artworld are also not covered in this current chapters.

of 'field-constituting events.' The two interview instruments are complementary. The first captures the actors' ideas, selected and reprocessed from memory, expectations, and imaginations, whereas the second can better capture the more intuitive ideas and instantaneous perceptions that emerged *in-situ*. In other words, the structured interview is biased towards 'here and now,' as the actors have consciously or unconsciously developed or designed the narrative that they find *appropriate* to tell an unknown other. Therefore, these answers are likely to be *selective*, addressing mainly the *actualized* events with an ex-post *legitimation*. For example, artists love to talk endlessly about their genius ideas, relentless efforts, and limited resources involved in an actualized, successful exhibition, but not many are keen on recalling those that are deemed failed. Likewise, gallerists like expressing how their aesthetic taste. and publicity strategies have helped to ensure the collaborating artists' success, but not about how they make money, i.e., their clandestine selling tactics. The informal interview and observation are necessary to reveal the sensual, perceptual structures that become only visible in the presence of practices. I could only discover the hidden layer of meaning in some seemingly ordinary practices when I worked as an insider in the gallery, i.e., the artist residency – inviting foreign artists to fly-in and produce artwork arduously on-site in a short timeframe – as a tactic to elude the high tax on importing artwork. In the western context, this is a usual practice for art-collecting agencies like foundations, but not art-selling agencies like commercial galleries. Such tactics are never brought up in formal interviews, artists' talks, exhibition introductions, and catalogs.

Participatory observation is the other main instrument I have employed in collecting data. My experiences as a gallery intern have primarily prepared me with the know-what(s) and know-how(s) of the typical roles, terms, practices, artifacts in the artworld, and what they generally mean for gallerists, artists and buyers. Such knowledge was gained through all kinds of formal and miscellaneous tasks, such as communicating with the contractors who are responsible for shipping and installing artwork, reading and archiving the artists' selling records and catalogs, catering and communicating with the visiting collectors and facilitating the sales, preparing for the opening dinner, and so on. Over time, I also befriended many young artists and curators, which created further learning about their professional practices outside Beijing. During the 2017 *Documenta*, my home in Berlin hosted many art pilgrims that had traveled from Beijing to Germany. Many missing pieces of the puzzle were found through my long-term, close socializing with these art insiders and my observation of their practices in distinct contexts.

5.2.3 Multiple role-taking and bridges in the field

As I have just mentioned, I have been in touch with the artworld for over four years. When I entered the field for the first time in 2013, I told the gallery colleagues up

front that my goal of working there was to map out the art related social network manifested in Caochangdi village. With my employer and colleagues' consent, I assumed the identity of a gallery intern and a researcher. In the beginning, my knowledge of the artworld was minimal, and I was not entirely clear about the relevant elements that define the contemporary artworld from the insiders' perspectives. My colleagues, the earliest informants of this research, have generously shared their personal experiences, disclosed how their lives unfold within and beyond the professional field. It is only out of such trusted relationships that I know the affordances and constraints the art graduates, artists, curators, critics, and gallerists experience all together in the artworld.

Just as McCall has warned, the roles that ethnographers adopt in their fieldwork are "perhaps the single most important determinant of what he [or she] will be able to learn" (McCall 1969, 29). During my subsequent field trips, finding new suitable roles to connect with actors of interest becomes a pressing issue. When I tried to step outside the friend circle, I had built, I realized that the identity of a Ph.D. candidate-researcher is far from necessary to access and approach informants occupying different social positionalities. Due to the lack of civil society infrastructure, many issues (like land-use plans) I try to investigate are not openly or formally accessible. I needed to find thereby an identity that appeals to my informants as an insider role. The types of roles (like art professors, museum directors, curators, critics, gallerists) one can take determines not only one's access to the artworld, but also the answers to one's questions.

Inspired by some friends who write reviews for art exhibitions as side jobs, I also adopted an identity of freelancing art critic, targeting international art journals. It was doable for me mainly because of contemporary art's marginalized position in the field of cultural production in China. Firstly, there is a lack of professionally trained contemporary art critics in China, as contemporary art is itself an imported good since the 1980s. Thus, in practice, the discussions of contemporary art in China are carried out by individuals from different professional backgrounds in social and literary science. Then, the discussions about contemporary art are only sporadically published in journals issued by domestic academia, which are endorsed by the national bureau of news and publishing and accredited as valid scientific achievements in the academic system. In contrast, they are mostly published on international art media. Yet, although the cultural currency granted by international journals are internationally valid, these journals, webpages have small circulation, their meager pay can attract only very few authors. Due to these two reasons, I managed to enter the field again by reviewing contemporary artworks.

After publishing two reviews on films, one report on a biennial, and a review of an art conference on several established media platforms, I officially acquired a critic/art journalist's status – an identity that opened many doors for me in the artworld. Artists, the directors of art institutions, and curators would open the door

for me because I might bring their work to public attention. The editors would open their doors for me because of my potential contribution. In addition, I also got access to conferences, public lectures, exhibition openings, and artist parties, especially when accompanied by other mediators. Practical concerns also necessitate the researcher to have an insider identity. Time and energy are precious resources for everyone, particularly true for the freelancing art community members, who do not benefit from institutional support while living at the edge of a vast city.

However, an art insider role is not a panacea to all access problems. Till the end of my field trip, I did not manage to access many administrators. As a journalist of a sort, it is challenging to approach state representatives and receive straight and unpolished answers. People tend to reveal partial truths to unknown researchers or untrusted interviewers because of their fear of trouble in a nebulous political climate. I was told that being interviewed is not part of their daily job, and they personally would not want to get involved with media journalists or researchers. Some interviews failed due to a lack of trust. For example, my interview with one administrative of 798 art district only achieved pre-scripted, propaganda-like answers, leaving subjectivities and historical factual details absent. I reflect on the consequence of the lack of administrative perspective in my research outcomes in section 5.5.5. Regarding my essential role as a researcher, despite being a Chinese person researching phenomenon in China, I deeply agree with Todorov's (1999 [1982]) idea in *The Conquest of America* that interviewing as a process is to turn others into subjects so that their words can be appropriated for the benefit of the researcher. Hence, I choose not to 'push' for answers in my field trips. Overall, my access to the field and my knowledge acquisition were achieved by constructing fitting identities to various social networks.

5.3 Artworld as a space of political economy

If someone wants to visit the contemporary *art spaces* in Beijing at weekends, art guides like artron.net[5] provide many options. In the city center, one is likely to encounter grandiose group shows titled under the theme of 'Sino-X cultural exchange,' juxtaposing artworks created by renowned artists from China and abroad. Such exhibitions are presented with lengthy introductions, well-printed catalogs and a long list of prominent international collaborating institutions. They take place most likely in grand state-owned museums, such as the National Art Museum of China (NAMOC, est. 1962). Across the street from NAMOC is the newly inaugurated Guardian Art Centre (est. 2018), where artworks are categorized and presented with evident meticulous professionalism, clear and precise value-based aesthetic

5 Artron. net is the biggest online art portal in mainland China.

directives, rules of bidding, paying and shipping in spacious, exquisitely decorated rooms. For a combined art and gourmet experience, you may encounter Beijing Parkview Green, a high-end shopping-hotel-office complex (est. 2012), where 500 pieces of Salvador Dali's sculptures and other visually powerful artworks from top-priced contemporary Chinese artists are on display. These artworks are displayed scattered and approachable, not on pedestals, but simply in various corners of the mall, as if they are just part of the interior, imposing no particular rules for visitors to follow. They await guests who know the cultural etiquette by heart. Located equally in Beijing's central area, many tiny off-spaces are established in former traditional courtyard housings in the hutong alleys. They are often young (most have opened after 2010), funded privately or by foreign art foundations, surrounded by bars, bistros, and flows of everyday lives of old and young locals.

In the northeast direction of the city, especially in the outskirts, around the fifth ring road, an extensive art quarter named 798-art district has filled the once-abandoned military electronics factory buildings since the late 1990s. The buildings, previously rented to private artists, used as studios or storage space, are now refilled by white-cube galleries, not-for-profit art institutions, designer boutiques, and architectural firms. This quarter is now known to both experienced art connoisseurs and regular tourists since 2008. Ten minutes' driving distance away, two villages-in-the-city next to Beijing's fifth ring road, are crowded with studios, alternative art spaces, design offices, and private museums since the 2000s. The art spaces juxtaposed with local peasants' self-built housings and typical make-shift amenities found nowhere else within the fifth ring. People would probably not go there unless guided by an art insider, as their existence at Beijing's urban-rural interface remains hard to find and reach. By the time I started my research in 2014, several new high-end residential, commercial, and office projects' construction sites have already loomed in the vicinity. They could be seen when standing at the villages' entrances. Similarly, several agglomerations of private museums, artist studios, and artist-run spaces are located at the southwest and west verges of the city. These remote places are known to art insiders, including Yanjiao, Songzhuang, each requiring a two to three-hour drive from downtown.

The above-described art scenes in today's Beijing show that sites designated for contemporary art are plural in number and form. Such scenes seem to resonate with Hito Seyerl's criticism, who argues that "contemporary art is a brand name without a brand, ready to be slapped onto almost anything [...] most closely linked to post-Fordist speculation, with bling, boom, and bust" (Steyerl 2010). Despite the lack of official census data, many indicators show Beijing is the hub for Chinese contemporary art. I was repeatedly told that Beijing's art scene is more vibrant and diverse than anywhere else in China. The insiders I met during my field trips have confirmed this point by the votes of their feet. Most of them were not born in Beijing city, nor did they grow up there, but they choose to live and

work there as an artist, art historian, dealer, critic, and so forth. The city hosts an immense number of artists, including the most significant individuals. In 2014, when I sorted the art events by 'city' on artron.org, the number of events that took place annually in Beijing outnumbered the other cities in total, and the forms rang from art fairs, design weeks, artist talks, screenings, theatre performances, and photography workshops. Beijing's artworld accommodates an outstanding variety of art forms, techniques, and subjects. The artworld's overall ecology has transformed tremendously within the last 40 years. Nevertheless, the surviving artist studios, non-for-profit art institutions, galleries agglomerate continuously at several urban-rural-interfacing corners of this vast city.

When probing the artworld with the lens of the political-economic system (by Harvey), one notices that the geographical distribution of the different types of art institutions (characterized by their economic capital making capacity) in Beijing is not ostensibly correlated with the city's land rental structure. Many world-renowned galleries are located side by side with privately funded non-for-profit art institutions in the villages-in-the-city at the urban edge. The number of large commerce-driven institutions sponsored by domestic and global capital (like the Guardian Art Centre just mentioned) is growing, but so are the smaller artist-run non-for-profit off-spaces in the urban center. As I have elaborated in-depth in Chapter 2, Harvey's framework presupposes the law of accumulation and alienation to be the causal agent. 'Materiality' is conceived to be the *means of production*. It is categorized by *use* and *exchange value* on the symbolic level and mobility properties in capital circulation. He defines and *classifies* the social actors' agency in terms of their *productive forces*, i.e., their capacity to mobilize and accumulate the means of production they possess. Thus, following these presuppositions, the social structure (i.e., the relatively stable patterns of political-economic relation that shape the form of social practices and movements of social goods in the artworld) shall first and foremost be deemed class structure.

To employ Harvey's conceptualization of space retro-ductively, I read the complex empirical data in diagnosable events according to the basic categories he postulated. A few prevalent social-spatial normative constellations in the artworld (i.e., *tizhi-nei* vs. *tizhi wai*[6] ; *Art District, Biennial, and Public Art*) are tentatively redescribed as ensembles of political-economic norms. Particularly, I am led to picture and redescribe the material and knowledge distribution, and labor division in these events. It includes, how this *transitive knowledge* is understood and enacted by the social actors, the implied division of social class, knowledge, and material arrangements in the empirical domain. Finally, I would *assess* if the proposed causal agent,

6 Tizhi-nei (体制内) vs. tizhi-wai (体制外) could be literally translated as 'within the institutional structure or official system' vs. 'outside the institutional structure or official system.'

the principle of accumulation postulated by Harvey, is efficacious to explain the observable norm-practice interactions in the empirical domain.

5.3.1 Tizhi-nei and tizhi-wai as primary norm ensembles

On different occasions during my field trips, I repeatedly heard about some dualistic or triadic lexicons (representations of norms). It includes the *tizhi-nei* and the *tizhi-wai*, i.e., inside and outside the institutional structure; *tizhi-nei/guanfang*[7] *shangye* and *duli*[8], i.e., the official, commercial, and independent; as well as the *chuantong* and *dangdai*[9], i.e., the traditional and contemporary. In public and everyday discourses alike, these lexicons are used without many elaborations, alluding to a high status of commonsense in Beijing's contemporary artworld. When reading them literally in the context of art, *tizhi-nei* and *tizhi-wai*, describe two opposing modes of art production, rules of capital accumulation and circulation, knowledge and techniques, and social-organizational structures. Similarly, *tizhi-nei/guanfang*, *shangye* and *duli*, imply a set of three distinct and disparate modes of art production around which social groups identify and organize. The *chuantong* and *dangdai*, are closely related to knowledge and technique in artmaking. Yet, in the broader sense, they represent two sets of economic, aesthetic and technical rules that structure the making, interpreting and circulating of two genres of artworks. When we read these terms formally, these normative dyads or triads appear mutually exclusive and dialectically negating. The questions are, what modes of art production do they represent, and how are the knowledge, rules and material resources deployed in shaping the social actors' social relations and physical landscapes in the artworld?

To test Harvey's postulated causal agent, I first redescribe the discourses and the norm-related events around *tizhi-nei* (in-institutional structure) and *tizhi-wai* (out-institutional structure), and then move on to redescribe the secondary ones (like the 'biennial,' the 'art district,' and 'independent art institutions'). From what I have observed, the referees of these notions in the empirical domain, are more muddled together than clearly demarcated and associated. For example, artist Xu Bing[10] – one of the most acclaimed contemporary Chinese artists recognized by international audiences – identifies himself as a *tizhi-wai* (out-of-institutional structure) artist, who applies and appropriates *chuantong* (traditional) Chinese art tech-

7 In these pairs of lexicons, the terms guanfang (官方) and tizhi-nei (体制内) are used indistinguishable. Guanfang implies a stronger sense of political justification, which is closer to "the official" or "the authorized" than tizhi-nei.

8 Shangye (商业) and duli (独立).

9 Chuantong (传统) vs. dangdai (当代).

10 The artist's professional profile, see, http://www.xubing.com/en/exhibition.

niques, narratives, and language in making his artwork. Xu's works are interpreted and recognized as *dangdai* (contemporary), exhibited in both *tizhi-nei* (state-run) and *tizhi-wai* (non-state run) art institutions alike. It demonstrates that actors in Beijing's artworld may play cross-sectorial roles associated with formally contradictory rules. Most of the contemporary artists I have asked have also not understood *tizhi-nei and tizhi-wai*, traditional and contemporary, as representations of temporally (enduring and repetitive) or spatially (homogenous, bounded, and exclusive) fixed rules for their artistic production. At this point, challenges have also arisen to associate dialectic modes of production, rules of social organization and resources distribution with these terms. We cannot characterize an individual's social position in the artworld by the singular productive practices one carries out (such as exhibiting in a state-funded museum).

In the political field, state bodies mobilize the lexicons of *tizhi-nei* and *tizhi-wai* in legislative, regulatory documents, designating artists and art institutions' roles and assigning means of production within the system. The review published in the *Art Daily of China*[11] is such an example:

> The *Beijing Federation of Literary and Art Circles*[12] is actively recruiting the non-Beijing *hukou* holding, *tizhi-wai* artists into the associations. Most associations under our supervision have amended their charters, annulated the constraints imposed on recruiting non-Beijing *hukou* holding artists. Thereby, the proportion of *tizhi-wai* artists in our federation has been growing. Currently, the municipal federation of Beijing has admitted around 21'000 members, among which 15% are *tizhi-wai* members [...] Our federation is keen on increasing the admission of highly talented artists [...] Since 2013, the federation started making exceptions for signing up those high-performing professionals whose labor relationship finds itself in Beijing city into our affiliated associations. We also started granting them with corresponding *zhicheng*[13] (professional titles). Our goal is to propel the professionalization of the non-Beijing *hukou* holding, *tizhi-wai* artists, gradually establish an evaluation system befitting the current development in the art and literature fields. (Art Daily China, 06[th]January 2017, translation and ellipsis added)

This announcement indicates that before the policy's revision in 2013, only the actors who *do* hold Beijing *hukou* and work within state-recognized organizations, i.e., *tizhi-nei* art institutions, are entitled to have art-related professional membership and credentials. By introducing a change in the *tizhi-nei* regulatory framework,

11 The Art Daily of China (中国艺术报) is a professional art media, funded and operated by China's association of literary and fine art.

12 Beijing Shi Wenlian (北京市文联).

13 Zhicheng (职称).

this announcement suggests the loosening up of the enduring rules. In this case, the regulatory body that attributes legitimacy rules is the Beijing Federation of Literary and Art Circles[14] (BFLAC), a *de facto* state-run top-level organization in the field. Its affiliating institutions comprise state-funded art associations, like publicly funded art academies, vocational schools, museums, theatres, newspapers, periodicals, and publishing houses. They operate under the supervision of municipal and district level administrations.

The *tizhi-nei* norms become constitutive to a social actor's political-economic agency by granting individuals quotas of Beijing hukou and professional titles. Beijing *hukou* guarantees one access to many types of social welfare in the city. The professional title represents the state reckoned technical qualification, which corresponds to the salary level one has in the state-run institutions. Each member of the association gets paid, however little, by state funding. In addition, these associations regularly organize exhibitions, typically in collaboration with state-run museums and institutions or comparable institutions outside China as part of cultural exchange programs. The exclusive access to exhibitions further strengthens one's status as an artist and access to economic capital.

In sum, the term *tizhi-nei* alludes to strong *class content* till this day, firstly in the political sense, and then in the economic and cultural sense. It associates with a set of rules and exclusive resources in the artworld, mobilized by small groups of actors. Their practices of art production and monetization are conditioned by corresponding *tizhi-nei* rules when they utilize these exclusive resources. It is unclear how far the rules become internalized and embodied by the pertinent social actors and how this affects their overall artistic practices and production. In other words: if, and to what extent, could we understand *tizhi-nei* and *tizhi-wai* as the *social structure of production and liberation struggles* as proposed by Harvey? To answer this question, let me delve deeper into the historical events regarding the *tizhi-nei* and *tizhi-wai* division's origin.

The following narratives are cited from an art critic's memoir and one artist's self-reflection. They both recognize that the dualistic framing – *tizhi-nei* and *tizhi-wai* – delineate two modes of artistic practices enacted by distinct social actor groups at the inception of the contemporary artworld.

In 1979, when mainland China ended its state of cultural isolation from the West, a new wave of avant-garde art was already evident. The role played by the actors

14 The BFLAC is a professional body administrating the state recognized art associations like the writers' association, the dancers' association, the painters' association, etc. in Beijing municipality. The BFLAC claims to be a non-governmental body, however, it is directly supervised by various cultural affair-oriented departments of the Beijing municipal government. The art associations under its administration are qualified to apply and are mostly funded by state-funding measures.

from *official art academies* in the avant-garde movement in China is an interesting one and an important point for discussion. The pioneering Stars exhibitions of 1979 and 1980 provide a good example. The Stars *avant-garde art group* competed with the *orthodox artworld* by using forms of expression in their works unimaginable to the Chinese Art Academy painters. The artists expressed their disillusion and spiritual wounds through what amounted to a criticism of the "dark side" of society, including the educational system. It is important to note that the artists of the Stars group were not related to the art academies but rather a group of *amateur painters*. This amateur status not only allowed them to avoid the stylistic and thematic restrictions imposed by the art academies, but it also freed them to work to "overturn" the orthodox, having no vested interest in maintaining it. (Shih in Valerie C. Doran 1993, 29, italic added)

I find living like a hooligan quite ok. I am, although not proud of being a *mangliu*[15] (hooligan), but also not ashamed about it. (I find), the Chinese people (in general) are in lack of the spirit of *mangliu* (hooligan). They (the Chinese) like to fix themselves in one position and get stuck in there, do not want to move upwards or downwards. It is not fun (to me). It is not that I would love to be a hooligan, but I have no other choice. My English is bad, but my understanding of the term hooligan is nothing but 'freelancer.' I am willing to be a freelancing photographer, capturing the people and things that interest me. That is what being a hooligan means (to me) (Gao in Wu 1990, translation and italic added).

We can infer from these narratives, from the late 1970s to the early 1990s in Beijing, the terms *tizhi-nei* and *tizhi-wai* were deployed in a sharp contrastive sense by actors in the artworld. Shih is an independent art critic. He associates the term *tizhi-nei* with the rules and resources from the art academies. It is also used to characterize the group of actors whose social status, means of life, modes of artistic practices are conditioned by such structures. It also applies to the forms of artistic practices (soviet-realism or traditional Chinese ink painting) and the resultant artworks. Hence, the *tizhi-nei* orders are deemed both constitutive and regulative to the *tizhi-nei* artist groups' productive practices.

Meanwhile, the actors whose mode of productive practices follow the rules *other* than *tizhi-nei* ones are categorized as *tizhi-wai*. In the second quote, artist Gao suggests that he is fully aware of the association between *tizhi-wai* and *mangliu* (hooligan), imposed by societal mainstream thinking. He clearly apprehends that the general public links particular social status and way of life to this notion while loathing them as denigrating and shameful. Notably, he deploys the term *mangliu* (hooligan), addresses his identification as a social dissident, refuses to reproduce its commonsensical meaning. He sees himself as rightfully positioned among the

15 Mangliu (盲流).

new and Avant guard art practitioners when speaking from his own experience. Thus, we can infer, on the perception level, *tizhi-wai* regulates Gao's self-identification and practice but does not constitute it.

Nevertheless, artists like Gao resist the normative principles associated with *tizhi-nei*, declare it to be conservative and orthodox – as an un-attractive constraint that they wish to be free from. From other literature sources (see, e.g., Yang and Li), characterizing artists' life in the 1980s and 1990s, we can see that the notion of *tizhi-nei*, by and large, represents a coherent mode of artistic production, associated with effective regulatory rules encompassing political, economic and cultural domains. It is reified as officially stipulated organizational and material forms like artist associations of national, provincial, and municipal levels; state-run institutions like national and provincial museums of art, workers' cultural theaters, children's theaters, *forms of events* organized under state-rules like annual national and provincial art exhibitions; *media channels* like the China Art Weekly; and the *style of artistic production* like the Soviet realism and traditional Chinese ink painting, and so forth. Meanwhile, *tizhi-wai* is interpreted more varyingly by different social groups. It is safe to say that roughly before the year 2000, the terms *tizhi-nei* and *tizhi-wai* denote distinct *modes of artistic productions*, ensembles of norms. Two groups of social actors' artistic knowledge, political stands and economic means can be thereby characterized.

I want to emphasize, the actors' artistic knowledge, means of production and forms of practices categorized under the term *tizhi-wai* have never been as coherent as that under *tizhi-nei*. In other words, there is no consensus on the productive forms and substantive contents of *tizhi-wai*. The art historian Wu Hong's description of the social-spatial conditions under which *tizhi-wai* artists live and produce art in the Dashanzhuang village-in-the-city[16] in the 1990s is quite illustrative to this point. I place it side by side with the depiction about the *tizhi-nei* artist groups by Shih from the same time period:

> Following Wang Shihua, a number of students in the Central Art Academy moved into Dashanzhuang in 1991 and 1992. ... Most of them were painters, who structure their artistic activities centering in the academy environment, not in the place they lived. This situation changed in 1993 and especially in early 1994, when some of these students (such as Wang Shihua and Zhang Huan) turned into *independent artists* after graduation, while an increasing number of jobless (*tizhi-wai*) artists (including Ma Liuming, Rong Rong, Cang Xin, Zhu Ming, and Xu San) settled

16 Dashanzhuang (大山庄) was a village-in-the-city located in the east side of Beijing city, demolished in 1994. From the late 1980s to 1994, the artists living there called it East Village (dong cun), echoing the name of the artists agglomeration in East Village, New York city. This name responds also to its geographical and temporal relation to the previously demolished art village Yuanmingyuan in west Beijing, which was named the West Village.

there after emigrating from the provinces. The village became increasingly an "art space," where the *tizhi-wai, self-trained avant-garde* artists carry out their experiments and hang out with one another. Here, it is the performance instead of painting that becomes the dominant form of their *artistic expression*. As their confidence increased, there was also a growing sense of an artistic community; both factors finally led these artists to reclaim Dashanzhuang as their own – 'east village' in Beijing. (Wu 2014, 58)

Today, the art academies in China function not only as the training grounds for *professional artists* but also as the source of employment and other benefits. Aside from salaries for artists and teachers, they provide the evaluation and qualification for various scholarships and official positions in the artworld. In a situation where national economic means are limited, the fact that the art academies exert direct or semi-direct control over the social and material apparatus for art becomes especially significant. For this reason, the *contemporary Chinese avant-garde art* movements are unable to escape the necessity of some kind of relationship with the official art academies, be it positive or negative. (Shih 1993, 29, italics added)

From what has been depicted by Wu and Shih, we can reanimate the *tizhi-wai* actors' professional practices and way of life in the east village. There, the term *tizhi-wai* appears to have less to do with the actors' formal affiliations and positions. It has more to do with a set of cultural and political orientations and practical rules that are defined in opposition to the *tizhi-nei* ones. In practice, it means also, artists cut off from the economic resources provided by the academy, give up the chance to realize the exchange value of artworks as salaries, publicly, credentials. They opt for creative production rather than reproducing artistic forms already prevalent in the academy. Nevertheless, the substantive cultural rules and economical means they deploy in creating new art are far from uniform. At this stage, their artistic production often does not generate *surplus value* in the economic sense, as we can infer from the lettering artist Rong Rong wrote to his sister in June 1994:

> As far as I know, none of us East Village artists has sold anything yet. Each person has his or her own way of making a living. Ma Liuming's elder brother sends him some money every month. Curse sells pirated VCDs. Zhang Huan sells his drawings (not artwork) to some company. I occasionally take jobs from the Worker's Daily or some commissioned photography projects, from which the income is just enough for me to buy films to produce my own photographs. (Oh, my elder sister and brother sent me some money again a couple of days ago. They keep doing so, which makes me feel ashamed.) (Wu 2014, 73).

When we see knowledge as *a productive means*, then we noticed that the knowledge mobilized by *tizhi-wai* artists during the 1980s and 1990s traveled from the

global artworld. A famous documentary entitled *From Jean-Paul Sartre to Teresa Teng* (2010) has represented a few established Cantonese contemporary artists' memory of their life in the 1980s. Artists have recalled their first experiences of encountering a plethora of intellectual and artistic legacies of previous centuries from the western discursive and imaginal world, including books, catalogs, and cassettes. For artist Chen Shaoxiong, he described the learning process as having a disordered but sumptuous western-style dinner, with many gangs of dishes randomly served. No one could get enough of them but still feel overwhelmed and confused (see ibid., 11:26-12:12). Later in the documentary, these actors who detached from *tizhi-nei* have explained how their artistic practices are inspired by the cultural forms learned from a different time and space – range from Impressionism and Expressionism to Cubism, Dada, and Pop art.

By identifying these demi-regularities, I would argue that the modes of art production associated with *tizhi-wai*, even when reading it formally, were in a *negating*, not a *dialectic* relation with the *tizhi-nei* ones. In the empirical domain, one can observe, some artists' artistic practices and the resultant artworks were *freed* from the ideological and stylistic control imposed by official institutions. They turned to undefined *tizhi-wai* cultural and political rules and *de*-affiliated from the cultural, political and economic capital associated with *tizhi-nei*. Instead, they engage with cultural rules, cultural and economic resources transmitted from multiple places and times. These new knowledge and resources are heterogeneous in form and substantially incoherent. One cannot find a unifying principle in *tizhi-wai* art practices. Thus, I would argue, the formal relation between *tizhi-nei* and *tizhi-wai* resembles that between the possessed and the dispossessed only *semantically*.

Furthermore, one can observe, the materialization of these artistic practices, based on trans-local knowledge and resource, is transient and unstable. The material form of *tizhi-wai* artworld – the social bodies and their associations, art artifacts, art spaces and so forth – is also transient and fragmented. My informants recall that apart from state-sponsored museums in the 1980s and 1990s, neither private run galleries nor alternative art spaces can run formally in Beijing. As a result, parks, diplomat's residencies, private apartments, and most of all, public space in the urban villages became emblematic sites for them to create and present their artworks. The artists who detached from *tizhi-nei* structures did not associate under unitary rules but the gradually emergent artistic tendency, political value, place-cultural identification with the central figures of a community. They migrate from small towns and cities to Beijing, Shanghai, Kunming, Guangzhou to associate with like-minded companions. The 'east village' represents a small group of very loosely organized artists who engage in *ad hoc* collective art production in Beijing Dashanzhuang village-in-the-city. These *ad hoc* art groups and the material, representational and lived spaces they produce in the east village, have lasted only for two years. Nevertheless, their ephemeral and fragmented existence is caused

by a 'law of accumulation.' After the incident of a police arrest in the east village, the working relationship these artists have formed relocated to the other sites in Beijing. Other well-known groups include Xiamen-dada group, the pond group, which have all dissolved in their original place a few years after their establishment (see, e.g., Lu 2015). However, many have survived and even expanded their community through relocating to new sites (e.g., Caochangdi village in Beijing).

Historical archives documenting artistic practices in the 1980s and 1990s show that the withdraw from social and economic *capital (funding, material facilities, space and social relations-guanxi etc.)* associated with the *tizhi-nei* mode of production was not part of the initial intention of all de-affiliating artists. The rules that cohere social actors detached from *tizhi-nei* were first and foremost artistic and political rules, hence give no structure to practices in the economic sense. Entering the second half of the 1980s, when the political climate was relatively loose, artists detached from *tizhi* made tentative trials to cooperate with *tizhi-nei* institutions through mediators who have inter-sectorial memberships, with the aim of accessing exhibition spaces and achieving wider cultural, economic exchange-value and acknowledgment. The most significant event demonstrating such attempts is the *1989 Modern Art Exhibition*. It took place at the National Museum of Art – the epitome of an official art institute[17] (Asia Art Archive n.d.). Furthermore, many informants recall that since the year 2000, many new forms of contemporary art institutions (commercial galleries, biennials, art fairs, a private museum, public art, independent curators) burgeon in Beijing. These institutions have introduced new normativity, propelled more intricate re-demarcations between the *tizhi-nei* and *tizhi-wai* means and modes of production. In the following, I redescribe the processes, practices, material distribution represented by the notion of *tizhi-nei* and *tizhi-wai* in the artworld after the *fin de* siecle.

Cultural and economic normative transformations were first put forward by trans-local actors, with contestant interests and dilemmas (see Tsao and Ames 2011, 1–28). Many artworks created by freelancing Chinese artists unaffiliated with *tizhi-nei* institutions were found featured in the most prestigious art institutions such as the Venice Biennale, the MOMA in New York, and the Pompidou Center in Paris. The demi-regularities are, such artworks have acquired recognition and market success abroad, due to the 'Chinese-ness' and 'Contemporaneity.' They are received by foreign audiences to represent 'Chinese-ness.' Their enrichment to the international contemporary art arena are thereby recognized. The circulation of these works and the actualization of their cultural and economic values were promoted by key cultural mediators, curators, and art critics working in- and outside China.

17 Despite its smooth opening, the exhibition ended on the same day due to the officials' reaction to a gunshot performance by two artists.

In the meantime, the domestic *tizhi-nei* art institutions, the official regulative bodies, and some private dealers and collectors attribute the success of these works with 'international artistic acclaim.' Thus, another demi-regularity can be identified, the artworks produced by some freelancing artists have realized their cultural value first outside China, and this cultural value gets transferred into economic values in the domestic and overseas market. Some art dealers, and sometimes the freelancing artists themselves, started to found gallery spaces and work with *tizhi-nei* institutions in mainland China, speculating further on the economic or cultural capital within China. Local slang describes this phenomenon as blossoming at home and obtaining fragrance outdoor[18]. It shows that the cross-cultural *misinterpretation* of the artist's cultural status and artistic value of the artwork is necessary to realize the artworks' trans-national circulation and monetization. These new actors and institutional agents operate with distinct norms depending on the contextual requirements. It seems that the modes of production in Beijing's artworld can no longer be formally categorized as either/or but as both *tizhi-nei* and *tizhi-wai*.

5.3.2 Art district, biennial, and public art as secondary normative ensembles

In this section, I continue to illustrate how exactly the artistic production and space production in Beijing's artworld is intricately shaped by *tizhi-nei* and *tizhi-wai* ensembles of rules, knowledge and resources. I foreground the examinations of three normative spatial representations – the *art district*, *biennial*, and *public art* and begin with the notion of 'art district.' It is the most predominant term adopted by urban administrators to conceive and construct the artistic space in Chinese cities. Xiang, the vice president of the institute of the cultural industry at Peking University, has described the fluctuations of the global art market, in relation to that of the domestic art district in the article *from the Art District to the Cultural Industry Park*:

> The year 2005 marks the boom of Chinese contemporary art. The contemporary Chinese artwork embraced wide reception in the global art market – subsequently, the domestic art market boom. Just one or two years later, the 798-art district, Moganshan Street No.50 art district (M50) […], come into shape. However, the global economic crisis has hit the market badly. Many of the galleries and art institutions located in this art district shut down in batches. Apart from the most prominent and established ones like the 798 in Beijing and M50, the other art districts hit their lows. The second spring of the domestic art market resumes in 2010 […] (Xiang, 18th February 2013, translation added)

18 In Chinese: 墙内开花墙外香

In Xiang's narrative, the art district's life and death are intricately linked with global art market. It implies that the monetization of artworks depends more on the global than the domestic art market. Xiang fails to capture or has deliberately omitted, the clash and collision in transforming new forms of urban art spaces into 'art district,' most representatively in the case of 798 art district[19]. The studies from Currier (2008), Yin et al. (2015), McCarthy and Wang (2016), among others, have documented the process of its transformation from a cluster of grassroots initiated underground art space in a dilapidated industrial site to a compound, officially legitimated art district. Due to its urban location, the land and build-ings' in 798 were originally owned by a state-owned company. As a grassroots art space agglomeration, it faced a top-down imposed demolition at first, and later an ameliorated version of commerce-driven restructuration and redevelopment from 2005 to 2008 (Kong 2009). After that, 798 art agglomerations were acknowledged as the core constituent of an enlisted cultural, industrial park, and one of the most well-branded and iconic tourism sites in Beijing city. When visiting the 798 'art dis-trict' in 2018, I found a mixture of commercial galleries, private museums, public sculptures crafted by domestic and international star artists, designer boutiques and flagship shops, fancy restaurant and cafes, art professionals, visiting tourists and even domestic and global political delegations. According to the authors cited above, the transformation of 798 from grassroots art site to art district is propelled by the municipal government's turn to neo-liberalist cultural policy. In other words, the urban sectorial administrators are driven by *expropriating* the 'surplus value (cultural and economic)' created by the established art community, including the rising rents. The process of *squeezing out* the emerging artists, account for just the unintended consequences. Taken as the main trader behind the transformation, these scholars also argue, the urban administrators' aim include promoting the city's international cultural image, the service and tourism industry.

To analyze the normative constitution of the notion *art district*, I find the nar-rative from the *Beijing Cultural and Creative Industry White Paper (2017)* tangent. It is issued by the State-owned Cultural Assets Supervision and Administration Office of the People's Government of Beijing (the office).

> To construct the capital city Beijing as the nation's cultural capital, the general ad-ministrative office of the municipal government of Beijing had released the guide-lines for developing cultural and creative industries (C&C industry) in Beijing in 2016. According to this white paper, all the industries are categorized under en-couraged, restricted, and forbidden. Among these, 44 C&C industry types fall un-der the encouraged industry, ranging from the cultural content production, me-

19 Despite the fact that I often visited the 798-art district during my field trips, I didn't select 798 as my case study, as its transformative trajectory was relatively well-researched.

dia, service industry, cultural-technology hybrid industry, high-end creative service industry, and the public cultural industry that aim to satisfy the cultural and ideological demands of the Chinese citizens.

The construction of functional zones shall be integrated into the development plans in the neighboring areas. By excavating local resources, renovating the urban neighborhood, and old industrial architectures, our goal is to propel the city's organic regeneration. *The 798 fashion and design functional zone* shall thrust some of the *art functions* to Caochangdi, the Dawangjing park, and the area neighboring Chinese Academy of Fine Art to facilitate the development of the art ecology in the neighboring area. (The office, 2018, 12, translation added)

The quotes above show that the 'art district' is primarily conceived as a 'functional zone' containing homogenous art and economic activities under the government's plan and regulation. Despite the lack of a substantive definition of creative cultural industry, we can infer, art-related practices are considered productive, profitable, amounting to a mobilizable visual resource (like design, fashion, and media). The creative cultural industries and the functional zones that contain these practices subject to regulation from the state-run Cultural Assets Supervision and Administration Office. This organization is responsible for making plans and rules to position Beijing city as the cultural capital city in both the national and international arena. The passages above also imply the planned strategies include introducing high-end manufacturing and service industries, cultural and industrial sectors endorsed by the state, and improving the image of the urban spaces. It justifies the logic of neo-liberalist development, the law of accumulation, espoused by the cited authors. However, the art entrepreneurs I have interviewed on the ground suggest otherwise. Their experiences allude to a disconnection with the neo-liberalist logic.

It is not easy to run the gallery business formally in Beijing. As you might know, many global gallery's Beijing branch run on deficit every year. We need to pay too many taxes, like the added value tax at the sales price (not by our actual profits), around 17%. After that, at least 40% goes to the artists' commission fees. We need to pay for the artworks' transportation and insurance fee, the salary to our staff, the high rent here at 798 for our space, all from our pocket. On top of that, I need to pay 20% income tax for what I earn. You see, in the end, it leaves little to no space for making any profit. (Interview G2], translation added)

The only beneficial policy that applies to a private museum like ours in Chaoyang jurisdiction is to rent the land at a reduced price, for the land is designated for constructing cultural space. That explains why, in China, many real estate developers build museums while having no long-term collections nor curatorial plan in mind. Those museums soon become empty shells when the sales of the real estate project close. [...] Many so-called museums rent out their exhibition halls for event organizers to compensate for their maintenance costs... There are currently

no tax deduction regimes that apply for a company that collects artwork and ex-
hibits in its own museum. [My experiences suggest] The state's funding source is
hardly accessible to us, and the application process is very bureaucratic [...] So far,
we mainly rely on our sponsors to support exhibition costs. Every year, we have
different sponsors like auto companies, fashion brands, a jewelry company, etc. It
is not sustainable. We need to strive very hard every year to get new sponsorships.
As a private museum, we don't account for the so-called cultural industry under
support. (Interview M1G, translation and ellipsis added)

These two informants are private art entrepreneurs who struggle with accumu-
lating the economic capital necessary to sustain their operations despite the fact
that their institutions serve the state-endorsed 'art function' in the state-endorsed
'art district.' They show neither consent, endorsement, nor approval to the im-
posed regulations but practical struggles to fulfill the imposed business and cul-
tural goals. The imposed regulations, for them, are instruments of control, more
constraining than enabling their business. It contradicts what Harvey has pro-
posed, that the urban administrator and entrepreneurs are driven by, and bene-
ficiaries of the law of accumulation and exploitation. Only when we look aside, or
in light of Harvey's notions of 'contextual embedded elements' and 'path-depen-
dency,' can we identify the heterogeneity of stake-holding actors and their modes
of productions underlying 798's transformation. The 798-art district's new admin-
istrating body consisted of the old property owner, i.e., 798 factory owners and
the landlord, and an urban investment and development cooperation founded by
the Chaoyang district government. These two parties are driven by revenue from
rentals, land leases and the value-added tax, respectively. On the abstract level, the
municipal government is interested in the cultural capital 798 art district gener-
ates, but it does not reify into any concrete resources distributed to the individ-
ual cultural producers and private entrepreneurs. In particular, the former factory
owners, are endorsed to expropriate the surplus value produced by the artists and
entrepreneurs reified in the rental and management fees, although they have no
actual engagement in producing art. As a third wheel, they are not immediately
motivated to foster relational goods with the art entrepreneurs, i.e., normative sol-
idarity, participation in management. As their regulatory status was granted by the
municipality than the artists and entrepreneurs on the ground, both administra-
tive parties are motivated to promote the *state*-endorsed image-making and the
accumulation of economic capital.

 The state, district administrators and the property owner are thereby driven
by accumulating politically reconciled yet economically and culturally bifurcated
capitals, in the forms of 'image of global capital city', 'land rents and value-added
taxes', 'property rents and service fees.' The freelancing artists, while accumulat-
ing their cultural and economic capital through trading their artworks with art

institutions in 798, have no share in the value valorization of this art district. 'Relational bad' is then generated from such a bifurcation. My informants suggested that both the rising rent and a lost sense of *genius loci* make artist studios, and even for-profit art institutions left the 798-art district. The ambiguous and poly-semiotic meaning of 'art district' manifests as the various modes of artistic practices present daily in 798. They range from state propaganda performances to activists' screenings and performances. The demi-regularities are, disparate orders rather than a shared neoliberal doctrine, inform the social actors' actual accumulative practices on the ground, in close proximity. The 798-art district can thereby be hardly read as an 'abstract space' produced by a coherent structure for capital accumulation and valorization. It is instead a 'concrete mosaic' produced by the interactions of social actors who are endowed with hierarchical political agency, aiming for various (political, cultural, social or economic) forms of capital.

I move on to discuss another secondary normative representation of art-space, the 'art biennial,' drawing on the descriptions regarding the third Shanghai Biennial (2000) by an art historian called Wu Hong and several other artist authors. In the global contemporary art's context, the term biennial, describes an institutionalized exhibition form, referring to large international art exhibitions held every two years. Since the 1990s Biennales blossom all over the globe. These cultural events are often conceived by renowned international independent curators, who address critical local issues that have global repercussions through selected artworks from worldwide. I redescribe the demi-regularities from the event of the first Shanghai Biennial in 2000. It is seen as the first art biennial in mainland China featuring contemporary artworks. It was co-organized by curators from the state-run Shanghai art museum – an official *tizhi-nei* institution – and two independent international curators and unofficial artists – the *tizhi-wai* art parties (Lu 2015, 545). According to Wu, this state-run museum was motivated to have a genuine international biennial for the first time in Shanghai. He describes, "soon after its opening- and long before it completed its full course – people already envision it to be a milestone in history" (2001, 45).

The event consisted of two sections: one was the biennial exhibition, the other was the so-called satellite exhibitions organized by independent curators and non-governmental galleries. The following texts are impressions of the two sessions written retrospectively by Wu Hong and an artist named Zhang:

> A strong sense of a series of linked happenings was generated by the exhibition opening within two or three days of each other and by the sudden get-together of a large number of artists and critics. Not only did the museum invite many guests (including some of the international renown), each of the satellite shows also formed its own public. While the gap between official (*tizhi-nei*) and unofficial (*tizhi-wai*) activities remained, participants often intermingled and roamed to-

gether from one show to another. (Wu 2001, 45, bracketed translations are added) Before the biennial opening, many participating foreign artists and critics, curators, and artists from China went to visit the shows of a few galleries. That was what is called the satellite shows. After making the tours for both shows, the Canadian artist Mr. Lin Yinmeng told me that "the works on the satellite shows are much more vital, but it is a pity that they are not included in the biennial show." I find Lin's perspective representative among the overseas visitor, as [I heard] people discussing them voluntarily in the workshop. The artists hold varied opinions with the biennial organization team. There is even a saying shared among art insiders living overseas, if you want to destroy a curator's reputation, just let him/her curate the biennial in Shanghai. (Zhang 2007, translation and italic added)

Both descriptions suggest, for the two authors, the *tizhi-nei* and *tizhi-wai* or official and unofficial, remain to be perceived as valid normative schemas to identify professional art practices, art groups and artifacts. However, in their descriptions, their relationality collapsed. In other words, they are no longer used refer to address two coherent modes of production, circulation and materialization. According to Wu and Zhang, the exhibition space was provided by the museum. The funding, the independent curators' curatorial practices, and publicity generated by the visitors and the media were shared in this compressed event in respect to both time and space. Despite of the separation as described by Wu, the satellite exhibitions were also integrated into the program. Wu described further how the concrete arrangements of certain objects in the biennial present paradox and that a satellite exhibition titled Fuck off curated by Ai Weiwei went surprisingly unchallenged by the authorities, and "uniformed voice cannot grasp this aspect" (2001, 46). It alludes again to the unclear rules underlying the conception and arrangements of the biennial. The *tizhi-nei* and *tizhi-wai* distinction remain although as a *perceptual* object, but less as *material* one. Without a thorough investigation into this event myself, I would not infer further how different modes of artistic production are played out in this event. These materials are enough for me to argue, in the actual domain of the Shanghai Biennial event, *tizhi-nei* and *tizhi-wai* rules are identifiable but get intermingled in materializing the biennial.

Concerning the third notion of 'public art,' I will analyze my own observations, recordings and interviews made in a themed event during one of my stays in Beijing. This event was organized to define public art in the context of planning Beijing's new sub-city center and set the rules for planning the public art projects in its territory. I will demonstrate the knowledge, materials and rules involved in producing 'public art.'

In October 2016, a two-day forum entitled Public Art and City Design International Summit took place in the Chinese Central Academy of Fine Art (CAFA). This summit is one of the many preparatory events for Beijing Tongzhou district's plan-

ning project, a 155 square km² area designated as the new sub-center of Beijing city where the municipal government would relocate to. The general secretary Mr. Xi Jinping announced the 'pursuit of art' as the leading principle of this city-making project[20]. This news was announced on 27th May 2016 by the central committee of the Communist Party of China (CPC). It explains why the term public art went viral suddenly, and the corresponding planning rules needed to be compiled urgently. As a result, the Tongzhou district administrations had signed a collaborative contract with the CAFA to do research on public art design guidelines in the Tongzhou sub-city center. The establishment of art and design bases is also promised to CAFA. CAFA has then established a new research center called the Visual Art Creative Centre in response and started recruiting researchers to undertake the commissioned projects. It seems, just like the first Shanghai Biennial in 2000, this summit is a one-of-a-kind milestone event. Prior to that, no art academy has ever been invited to participate in a planning project of such significance (sub-city center of the capital city), let alone of taking the leading role of organizing a conference across the field of art and urban planning.

In the program, the first day of the summit included keynote speeches around the public art project's legislation issues in urban space, best-practices from around the world, and regulatory rules needed in art-led urban regeneration practices. The second day was set for roundtable discussions addressing the potential public art themes to be integrated into the plan: *the Strategic Development of Tongzhou Sub-city Center of Beijing*. The summit's first day was open to the public. Anyone who is interested in the event can easily register beforehand through Wechat. However, the registration did not explicitly say that the second day's discussions were behind closed doors, open only to invited speakers and organizers.

On the first day, the summit took place in the academic lecture hall located on the CAFA art museum's ground floor, a venue that is commonly used to host high-level events. When I arrived in the morning, the hall was fully occupied. The invited speakers and guests and the invited journalists were arranged to sit in the four front rows. Slightly after 9 am, the summit began with the welcoming and opening speeches from the organizer – two chief administrators of CAFA, including Prof. Pan, the president of the CAFA, and Prof. Hang, the president of CAFA's school of design. There were no factual statements in these speeches, but the political significance of the Tongzhou project was readdressed. It is similarly stated in the invitation:

20 From 24th March 2016 to 13th September 2017, regarding the planning and designing Tongzhou as the sub-center of Beijing, China's general secretary Xi Jinping and the state council have repeated emphasized "having international vision", "pursuit the spirit of art", "showcasing the Chinese characteristics", "enhance of the charm of the city" ?.

> The general secretary of the Communist Party of China, The chairman of PRC, has proposed the idea and demand of "constructing history and pursuing art" to plan, design and construct the sub-city center of Beijing. The government of Tongzhou district and CAFA hereby communicate and collaborate closely to explore a brand-new path of urban development, namely, the "art-oriented urban innovation. (sina.cn 2016, translation added)

Subsequently, two representatives on *the state ministry level*, the former director of the Ministry of Construction and the director of the evaluation of national new-type urbanization projects, have each given a 5-minute talk. The former, Mr. Song, stressed the significance of integrating public art projects into urban planning and design as a strategy of remedying cities' *poor artistic taste* and *quality of life*. The latter, Mr. Chen, contended that public art in the urban design should represent *shared collective memories*. "Following the one belt one road national strategy, the public art shall stress the *national identification*, achieving the 'international expression of Chinese culture.'" (source: private recordings). In this opening session, a strong nationalistic ethos and political value were proposed to be infused in public art production. The politicians left soon after their speech, as their official status and presence have already made all the points. Following this, Prof. Liang, the chief planner from the Chinese Academy of Urban Planning and Design – the leading state-run planning and design institute, which is commissioned for coordinating the planning of the sub-city center project – presented the topic titled *Art city: Tongzhou's vision*.

To illustrate what role public art could play in urban planning and design, Liang took "architecture, sculpture, street furniture, and graffiti" as examples to illustrate public art categories that he (in his role) would justify. He stated that public art could help "eliminate the banal functional-oriented development of urban space and help to cultivate the public aesthetic tastes." He then referred to the case of Wuzhen, a historical town appointed for hosting the International Internet Summit. Hangzhou is another best practice case, which has once hosted the G20 summit. They are both deemed to have illustrated the positive impacts public artworks can and ought to deliver: re-shaping the city's image and thereby stimulating capital accumulation for public and private bodies, reinvigorating urban economic development and construction. As the head of a professional planner's community and a quasi-cadre, Liang's functionalist and instrumental definition of public art was in line with that from the minister, Mr. Song. In his speech, Liang emphatically clarifies the political status of Tongzhou jurisdiction, "Beijing is the capital city. It is, without any doubt, our political center. The Tongzhou sub-city center's political position presupposes the non-capital functions it ought to accommodate. It could (only) be shaped like an art center, not a cultural center. A cultural center has a profound connotation" (private recording, 2016, translation added).

Liang's speech revealed a normative rule commonly followed by Chinese urban planners. That is, the city of Beijing has long been appointed with a threefold positionality and functionality. It is expected to be the *capital city*, the political and cultural center for the state; a municipality ruled by local legislators, under the direct administration of central government; and an *inhabitable city* for people living and working in Beijing. Urban planners recognize the city's first two positionalities and associated functions, administrations, and rules to be the source of many administrative conflicts and urban epidemics like congestion and urban sprawl. By planning and constructing a new sub-city center in an adjacent but different locale, the secondary positionality and functions could be channeled to Tongzhou District. In contrast, the current central Beijing area is planned to remain as the political and cultural center. The media reports have already revealed one core project in this plan – the relocation of the Beijing municipal government to the new sub-city center. Considering this, it becomes clear that the concept of 'public art' or the 'city of art' applied in this particular context is inherent to the top-down *designated political normative orders*. The meaning and form of *public art* are pre-tuned to reproduce the assigned political order.

The remaining speakers, categorized as domestic (including Hongkong and Macau) and international guests, were scheduled to give speeches in mixed orders. These speakers' views about public art and how to carry it out materially in Tongzhou's context ranging from the very progressive (public art as the activist movement) to the very conservative (public art as an enduring form of craftsmanship). There was a pro-business cultural minister who sees public art as a creative catalyst. There have also been art educators who endorse art as a means for public empowerment on stage. I could recognize some established *tizhi-wai* artists' faces, who hold very different political and cultural stances, on the audience side. My first impression was that it was a very open-minded platform that enabled different voices to be heard. However, a focus group for the planning project, i.e., the current residents of Tongzhou district and the relevant citizen communities whose personal space would be transformed, were missing on this occasion. As usual, the planning experts have conceived *volk* as only an imagined community, not the actual citizens who have values, desires, and actual needs in mind. I quote one more speech to demonstrate the discrepancy of views among the speakers.

The context of this public art project is in Pindong, around an old house that partly survived from the famous flood in 2008 [...]. When we conceptualize this project, we want the process to be instrumentalized for environmental education, instead of just a static art object finalized and delivered by us. We have deployed many water pipes as the carrier to tell the story we collect from survived experiencers. That is to say, the people who come here would get to know the past of the local place through this artwork. We want to address the interrelation between the

artwork and the people, encourage critical reflection it might induce... (Ms Wu in private recording, 2016, translation added)

Gradually, towards the end of the day, the meaning of 'publicity' in 'public art' had been addressed by several speakers from entirely different angles. The ideas range from *public accessibility* in the physical sense – the artwork (like a sculpture) shall be situated in an outdoor space (like a plaza) accessible to the public – to *communal identity* in the symbolic sense – representing a collective-public identity. The discussions also covered who shall be involved in producing public art, defining and examining the existing cultural and material context, translating the production process into legislative forms to guarantee the equal distribution of art funds, and many other topics. However, while these discussions occurred, the room was only about half full.

On the second day, the roundtable discussions were held in a much smaller conference room for about only 40 people. On a Sunday morning, the entrance to the building where the roundtable took place was closed, so the participants were let in with security guards' permission. Around the table in the conference room sat the speakers from the first day, but the politicians were absent. I sat in the back row. The others who sat next to me were organizers and researchers affiliated with the CAFA, who would later participate in the project.

The discussions began with questions regarding significant contextual elements and then the preparation for a call for proposals of the concrete theme for the public art projects in Tongzhou sub-city center. The discussions were open and heated at first, and the participants raised the issues like preserving the artist village agglomerations in Tongzhou, the potentials of integrating existing art spaces into the plan, and the forms of folk culture in Tongzhou. There was no sign of consensus about whom the public art projects would be done for, nor about the form, about how public art projects could integrate into the planning process. Liang mostly remained in silence during the discussions. Only at the very end, he took over the floor and wrapped up the discussion with a short but compelling note. I cite his main arguments here:

Without a doubt, the grand (Beijing-Hangzhou) canal symbolizes the collective memories of the (people of) Tongzhou and that of Beijing city. It shall be addressed as an essential cultural landmark [...] planning is an integral science; everyone here should attend to one's own (designated) *role* instead of attempting to intervene that of the others. ... The CAFA team was asked to kick-off, to help to invite the artists and experts to coordinate with us (the urban planners and Tongzhou administration), but not to lead the project. (private recording 2016, translation, ellipsis and italics added]

After Liang's speech – who spoke on behalf of the urban administrators who were absent – the rules for conception and division of labor emerged. It becomes clear who is in the deciding role. However, such an *order* was not achieved in a confrontational, rather a soft but coercive way. The moderating professor from CAFA, despite his overt skepticism towards the politically designated theme and the planner's conception of publicity, did not debate further. He attempted to resolve the tense atmosphere by alluding to his lack of expertise in planning instead. It is also clear that he was not in a position to argue against Liang, who represented the commissioner and examiner of the collaborative project. One could already infer from the order that emerged in this roundtable that the proposals for constructing public art and integrating a funding system for public art projects in every planning project would otherwise not be endorsed.

An event like this might be one of a kind, as rarely any city-making project shares the same level of political significance as that of the sub-city center of Beijing. The forum is partly performative. It is organized to signal an open discussion and debate between different actors, including the state representatives, the state-funded artists, the freelancing artist groups, local and international researchers and activists. Yet, this event has made the polysemy and vagueness of the notion of 'public art' and the participants' discrepant cultural, political and economic stakes apparent. This becomes especially lucid on the second day when diverse opinions about how art relates to the public in a city were raised. The focus was no longer on the factual nor conceptual debates but rather on the distribution of roles, knowledge, means, jurisdictions and liability. Nevertheless, this moment of establishing roles and order, divorcing values from practices, took place behind closed doors.

Later, I asked one informant from CAFA who is recruited into this project about his understanding of the collaboration and how he feels about *tizhi-wai* artists' role in this project. He stated that CAFA could get commissioned design projects, a new base in Tongzhou, and funding as students' scholarships. This is only possible through following the government's guidelines in this commissioned project. He sees the project as a positive opportunity for the *tizhi-wai* artist to collaborate with CAFA, to earn money and cultural capital through the practice of city-making. He also sees the imposed political rules as less of a problem, as "the political actors will embrace the new art forms/language as they are exempt from the text. An abstract artwork without text is mute. It can say everything or nothing to the public" (Interview CA1Z). This implies that actors would continue carrying out the mode of *tizhi-wai* art practices in negotiating the cultural meaning of public art. It is possible due to contemporary art's esoteric language.

In this state-commissioned collaborative project, the two sides are consolidated under the hierarchical political and economic order. The relations between politicians and artists cannot be translated as pure political-economic exploitation, solidarity, nor resistance. The *tizhi-nei* and *tizhi-wai* modes of artistic practices are

merging in accumulating political and economic capitals, leaving the production of cultural capital a separating domain. The boundary between the *tizhi-nei* and *tizhi-wai* structures is further muddled in the practical domain for the individuals engaging their livelihood and dream in Beijing's artworld. A separation remains, in the production of cultural value, in the forms of utopian dreams, when some actors manage to navigate specific rules and tacitly insist on reproducing their own forms of knowledge. *Tizhi-nei* and *tizhi-wai* mark thus no longer a material divide between two social groups in producing art district, biennial, and public art, as the two parties share the principle of accumulating economic capital.

5.3.3 Independent art institutions and intersectoral social practices

According to my informants, alternative art institutions have emerged in cities like Beijing, Shanghai, and Guangzhou since 2010. These institutions are generally referred as '*duli* (independent) art space' in the artworld. To understand the referents of this term, one can neither find a shared definition, a registered association, nor a regulatory body. In December 2015, I attended a forum entitled *How independent art spaces survive*, organized by a private museum, and took place in the Ullens Center for Contemporary Art in Beijing's 798 art district. Thirteen founders or directors of art institutions who identify with the quality of independence were invited to discuss their self-defining indicators while showcasing their daily operations and milestone projects. At the beginning of the forum, the curator, Mr. Feng proposed a tentative definition of independent art spaces as: "the art institutions that are independent of the art museums, galleries, art district, and other established art institutions. They are often self-organized, dynamic private organizations, playing an important role in balancing the overly marketized, institutionalized artworld mainstreams" (private recordings, 2015, translation added). Feng's deployment of the term is neither substantive nor normative. It is at most a descriptor of various types of art institutions alternative to those solely funded by the state and market.

The participants all come from reasonably young institutions. The disparate social-economic attributes of the alternative institutions are manifested, first of all, in their founders' biographies: their birthplaces range from metropolitan Shanghai to rural Guansu in China, from Hongkong special administrative region to Stuttgart in Germany. Their professional identities range from the curator, university professor, village leader, and freelancing artist at large. After listening to 13 presentations, the common ground I could discern was that they address an experimental tendency in their artistic and curatorial practices. Speaking of funding sources, some rely on meager funding from collaborating with commercial institutions (such as insurance companies and publishing houses), some are registered as the non-for-profit organization (NPO) and get supported by international art funds, some work with one-time fund directed by the local government funding

vehicle[21] (like the one who runs Beijing international design week). In contrast, others operate informally through private donations.

The forms of artistic programs presented are also very diverse: one art center based in Hong Kong specializes in archiving Chinese video art; an art NPO runs residency projects, accommodating European artists to practice in the Beijing hutong-courtyard; one village museum located in rural Gansu exhibits the local villagers' amateur artworks together with artworks from established artists following the *tizhi-nei* structures. Apart from attending to their self-representations, my visits to several independent art spaces in Beijing the days after the conference were also illuminating. Interestingly, none of the so-called independent spaces I have visited were contained in 'white cube' spaces, nor were they located in the state-reckoned 798 art district. They instead scatter in suburban villages, private apartments, and rental housings in downtown hutong allees. Lab 47, a one-room exhibition space dedicated mostly to young emerging artists' experimental projects, was founded by a Chinese anthropologist and a French ex-pat artist. An organization called the Institute for Provocation operates as a critical art think tank and organizes exhibition and residency programs funded by various European and Australian art foundations. I cannot abstract a unitary mode of material and value production to characterize these institutions' political, economic, and cultural features.

However, I venture to draw a demi-regularity that the artist-run space is the most common form of 'independent art space' operating in Beijing. They are financially sponsored, managed, and operated by practicing artists. Interestingly, the boom of the so-called independent art scene correlated with the revival of commercial galleries after the economic crisis around 2010. When we read from a lens of capital circulation, the substantive difference between the independent art institutions and those already established becomes clear. This correlation is then explainable. I take the case of an artist-run organization called *On Space* to illustrate this. On space is operated by five young artists in a townhouse apartment located in Yanjiao, some 35 km away from the city center. Lian is one of the founders of this organization who also works as an independent artist. He is young (born in 1988) and graduated from one renowned art department in Beijing. Lian's understanding of the independent art institution is as follows:

> I see the independent art organization's role in the current moment to be no longer an *alternative* to the gallery or museum. It is rather an *extension* to them. To be honest, some of the works exhibited in our space could also be exhibited in a gallery. Their artistic language and concept suit there too. The extent of detail is the same. However, as artists, we find it necessary to have this space to reflect

21 The local government funding vehicle (LGFV) is the special government endorsed company who financialize the urban development or re-development projects.

on our status as artists, to experiment, and to explore the margins of what can still be defined as artwork and artists. The feedback we received from our peers here would also help us to think about that. (Private recording, 2015, italics and translation added)

In Lian's description of their past projects, the experimental approaches manifested in, for example, the team spending on average two months to conceive and implement an exhibition plan. Such a timetable is unimaginable under the rules of commercial galleries. "The gallery does not do curation, and their exhibitions follow very fixed schedules. They just lay out the artworks and put the most demanded work in the most pronounced spot" (Interview IA1L). Lian also mentioned that the existing rules of the gallery would not support the artists to work on or regularly revisit the same theme continuously. It is also hardly possible to persuade a commercial institution to employ an open-air setting for exhibiting artworks. To illustrate this, Lian recalls an exhibition project they once curated in a natural environment called Chaobai river. This river marks the physical boundary between Beijing municipality and Hebei province's jurisdiction, two adjacent but administratively and economically polarized areas. They have curated several art projects around this river, in different seasons and with different groups of artists. Their goal was to explore the social-ecological, cultural and environmental affordance of the river in-depth, to continuously explore the new forms of art this context could trigger. At this point, we can see how these self-identified independent art institutions set themselves apart from the modes of practice and value production common to galleries and museums.

It is not disputed that the independent art institutions rely on sustenance resources, which are usually not *immediately* transferred from existing art institutions, marketized or state-funded ones. Their actual funding often comes indirectly from the *surplus-value* artists gain from the market or the state. In Lian and partners' art space, they mobilize their individual gains obtained from selling artworks in the gallery for operating the art space. After graduating from top art schools, these artists already made a name in the artworld, and achieved a good selling record, despite their young age. Lian was already collaborating with two galleries and had exhibited in one private museum by the time I met him.

Such a crowdfunding approach was commonly employed by the artist-run art spaces I have visited. Their founders sustain the space financially by redistributing personal income gained from gallery commission or other lucrative jobs such as collaborations with fashion brands to their own art space. Very often, rent constitutes the main cost, if not the sole expenses, as they do not calculate their own administrative service or physical labor as costs. It also means the artists who want to respond to their curatorial call shall pay for their own material expenses and labor. I would thereby argue that the means of production (money, knowledge, and cultural

recognition) these self-identified independent art places rely on are de facto surplus-value individuals gain in the *tizhi-nei* and commercial mode of practices collaborating with private galleries and state-funded museums. Through alternative art practices, they further produce the immaterial cultural 'use-value' recognized by share-minded art community members. These individuals play cross-sectorial roles, accumulate economic capital, social capital, and cultural capital through enacting various forms of practice in line with distinct contextual rules. The alternative mode of artistic practice materializes into experimental art artifacts, likeminded social groups and physical exhibition rooms.

In another case, the founders of the IAPs alluded to me that artist can generate one particular form of *surplus-value* while collaborating with independent art space. Cultural and social capital as such, are recognized with distinct *exchange value* hence *circularity*. One artist explains that, in the Chinese artworld, even the very established artists favor collaborating with artist-run off-spaces regardless of the zero to negative economic payback. The value generated lies in individual artistic freedom and exchange value in the forms of constructive peer reviews and media publicity. The independent institutions draw attention from art critics and journalists due to their perceived marginal, alternative status. One informant clarifies that "art media attends more to the underdog. The experimental spirit of off-space is a relatively scarce asset, which worth their attention already" (interview CE1W-1, LA1C). As a result, the exhibitions there get portrayed more in written reports, criticisms, catalogs, and so on.

Drawing on the short developmental history of contemporary art in China, I find that Lian and his friends' strategies and tactics in navigating the artworld resonate with many of their predecessors. In his book, Wu (2000) depicted how an artist called Zhang Dali, on the one hand, lives as an artist-activist, known for his graphite works on the demolition sites of Beijing, while on the other, sells his photography and oil painting in distinguished art fairs. The prevalence of such *intersectoral* practices imposes again challenges to a dualistic or triadic understanding of the artistic production field among the so-called independent, commercial and official. A dialectic rationale of capital accumulation and exploitation directed to the possessed actors and institutions as coherent parts, fails to explain the dynamic events nor the resultant material layout depicted in this section. However, the epistemic forms of use-value, exchange-value, material and immaterial means of production, capital circulation and accumulation, when applied to individuals, are helpful to 'explain' the intricate differentiations and entanglements in the transformation of the artworld.

5.3.4 Summary

In this section, I have adopted the political economy lens to read the norm-related events in the artworld, around two primary (*tizhi-nei* and *tizhi-wai*) and a few secondary normative ensembles (the independent art, public art, commercial art, art district, biennial). This means, while I sample and organize the empirical and literature materials, I have tentatively assumed a dialectical relation between two modes of space production, each associate social actor possessing particular means of production and knowledge. I found that before 2000, the *tizhi-nei* and *tizhi-wai* division can be well-read as a social division of class, knowledge, and material. However, the presumption of dialectic relationality – i.e., the former accumulates by taking over the latter's surplus-value – is not congruent with the evidence found. The social positions categorized under *tizhi-wai* are plural and fluid. This notion thus represents the sum of a plurality of trans-local actors associated with heterogenous means of production. The knowledge (academic and commercial) and value (economic and cultural) production and circulation in the normative field of *tizhi-wai*, are embedded firstly in the global contemporary artworld and then the domestic one.

The modes of space production represented by the Shanghai Biennial 2000, the 798-art district, the public art projects in Tongzhou, are the prototypical for big cities in China after 2000. In my reading of the situated events associated with representations of the 'art district,' 'art biennial' and 'public art,' I can identify a plurality of productive forces, yet an underlying political order structuring the distributing of state-assigned material and immaterial resources (land, material space, credentials, legal legitimations and so on). I would thereby not relate the corresponding processes of space production to a sort of "post-modern diversity, freedom, fragmentation or eclecticism" (Stallabrass 2006, 112). The actors' modes of production are entangled in the material and symbolic space they produce. To reduce their layered subjectivities (especially artistic orientation) to their class status obstructs the understanding of the mosaic form of art spaces being produced.

Finally, alternative art spaces are produced by social actors who play inter-sectorial roles in the existing differentiated fields of production. They produce and accumulate cultural, economic and political capital by appropriating contextual rules across these systems. They then redistribute these resources into materializing alternative artistic imaginaries and order. The *tizhi-nei*, *tizhi-wai* or the possessed and disposed grammar, have lost the holistic, mutually invocating character of syntax. Furthermore, only if one read the meaning of formal relationalities contextually could the observable social-spatial agglomeration and fragmentation in Beijing's contemporary artworld be explained.

5.4 Artworld as a space of everyday practices

As previously mentioned, the contemporary art scenes are relatively new to Chinese urban spaces. Within a brief development period, normativities in the artworld are far from coherent, making a straightforward structural perspective problematic. In this section, I employ an actor-centered perspective to read the artworld on the level of everyday practices. To be more specific, I adopt the analytical framework from Martina Löw as an 'initial theory' in redescribing my empirical materials. As discussed in chapter two, Löw and Thrift's theories have both addressed *practice* as the central analytical dimension, but their conceptions are built on different ontological footings. Epistemologically, both scholars have distinguished the 'pre-reflective-perceptual' and 'reflective-cognitive' aspects of the practices. Concerning primarily the pre-reflective practice, Löw deems the social actors' internalized social structure (the 'habitus') to be conducive to the space of the everyday. Here, I will employ her analytical concepts such as *synthesis, spacing, institutionalization,* and *atmosphere* to redescribe the space constituting processes related to a few relatively consolidated spatial forms, i.e., the 'artwork,' 'loft,' 'art village' and 'exhibition.'

I single out 'art-making,' 'studio-ing,' and 'exhibiting' as patterned events shared by the contemporary artists. I examine the forms of the event constituting everyday practices, socialization in the family and professional fields and the visible forms of material arrangement (placement), such as lofts, studio agglomerations in villages-in-the-city, and exhibition spaces in Beijing's artworld.

5.4.1 Becoming artists: four biographical narratives

To begin with, I redescribe the typical ways in which four contemporary artists *socialize* in family and the professional fields, develop *certain perceptual patterns(synthesis)* conducive to the everyday routinary practices. As a qualitative attribute, no public survey data are available to derive perceptions forms. Hence, I draw on the life stories I gathered from four artist interviewees, whose biographies are emblematic and representative of those I met in the field. They told me about how they carry out artistic practices and professional engagements in the artworld, about significant past experiences that matter to them, and how such experiences affect their daily life. The narratives are organized in roughly chronological order.

Li (Interview AFA1L, translation added) is both artist and co-founder of an artist-run art archive space, whose current life and work oscillate between Beijing and Guangzhou. Li was born in 1981 in Guangzhou city to a scholarly family. Her father is a traditional ink paint (*shuimo hua*[22]) artist, a minor celebrity in the local painters' circle, while her mother is a local high school teacher. Li studied painting

22 Shuimo-hua (水墨画).

with her father since her childhood and subsequently attended the high school affiliated with the fine art school, where her father teaches. The childhood experience brought her life close to art. However, instead of pursuing straightforwardly in art, she decided to study design in the U.S., a decision realized with the emotional and financial support from her parents. She turned to art again later by pursuing an MFA in experimental art at another graduate school in the U.S.

"I'm not cultivated as an artist by my family as others think," Li explains, "despite my father and some relatives being artists, they are traditional artists. I was not sure if I wanted to become an artist like that, so I studied design instead of art for my bachelor's degree." Li carries on explaining that it was an accident that contemporary artworks entered her horizon and changed her life. "I was so much impressed by video art presented in one art center. So, the video became the medium I work with ever since."

Economically, Li appears to be in a good position as a young artist. She has a fairly spacious apartment/studio within walking distance to the 798-art district. Her work had already been shown at distinguished short film festivals and in several not-for-profit art centers in Europe and the U.S. back in school time. After graduation, Li decided to return to Guangzhou city to become an artist, as "the life there appears more intriguing and offers different conditions in which I can explore my relationship with society." In China, her new works featuring the resistant practices of women in their daily life are exhibited in various institutions, ranging from off-spaces and galleries to biennials. Her participation was achieved mainly through invitations from "the friends she has gotten to know over the years." In 2010, Li moved to Beijing, both due to an invitation to teach a course at a local art academy and her intention to anchor herself in the more dynamic artworld there.

Besides being an artist, Li and two other artists have also co-founded an art NPO since 2012, which archives contemporary video artworks from Chinese artists, with branches in Beijing and Guangzhou. It was intrigued by an offer from a real estate developer acquaintance, who provide them a room free of charge for some years. This makes "try something out physically" possible. After having got a room, "we figured out that we could make it into a video art archive space." The archiving protocol was gradually developed by experimenting with artworks from a small circle of artist friends. Their practical approach is "learning by doing." The organization has already become a credible and irreplaceable art institution in the field of video art in China.

Yan (Interview IA3Y-1, IA3Y-2, translation added) is an artist who has lived and worked in Beijing since 2014. Born in a third-tier city in south-west China in 1979, Yan describes her parents as someone who "have zero ideas about art, let alone contemporary art." Yan got her first university degree in English literature in Beijing. Like many high school graduates who do not choose their practical major on their

own, Yan pursued her own dream after fulfilling the expectation of her parents – she went to Canada and got her second B.A. in Fine Art. Later, she got admitted to a distinguished graduate school in the U.S and achieved her MFA degree. Her works have been exhibited in group or solo exhibitions in galleries in Canada, Australia, and China. I got to know Yan as she is socially very active and closely connected to a group of overseas returnee artists in Beijing.

Though the trust mediated by some mutual friends, Yan alluded to another important private reason that compelled her to settle her life and work back in Beijing – the divorce with her then Canadian husband. The loss of an emotional foothold in Canada also made dwelling in China more appealing. Back in Beijing, she quickly managed to settle in her studio and rebuild her private family and friend circles in Heiqiao village, one of the art villages close to 798. She met her now-boyfriend in Beijing, who is both an art critic and an artist-activist.

Yan's daily schedule became much busier in China. Through interviews and following her social media account, her presence in residency, exhibitions, and artist talks in different cities and countries can be noticed. As a result, her paintings have been exhibited in small artist-run spaces, as well as in grand art fairs like the Shanghai biennial. Apart from engaging with painting, she has also engaged in feminist discussions, initiated female impact-journalist workshops in off-spaces and private museums. On the side, she also contributes art reviews to different media platforms.

Zeng (Interview IA4H-1, IA4H-2, translation added) was born in 1973, in a small village in a comparatively deprived western province of China. Both of his parents are farmers. A curator friend introduced Zeng to me as a representative figure of the Chinese artworld's independent spirit. At the age of 16, Zeng had enrolled in a school for pedagogy and became a middle school teacher when he turned 20, a privileged and decent job in the eyes of his parents and peers. A few years later, he quit his job and started preparing for the college entrance exam as an older student. Zeng failed the exam for the first time, but after trying again in the subsequent year, he got admitted into the ink painting department at the Xi'an Academy of Art. One year after graduation, He came to Beijing to continue antistatic practices, as "Xi'an is a provincial place, with too few like-minded people around." Zeng explained, "I was hesitant to quit my job at first, but after the first failure, I realized that I have to cut off all the safety net that kept me there. After a year in the art academy, I found that very few of my professors understand art. So, I started to explore my own way again."

Soon after Zeng's relocation, he achieved some initial success in Beijing's artworld. His painting works were exhibited in solo shows in two established galleries in Beijing, although he attributes this to external reasons: "the art market was thriving in Beijing back then, lots of opportunities." Later, instead of deploying ink and water (his major in school), Zeng favored performance as his medium of artistic

expression. It is not an immediately collectible or valorizable art form, if at all, as it can be exhibited only following its creation, in forms of photography and video documentation. Subsequently, Zeng has co-founded an artist-curatorial group in Beijing with two other well-known art peers from Xi'an. The group was united by a strong identification with classical Confucianist moral values, addressing artists' social responsibility for generalizing public good. They have curated a series of performances in non-gallery spaces, like relics in a demolition site or discarded building. While realizing value-charged artistic projects and having no paid bills, Zheng managed to have basic financial security through working as a part-time art editor in a journal for three years.

By the time I interviewed him in 2016, Zeng lives and works in Heiqiao village, getting by his everyday life with "not too little, not too many" art commissions. The art group was disassembled, as his close art partners have embarked on a normal life back home, out of family or health concerns. The paper-based journal has been bankrupted for a while, and the heyday of galleries has also faded. Among all these changes, he admitted a disengagement with social affairs but tried to pursue his individual moral and aesthetic potential to the full through practicing art.

I met *Wu* (Interview PCA2W, translation added) while interning in a gallery where he is signed for long-term collaboration. Wu is a local Beijinger born in the early 1980s. He studied advertisement for his bachelor's degree and then switched to a distinguished art school in Beijing for graduate study, under the supervision of a first-generation experimental art professor. Wu also become one of the first academy-trained experimental art professors in the academy, as the department was set up just one year after he enrolled in 2004. Wu follows his supervisors' genre and deploying traditional Chinese folk-art language in his conceptual art.

When I met him, as a 40-year-old artist, Wu is already an associate professor and a researcher in Traditional Vernacular Art Research and Conservation Center – a state-funded research institute under the national cultural ministry. Due to his footholds in both *tizhi-nei* and *tizhi-wai* institutions, Wu's works have been widely exhibited in the state museum system, galleries, domestic and international art fairs, and biennials.

To summarize, these four artists grew up in post-reform China but from very different social-economic family and regional backgrounds. Professionally speaking, they have all been trained formally in the art academy system in Beijing or elsewhere. However, their professional artistic practices have not necessarily been shaped by how they are trained in the university systems. Three of them are not Beijinger by birth but moved there deliberately to integrate into the local artworld and pursue a career as a contemporary artist.

Judging by the professional credibility they have achieved, indisputably, they have 'made' it in the Chinese artworld. They represent the very active actors in Beijing's artworld: having substantial exhibition records, broad collaborations with art

institutions ranging from off-space to commercial galleries to state-owned museums and academies, in and outside China. One can easily find two to three full webpages of articles reviewing their works and other publications. The steps they follow to become an artist in Beijing appear vastly different from those in western cities. In Paris, for instance, artists are bound to climb up highly hierarchical, institutionalized legitimating organs, from local and central institutions to prominent gallery exhibitions (Hanquinet 2016, 202–3). Thornton has described a similar pattern in New York City:

Since the 1960s, MFA degrees have become the first legitimator in an artist's career, followed by awards and residencies, representation by a primary dealer, reviews and features in art magazines, inclusion in prestigious private collections, museum validation in the form of solo or group shows, international exposure at well-attended biennials, and the appreciation signaled by strong resale interest at auction. More specifically, MFA degrees from some art schools have become passports of sorts. (Thornton 2012, 45–46)

What Hanquinet and Thornton have both pointed out is that to be an artist requires one to climb a staircase set by a wide range of legislators, i.e., the art school, dealing agency, art critics, collecting clients, and so forth. The credentials that artists acquire from these legislators would then positively correlate with their perceived success in the artworld.

Despite my representation of the seemingly distinct life and career trajectories of Li, Yan, Zeng, and Wu, they all seem to build their career following 'chaotic' rules. In other words, their professional career path is *non-linear*, not tied to a single or fixed set of professional posts and credentials. In addition to an artist, one can use lots of names to introduce them, such as curator/editor/critic/lecturer/researcher, and so on. By playing in different games situated in different contexts simultaneously, they manage to achieve various goals in the relational matrix. To draw a connection with our discussions in the last section, these actors connect and work actively with multiple types of rules and resources (*tizhi-nei* and *tizhi-wai*, public and private, domestic and foreign), more or less at the same time. A young curator, Mr. Song, has once made an illuminating comment: "I actually know no contemporary artist graduates from CAFA's experimental art program. Instead, classical programs such as oil painting and sculpture have brought out quite a lot of talented artists" (Interview EAA1S-1). He also implies that the graduates who follow a linear path often fail to survive in the artworld. The *non-linearity*, I would argue, has shaped the art professionals' perception and practices navigating the artworld in Beijing.

In the following, I focus on re-describing the events of *making art, dwelling*, and *exhibiting* through Löw's framework. On the level of practice, I examine what *recursive perceptions* and *everyday practice* have led the dislocated life trajectories to be in the commonplace. I will also examine how they relate to constituting the consol-

idated parts in Beijing's artworld: the artwork, loft studio, and exhibition. At the end of this section, I *assess* if and when the causal agent postulated by Löw, the principle of repetitive social doing, is efficacious.

5.4.2 The practice of making art and spacing the artworks

The urge to live differently

The four listed artists, as well as many of my interviewees, have alluded to a lack of or detachment of social rules they acquired in the family/school environment and the rules they follow as life/professional orientation. This is especially salient in Yan and Zeng's cases. Yan's parents are in their late 60s, living in her home-town – a third-tier city 2000 km away from Beijing and far away from Shanghai, Guangzhou, Chengdu, and Yunnan. In other words, they are far away from all the cities in which contemporary art scenes flourish in China. Yan mentioned that even though her father enjoyed classic ink-and-water landscape paintings when she was a kid, what her parents want the most is for her to study and have a decent and secure job. She further stated that "my parents understand (visual) art merely in terms of painting or drawing. They understand art as one's skill to depict some-thing on paper realistically and beautifully." (Interview IA3Y-2). When I interviewed her, as a 39-year-old female artist, she lives with her boyfriend, also an art-insider, in their shared village studio. This way of life is clearly not fulfilling her parents' expectations.

When I went abroad to study art, they expected me to be a university lecturer or high school teacher after graduation. Studying abroad is a good thing in their eyes, but they did not understand that art can also be a good career until two years ago [...] What triggered the change in their mind was when I took them around the finest galleries in 798, you know, like Pace Beijing and Beijing Commute. They finally accepted that an artist could be a job that offers decent social and economic status. [...] Still, I cannot say that I am fully economically independent, and my way of life is still and always is a concern for them. (Interview, IA3Y-2, translations and ellipsis added)

In Zeng's case, his motivation for being an artist was first to break away from the 'meaningless' way of life lived by his parents and to escape the destiny of 'a small-town man':

Whenever I thought about the industriousness of my parents and the repetitive and bare nature of their lives, I feel like, they have failed their lives. The boredom I experienced while teaching in local high school drove me to explore a bigger world. I always liked literature, history, and especially art. Also (to change my life), the art exam was the easiest one to pass compared to other subjects. (Interview, IA4H-1, translations and ellipses added)

In the 'entrenched perceptions' of Yan and Zeng, to do art is challenging. It involves a lot more uncertainty than a commonly defined 'normal life' – to get a regular and stable job after a university degree. It also involves a lot more excitement. In fact, 'still and repetitiveness' are very distant words to describe their way of life as freelancing artists. Their daily lives involve frequent traveling from city to city for residencies, exhibitions, artist talks, and workshops. When he is alone in the studio, Zeng suggests that he is busy practicing calligraphy, reading, watching football, conceptualizing his performance artworks, composing poems, posting and interacting with others on social media. In between our interviews, he got a call from a curator from Nanjing, who invited him to participate in a group exhibition in the following month. Yet, in the later interviews, Zeng admitted that he had changed his mind about the value of banal and repetitive lifestyles. "When my father died three years ago, I lived at home (in the village) for a long while, carrying out life as he did. I felt enlightened while working in the field. I become *conscious* and yet accepted life's meaninglessness" (Interview, IA4H-2, translation added). Later, he also transforms this *highly reflective* experience into a piece of artwork.

In both cases, the artists' life orientations have *deviated* from the meaning system lived by their parents. This is more so in Zeng's case, who has ruminated what he *ought to* pursue in contrast with what is taken-for-granted in a small town. His *conscious* reflections and *physical desire* (repellent emotion, in this case) against his parents' lifestyle, without a doubt, constitutes the "necessity of changes" (Löw 2016 [2001], 156). In less intensive forms, many informants often lamented or teased about their parents' and friends' bizarre imaginations about their professions, with terms such as 'bling-bling designer,' 'craftsman' or 'pure timewaster.'

For Li, her choice of art as a profession might seem to be a product of her primary socialization. Her father is, after all, a well-known traditional Chinese painter who also supported her to attend art high school from the beginning. Yet, to me, her rebellion is just of a more nuanced kind. Li mentioned that she did not take the fine art program for her Bachelor's major due to skepticism to arise from observing her father and relatives' practices. She wondered whether art is worth a lifetime dedication. Her parents' understanding of art as a career, and their support of her own choice, might be read as an indirect or neutral influence. As Li suggested, she could communicate with her father about art on some particular dimension, such as what they find innovative. However, she also felt: "my father cannot understand the media that I am using. He also finds some of the form s or theme of my work not artistic at all" (Interview AFA1L).

Instead of linking one's disposition, artistic tendency, and life orientation with views cultivated in their familial and educational milieu, my informants present more differentiation and distancing between them. Often, the well-reflected gaps, misunderstandings and the withdrawal from their parents' generations entrenched perceptual patterns that are taken as the guiding principles for their life orienta-

tions and artistic practices. This coincides with what Löw termed as a 'deviation' – the actors' practical tendency in abandoning old habits and in favor of new routines. The space constituted in such processes is termed as *counterculture space* (ibid., 156).

However, I would not claim such forms of perception and practices to be immanently consolidated nor enduring. As alluded by my respondents, their peers and friends tend to fall back to the regular track of life when they move back to their hometowns. From my interviews, other demi-regularities could be identified, including the *inter-personal relationality* (e.g., live among like-minded people) and *external material affordances* (e.g., dwelling in the art village) as the necessary conditions for sustaining the practices constituting countercultural space. In sum, a social-spatial condition that ensures an abstention from old habits allows contemplative practices and assigns resources to actualize alternative desires is constructive for achieving the change and conducive to constitute countercultural space.

Incoherent indoctrinations in art schools

I now move on to examine if and how art school educations shape artists' forms of perceptions and artistic practices. When I had conducted my field trip, the certification of art schools played the role of a legislator of the entrance to the artworld. To claim this, I have to admit a potential bias in my sampling, as the artists who agreed to talk to me were mostly under 40 years old. They belong to a generation with (relatively) easy access to art schools compared to their predecessors and successors[23]. According to a statistical report carried out by artron.net in the year 2013, with 80 active post-1975 born artists, 85% of them graduate from one of the ten listed art academies in China. 30% graduate from CAFA, while the other 55% graduate from domestic *shifan*[24] (general) universities or overseas universities (Artron.net 2013). Among my informants, the relatively older ones have sometimes studied in similar disciplines like design or architecture and later switched to an art major through a master's degree in fine art or film. The younger ones tended to study art programs all the way through. Yet, in the professional field of art, art school credentials are not functionally specific.

As previously stated, Wu switched from an advertising to a fine art program and now teaches in the experimental art department despite his artistic language

23 The art school in China resume recruitment since 1978. Experimental art and the similar programs (media art, experimental art, inter-media art, and so on) are adopted as pedagogical program in Chinese universities since early 2000s. The legitimation process take place later. The experimental art became an entry category in the National Fine Art Exhibition in 2014, and designated as a new discipline by the Education Ministry (see Yan 2014).

24 Shi-fan (师范)

and inspirations coming primarily from ancient vernacular Chinese myths. Wu jus-
tifies his hybrid approach by referring to the undifferentiated subject formations
in the artworld and the corresponding lacuna in institutional settings: "experimen-
tal art is new in China and very open to all artistic languages, more and more so."
(Interview PCA2W) He was recruited in "a freshly established experimental art de-
partment where no rules are set." Wu perceives folk art symbols, materials, and
language justified in the realm of contemporary art, as "it is the most effective
language to express my ideas." (ibid.).

In terms of changing artistic orientation, Zeng is another extreme. He was
trained for traditional Chinese painting and calligraphy but has employed mainly
performance, video, and poetry as his professional media. He still practices callig-
raphy to maintain his overall wellbeing (*qi*), and paints with water and ink from
time to time, simply because "it sells better than conceptual art forms like video
and installations." This alludes to the fact that, very often, the knowledge and tech-
niques artists acquire from the public education system is not fully embodied or
incorporated into their practice of making artworks, as they may be incompati-
ble with the market preferences or with the rules artists set for themselves. In the
latter cases, artists develop a keen sense (perceptions) of telling art from non-art,
according to their inner-most preferences.

Some university students studying in art academies have also offered illuminat-
ing insights about how art is learned and understood under the university's norma-
tive rules. A difference is first drawn between art students[25] and normal students[26]
before entering the art schools. To be admitted into an art academy, a high school
student needs to pass both general college entrance exams[27] and a test for artistic
techniques and specialized knowledge requested by art schools. Their performance
in the general tests is merely a partial indicator, meaning that they can be admitted
to a university with low scores in scientific subjects. The fine art program's special
tests are heavily technique-oriented and dogmatic, including subjects like color
and pencil sketches; the test for traditional Chinese art programs includes water
and ink painting on bird and flower themes. For many young students I knew, art
school might not be their ideal choice but remains a lower hanging fruit amidst
the fierce competition in the regular exam subjects. An art degree maintains its
exchange value as a bachelor's degree, a watershed between white-collar and blue-
collar positions in the job market. These students are most likely not going to be a
professional artist after graduation.

25 Yi Kaosheng (艺考生).
26 Wenke-sheng/Like-sheng (文科生/理科生). Their examined scientific subjects consist of so-
 cial and natural scientific knowledge.
27 Gaokao (高考).

Those admitted to art schools learn tangible art-making techniques more than critical thinking skills. In addition, school programs do not guarantee a contextualized learning. Taking the most prestigious art school, CAFA, as an example, the non-applied art programs are categorized under two parallel divisions: one focuses on traditional Chinese art subjects, like ink painting, calligraphy, folk art, ceramics, jade, furniture, bronzes, and so on, while the other includes oil painting, printmaking, sculpture, mural painting, and experimental art. What is worth noticing is the separation between traditional Chinese, modern, and contemporary subjects and a juxtaposition between experimental art and other programs. As mentioned, the contemporary and experimental art discipline is new to Chinese universities and remains marginal. Only since 2000 have experimental subjects been integrated into an official program and freelancing artists[28] invited to teach. These experimental art courses remain to be a result of individual efforts than institutionalized reforms. Students from CAFA reflected that the institute's actual teachings are not as clear-cut as the names suggest. They are organized by studios instead of by departments, where artistic tendencies and evaluation standards are up to the professor in charge (Interview SCA1L). The relation between the decentralized training system and the individual developments is just as Tan, the vice president of CAFA commented that "in each art school, it was like a small sparkle of fire lighted by one individual teacher. When this individual is powerful enough, then it may grow to a studio and a department" (Liu 2015).

Apart from their critical reflections on educational experiences, I am more surprised and impressed by the artists' *reflective qualities*, directed particularly to challenge the existing rules and norms in art practices. The artists I have interviewed (those who survived a few years in the artworld after graduation) demonstrated a profound knowledge of language, techniques, concepts, configurations, and materials applied to works in the artworld. They inform themselves about their peers' work, resorting to the internet (via VPN) if they are too remote. I would argue, in their perceptions, artwork is permanently *differentiated* in relation to those that appear in established biennials, art fairs, auctions, and even the artists' own works. Even art critics like to draw on existing ordering principles in art history like Impressionism or Dadaism to position someone's new work, the artists themselves are predetermined to 'make a difference.' They may appropriate the same techniques and use similar materials in their artistic creations as their counterparts in the other parts of the world. They hold dear to the idea that a real artwork has to be unique. I would thereby argue, unrelated to the form of training one gets, a high sense of reflectivity is the defining feature of true artistic practice.

28 According to Peng (2011), The recruited individuals under the spotlight are those like Lv Shengzhong, Qiu Zhijie, Feng Feng, and Zhang Peili, who have established an international profile and have managed to hold a career both inside and outside the *tizhi*.

Overall, with regard to artistic practice and professional orientation, I did not find a practical connection between my informants' family, school indoctrination, and their current forms of perception and practices on a general level. Artwork is an artifact result from routinary artistic practices, yet it cannot be explained as an institutionalized material form resulting from pre-reflective practices. Instead, it is unique forms come from highly reflective perceptions, reflections and practices.

5.4.3 The practice of studio-ing and the spacing of studio and art village in suburban Beijing

Figure 8 Narratives of studios, by a few established contemporary Chinese artists, at a group exhibition titled 'The Studios.' (Photo by Xiaoxue Gao, 2016.10. Qiao Space Gallery, Shanghai, China)

"Painting allows me to enjoy solitude, and the studio is a personal space in which to reflect and experience." ——Ding Yi

"Creating an artwork feels almost like the shaman wandering alone in the wilderness, amongst the three realms without sense of sinking or awakening..." ——Jia Aili

"For an artist, their studio is their magnetic field; their harbor; the fountain of their imagination; an enormous, inconceivable vessel..." ——Liu Jianhua

"Studio to me is the reality's landing point, in which the works serve as thoughts' remains, and spectacles that are natural by definition." ——Liu Wei

"Take some scaffolding, cover it in canvas to create a 10-square-meter pavilion. Paint inside, and when finished, take it apart. This is my studio." ——Liu Xiaodong

"I enjoy the studio light / Projected onto the canvas / And those unfinished works / Even and fine / Exquisite light / Projected even onto the artworks' reverse – / A hidden, invisible void / And yet / They seem but more powerful" ——Mao Yan

"The company is the place where we go the most." ——Xu Zhen

"The only place that can make me feel truly happy is my studio." ——Yan Pei-Ming

"Sometimes it is neither here nor there, other times it is abnormally shrill." ——Yang Fudong

"No matter how hectic the world outside becomes, once I close my studio door, everything else becomes meaningless. Here, there exists only myself and my art, and I need only converse with my soul." ——Zeng Fanzhi

"For me, the studio is a nest where a chicken can lay her eggs." ——Zhang Enli

"The studio is a sanctuary in which artists can escape society and forget the existence of death. It is a private chapel in which one can, in a dreamlike state, commune with heaven. It is a place for self-reflection where the soul can be cleansed. Here, emotions intertwine and mingle with one another - confidence, self-doubt, arrogance, masochism. This is a testing ground, where suffering takes pause and we are often pleasantly surprised. A true studio should be the place where one can see the clearest reflection of an artist's individual qualities, and is also the domain in which an artist's attitude to life and the way in which they live are revealed. The studio should be the opposite of a stereotypical, impersonal production workshop, or some parody of public space. A true artist will leave the best version of themselves in their studio, as well as the majority of their time." ——Zhang Xiaogang

The citations in the photo above (fig. 8) suggest that artists often represent their studio space as a sacred place of solitude, where artworks are created by the hands and souls of these solitary beings. It is deemed a personal space. "Alone in the wilderness," "landing point," "sanctuary" are the common terms deployed in enchanting the studio. In a banal everyday context, the studio is also known to be where professional interactions occur, such as meetings with professional assistants, partners, curators, dealers, and collectors. The visits paid by the latter three groups are often known as 'studio visit.' This refers to the necessary informal viewings, discussions, and negotiations between collaborators around the artworks before formal agreements are made.

Coming back to reality, for many artists living and working in Beijing, to have a studio (regardless of how small it is or whether it is shared) means to have the pre-condition of being a professional artist. It is also a meaning-charged notion that can be used as an icebreaker to any conversations, professionally or casually, among the art insiders in Beijing. It is the case for two reasons. First, for many artists, their dwelling and working take place in the same bounded physical space. The studio is thereby a notion treated by many as interchangeable as 'home' and 'office.' Someone jokes that to see if an artist is successful, one just needs to know if (s)he lives in their studio (resource: interview IA5L). I do not know the extent to which this joke reflects reality, but very few artists I have known or heard of have two separate sites for working and living. Thus, one can casually ask, "what are you up to in your studio lately," suggesting either a personal or professional curiosity. In Beijing's context, the notion of studio is also intricately linked with many broader societal topics crucial to the artworld, e.g., the commodification of housing in cities, demolition of informal housing in village-in-the-cities, and precarious welfare available to the art community. Almost everyone can share one heartbreaking story about studio demolition/relocation from their experience or hearsay. In discussing studios, the art community members exchange not only practical knowledge and tactics to deal with their everyday challenges but also sympathy for each other's troubles and pains.

After frequently participate in the events held in various artists' studios in Beijing, I propose to further redescribe the artists' processual practices that constitute the studio, under the events of 'dwelling,' 'practical coordination,' and 'networking.'

Dwelling and 'loft' in the village-in-the-city

A studio of one's own is deemed a self-evident pre-condition for a *tizhi-wai* artist, as they have access to neither offices nor studio rooms provided by public and commercial institutions. In Beijing, artists tend to adept specific rural houses (with

high ceiling or warehouse structures) in the urban fringe or, be more specific, in the villages-in-the-city, to studio spaces. Despite this, these houses/structures had ambiguous legal status in the land administration law before its revision in Jan 2020.

Figure 9 A studio called Iowa in Caochangdi, transformed from a greenhouse by inhabited artists. (Photo courtesy, artist Zhang Ruo and Zeng Yilan, 2014. Caochangdi, Beijing, China)

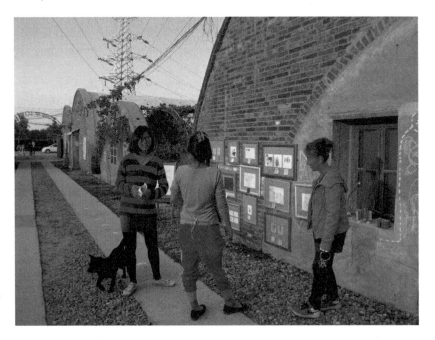

Firstly, I could identify a demi-regularity in that artists in Beijing tend to inhabit factory spaces, greenhouses, warehouse structures and convert them into 'loft' forms. In Beijing's villages-in-the-city like Heiqiao and Caochangdi, lofts are constructed by different actors at each village's different developmental stages. At an early stage, most artists rent rural housings from the villagers and convert them into lofts themselves. The attic's location and size are flexible, dependent on the old structure and the artists' preferences. I have once visited an artist's place in a remote village-in-the city called Luomahu, who had transformed only the roof level of a three-floor house into a high-ceiling studio space and kept the structure of the downstairs space as a family living space and lounge. In her case, a studio was constructed in juxtaposition with a normal housing unit in the same building. One has to pass through their lounge and dining room to the studio space. Thus the

boundary between work and life, is although fluid, but more or less consolidated by the doors and walls. In the later stages, the artists' preference of loft is known to many stakeholders. Either the villager property owners, artists or developers, start to construct buildings directly, following basic industrial warehouse styles and then rent it out to artists as target clients. The artist tenants then re-adapt this basic structure into loft-shape studio space once they move in, with minimum effort. In the latest models, an attic block is already included in the design. A classic built plan called loft is copied all over the art villages. The double-floor part comprises an attic level room at the inner end of the studio, accessed by a ladder, a kitchen and toilet, sometimes even a small living room on the ground floor underneath. The rest of the studio is a large space with a high ceiling, remains flexible at the artists' disposal, which can be adjusted according to their needs for their art projects (see fig. 9 and 10).

Leaving the cheap rent in the village-in-the-city aside for the moment, my informants associate studio dwelling closely with their preferred way of life. They find the rural/industrial housing structure, first of all, practical, as they need the high ceiling and enough room to hold their sculptures, canvas, materials, books, parties, and imagination. The warehouse structures set fewer hard borders than the functional compartmental rooms commonly found in ordinary apartment buildings. Without exception, I was told by my informants in one way or another that 'loft' is for them the ideal architectural form for maximizing their artistic freedom. In response to my questions about the charm of the loft, I was often told that it is "how studios are supposed to be" (Interview IA6ZR). One extreme example is that one artist and his family relocated from Caochangdi to Berlin in 2016 and reconstructed an almost identical loft studio there. They confirm that loft as *the* form of the studio is deeply known and widely shared by the artist. Looking aside, one can find studios in art schools in Beijing, structured as lofts. The loft form can also be found in the catalog images or studio tours in foreign countries.

Now, let us talk about the locational feature of the loft studios: they situate mostly in the so-called art villages, i.e., villages-in-the-city where lots of artist studios and institutions agglomerate. As suggested previously, calling a place of dwelling a studio instead of home implies the shared social condition faced by many artists: most of the freelancing artists living in Beijing do not have a Beijing *hukou-local household registration*. They have no way of acquiring one unless they are deemed qualified for their exceptional performance by the official association and are willing to succumb to legislators' ruling (this point has been addressed in 5.5.2). As a result, most artists have constrained access to public services in Beijing, like public rental housing[29], license plates for cars, public health care insurance com-

29 Even without Beijing hukou, one could access commercial residential housing, with higher rates of down payment and less percentage of bank loans.

Figure 10 Typical self-restructured 'loft' studio in Heiqiao village, Beijing. (Photo by Guzi-dao (2016), retrieved in October 2016 from https://mp.weixin.qq.com/s/YYabG2yNCp-EZF x3AYxMxQ)

pensated by employers, and quotas for public kindergartens and high schools. The studio, then, becomes a *provisional* solution for most of these problems. In villages-in-the-city, one can (informally) access spacious studio spaces and affordable village public infrastructures (i.e., cheaper food options). Also, as most of their peers and art institutions are located in the vicinity, there are fewer travel costs for work. Although dwelling in the studio and village cannot make artists immune to all the issues mentioned above, it offers feasible alternatives.

However, in the villages-in-the-city, as I have depicted earlier in the case of Caochangdi, world-renowned artists live in harmony around the overwhelmingly dynamic village typologies. The villages-in-the-city offer and afford diverse lifestyles to be co-existed in proximity. One can choose from a 2 RMB pancake or a 50 RMB coffee. These elements co-constitute the perceived dwelling environment for artists in the art village, not straightforward alternatives to institutional provisions. It reveals another demi-regular event. If it were only out of practical need or navigating structural constraints, the renowned artists could have opted for private services anywhere in the city. There will also be no supply of luxury goods like coffee. It is common for artists in Beijing, even those who are very established, to live in the village-in-the-city. These villages accommodate both the

Figure 11 A 'loft' studio in Songzhuang village, Tongzhou, Beijing. (Photo retrieved in September 2018, from Basha art (2018), https://www.94477.com/article/1959014.html.)

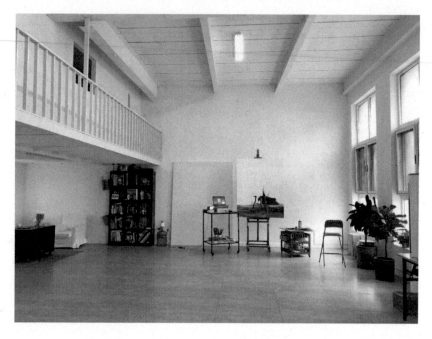

economically thriving artists and the young and unestablished art graduates who have different means and demands for their productive and everyday existence.

The bare, rough, and dynamic aesthetics in the village-in-the-city is often described by my informants with a positive tone, as 'authentic' and 'stimulating.' This could only be explained by the 'alternative aesthetic' shared by the art community. When reading it with a *trained eye for alternative aesthetics and atmosphere*, the village-in-the-city is also home to contra-modern material settings, contra-homogeneous social environments, and contra-unitary aesthetics. "The streetscapes and people here are very adaptive. It has a life full of struggles and vitality," says Guo, who often travels between New York, Milan, and London, and has a good taste of cognac, but settles his studio close to a landfill in Heiqiao village (Interview IA2G-2). It implies that the artists intend to physically and mentally *position* themselves in closer relation to the underprivileged proletariat in society. At least, they want their positions to be seen like that. It also implies the artists' shared *anti-establishment spirit*. I would thereby argue, the artists shared aesthetic *habitus* is necessary to understand their practices of village living. It enables a shared *synthesizing* of selected heterogeneous elements constituting the artworld in the village-in-the-city as a

whole, against the backdrop of mainstream urban living. When looking through a contemporary artist's eyes, the dwelling in the village-in-the-city has enabled their ways of lives detached from *tizhi*-specific rules and resources, their unique work-life arrangements, and a shared anti-establishment sentiment.

Very rarely, I met artists who work and dwell in regular apartments in the city. Li is one of them. She said she has been lucky, as both she and her husband's (not an artist) parents have supported them financially to buy an apartment close to 798 art district and Caochangdi art village. It allows her to engage with the activities in the artworld easily. For explaining her 'exceptional choice' of living normally in the city, she firstly attributes the reason to her medium – video art: "it is compatible with the space layout in the normal apartment." However, after interviewing many married couples in the artworld, I noticed that family structure also plays a critical role in explaining how they live and work. Many female artists state that, regardless of the type of artistic practice they engage in, once their kids are born, they must move back to the city for accessing kindergarten, medical services, convenient public transportation connections, and so forth. As parents, "it is not ideal to allow kids playing close to the landfill and eating takeout as we do" (ibid.).

In light of the constitution of (everyday) space by Löw, I would argue that the artists' *habitual appreciation* of authenticity, versatility, and life-work integrity; their *practical need* for flexible and spacious material structures, and the *indoctrinated yearning* for an alternative positioning in society, contribute to the reproduction of studio spaces in the form of a loft in various villages-in-the-city settings, at the urban fringe in Beijing city. These preferences are bundled with highly individualized lifestyles. Once these artists' work and life enter into other consolidated relational configurations (e.g., family, art academy), these preferences would be compromised and shape other dwelling and working space forms. The practice-oriented approach by Löw offers a strong explanatory power to read and understand the constitution of studio space in loft form and their agglomerations in the village-of-city settings.

Practical coordination and the 'art village'

By the time of my last field trip at the end of 2016, the notion of 'art village' has again drawn everyone's alarming attention in the artworld. Demolition orders were put up at every corner in Heiqiao village, a famous art village adjacent to Caochangdi accommodating around 1000 artists and 78000 migrant residents. The deadline for the final evictions was set for February 2017. Artists had been living there since 2012 when nearby villages became saturated, mostly emerging young artists, including artist He and Yan. Heiqiao is just like Caochangdi, another village-in-the-city, which means that almost all rental housings there are self-built without planning permission. While their existence has violated the planning and construction

codes of Beijing city, they are tolerated by the authorities. It is common for village-in-the-cities, given their limbo status between the urban and the rural. To cope with the eviction order, artist Zeng chooses to move to an even more remote art village called Luomahu, where "a few neighbors already settled, and they helped me find a place" (ibid.). Due to the eruption of incidences as such, a demi-regular event regarding informal coordination (in land-use, rental contracts, social relationships etc.) across social groups (artists, villagers, developers, administrators) is exposed. The forms of connections and coordination among these cohorts of people are re-shaped and redistributed.

An art village often grows from one or two key settlers. It could be an artist who is acquainted with a resourceful local villager or developer and negotiates with village committee members to settle a reasonable deal on behalf of the art community. This initiator further plays a middleman's role between the landlords (the village collective) and developer in transforming the original meaning of village housing, factory warehouses, or whatever discarded structures found into tradable studio spaces. Gradually, words about available studio spread and informal rental relations are established between the art community and locals in a village. However, words do not often spread evenly. One block of studios in Heiqiao, for example, is rented by a group of artists who all graduate from Sichuan Art Academy. Pre-existing social relations like alumni and friendships are often reified in coordinated dwellings in art villages after their relocations to Beijing. In other cases, depending on the scarcity of land and the opportunity to transform housing units, social relationships of different strengths are at play to mediate this coordination. From close to distance, they range from friendships, fellowships or *lao-xiang*[30] (people of the same place of origin), teacher-student relationships, alumni relationships, and contractual relations with no strings attached.

Once they are all settled, practical knowledge is circulated among the artist tenants from one day to another. One respondent told me: "judging by our tenant Wechat group, around 100 artists live in this block, both Chinese (from different provinces) and foreigners. I am not friends with everyone, but I got the impression that most are friendly. We share knowledge and resources about stuff like how to insulate the roof, how to install the water filter, which heater suits the best for the studio, and how to negotiate with the landlord." (interview IA8G). These are common practical issues affecting the artists' everyday life qualities in Heiqiao. Their studios are mostly rented in a crude shape where necessary infrastructure like heating was lacking, insulation was generally insufficient. One can infer that these issues *become* common among artists in the art village. It stimulates social

30 The term *laoxiang* (老乡), in principle, refers to people who come from the *same* region. In pragmatic uses, the range of the 'same' region is never objective but identified mutually by the participating parties.

coordination due to the artists' similar *habitus* and basic trust with each other. Migrant workers in Heiqiao, on the other hand, live in similar low-quality housing but not coordinate with the artists in this regard. They do not see the installation of filtered water and clean heating in their temporary rental home as necessary.

I would not venture further to argue, such coordination is found on shared identification, internalized values or rules. Very few artists dwelling in art villages are local, their different economic and social status is immediately visible from the solutions they adopt in fixing similar problems. Some refurbish their studio to the finest, while others commit to a minimal, functional repatching. Considering this, I read the banal coordinations and collaborations like solving practical problems, sharing meals, and Didi taxi rides with the close neighbors to be *emergent from* their shared engagements with the art village's physical set-up, the *material affordances*.

When attending to coordination and collaboration in art villages beyond the everyday, one can notice a *surge* sense of collectivity and solidarity when conflicts occur with an intruding outer group (most likely, the village committee/local villagers). Such occasions range from rent rise, landlord scaping contracts, lousy property management services to eviction. These incidences elicit the formation of new collective and coordinated defense among the artist tenants. Incidences like this take place, although not daily, but *recursively*. For example, in September 2015, in response to an unfair and forcefully charge of parking fees imposed on the non-villagers by the village administration, almost all artists in Heiqiao signed for a protest. Under this circumstance, the artists swiftly coordinate their actions in solidarity. The recourse to the media in the name of one collective, voluntarily represent the other floating residents (mostly migrant workers who drive informal taxis for a living) whose rights also got inflicted. Such a cross-group alliance does not exist as in everyday scenarios in art villages: artists hardly socialize with the other migrant groups due to their different rhythms and standard of life. However, when a *shared* opponent appears, artists extend their alliance to the other similarly inflicted migrants. The artists see themselves as having the social responsibility to help the ones with fewer capacities and resources to take action. The shared perceptions *of economic affordances and threats* emerge and drive new forms of collaboration beyond art in the art villages. In section 5.5, I would explicate more on this aspect using elaborated events observed from Caochangdi.

Networking and the 'art village'

For artists living in Beijing, the notion 'art village' speaks little to a dichotomy between the private and the social sides of their life. A demi-regularity is that, many artists tend to socialize with their peers who dwell in close vicinity. In studios, the active ones regularly host wine tastings, hotpot dinners, film screenings, ping-pong game, and many other activities. In each studio that I have visited, at the

very least, a sofa or dining table is placed for accommodating friends and visitors. A curator has once pointed out that "dual sets of teawares and red wine glasses" are the default tableware for studios nowadays (Interview CE1W-1). Studios in Beijing's art villages embrace spontaneous drop-ins. I cannot remember how many times I have been taken as a 'plus one' into an unknown studio party. My informant Bin said that when he is not working for a particular exhibition deadline, he drinks and debates with other neighboring artists until dawn and repeats the same thing the next day in the early afternoon (Interview IA9LB). Even as a researcher, I was invited to drink and eat homemade lunches after the interviews. The lunch topics range from the 'me too' movement in the U.S. to the rise of right-wing parties in Germany.

Artists deem the 'art village' the right place to broaden their professional and intellectual horizons. To have the opportunity to bump into someone and join activities together was described by many of my respondents as a benefit of living in an art village (see figure 18 in this book). Teng, an artist from Chongqing, explained to me, "I had never heard about the critiques of neo-liberalism in my hometown. Back then, all I hated was what I thought of as 'collectivism' – the suffocating factory and its assembly lines. I thought that any system other than collective socialism would be better. I started to understand neo-liberalist rules when I came to Beijing. This awareness arose through talking with other like-minded, but more knowledgeable artists" (Interview IA7ZH). A nourishing atmosphere was not always foreseeable and sustained in an art village. It requires social subjects to have a minimal level of mutual identification regarding the political and cultural values and endurance for cultivating the shared topics. Teng also lamented on the fragmentation of intellectual exchange in his village, as many friends moved away from that particular art village over time. He blamed the "ruthless eviction and rental rises" for that (Interview IA7ZH).

Through my observations, in art villages, knowledge transfer takes place on mutually selective bases. Sometimes, the neighboring relationship is pre-supposed by pre-existing mutual artistic appreciations, friendships, or similarities in social and economic status. In this case, knowledge transfer naturally follows. It applies to Sui's case, the dean of the Sculpture Department of an established art school. In a courtyard, he set his studio up in Guigezhuang, neighboring another two equally established artists affiliated with the same school, and a private art foundation directed by a friend of him. In other cases, knowledge exchange emerges from physical proximity and shared cultural capital. One artist, Xu, told me that he rented his current studio because of his neighbor, whom he admired deeply. "When I got to know that this studio was vacant, I immediately decided to take it. To have X as a neighbor has saved me ten years of muddling in the artworld" (Interview IA10X). It means, Xu expected the form of relational good potentially arises from such a

neighbor placement. Through acting upon it over time, the physical relationship evolves to actualize other relational good and bears other transactive practices.

5.4.4 The practices of exhibiting and spacing of the exhibition

Every artist I met confirmed that exhibitions are their occupational necessity. It is the exhibition rather than the artworks, the artistic capacity that confers one with the status of artist (Interview IA7ZH-2). As a form of event space, the exhibition results from joint practices or interactions, by definition. Phillip Hook, the director and senior paintings specialist at both Sotheby and Christie's with thirty-five years of experience, refers to exhibitions as "assemblies of works of art put on view to the public for limited lengths of time" (2014, 228). Hook further addresses that exhibitions are held in different places to make different points: "they can be museum shows which juxtapose paintings of the past that would not normally be seen together in order to make an art-historical point; or they can be commercial gallery exhibitions showcasing the latest developments in contemporary art, sometimes comprising works by a single living artist" (ibid., 228). We can infer, the constitution of 'exhibition' is pre-supposed by different forms of interactions among a wealth of collaborators: curators and directors, art critics, art media, dealers, collectors, public audiences and so forth.

Hook also implies that in a highly institutionalized artworld, well-differentiated rules would ensure institutions to hold exhibitions for those artworks with corresponding value. Furthermore, the exhibitions would be orchestrated to allow the audience to recognize and reproduce such value. These values would reify on art-historical comments and on the artworks' price tags. In the context of Beijing, insiders widely believe that, artistically valuable exhibitions do not always promise good sales. The artworks' economic value often does not match with their artistic value, especially true for contemporary artworks. Their spectrum of language and aesthetics are open and fluid (Interview CR1LJ). In light of Löw's constitution of the (everyday) space, I capture these bundled interactions in the events of the exhibition, including *negotiating access, translating meaning* and *material arrangement*. I redescribe the perceptual and practical patterns observed in these events, the rules and resources incorporated in the occurrences, and the placement of social bodies.

Archer (2018) has studied the catalogs produced by Sotheby's inaugural auction on contemporary Chinese artworks in October 2004 and revealed the networked activities of a small group of dealers, critics, and curators. They act as cultural mediators and have created the cultural value and global market for the artwork of a select group of Chinese artists. "The primary mediators to whom the weight of this translocation points are curator/dealer Johnson Chang, Chinese curators Gao Minglu, Wu Hong, Li Xianting and Hou Hanru, and two Swiss men- collector Uli Sigg and curator, Harald Szeeman" (Archer 2018, 3). A decade later, when I explore

the contemporary artworld in Beijing, there are (as demi-regularities) an increased number and variety of spaces for exhibitions. However, it is still the fact that, a few cultural mediators and legislators, who transfer and translate the cultural and economic value trans-locally and mediate them inter-institutionally, remains crucial for realizing circularity and various forms of value.

Through observations at exhibitions and interviews with young artists, curators, and gallerists about their experiences, I have identified three events integral in constituting and giving shape to an exhibition. The very first and most obvious one is *negotiating access*. Many informants told me that in Beijing, exhibitions could be incubated in many ways. It could start from an art institution, which releases a curatorial concept and ensure by calling for artworks, screening the artworks, and putting them into place. It could also start from a group of well-connected people or well-known artworks, the curatorial idea, materiality, means of communication, and collaborating institution are negotiated along the way. Artists tend to 'display' their works in their studios, on the internet, or on social media, when neither commercial, academic, nor media partners are present. These self-organized events are although noted as 'exhibition' in the artists' own CV, get less recognized by other stakeholders in and out of the artworld. Thus, circularity is at the core of an exhibition. In 2016, when artists are asked about how they managed to have their first exhibition outside the campus, the response was always "through whom you know" (Interview FM1W, IA5L). Young artists are also aware that many institutions cannot or do not have long-term plans themselves, nor do they operate with constant resources and fixed rules. They are conscious about the fact that institutions may relocate, recruit, re-ally, and re-structure. But, core cultural mediators are mobile and adaptive. In their eyes, to bond with core mediators is more substantial than a contract, who ensured circularity, and whose reliability supersedes the written rules in the currents of institutional developments. The placement resulting from such *perceptual patterns* is the loose social network with multiple centerings occupied by the key mediators and artists. These social networks can be identified in Wechat groups, social gatherings, exhibitions, zoom meetings, among others.

As I have indicated in previous sessions, although all of my informants – those active artists – hold a BFA or MFA degree issued by art academies, they report no sensible connection between these credentials and access to exhibitions in Beijing. My informants also report that the way they negotiate access to exhibitions varies with the *momentums* they sense from a particular location and time in the contemporary artworld. An artist named Tian once illustrated such a good momentum in his experience. As an elite art academy graduate, his first exhibition opportunity was offered by someone who followed him and appreciated his work on social media. When the market is good and vacancies abound, access to an exhibition can be actualized through very weak social ties. Many informants recall similar stories of accessing exhibitions through side jobs and contingent networking activities when

the art market in Beijing was booming. It was before the global economic crisis in 2008 and shortly after in 2010. The locally sensible momentum indicated varied opportunities and fluctuating thresholds.

Secondly, I have identified *translating meaning* as necessary bundled events shaping an exhibition. The core practices are often carried out by the cultural mediators mentioned above. This could be illustrated by my own observation in a studio visit where I accompanied a gallery curator named Lewis to Heqiao village. In the third studio visit of our trip, Lewis had picked up an abstract oil painting. On the painting, the fuzzy geometrical lines could be seen within foggy grey hued background layers. Lewis believed that the work was of value to a few clients he had in mind and thus decided to include it in the next group exhibition. He asked the artist about the concepts behind the painting, and the artist replied that it was an expression of her personal dark memories. When this painting was later exhibited in the gallery space in Beijing and New York, it was interpreted as environmental art, refer particularly to Beijing's air pollution.

Lewis, just like and the other trans-local critics, has played the role of a cultural mediator. His selection, curation, and review of the artworks were *ordered* according to their understanding of the logic of targeted market and clients. Through such deliberate and institutionalized misinterpretations, artwork, gallery spaces, reviews, patrons, and money were brought together in a *relational placement* to realize a part of the event space called 'exhibition.' As I have mentioned, patrons who consume contemporary Chinese artworks primarily come from the western market. The practice of interpretation is always, to a great extent, *translation*. A dealer I spoke to also addressed the necessity of translation to ensure further transactions: "our western clients favor 'mischievous and quirky' artists, and 'one-of-a-kind' artworks, while our Chinese clients favor the 'well-acclaimed artist' and the artworks that resemble the established ones. To supervise their investments, I need to explain to why a certain piece of artwork is deemed a good deal in the eye of the other" (interview, CE1W-2).

Thirdly, I will redescribe how artists and curators, together with other collaborating actors, negotiate the *material arrangementd* of an exhibition in the course of its happening. To kick off an exhibition, setting up the vernissage is of primary importance. In 1910, Apollinaire described the attendance at the opening of the annual exhibition of the *Société des Artsten Français*, including lovely ladies, handsome gentlemen, academics, generals, painters, models, bourgeois, men of letters, and blue stockings, and so on. From what I have observed, in 2016, an exhibition opening at a gallery in Beijing Caochangdi was attended by art students, academics, curators, media journalists, professional friends of the artist, internet influencers, and many others. The gallery staff, typically only a small crew of two or three people, spent more than two intensive weeks preparing the opening. Galleries usually follow a similar timetable and work with the same group of contractors in preparing

each exhibition. Some of the labor is materialized into products presented to visitors, including promotional material like posters and invitation letters, catalogs in print, announcements and newsletters posted by art media and mailing lists, artwork installed with the help of the contractors, insurance for the artworks and their logistics, visual archives and price lists, catering service, and drinks, and so on. The list is endless. These material and social bodies, and the way they are ordered in relation to one another, are institutionalized to a greater or lesser extent.

For one commercial gallery, the *principle* one applies in placing the exhibiting items usually is 'maximizing revenue.' Undoubtedly, artworks differ in material, form, and size. Their layout plan needs to meet the capacity of the room, gallery staff, the allocable budget, resulting from negotiations between the actors (mainly the artist and the gallerist) involved. The most desirable works are always placed in the most prominent spot.

Above all, *social bodies* (audiences), particularly the guests invited to join the social dinners, constitute central elements of an exhibition opening and exhibition. The presence of a big group of distinguished guests would be read as a precursor for an impactful peer review. Ideally, the event should be well-orchestrated to generate the right momentum for making sales. The right food and drinks are served to prompt that atmosphere, and hence, the expected conversations. These social bodies' gathering does not just happen by sending out catalogs, posters, and Instagram and Wechat posts. It is actualized through the exhausting and meticulous labor of the gallery personnel. The first round of invitations takes place months or weeks ahead of the event through emails, Wechat texts, short messages, and phone calls. The gallerist invites VIP guests, who are either long-term patrons of the exhibiting artists or potential candidates, with personalized messages. For non-VIP guests – curators of art festivals and museums, directors of public and private museums, auctioneers, art journalists and editors, art academics, potential collectors (diplomats, designers, celebrities, influencers, public relation managers, partners and CEOs of firms etc.), and other artists in collaboration with the gallery, and friends of the artist – the gallery director customizes a list based on people's economic competency, professional status, their level of being 'in' the artworld, and the closeness and endurance of their relationship (guanxi) to the gallery. The feedback from these targeted guests is continuously updated in an Excel chart until the last hour of the vernissage.

Despite all the intentional efforts put into practice, neither the form of an exhibition nor the subsequent sales would turn out exactly as planned. The desired guests' availability is unpredictable, especially considering the successful actors in the artworld have cosmopolitan lifestyles flying worldwide. In principle, no one is obliged to attend a vernissage or social dinner apart from the exhibiting artist and the gallery's crew. Some art critics/peer artists are present due to their own artistic or academic interests; some collectors appear to check the artwork and the

crowd to decide if the timing is right to invest. Their presence and form of involve-
ment are mostly conditioned by their own professional or personal preferences and
itinerary. Some actors (e.g., the gallery's contracted artists) who are not directly in-
volved in the selling-buying transactions may show up out of emotional obligation.
They expect others to do the same for the set-up of their own exhibitions. Some-
times, famous art historians appear, as they got paid for their visit, as well as a
positive review after the opening. These people are most likely to act as 'planned.'
Finally, some unpredictable visitors may be brought by a friend who falls outside
the category mentioned above.

Even for those social bodies (gallerist and artist) who are bound by formal con-
tracts, how they relate to each other in dynamic interactions have impacts on their
perceived form of the 'exhibition.' For instance, artists and art dealers live on con-
tracts individually settled with commercial or not-for-profit art institutions. De-
spite the contractual clauses, their actual agency in forming an exhibition usually
do not come across loud and clear. The gallery personnel often express their anx-
iety about sustaining the long-term collaborative relationship with certain artists
whose status/price rises too fast and outpaces their offers after a big show. On
other occasions, the gallery is the more established party, making exploitative use
of the vague rules. When collaborating with an established institution, artists often
perceive themselves as the favored receiver, agree on more exploitative contractual
terms and disadvantageous profit-sharing plan. The number of resources to be in-
vested in the extra services, such as reaching out to art critics, doing P.R., or events
that enhance the artist's cultural capital are also to be negotiated. Despite the labor
and revenue division formally set on the contract, artist or gallerist can act as the
more dominant party, deciding on how to constitute the show. Thus, the collab-
orative practices in the exhibition and its constitution are positively or negatively
reinforced by unceasing negotiations.

In light of Löw's conceptualization of (everyday) space, I could first confirm that
the *temporal and spatial arrangements of an exhibition* result from partial institution-
alized forms of perception and practice. The material entities (artworks, posters,
catalogs, exhibition halls, catering food and party furniture) are similarly set up
from one exhibition to another, implying a similar 'ordering principle' and stan-
dardized sequence. Yet, as described above, from the perspective of the organizers,
the gathering of the social bodies and the forms of their interrelations constituting
the exhibition is hardly an institutionalized process. In particular, in a young and
marginal social sector like contemporary art, there are few fixed binding rules or
resources to ensure the presence, relatability, and predictable forms of interactions
among art patrons, independent art critics, celebrities, journalists and surprising
guests. A cognitive disparity is enduringly perceived and presented by the collabo-
rating parties in negotiating the peripheral spatial arrangement of the exhibition.

Contingencies are also abounded and could critically affect the peripheral social-material constitution and the individually sensed atmosphere of an exhibition.

5.4.5 Summary

In this section, I have redescribed the events of *artmaking*, *studio dwelling* (including practices of dwelling, practical coordination, and networking), and *exhibiting* (including practices of negotiating access, meaning translation and material arrangement), enacted by the art community insiders. I have drawn on Löw's thesis of the constitution of (everyday) space in re-describing them and examine, if and what 'repetitive everyday doings' result in the constitution of *artwork, studio space* (loft, art village) and *exhibition*.

By deploying the categories of socialization, habitus, reflective and pre-reflective practice, synthesis and placing, I have read the artists' *art-making practices* as highly reflective and individualized. Although they are repetitively practiced, the resultant material-meaning figuration – the artworks – are not institutionalized. I see Löw's presumed casual relations between the repetitive social doing, the atmosphere, and the spatial figuration, very well accordant with how dwelling and working practices are related to the configuration of the studio in loft form and the community-dwelling in the form of art village. On the level of individual everyday practice, the configuration of 'loft' and 'art village' is explained by artists' internalized idea of studio space, their indistinguishable perception of work-life practices, and their attunement to alternative aesthetics. The prescribed causal agent explains the prevalence of loft studios and art villages in Beijing's suburbs.

On the other hand, 'art villages' in Beijing's can be read as different relational configurations when we focus on different social actors and their space constituting events. Practical coordination and networking are commonly enacted by old and new art inhabitants around their studios. In Beijing's dynamic urban-rural-interface, such joint practices are often not structured by clear normative rules and often interrupted by contingent orders imposed by the outsiders. The practical *coordination* can be interpreted as pre-reflective practice emerging from art community's shared perceptions of material and social conditions in the village-in-the-cities. The practice of *networking* also prompts the agglomeration of studios and the formation of art villages. I shall argue, art village is differently constituted by social actors who not only act reflexively in light of existing relations but also on/with/through an external social-material relation that is continuously emerging and changing.

Regarding the event of *exhibiting*, I have redescribed the demi-regular practices of *negotiating access, meaning translation,* and *materialization*. The enactment of these practices has entail different extent and forms of contingency. Social bodies (of the artist, the curator, the gallerist, the dealer, the collector, the museum director, etc.)

act upon an inherent idea of 'exhibition' but also on non-reciprocal and mediated frames of meanings. In addition to attribute causes of temporally and materially fixed arrangement of the exhibition to such inherent meaning, I also attend to the mediated, contested, and transient perceptions in constituting the periphery form of 'exhibition.'

5.5 The artworld in Caochangdi: a manifold analysis

In 5.3 and 5.4, I have examined a few consolidated spatial configurations (artworks, lofts, art villages, and exhibition spaces) that result from the observable events enacted by Beijing's contemporary artworld's insiders. This section pays particular attention to the multi-linear events anchored in a place called Caochangdi. These events are not tied to each other yet constitute divergent temporary socio-material parts of the artworld. The three previously discussed conceptual frameworks of space are all deployed here to enable manifold coding and interpretation of such events. I aim at revealing the co-existent generative mechanisms that underscore the divergent artworld constituting events observable from *Caochangdi*.

In line with CR ontology, this section begins with a search for demi-regularities at the empirical level of reality. In 5.5.1, a re-description of Caochangdi's developmental history was guided by the political economy theory of spatial production (Harvey). In 5.5.2 and 5.5.3, empirical re-descriptions are carried out using the lens of the everyday (Löw) and assemblage (Thrift) of space. At the end of this section, I conclude with how such an analysis identifies a multitude of causal mechanisms driving current transformation trends in Caochangdi, a typical art village in Beijing.

5.5.1 Caochangdi as a Village-in-the-City

In Beijing, just like in other first and second-tier Chinese cities, the term 'village-in-the-city' (VIC) has been coined to capture a type of social-spatial phenomenon that crops up in the rapid political, economic and material transformation processes. Such social-spatial phenomenon usually straddles geographic, legislative, and socio-economical urban and rural institutional structures (see, e.g., Wu, Zhang, and Webster 2012; Lin, Meulder, and Wang 2012; Bach 2010). As a territorial unit, it often locates within but on the verge of an urbanized area, gets encircled by legally defined urban land and administrative system. In terms of social features, more than any other city quarter, VIC accommodates social-economically heterogeneous local rural collective and migrant workers. Administratively, the village committee is a self-organizing administrative unit, while not being part of the formal hierarchical governmental system, it has to respond to rural and urban administrative

rules and solve practical problems for the rural collective. Departing from the notion of VIC, a politically and economically loaded term, I will redescribe the events that give form to Caochangdi as a political-economic totality. This includes tracking and redescribing the moments and processes where the stakeholding actor groups come together, mobilize various *means of production* (labor, land, capital), acquire, transform and redistribute their capitals from their relative *political-economic positionality* (e.g., in Beijing's urban-rural administration, household registration system, and land-use structures). Finally, I examine if and how the *law of accumulation* explains the observable material arrangement.

Caochangdi satisfies the 'primary parameter' of being a VIC due to its limbo geographical location and its hybrid land-uses. It is located 20km northeast of Beijing's city center and only 14km away from Beijing's capital international airport. Its territorial boundaries are adjacent to the intersection of the fifth ring road and airport express road, which were seen as markers of the end of Beijing's urban proper area at the time I conducted my field research. Once a *ziran cun*[31] (natural village) consisting only of a local rural community and their farmland and settlements, Caochangdi's approximate 1.2 square km^2 area is now densely covered with informal housing, 'rural' public infrastructure (kindergartens, middle schools, rural community centers), and 'urban' infrastructures (police stations, art institutions, light-industrial, and small-business facilities, small green spaces and parking lots). These appropriated forms of land-use, make-shift building forms, and informal economy indicate either no effective laws and regulations exist, or they are not strictly enforced.

The social constitution of social bodies living in Caochangdi also fit the descriptive definition of a VIC. As a *de jure* rural self-organized social unit, Caochangdi's legal members are the registered local rural community, consisting of only 295 registered rural households – around 1100 individuals. In the context of the perennial dualistic urban/rural land tenure and household registration (*hukou*) systems, only the local rural community is still legally entitled to Caochangdi's land and can access the rural public services. However, Caochangdi's inhabitants are predominantly migrant communities. The only existing public census data from the year 2013 shows that 30,000 migrants live in Caochangdi, 30 times the normatively defined 'local' population (Liu et al., 2013). Through my observations and interviews between 2013 and 2017, I could confirm that migrants constitute the dominant majority of residents in Caochangdi.

Caochangdi's migrant inhabitants' socio-economic status is heterogeneous. They situate in divergent political and economic *positionalities* across 'rural' and 'urban' systems. The defining attribute includes their *hukou* (Beijing or non-Beijing, urban or rural) and labor status (formal or informal, long-term or flexible, white

31 Ziran-cun (自然村)

color or blue color employment). These attributes are critical in characterizing their productive and reproductive agencies in Caochangdi. I put them into three social groups. The first group consists of the local villagers. They hold Beijing rural *hukou*, which grants them the ownership of Caochangdi's housings and land and access to social welfare from the Beijing rural system. They are economically well off, as they gain income from private rentals and shares of renting the rural collective land. The second group consists of low to middle-income[32] migrants coming from rural and urban areas out of Beijing. The low-income actors usually work and live in the VIC, self-employed or informally employed (as platform taxi drivers, construction workers, vendors, gig-economy delivery staff, or short-term workers, freelancing artists, or interns in art spaces). They are excluded from both urban and rural social welfare in Beijing, and hence are most dependent on services and opportunities in Caochangdi. The middle-income actors usually live in the VIC but have a formal job contract either in the VIC or in the city. They are mostly blue-collar and white-collar workers in the manufacturing, hospitality sector and art institutions. The third group consists of high-earning actors who work formally in Caochangdi, live and register in Beijing city. They are the relatively well-educated and well-paid creative social class and international art crowd. They are either citizens of Beijing or migrants from other 1st tier Chinese or global cities. Their lives mostly unfold in urban areas, and they come to Caochangdi only for professional issues.

Finally, Caochangdi's immediate administrative body, the village committee, is ruled under both the rural and the urban administrative systems in Beijing. The rural administrative system consists of village, township, and county levels of governments, offering meager but stable funding to cover the rural community's social welfare. On the urban side are the neighborhood, district, and municipal levels of governments, to whom it is of utmost importance to evaluate and regulate non-agricultural land-uses and economic activities in the previously rural region and to withhold an 'urban' image. As Beijing is China's capital city, the Caochangdi village committee is also inevitably subsumed under the state administration, who might impose general rules and plans affecting the VIC's administrative operations.

Now, let me redescribe Caochangdi's developments in terms of the three groups of stakeholders' social positionality, their means and forms of productive activities while addressing the transformation of Caochangdi's social, normative, material constitution and boundary. According to the village archive (2007), Caochangdi has

32 Between 2013 and 2017, my informants cited a net income of 4000 RMB/month to draw the line of 'surviving' or 'getting by'. It was commonly perceived that a medium level income would fall between 4000 and 8000 RMB/month. Therefore, I adopt these two numbers, 4000 RMB (around 550 Euros) and 8000 RMB (around 1100 Euros), to mark low- and medium-income categories.

Figure 12 Map of Caochangdi village's built-up entities in 2007. (Adapted based on a map released by Caochangdi's village committee (2011), retrieved in November 2014, http://ccd.g rwh.cn/)

草 场 地 艺 术 区 平 面 图

been recognized as a natural village since 1949. It is made up of around 1400 *mu*[33] (0.94 km²) of collective rural land, among which 200 *mu* is assigned for the rural community to build up their homesteads, 800 *mu* is designated for collective agricultural production. During the communist era, the villagers engaged solely in farming under the organization of a 'people's commune.' The people's commune, the private rural housings, the homestead, the arable land amount to a material totality for capital accumulations and flows. The material circulations are mostly internal and non-capitalized. Since the onset of economic reform in 1978, several resourceful local villagers have appropriated pieces of arable land, established small family workshops in the name of a collective rural economy. At this stage, new raw materials came in, and commodities went out – capitalized material circulation break off Caochangdi's territorial and administrative boundaries. However, the most important means of production – the farmland – remains collectively

33 Mu (亩) is a commonly used land measure unit in China, 1mu equals 666 2/3 square meters. 1400 mu is around 0.94 sq km²

Figure 13 Local villagers' residential housing on the northern area of the site (homestead land) in 2007, before widespread self-initiated housing densification processes. (Photo retrieved from the Caochangdi village archive (2007), preface page)

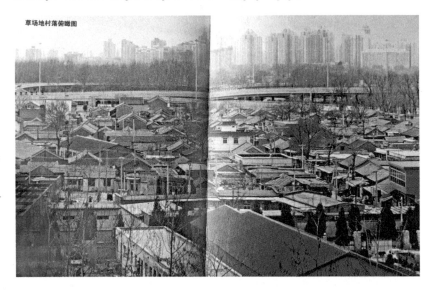

owned and used by the rural community. The political-economic (ownership, user-ship, designated rural function) barriers of the land make its value not-exchange-able to the non-community members. The rural community's labor force is capital-ized, but to a minimal extent, as their capital gain is spent entirely on paying taxes, reproducing their labor force and maintaining their industrial infrastructure.

Since 1992, increasing amounts of villagers ceased to farm, and more farmland became vacant. From 1993 to 2007, for Caochangdi's rural community, the estab-lished capital circulation loop – from monetizing the collective-owned farmland, producing profits to reinvesting in the collective public infrastructures – was grad-ually expanded and reinforced. In response to inquiries from both local members and their collaborating non-local entrepreneurs, the village committee expropri-ated more and more farmland for constructing industrial building structures. The rents from these building structures became assets to the villagers' collective, while the competent local villagers (as tenants and as the business owner) also obtained a private share by operating businesses in these buildings. The village public infras-tructure (such as improvements to the water sewage system, gas supply, gating and fencing, Asphalt roads, and streetlights.) was developed, funded and supervised by the village committee. In the meantime, such 'self-modernization' practices were

Figure 14 Informal housing on the northern side of Caochangdi. The photo was taken under the fifth ring road of Beijing, towards one of Caochangdi's entrance. (Photo by Xiaoxue Gao, Jan 2014, Beijing, China)

tolerated by the upper-level government – Nangao-Cuigezhuang township – which is an under-financed rural jurisdiction.

Increasingly, most of the rural community, following the footsteps of the few competent peers, has reoriented themselves to engage in profitable light *industrial production*. The hiring of outsider labor forces was not yet common. Meanwhile, as shown in figure 13, the private housing on the northern side (on the homestead land) of the village remained underdeveloped until approximately 2007. These properties are mostly one or two stories high and resided solely by registered local villagers and their family members (interview CVC1). The under-development of private housing property also suggests that, until then, the surplus value generated by the modes of collective and individual production was not yet sufficient to materialize as private fixed assets properties.

According to several villagers and artist interviewees, Caochangdi's most rapid political-economic, and physical transformations took place between 2007 and 2011. For the first time, several large portions of land in the southern part of the Caochangdi were leased to external developers, which were soon transformed into agglomerations of art institutions and studios (see fig. 12). Alongside the overall village industrialization and urban sprawl of Beijing, the northern part of

Caochangdi began to accommodate a growing number of non-local actors seeking dwellings and livelihoods. They rent and live in the rooms of local villages' self-built houses and/or shopfronts, running small businesses. In response to the increasing demand, individual rural households carried out numerous renovations and floor-lifting projects between 2007 and 2010. The traditional courtyard housing typology was replaced by densely laid-out 3 to 4 story concrete box buildings, whose height and floor area was maximized for accumulating rental revenue (interview CVC1). Simultaneously, numerous small businesses catering to the residents' daily needs began to appear as ground-floor shopfronts or vendors on the street, expanding quickly from street intersections to all main alleys.

By 2011, these commodified forms of private housing land were consolidated into various hybrid forms of land-uses and building structures in Caochangdi. Continuous, small-scale and incremental turnovers take place in this already cramped dense environment. Several local villagers continue to refurbish and renovate their housing, materializing the rents they accumulated from migrant workers (interview CVC2). In this process, most local villagers have repositioned themselves again from industrial workers to professional landlords. The individual household's homestead is largely commodified into rental housing, and their surplus-value become more and more fluid. The socio-economic boundary of Caochangdi has also become porous and extensive.

From 2014 to 2017, I also witnessed an increase in the number of upscale de-signer boutiques, supermarkets, and coffee shops that supply imported alcohol, snacks, and flat whites. The village committee continued to seek and negotiate with new private investors in transforming their rural-communal public infrastructure. The small vendors at an old communal food market, for instance, were entirely wiped out and replaced by 'hipster' restaurants and boutiques. In 2017, both high-end and budget service options remained co-existent in Caochangdi. The two types of land, the homestead and the former arable land, were eventually commodified in similar ways but by divergent stakeholders, social relations, capital accumulation, and redistribution loops.

Meanwhile, in response to funding and executive orders issued by different upper levels of sectorial governmental bodies, the village committee sporadically initiated thorough micro-scale projects to improve the public infrastructure for the rural community in the village. These sectorial rules and resources were in-tended to enhance services in their own purview of the legislation. Such announce-ments could be found on the posters in the village's official bulletin boards or on the homepage of the Cuigezhuang 'diqu[34](area)' office, a transitional urban-rural administrative body that has governed Caochangdi village since 2004. The 'area' of-fice was designated to facilitate the pan-urbanization process in Chaoyang district

34 Diqu (地区).

before the comprehensive rural-to-urban land requisition and conversion are in place. All 19 township-level administrative units situated within Chaoyang district were transformed into 'area' by 2004, which operated under the concept of 'one administration, two names[35].' This indicates that the village committee of Caochangdi submitted solely to the rural system of rules and resources before 2004. After 2004, the municipality acknowledged the *de facto* urban developments in its rural jurisdictions and gradually integrated them under an urban administrative system. The rules issued by the urban and rural system from top-down is not well coordinated. Nor are they enacted in coordination with the on-the-ground actions by the villagers, migrant workers, art and non-art entrepreneurs. Under the rural system, the village collective and committee were given higher administrative and operational responsibility yet limited fiscal resources. Under the urban system, the village collective and committee are funded to operationalize the urban-regional plan.

As this rural-to-urban governance transition unfolds, Caochangdi falls between the rural and urban regulatory systems. These urban plans introduce conflicts with the local actors' capital accumulation interests and practices. Especially under the urban governance, the local actors' utilization of farmland for non-agricultural purposes is illegal, or at best, informal. From my informal interview with the village committee representative and villagers, they all admit such informality but insisted that that is the only approach they can take to improve lives. The village committee's self-justifying narrative is, to a great extent, made *ex-post* for the higher political governors who carry out evaluations from an urban regulatory perspective. The individual and collective's illegal commodification of rural land and services was ameliorated in meaning. At the same time, the committee representative addresses their compliance with several documents issued by the central government in 1994 and 2004 for protecting farmers' land-use rights in the process of urbanization, industrialization and guidelines for restoring farmers' living standards and securing their long-term livelihoods. These justifications were also upheld by the villagers interviewed. Some senior locals mentioned that, prior to the transformation, they needed to visit the township center to access public services, which were scarce and of low quality. Some recalled collectively initiated modernization projects that were never visible to me, including the waste collection system, the wideband and later the fiber internet network, and so on. It affirms that the village community's self-initiated value transformation practices were not driven by capital *accumulation* at first but by sustenance. Nevertheless, it sets off a momentum where more and more transactions became monetized and commodified. The local villagers and committees were also able to accumulate more profit from the inflow of migrant workers and external entrepreneurs later.

35 In Chinese: 一套人马,两块牌子.

Some contingent rules can be mobilized to the rural community's benefit. For example, Beijing's municipal government has generally held an ambiguous attitude towards the migrants, seeing them both as labor force contributing to city's economic development and a potential menace to its political stability and the image of a global city. In this context, Caochangdi's existence offers an *ad hoc* solution to the urban administration, which fails to provide low-cost and legally protected housing for migrant populations working for the urban economy. The come-into-being of the informal villagers' private housing, the so-called small-property-right housing, can thus not be explained by a coherently functioning neoliberalist economic and political logic.

In the village administrators' narrative, 2007 was one of the turning points for Caochangdi's development. The Cuigezhuang area and Chaoyang district government-endorsed Caochangdi as a pilot site for experimenting with the village-based development of 'art and cultural industries,' guided by and under the Cultural and Creative Industry Development Plan revised and permitted by the Beijing municipal government (People's government of Cuigezhuang township, Chaoyang district, Beijing 2010). The endorsement from both rural and urban upper-level administrative bodies explains the empirical tendency I have observed, more plots of land were rented out to artists and developers, and the number of art institutions in Caochangdi increased rapidly since 2007.

The top-down allocation of resources to area development became especially frequent since the end of 2010 when the urbanized Chaoyang edged closer to Caochangdi. For example, the village community center, together with a township-owned management company, was set up for formalizing the property management in Chaochangdi. One can also observe various political agendas and materializations subsequently occur in Caochangdi: "converting village into community pilot project" and "rural collective property rights reform" (2011). Both were issued by the Chaoyang district's working committee, targeting at non-agricultural rural communities in its jurisdiction. The construction of new rental spaces in the southern collective farmland was carried out according to the policy framework aimed at "constructing creative and cultural industry" of Chaoyang's urban cultural industry development office. A series of environmental beautifying projects (cleaning up wire poles, distributing recycling garbage bins, and so on) were implemented in alignment with the "Beautiful Countryside" (September 06, 2018) framework imposed by the Cuigezhuang township-area office, as well as the "three new modernizations" and "constructing the second urban green belt" planning frameworks prescribed by the district's Reform and Development Office – representing Beijing's municipal government. Judging by the area office's financial report, these 'urban' *or* 'rural agendas' are assigned with corresponding 'urban' or 'rural' fiscal supports, executed by the Cuigezhuang township-area office together with the Caochangdi village administration. According to Liu et al. (2013),

Caochangdi village collective's revenue has become more transparent. This revenue was partly (around 70%) spent on maintaining the rural collective's communal infrastructure, such as water, heating, and gas pipes, and partly (30%) shared among the registered rural community members in the form of an annual bonus.

The political-economic conceptual framework brings the relative positionalities of Caochangdi's stakeholders in the urban-rural administrative, land-use and welfare systems into the foreground, which are causally related to how these actors collaborate in space-time and under various types of rules and material resources. An informal economic alliance is visible. The village administrative committee, in charge of the rural community's collective revenue, ally with the migrant workers and art and non-art entrepreneurs who pay them direct rent. Particularly, the scaled enterprises (mostly galleries) are deemed as an economic alliance, as they contribute to the township's revenue through paying management fees. Following the pathways of economic capital's circulation and accumulation, we can define a relative totality of quasi-rural Caochangdi.

Politically speaking, Caochangdi is officially constituted by the village committee, registered local villagers and their rural land, housing and shared public asset. The Cuigezhuang township-area urban administrative issue administrative rules and allocate resources to Caochangdi village committee, to ensure the rural villagers' economic sustenance and political stability in the short term. In the long term, it aims for Caochangdi's overall integration into the urban political system. It means replacing the rural community committee with an urban neighborhood administration under the rule of Beijing-Chaoyang administration. The rural land tenure will be replaced with state-owned land tenure and the chaotic rural spatial image with a neat and tidy urban one. In other words, the Beijing-Chaoyang government is in charge of Caochangdi's land requisition and organizational integration. From a political perspective, despite migrant workers' and enterprises' contribution to the Caochangdi rural community's informal and formal economy – through sales, added value tax, and corporate income taxations – its significance is not comparable to their political alliance.

Caochangdi, just like many VIC located in suburban Beijing, its political-economic position has shifted slowly from rural to urban. Its rural community members and administration subject to access more and more urban resources, aesthetics, and regulatory norms. Despite the growing amount of accumulated wealth, the village community and its administrative committee has less autonomy in drafting their own decisions. The direct manifestation is that the rampant private building practice comes to a hold. More and more beautifying projects are initiated, with the funding directed from the upper-level area-township government. I would thereby argue, in the context of a top-down plan of integrating Caochangdi's rural community and land in urban political-economic systems, Caochangdi rural community's disjunct political and economic positions, coincide with the observable conflictions

between their own modernization narratives in the political sense and the practices of exploitation rural land and migrant workers' income in the economic sense.

In short, when reading Caochangdi's transformation through a political-economic lens, I could identify and code the following *demi-regularities*. The socialist regime had left Caochangdi with a community-based social organization and a collective land tenure structure. Its members are entitled to mobilize their own homestead and a share of the capital earned from the shared farmland. The rural community's *mode of production* has noticeably transformed from agricultural to industrial (with initial internal labor force and later migrant workers) and services (run by local villagers). The stakeholders' *means of production* have also changed drastically. The local villagers' extensive expansion of informal housing can be read as private capital accumulation, extracted from the migrant workers' and tenants' surplus value. The renting of arable land to art and non-art entrepreneurs helps the rural community accumulate economic capital. I would argue that the Caochangdi rural community's private and collective economic capital is accumulated by appropriating their *rural political status*. However, as the top-down plan integrates rural communities and their land into the urban system, the rural community's sustenance relies more and more on the grants allocated from the urban administration. In this context, the modes of production and materialization of space in Caochangdi result from stakeholding actors' juggling between two different principles of capital accumulation in the urban and rural systems.

To sum up, the political-economic framework of analyzing space production proposed by Harvey has brought several groups of actors' political and economic positionalities, their means and practices of value production, transformation, capital circulation and accumulation to the foreground. The law of accumulation has clearly explained the process whereby the local rural community valorizes their collectively owned farmland, industrial infrastructures, and their own private housing. However, Caochangdi's stakeholders' political-economic agency also changes, as their positionality in the urban-rural system change. Suppose these urban-rural political-economic fragmentations were not there, a more radical 'exploitative' mode of development would occur in Caochangdi, which already occurred in its immediate, surrounding area. Nevertheless, these co-existing and fragmented political-economic logics have manifested as variegated commercial and industrial practices and a diverse landscape of dense urban-rural settlements and public infrastructures. As a particular case with historical details, the law of accumulation cannot fully explain the material form of Caochangdi co-produced by actors from near and far.

5.5.2 The rhythms of life in Caochangdi

The political-economic lens has left some gaps capturing the underlying causes of social actors' conflicting modes of perceptions and patterned practices. It also fails to attend to the stakeholders whose agencies are marginalized in the formal political-economic frameworks. To fill these gaps, in this section, I adopt the perspective of everyday space constitution from Löw and the non-representational theory from Thrift. Before I start my analysis, I would like to invite you to take another look at the village streetscapes (see fig.15, images to the left). Despite the mediation of the photo, you might still sense the discrepant atmosphere on the northern and southern sides of Caochangdi.

You may have noticed the labyrinthine narrow streets on the northern side. Houses are towering four or five stories high on either side, hardly allowing sunlight to reach in. The ground floor shopfronts offer all one needs to sustain a low-budget and fulfilling lifestyle. There are numerous restaurants, 24-hour supermarkets, pharmacies, post offices, laundry, internet cafes, electronics services, barbershops, dentists and public baths. From the second floors up, these buildings are filled with rooms for rent. Some are equipped with heating, air conditioners, individual bathrooms and kitchens, while most are only plain simple rooms. Amidst all of these, one can also find 'hipster' restaurants and artist-run cafes, mixing in in an unremarkable manner.

On the southern side, the streets are much broader and noticeably less lively (see fig. 15, images to the right). On the sides are mostly factory and warehouse structures that are adapted by creative communities and related service-providing companies. These architectural compounds are built of the same material as most of the private housings in the north. One can notice, unlike their pragmatic neighbors, they display an intentional, minimalistic aesthetics. Among them, the 'red courtyard' is the most well-known art block and occupied primarily by distinguished art institutions. The 'grey courtyard' is another big block, consists primarily of artist studios. Both are designed by internationally famous artist and architect Ai Weiwei, who has also set up his own home and studio in the village. In total, Caochangdi is home to 21 galleries, seven not-for-profit art institutions, 28 listed studios hosting established artists, and 43 art and design-related enterprises[36].

On any ordinary day, anyone can notice the vastly different rhythms of life occurring in Caochangdi. People who live in the northern part of the village rush out to their workplaces in the city early in the morning. The breakfast stands accommodate customers before 6 a.m. in the summertime, as many tenants in Caochangdi need to travel one to two hours by public transport to their workplace in town.

36 The number of active operating art institutions in Caochangdi always fluctuate. This calculation was done by the author in July 2014.

Around 9 a.m., the streets in the north slowly calm down. The street vendors disappear, and the breakfast stands start to fold away their tables and chairs. Meanwhile, on the southern side of the village, the day has not yet started. Most art institutions open from Tuesday to Sunday, from 10-11 a.m. to 6 p.m. Shortly after 10 a.m., the murmurs slowly begin in the village's southern part: galleries start to open. Street vendors operating on tricycles shift their frontier to the street that sits in-between the residential area and the 'industrial' site, as they refer to it (see fig. 16 images to the right). The art institutions' buildings are usually very spacious, occupying between 400 to 1200 square meters of floor area. The spaciousness is magnified in my perception as they are operated by very few staff, typically between three and five. Walking around these art spaces, if you don't peek through the office doors, you will find nobody in the exhibition halls. During the day, local villagers roam around the village streets, walking their dogs, greeting their neighbors, and running their daily errands. They rarely take the smaller pathways between the galleries and studios. The pathways and the small open space within the red compound – a block of art institutions – appears usually deserted from Tuesday to Friday afternoon. They only get filled from Friday evenings till Sunday evenings, when artist talks, book launches, exhibition openings, and screenings take place.

At times, the daily life rhythms change at remarkable speed and frequency in Chaochangdi. During Caochangdi art festivals, art crowds from worldwide fill up large and small alleys, making their presence known by their moving bodies, music, and unexpected spatial appropriation practices (broadcasting, photographing, videoing etc.). At other times, during the 'two meetings[37],' for instance, the village streetscape becomes instantly pristine: all vendors and small businesses are notified that they must close, and the practices of artists are surveilled more stringently. Some changes affect the daily life of all social groups in Caochangdi, some only partially. In section 5.5.2, I redescribe two entangled forms of these rhythms. I call the first event 'drifting co-existence,' referring to the processes when different social and material entities come together in Caochangdi as a horizontally integrated, provisional whole. I call the second event 'obscure turbulence,' referring to the scenarios in which strict, incoherent and fragmented rules are imposed by external authoritarian actors. The first group of events describes the process when heterogeneous social and material bodies come together in Caochangdi, establish relations. The forms of relations get increasingly stable over time without any party monopolizing an overall ordering principle. The second group of events showcases how disruptions affect the existing composition. I identify the demi-regularities regarding the *patterns of perception* from different acting social groups in Caochangdi,

37 In Chinese, Lianghui (两会).The term is used by the mass media and in everyday conversation as a reference to the annual plenary sessions of the national or local People's Congress and the national or local committee of the Chinese People's Political Consultative Conference.

and *the forms of relations* inherent to, and emergent from, interactions among disparate social actor groups, in these two orientation processes.

Figure 15, Life rhythms observed in different areas and at different times in Caochangdi. On the left, from top to bottom: Street views in the northern residential side, in the regular mornings and late afternoons, at time of political inspection (during the 'two conferences'). On the right, from top to bottom: Street views outside art spaces, in regular mornings and afternoons; inside the red courtyard during exhibition openings. (Photo by Xiaoxue Gao, 2015.10-2019.3, Caochangdi, Beijing, China)

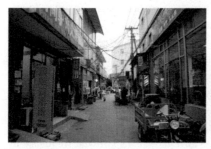
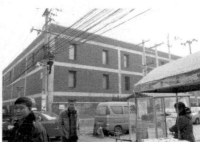

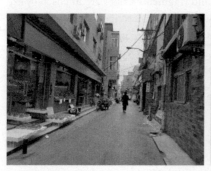
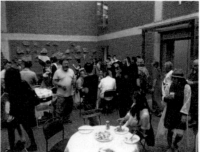

5.5.3 Multi-centered co-existence: space constitution at regular times

Caochangdi constituted by villagers and migrants

At about the end of 2013, I passed by a construction site where a local rural family was extending their private house. I got a chat with the head of contractor on-site, asked about the project's progress. He explained:

> Our clients, a local family, decided to extend their three-story house to five stories. They believe Caochangdi will not get *chaiqian*[38] (demolished) any time soon. After completion, there would be thirty-some more rooms available for rent! The new rooms are equipped with independent bathrooms, which was not possible with the old structure. The construction will take four months in total, and now there is just one more month ahead of us. The interior design and facility installations would probably take another one to two months, but the whole project could be finished before the Lunar New Year. [...] Design? No [...] we do not need that since it is a standard project. We have years of experience in building housing of this kind here in Caochangdi and other villages. We plan in our minds. The price [...] um [...] it is not expensive [...] Our client drops by very often to check the progress and discuss the preferred material and their prices with us as the project proceeds. They didn't have enough money to build a taller house a few years ago. Now they just seek the chance [...] (interview CVC3, translation and ellipsis added).

The contractor's narrative shows how hastily and proficiently self-built residential buildings come into being in Caochangdi. In 2014, I could find no vacant land or scaled courtyard housings left for further densification. The village's physical space was saturated. After chatting with a few locals, I recognized three incidents, which were perceived as crucial triggers for the frenzy construction between 2007 and 2010. The first event was that, the township-area office re-positioned Caochangdi as a creative industry tourism-oriented village. The villagers understood that the township administrators approved and encouraged them to lease land further and attract investment in the creative and cultural industry. They reacted thereby by building more rental rooms to accommodate the expected influx of art entrepreneurs, working on their collectively owned farmland. The second event being taken seriously by the local villagers was the release and enforcement of the *National Property Law* by the national congress – the highest legislative body – in 2007. The new law acknowledges villagers' rural land-use rights as quasi property rights. To utilize their new rights, villagers reacted by expanding their private housings on homestead land. Finally, every local in the village sensed the momentum of growth – in the wake of the upcoming Beijing Olympic Games in

38 Chaiqian (拆迁).

2008 (the third event) – more people move into the city and search for places to stay. In this context, of course, many jumped at the chance to build more and lease more.

Regardless, between 2007 and 2016, Caochangdi is also co-articulated and constructed by the local villagers, migrants, and members of the art community in the mundane everyday scenarios, in a relatively uninterrupted manner. As I have characterized in 5.5.1, these three main social groups have disparate political-economic backgrounds. In light of the everyday constitution of space, I redescribe their everyday interactions to see if and how their dispositional perceptual habits shape their practices and condition their interactions with one another in close physical vicinity. I begin by redescribing the everyday interactions carried out by local villagers and migrant workers.

These incidences, as mentioned earlier, were organized and announced more or less abruptly by different levels of administrations. On the ground, the local villagers and village committee were not able to anticipate the timing of their arrival, grasp the magnitude of new rules and resources, nor fully comprehend the subsequent impacts on their daily lives. Nevertheless, they responded agilely when strong signals reached them, actualized whatever was practically possible and made sense to them. I was repetitively told about the importance of following the *momentum*, do what your peers do: "some early movers have torn down their old houses and built three-story housing, and nothing happened. More and more families just imitated this, including me" (Interview CVC4). The villagers see their own community members and even rural villagers from the nearby area as good references. The underlying perceptual logic is that, they share similar social-economic conditions. Furthermore, if something goes wrong, the law cannot punish everyone when they are all offenders.

Gradually, more migrants have noticed the increasing amount of available housing supply in Caochangdi. The title of Ray and Mangurian's (2009) book *Caochangdi, Beijing Inside Out: Farmers, Floaters, Taxi Drivers, Artists, and the International Art Mob Challenge and Remake the City*, has aptly captured the heterogeneous social backgrounds of the migrants living and working in Caochangdi. The migrants I talked to – who make their living through informal contracts in VIC or city center – perceive the booming economy in Beijing and the low living expenses in Caochangdi as their opportunity. They may get twice or three times more salary for the same type of job compared to the same posts in their hometowns. Many are young, in their twenties, who hope to seize the opportunities to improve their quality of life. Some are elders in their late 40s or 50s, whose children are studying at home, they want to make extra money to support their family members. They both do not plan to stay longer, let alone settle down in Beijing or Caochangdi. They are aware of the temporal nature of their work status and their restricted

rights to housing quotas in the city. They also live without full access to local public welfare like medical services.

My interviews conducted between 2013 and 2015 confirmed what Ray and Mangurian called 'chain migration,' "the mechanism by which rural residents from the same village make a move to a large urban area, usually in search of work and better opportunities, aided by previous immigrants from their village" (2009, 124). Yet, I also met some actors who enter Caochangdi through contingent social relations, like friends on Douban[39] website, in addition to pre-existing private social connections, such as extended family relations, *laoxiang* (fellow man), colleague, or alumni relations. For example, Ms. Shen was around 50-year-old, working as a cleaning lady in an art institution. She first settled in Caochangdi alone and found her first provisional job by replying to a call on a poster. Her husband relocated to Caochangdi after her, works as an informal and sometimes Didi[40] taxi driver. Following him, his younger brother relocated to Caochangdi subsequently. The two brothers run a shared taxi business, take day/night shifts and pick up people travelling to and from Caochangdi. They find their business lucrative, as the lack of access to metro stations close to Caochangdi makes informal taxis a necessity, Shen explained. Particularly, when they take regulars from the village, they run 'black' and pay no money to the third party.

Most social actors carry out their lives in the village at regular times within their small circle of peers, like Ms. Shen, who does not know her neighboring tenants, as "they are mostly young people." At the same time, they are aware of each other's practical needs, willing to connect with other distant acquaintances. A demi-regularity is that 'the practice of renting' constitutes the very shared experience among actors in Caochangdi. Through *renting*, they build weak ties with one another. Shen suggested that she has a good relationship with her landlord, who is of a similar age. They chat and help each other out with daily chores (Interview MR1CS). Another example is Ms. Chen, who worked as a gallery intern. Chen told me that she got her room from her colleague, who quit her position shortly before. Her rental room was located in a four-story building in decent condition, comparatively spacious (22 sqm.). It is heated, with a single bathroom. In her building, she recognized two other art graduates – two young men and a couple of white-collar workers from an animation production company in the village. Through everyday encounters, Chen knew her neighbors' faces, but not much more, as "tenants move very often in Caochangdi" (Interview G3CJ).

39 Douban (豆瓣) is an interest-based social networking platform, whose main users are white collar urbanites and university students. Actors can form social groups under their music, film or lifestyles they share.

40 Didi taxi is a service provided by independent drivers via Didi platform. Its concept is similar to Uber.

Finding a basic room in Caochangdi does not require much money, time nor bureaucracy. In Jan 2019, the monthly rent for a single room around 20sq meters cost around 1600 RMB in Caochangdi, half the average price in the nearby formal 'urban' residential buildings. My informants recalled the procedure as simple as, calling the landlord by the number written on the poster, who then most likely comes downstairs immediately and shows one the available room. When a tenant is satisfied with the price and living amenities on offer, a one-month rental contract could be agreed upon within an hour. I often heard things like: "the landlord prefers to have us young artists or white-collar workers as tenants because we pay our rent regularly. They see us as trustworthy" (Interview G3CJ). However, stories about landlords revoking the contract clauses were common, especially when "tenants from nearby art villages undergo eviction. The rent in Caochangdi would get raised immediately. One has to choose between acceptance or leaving" (Interview EC1ST). Hence, for newcomers, it is not difficult to plug into and reinforce Caochangdi's weak social-material ties through finding temporary accommodation or informal jobs. In the context of highly dynamic VIC, social actors accepted the norm of reaching short-term solutions via mediated weak ties. These weak relations are perceived external, hence often not do sustain in a network of flexibility. The collaborating social actors re-evaluate the quality of their relationality (i.e., with an informal landlord) when new actionable elements (a regulator/higher bidder) enter the network. The everyday interactions across these social groups constitute thereby a network of heterogeneous entities connected with *relations of exteriority*.

The missed opportunity referred by the contractor above was an abrupt order issued by the Chaoyang district government. It was propagated through the village committee to all inhabitants in Caochangdi, about Caochangdi's demolition in 2011. This notice claims that Caochangdi area fell into the planned land-bank conceived by the Chaoyang district administration. Concerning 'public interests,' Caochangdi area is requested to be converted to urban land to fulfill the greening and development plans of the municipality. The villagers could be compensated with resettlement apartments elsewhere and/or monetary compensations. Judging by my local villager interviewees, they interpreted the notice as a positive opportunity to improve their economic status. With the demolition order in sight, between 2009 and early 2011, they built more at faster speeds. They took similar land-retrieval and demolition cases in other VIC in Chaoyang district as reference and motivation. From their perception, the more housing square meters they own, the more money or apartment compensation they could later obtain (Interview CVC4).

The 'responsive construction' carried out by the villagers, the 'responsive renting, job-seeking and socializing' carried out by the tenants can be identified as prereflective practices. They are enacted as the first-order commentaries, subjected to

a sense of immediate opportunity and risk. I call it a shared risk-driven perceptual pattern. I would argue, it is condemned by local villagers, migrant workers, and freelancing artists' long-term deprived political and economic agency in urban-rural systems and access to transparent information. I would also argue, the coming together of the local villagers, migrant population, and art community during regular times was, in some way, a result of shared perceptions of (substantially different) risks. For the most part, the actors' daily practices *drift* with the peers they recognize situated in similar social-economic scenarios. The overwhelming sense of risk makes it harder for anyone to form a clear and coherent orientation. Drifting together, their personal identities are absent.

I would not argue for a common frame of meaning consciously shared among these heterogenous social groups. In my interviews, I could barely recognize any villager who could recall the names of the galleries or the iconic artists living in Caochangdi. As indicated, the social backgrounds of the actor groups in Caochangdi vary significantly, so are the frameworks of meaning applied to construct their everyday space. In terms of 'resources,' the material distribution across the social groups is *vertically* disintegrated, which hinders the discrete social groups from perceiving each other as part of an interest-sharing totality. Concretely speaking, Caochangdi's rural public infrastructure is mostly funded by the rent collected from non-local entrepreneurs and art community. Yet, for the individual local villagers, such a connection is not easily perceivable. Since 2011, the processes in which the land rental revenue materialized into the public facilities have become *more vertically mediated*. The value-added tax generated in trading artworks and other relevant businesses in the village is firstly channeled to the Cuigezhuang county[41] tax bureau. The redistribution then takes place on the municipal level in the form of project-based financial transfer payments and rural social welfare. Furthermore, even rent is anonymized in the long chains of transactions between the gallery representative and developer, between developer and village committee, village committee and the individual villager. This long chain of interactions makes the transaction functional, mediated and impersonal. The question of meaning would only occur when conflicts arise. Moreover, for the local villagers, the meaning of rents is immediately attributed by the village committee as a communal bonus, further strengthening the perceived hierarchy between them.

During my stay in Caochangdi, I have also observed new intersectoral practices. It includes artists operating art cafes, vendors at the farmer's market, and village leaders patronizing contemporary artists. These practices, are although transient, allude to horizontally integrated parts of Caochangdi. A concrete example is that

41 Some galleries registered elsewhere in Beijing city, while physically locate in Caochangdi village. In this case, they pay tax to the jurisdiction of registration than location.

when exhibition openings took place in galleries on Saturdays, villagers, migrants, and their children living in the village would be the first to arrive. Over time, these non-art inhabitants of Caochangdi have learned about free pastries and drinks served at the art events. They feel happy to have a taste but still intimidated to interact with the art community. Nevertheless, the staff at the art institutions, having their neighbors' visits in mind, would put out some snacks before the art community's arrival.

By and large, divergent social actors' day-to-day interactions unfold through *weak* but *horizontal ties* based on shared perceptions of risk, practical needs and opportunities, i.e., informal contractual ties, provisional business cooperation. One can also notice traces of sympathy. In the everyday scenarios, due to the lack of transparent and integrative communication structure, these actors although co-constitute Caochangdi on a daily basis but fail to discern the actual meaning structure that underscores the others' practices. Yet, these risk-averting, practical and opportunistic practices come together in multi-linear events, give form to rhythmic placements among heterogenous social bodies and material entities (see fig. 15) without a spoken plan. These cross-group interactions materialize into more or less transient placement, like short-term rental rooms, rotating usage of streets, provisional parking places, makeshift posters, and external staircases as the exclusive entrance. These intricate changes make Caochangdi a dynamic and static space at the same time.

Caochangdi constituted by the art community

Now, I turn to redescribe the art community's routinary perceptions, practices, and ways in which they relate to other social bodies and goods in Caochangdi, both symbolically and materially. All my informants repeated the narrative: Caochangdi as an art village began from the relocation of Ai Weiwei's studio in 1999. Ai rented out a piece of land from the village committee, conceptualized and built his studio there. Later, together with partners called Hans van Dijk and Frank Uytterhaegen, he found the first gallery in Caochangdi, named CAAW. After the relocation of Ai's studio and gallery, a resourceful local villager called Sun leased a few plots of land from the village committee in 2001. Sun constructed several factory and warehouse-like structures while having no concrete investors or businesses in mind. Later, a few artists and gallerists, socially connected with Ai, responded to Sun's call and rented and transformed those structures into studios and galleries.

As indicated, the main gallery block in Caochangdi is called the 'red courtyard.' A similar story was told about the origin of this block. Through the mediation of Ai, an artist-entrepreneur named Mao obtained a 20-year lease contract from the village committee for several plots of vacant land. Mao planned to build spaces for art institutions and commissioned Ai to design them (Wang 2012, 28). The design

was quickly done, consists of reasonably simple structures and the cheapest local material – brick and concrete. In his book *Fake Design in the Village* (2008), Ai has documented his own studio's building process. This 400 square meter space was constructed in 1999 by a team of local construction workers in 100 days, costing just 100,000 RMB[42]. Although I wasn't able to obtain an updated cost of building in Caochangdi during my field trips between 2013 and 2017, I have observed the same building structure, material, the contractor team are still at work. The buildings are constructed at equally fast speeds. Therefore, I could infer the costs remain cheap, especially in comparison to the costs of land price and construction in urban Beijing.

Figure 16 The bricklayers at work, constructing the red brick galleries in the red courtyard, March 19, 2007. (Photo from Eduard Kögel, ed. Ai Weiwei Beijing. Fake Design in the Village. Berlin, Germany: AedesLand. 2008, 54)

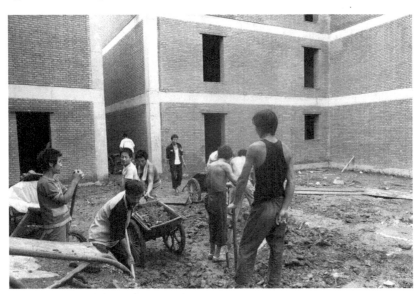

The subsequent storyline shared by the art community is, artist individuals transformed those pre-existing abandoned factory building structures into art spaces. They acquired access to the buildings mostly through sub-letting from

42 According to the exchange rate (1: 8.28) between USD and RMB in 1999, issued on the Statistical Monthly by UN, 100,000 RMB equals to 12077 USD in 1999. Source of reference in Chinese can be found on the website of national statistical bureau, http://www.stats.gov.cn/ztjc/ztsj/gjsj/2000/200201/t20020111_50742.html

local villagers (who rent from the village committee) or previous entrepreneurs (Interview EC1ST). The tenant turnover in Caochangdi was high, the frequency correlated with the global economic crisis. Non-Chinese galleries often react faster in retrieving their financial investments. Nevertheless, the buildings are constantly re-filled by new aspiring gallery and off-spaces owners through second-hand or third-hand leases. I confirmed this narrative. In early 2016, I found that only 12 out of 28 art institutions sustained more than five years of operation in Chaochangdi. The remaining ones are the most prestigious galleries and art institutions in China's contemporary artworld.

Despite distinct storylines told and the stakeholders involved, the art community follows a similar principle in structuring their dwelling and constructing practices in Caochangdi as with the villagers. Their practices can also be characterized as a fast *reaction* to changes (increasing risks, profits) in the art market and *drift* with the tide co-created by their peer groups. Most art institutions came to Caochangdi between 2005 and 2007, when China's art market was thriving (Interview EC2YB). Prestigious international galleries chased the opportunities in the thriving art market from global cities like London and New York to the art villages in Beijing's suburbs. The art spaces in Caochangdi were not erected according to a collectively conceptualized plan but constructed gradually, in batches, by many actors. Nevertheless, the placement of the art institutions in Caochangdi was assembled by a few well-connected actors in the center of this scene. The red and grey courtyards designed by Ai Weiwei were mostly rented to a small group of established art institutions and individuals. These buildings offered perfect solutions to the gallerists and directors who seek spacious and affordable space for exhibitions and want to remain close to the city's expensive art neighborhoods in Chaoyang-Wangjing area. The magnetic elements include the 798-art district, the art academy CAFA the Liquor factory art zone, art villages named Heiqiao, Huantie, Jinzhan 008...

When asking these actors why choosing Caochangdi, I got two common answers: "to know the people" and "ride the wave/momentum[43]."

> Back then, the rent rose extremely fast in the 798-art district. We saw more and more artists and institutions moving to Caochangdi. We sensed a positive momentum in Caochangdi. Also, considering it is very close to the ring road and airport, we relocated here (Interview CR1LJ).
> I knew Ai Weiwei when he was living in New York, and we had already collaborated in our New York space in early 2006. Late that year, when I visited him here (Caochangdi) in his studio, he suggested that I should open a new space in Beijing [...] He took me to the site, and it was still full of trash [...] I thought ...hmm But

43 Jieli (借力) or Jieshi (借势).

next year in February, all the trash was gone, and I could easily envision a promis-
ing cool gallery space based on the already built-up foundations. This space here
allows us to experiment with big group exhibitions in Beijing. We can gather the
feedback there from the market in Beijing, and we can then (better) select the
group to exhibit in NY (Interview G1MC).

More concretely, *momentum* refers to the positive *atmosphere* exuberate from the
agglomeration of established art individuals and institutions in Caochangdi who
possess rich social, economic, and cultural capitals. A plurality of individuals, so-
cial and material resources come into relationalities around multiple centers (key
figures and institutions). The for-profit art institutions in Caochangdi share the
cohering principle of 'profitability.' Due to the ambiguous nature of 'collectability'
in the contemporary artworks, sharing client resources within close professional
networks is at the core of the gallery's business operation. One of my tasks as a
gallery intern was to guide distinguished collectors from various parts of the world
in Caochangdi, walking around the institutions and studios that share tight *guanxi*
with my employer. Moreover, artworks are material whose devil lies in the visual
details. The art institutions' physical closeness is also crucial for collectors to see,
feel, and compare the pieces. I was told that "global art collectors and critics have
very tight schedules in each city, some of them just half a day in town. Once they are
in Caochangdi, of course, we shall let them have a quick look at what is presented
in our friends' spaces" (Interview CR3YM).

 Placements of art communal members centered around 'fun' and 'artistic
knowledge' are also common in Caochangdi. From year to year, the art com-
munity, especially the non-for-profit ones and the freelancing individuals in
Caochangdi come together as temporary collectives in the forms of festivals, sum-
mer camps or pop-up parties. The Caochangdi Art Festival in 2012 was initiated
by very few prestigious non-for-profit art institutions. It was instead organized
in a decentralized and voluntary manner, funded by crowdsourcing. Each par-
ticipating institution was invited to open their doors and plan their exhibitions
independently while keeping in line with the festival's timetable. The event was
crowdfunded so that each participating gallery is asked to contribute only a small
amount (5000 RMB, around 625 Euros) and non-for-profit art spaces for just half
of this price. The fund was raised just to cover the shared publicity material, while
all the administrative work was voluntary. For the first time, Caochangdi's art
institutions were represented together as a collective. (Interview CR1LJ).

 Such horizontally integrated organization and collaboration exist mostly tran-
siently, such as during the Beijing design week (fig. 17 to the bottom) when a shared
other (audiences) was in sight. On regular days, most art spaces schedule their
programs independently. Caochangdi is in not short of spontaneous parties (fig.
18), related or unrelated to exhibitions or businesses. The principle is that friend's

friend is another friend. Yet, institutionalized associations like workers' unions or tenant's associations do not exist in Caochangdi. Despite stronger ties (formal and informal, external and internal) exist among many art-related individuals and institutions, the multi-centered art community in Caochangdi as a whole cannot be considered as an institutionalized community form.

Figure 17 Top: Representation of the art institutions in Caochangdi as a collective during the Caochangdi Art Festival (2012). Down: Representation of Caochangdi as 'community' during Beijing Design Week (2014). (Illustration retrieved in October 2017, from http://201 7.bjdw.org/bjdws/FHC/FHC201719.html)

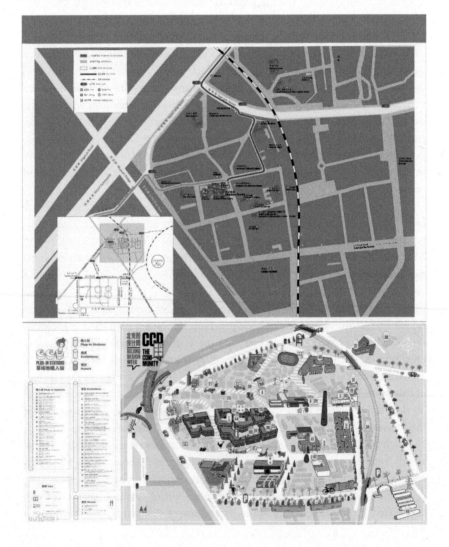

Figure 18: A scene from regular weekend party organized by artists living and working in Iowa studio compound in Caochangdi village. It opens to spontaneous guests. (Photo courtesy: artist Zhang Ruo and Zeng Yilan, Caochangdi, Beijing, China)

5.5.4 Obscure turbulence: re-assembling at disruptive times

I have so far redescribed how social groups carry out their daily lives in routines and interact with one another in Caochangdi through flat, weak, and mediated social ties during regular times. These practices shape the multi-centered configurations of the social and material bodies in Caochangdi during uneventful periods. By eventful, I mean particularly the times when external authorities challenge the legal status of land and housing uses. Informal land uses and rental practices in Caochangdi, as in all the other VIC, are deemed as a potential landmine by all stakeholders. It is so powerful that, once triggered, can overthrow the enduring symbiotic social-material co-existences between the art and non-artworld observable in Caochangdi. One gallerist from the red courtyard told me that despite having a rental contract with the developer – a 15-year written lease contract – in black

on white, he would not exclude the possibility of being evicted overnight: "the de-molition order was like the story of the wolf coming from Aesop. No one knows when the actual wolf is coming or even who the actual wolf is" (Interview G1LC). Re-describing and analyzing the events of movements and re-assemblage of the art and non-artworld in such times are the goals of this section. I opt for non-repre-sentational theory (by Thrift), as the concept of assemblage centers on the ongoing processes of forming associations among heterogenous social entities.

As mentioned, around August 2009, one turbulent event occurred in Caochangdi: all villagers and tenants received a printed notice from the town-ship-area administration on behalf of the Chaoyang district administrations. The township representatives would take action to register and measure the existing properties in Caochangdi in short due. According to my informants, the art community in Caochangdi presumed, this order prepares for the villagers' relocation and compensation. They learned from previous cases that demolition come shortly after. Yet, nothing happed in the subsequent months. In April 2010, the art community was further noticed by Caochangdi's village committee, that all buildings in the area would be demolished in a short-term period. An exact deadline remains to be announced. A colleague who experienced this event recalled that "the second order of eviction came from the village committee. It sounded more concrete than the first one, and we have all believed it. The survey company came and measured the villagers' homestead and housing. They (local villagers) actively supported the demolition and aspired for getting rich through high compensation fees" (Interview IA6ZR). In the eyes of the art community, the village committee, together with the villagers, have betrayed their rental contracts and upheld the demolition order. The ambiguous legal prerequisites of renting in VIC left the art community in a disadvantaged position to defend their contract. The art community also believed that the village committee has some authority behind such a decision. If the demolition order got enacted, the rental contracts that bind artists, founders of institutions, and the village committee together would be immediately invalidated.

The demolition did not occur in 2010. I was intrigued to understand the full threads in this event regarding what has happened in resolving this turbulence. What has spared Caochangdi from the tragedy of destruction? As I proceeded with my interviews, I realized that different groups had very distinct reasoning based on what they knew from their relative positionality. They enacted actions and re-formed alliances based on their extrapolations of how the authority or the major-ity would associate and act. One villager informant stated that she and her family were entirely sure about the execution of the demolition order, as it had already oc-

curred in several nearby villages[44] in Chaoyang district. Before executing the order, a resettlement plan had to be settled that satisfied the expectations of all stakeholders. She recalled, some villagers were unsatisfied with the uniform compensation plan offered by the administrators and developers due to the size and quality difference of their properties. These villagers assumed that their peers would fight together on this position, especially the village leaders. The villagers were split into two camps. My informant addressed, "I did not care about what the others want; for this house we have here, I need four more resettlement flats or an equal amount of monetary compensation for my family" (ibid.). However, this appeal was eventually left ignored. Another informant told me, the village committee reported later that the district administration gave up on Caochangdi due to its meager size and problematic electricity infrastructure. These factors made the area unappealing to developers (interview CVC4).

On the other hand, a curator informant told me an entirely different story. According to him, the happy ending was hard-won through a joint effort among the art community residing in Caochangdi and their strategic alliances with higher-level administrators.

> Rongrong, the Caochangdi art festival's core organizer, has some connections with those artist deputies participating in Beijing's Congress meeting. They have helped to draft a petition letter with all the signatures from the art community here in Caochangdi. Both the individuals and institutions showed real solidarity in standing for our spaces. Many friends who work in the media have also reported on this incident. They convey their sympathies to the artists while criticizing the short-sightedness of the government. I also heard that some established artists pulled some strings with people working in the ministry for culture. That is how the district politicians issued an exception order to cease their action [...] (Interview CDA4C, translation added)

The stories told by the villagers, the artists and the curator contradict each other in the empirical domain. Yet, according to CR's stratified ontology, they might all be true, according to the events they have experienced. These narratives help to reveal the underlying plural generative mechanisms and their interactions transforming the artworld in Caochangdi. In my field trip, I was often surprised by the artists and gallerists' lack of knowledge about their renting contracts' legal status and the participating parties' legal liabilities. The village committee, the immediate and primary landlord, did not disclose all legal risks to the art community and other

44 According to the report on New Beijing Daily, by the end of 2011, 9 villages (de facto VIC) located at the urban-rural interface in Beijing Chaoyang are to be demolished. In total 4 square km² of collectively owned rural land are reclaimed, and repurposed for village resettlement, urban green belt, and road and industrial constructions (Tang, January 13, 2011).

migrants. Moreover, the art entrepreneurs and individuals generally have no idea about the plural political bodies and their fragmented administrative agendas regarding the development of Caochangdi. Even when the contract is declared legally sound, the Beijing Municipal Bureau of Land and Resources's higher administrative decision-making power (over township and village administration) can make the final decision, the land reclamation invincible.

Confronted with two distinctive explanatory narratives from my interviewees, I decided to triangulate the process by requesting interviews with the village committee. However, my requests were rejected. Nonetheless, the reports from the Caochangdi administrative committee's homepage – a website run by the village committee – shed new light on what might have (also) happened. Several reports were released under the *lingdao shicha*[45] (leaders' visits) in March 2010 – three weeks before the eviction order was distributed. One news piece reported that Caochangdi village leaders had accompanied the politicians from Chaoyang district on their inspecting trip to research the development of cultural and creative industries in Caochangdi village. The village leaders proudly presented the art institutions as their achievements to the township and Chaoyang district-level politicians. The reports implied strongly that the district politician was impressed by the flourishing creative& cultural industrial scene in Caochangdi. Credit was given to the village committee for their support to the art community and entrepreneurs. If these reports represented the village committee's real political-economic motivation, it is incoherent with that known by both the villagers and the artist community.

Having no chance to access the full communication processes among all stakeholders, such as correspondents among the township area office, district administration, and politicians from the ministry of culture, I have to admit that I cannot reconstruct or represent the full picture of the events in the actual domain. In line with the spirit of non-representational theory, representations are highly likely to be deceitful in this case. To me, it is neither a theoretical nor empirical necessity to know whose description is closer to *the* 'truth,' as the truth might consist of plural generative mechanisms interacting with each other in this case. The ways in which heterogenous actor groups *react* and *re-associate* according to what they have experienced, believed to be real and feasible is of significant research value, as we can probe retro-ductively to find the generative mechanisms. This approach also coincides with what Ingold claims, "to perceive an object or event is to perceive what it affords" (Ingold 2011 [2000], 166).

In this case, when practically no one had the agency to access all relevant information nor engage with the entire ongoing process, all my informants have ex-

45 Lingdao shicha (领导视察). Relevant reports, see http://ccd.grwh.cn/2010/lingdaoshicha_03 22/843.html.

pressed their senses of the evasive, risk-laden atmosphere that *emerged* in their experiences of the interminable events. The non-representational theory addresses the *background spatial and temporal conception* that illuminates the schemes that actors employ for interpreting and justifying their practices. I would claim, the socially divergent actors' experiences of incomprehension and disorientation have propelled the previously formed horizontal associations across social groups into a new, unexpected shape.

The issue of *affordance*, to my understanding, comes to the fore in understanding the socio-material re-associations during these events of 'obscure turbulences.' In the context of irregular and changing conditions, the symbiotic, intermediary and weak horizontal coalitions were challenged. The artworld in the Caochangdi are noticed to de-materialize hence facing de-territorialization. The social actors' instantaneous perceptions thus create responsive and practical knowledge for re-associating and re-territorializing. Their interpretations *emerge* from reactions against the contingent top-down orders. Drifting or aligning with what 'peers' do remain common, but how social groups place themselves against one another became very different. I was informed that the wealthier local villagers re-grouped with the village committee in this turbulence, associated by their interests in defending shared material possessions, the homestead, private housings, or another current 'absent' but 'possible' form of them, the 'compensated apartments.' The art community re-grouped – through the mediation of various well-known artists – with the ministry of culture, associated by their shared interests in defending studios, galleries, creative industries, art events and so forth, or more precisely, Caochangdi as a space of all these possibilities. Such rapid re-orientations and placements are not easily grasped in relation to one's habitus, conventional normalities, or principles of capital accumulation and class conflicts. As the turbulence escalates, all social groups' re-associations have willingly or unwillingly reinforced the political decision-making hierarchies and urban-rural divide. Each group resorts to an 'affordable' vertical and asymmetric social relation with actors of higher status in the political hierarchy, with whom they believed their interests are aligned. Whereas, at regular times, art community members intentionally distance themselves from the politicians, if not position themselves on the opposite side. I would claim, the art community's power-submitting practices amid the disruptions do not necessarily constitute their everyday practices. This alludes to the dynamic conflicts between a vertical urban-rural (heterophilous) and versatile horizontal (homophilous) interactions.

Another critical message the non-representational theory sends is to examine the shifting re-definitions of the parts and whole and the modes of motion occur repetitively. In late 2016, I saw a brand-new art compound standing on the southeast edge of Caochangdi. It consists of some nicely built studio spaces, greened with planting and flowers. Two gated entrances were set up, unlike the other un-

guarded 'grassroots' art spaces. I heard from one tenant, an owner of a video studio, that the compound was built by a developer, who obtained the legitimate land lease from the Cuigezhuang township-area office. He suspected that the Caochangdi art village would obtain the legal status of 'art district' from Beijing's municipality, just like 798-art district did. Just when I was about to believe him, at the end of July 2018, news of studio demolition broke out in Caochangdi once again. Eleven days later, two galleries, several studios, and a restaurant were confirmed to be the target of this round of demolition. I was not in Beijing when this event occurred but was informed by one artist who witnessed it. According to Lu, the artists had contacted the village and township offices who responded that their studios fell within the 'green zones' of the railway: "it violates the planning codes according to Beijing general planning 2016-2035" (Interview IA6ZR). The studios were categorized as unsafe structures.

Though the railway has always been there, long before any artist moves into Caochangdi, this sectoral order targets the illegal building structures and the lack of a buffer area around the green belt. It ignores the other forms of lives unfolding in Caochangdi and how such partial interventions may break the balances they have reach with other social beings and entities there. Lu mentions that the developer of this plot of land owns a valid contract with 13 remaining years of permitted land use, while tenants have valid contracts with the developer for 3-5 years of architectural use. The two poor victim artists had just finished the interior renovations one week before the arrival of the demolition order. The narratives from the victim artist are that "the developer was on the same side as the village committee. We infer that this piece of land has been sold to someone else. The developer must have been compensated already. He simply disappeared and was uncontactable after we got the demolition order" (Interview IA6ZR).

As in the previously described events, new social and material bodies come to form provisional assemblages. The third-party demolition contractors, the village security guards are recruited by the Cuigezhuang township-area office to ensure the implementation of the top-down order. They have brought the excavator, roadblocks to forming their provisional spatial assemblage. The non-inflicted art community members come to join the protest initiated by their peer victims, while journalists and curators produced news bits to expand and strengthen their provisional assemblage. Nevertheless, the demolition took only five days, or to be exact, five nights, as demolitions are carried out in the evenings. This time, the demolitions were much smaller in scale and faster in speed. The inflicted art entrepreneurs and artists failed to reach to any higher politician for help. I take this event as the epilogue to my study about Caochangdi, as the way it evolves repeats what has happened between 2010 and 2011 and many small incidences between 2012 and 2017. This shows that, for all social groups, the hierarchical and fragmented governance remains dormant or absent in their everyday perceptual and practical constitu-

tion of Caochangdi, the social and material bodies come together horizontally as a loosely structured, multi-centered, provisional whole. In the event of mighty, external interventions, the shared senses of fear and risk-aversion have triggered the perception of political hierarchy and practice of submitting to a higher authority. Another intriguing aspect is the recurrent cyclical trend whereby the totality of Caochangdi shifts from being relatively integrated to relatively disintegrated and back again.

5.5.5 Summary

To summarize, in light of the ontological-methodological link proposed in Critical Realism, I have mobilized the space of economics (by Harvey), the constitution of everyday space (by Löw) and non-representational theory (by Thrift) in this chapter, to give manifold descriptions and explanations of a complex and dynamic phenomenon, the artworld in Beijing. It is exemplified by the case of Caochangdi art village. Probing into the empirical materials retroductively, I have identified several demi-regularities regarding the changing modes of practices and associations among heterogeneous social and material bodies.

Most art historians and critics see the own history of Caochangdi as utterly unimportant: not many native Beijingers know this name and its mode of existence. Its transformation process resembles that of many villages in suburban Beijing. On the contrary, I read and analyzed Caochangdi first and foremost as a village-in-the-city, whose particular geographical, social-economic, political positionings matters to explain the artworld-constituting events occurred there. Applying the lens of political economy (by Harvey) retroductively, I have captured the rural actors' slow reposition and re-orientation in a fragmented and dynamic urban-rural system between 1990 and 2017. It is particularly due to Caochangdi local community's and land's ambiguous rural status, their changing political and economic interests/values, make the inflow of the artworld and the materialization of art spaces possible.

When applying the lens of the everyday constitution of space, I have captured, how at regular times, divergent social groups come together in Caochangdi, forming a horizontally integrated and multi-centered whole. Milieu-specific perceptions and practices are at the core of understanding the constitution of relatively homogeneous socio-material constellation. I was able to identify how milieu-specific perceptual patterns propel a social group (the art community, the migrants and local villagers) to form particular daily rhythms, alignments with in-group, out-group members and particular materialities in Caochangdi. These constellations have porous borders, which regularly interlace with that constituted by other social groups. Across these groups, coordinated practices based on a shared pre-reflective sense of risks and profitability are also noticeable. The causal agents proposed

in Löw's conceptualization of space, the 'repetitive everyday doing' and 'habitus,' can well explain how different modes of lives appear coordinated and materialize as mosaic landscapes in Caochangdi. In addition, at both the regular and disruptive phases of Caochangdi's developments, central figures (like resourceful local developers, established artists like Ai Weiwei or Rongrong, the village leaders) play significant *mediating* roles in translating, and hence bridging the epistemic gaps across the groups. The mediators and translators facilitate the process of translation and reconciliation of the heterogeneous interpretive schemas employed by disparate social groups, who can thereby co-function in the absence of clear formulated rules and transparent multilateral coordination.

At *disruptive times*, the demi-regularities are the swift disintegration and regrouping among social actors and material entities. By adopting a weak epistemological principle from Thrift, I am propelled to ask how particular new relations appear and hold together across differences and contradictions? I have captured, when disruptions like forced evictions and demolitions occur, everyday interactions based on weak ties cease to-exist, fear, distrust, anger and duplicity emerge. New forms of vertical relationalities arise in the Caochagndi assemblage, when the distribution of agency and ordering principles are re-negotiated. Actor groups re-associate with their perceived peers and act in coordination with political authorities within their reach. In this context, undoubtedly, the agents' vastly different indoctrinated perceptual and practical schema explains to a great extent what material entities they choose to hold on to and with whom they choose to associate with. However, the introduction of new political bodies, the emergence of new hierarchical order, and the transient forms of re-orientations observable in turmoil situations, can not be well explained by 'repetitive social doings.'

It is not helpful to simply state that social actors' indoctrinated schema is fallible. Or, their outlooks or practices are always affected by contingent social factors, which are not thoroughly diagnosed or discursively penetrable to them. In this context, I have identified 'hierarchy' yields an underscoring affective and cognitive ordering principle in people's perceptions and actions. A hierarchical sensible-cognitive structure (my claims in 3.3.2) is mobilized by actors across social groups at turbulent times. It emerges only when it gets triggered. This structure is indispensable in explaining why some villagers stop collaborating with the artist and entrepreneur community, relinquish their economic values associated with private housing, homestead, and collective farmland, re-group and re-orientate with the village committee when negotiating with the urban administrators. It also explains the anomic practices of the art community. Facing top-down imposed eviction and demolition orders, they choose to ally with municipal and state ministerial authorities, who own higher political agency regarding the development orientation for Caochangdi. In each turbulent event, the actors' perceptions of, and submissions to, an asymmetrical power relation explain how such different spatial and

temporal processes are drawn together at these conjunctures and made stable. To deploy the lens of non-representational theory help me to uncover the generative mechanisms of these events on the level of affection, in relation to the nominative political-economic structures. In these events, the territorialization and re-territorialization of new social-material assemblages can be interpreted in the dynamic balance between the co-existing vertical (heterophilous: fear, reverence) and horizontal (homophilous: trust, intimacy) generative emotions. They make up the continuities and discontinuities of the artworld in Caochangdi.

6 Conclusion

Beginning with the simple goal of understanding how a particular complex spatial phenomenon (Beijing's contemporary artworld) has come about, endured and transformed in the contemporary Chinese urban context, this research has taken a big but necessary detour. The contemporary artworld, just like many social-spatial entanglements recently emerge in China's first-tier cities, has been formed by a multiplicity of contemporaneous processes. Yet, until recently, spatial phenomenon situated in contemporary urban China are mostly described and explained via learned notions, linear laws (see, e.g., Ma and Wu 2005b; Chen 2018; Wang and Liu 2015). There are rarely any methodological reflections made on generating context-sensitive knowledge regarding such situated, complex but common, social-spatial phenomena.

At this point, a logical solution is to simply avert substantial lenses, resort to the relational theories, or grounded theory for space-related knowledge production. Nevertheless, the relational position is broad and far from coherent. The grounded theory renders one's research particular, hence insignificant. I have shown the epistemic complexity in thinking of space relationally. The three prominent traveling relational spatial theories under scrutiny here (see chapter 2) build on divergent social ontological and epistemological footings. Meanwhile, the traditional Chinese thoughts – Confucianism and Daoism – demonstrate inherent relationality on both ontological and epistemological levels (see chapter 3). Moreover, chapter 4 has shown how local epistemic context and communicative rules play out in the recontextualization and production of spatial knowledge.

For a pragmatist, this problem could be solved by employing mixed theories and methods, carrying out multi-linear research to triangulate one's arguments and knowledge produced. However, to me, this 'solution' is chaotic at best, if not conducive to acute epistemic conflicts and confusions. The applications must be done in such a way that differently defined epistemic forms do not get conflated, and epistemic rules are kept coherent. One shall also attend to the *limitations* of their explanatory power and the *possible incompatibilities* with the contextual knowledge hold by subject-to-be-known. In this concluding chapter, I first re-address how I have employed CR ontology, developed a roadmap to engage with method-

ological pluralism without reproducing epistemic fallacy. Following this, I conclude on the challenges of conceptualizing space relationally for studying contemporary urban China.

6.1 Critical realism and compressed modernity studying space relationally with plural social-spatial theories

When facing plural (European and Chinese) theories and Chinese reality, one would inevitably experience epistemic uncertainty, and ask, which ones shall I employ for best understanding my subject, and how? Like all important questions, there are no easy answers. This question has been raised previously mostly by researchers whose research subjects locate in a culture/social context other than their own. In this book, this question is raised in the Chinese urban context, in condition of compressed modernity. It means, the constituting entities of the urban phenomenon (materials, capital, social actors, technology, nominative rules, practices, and so on) may have travelled from different corners of the world (mainly from the Global north). Moreover, the phenomenon-relevant events on the actual level may be generated by both trans-local and local structures. These challenges are common for researchers whose research subject locates in the rapidly transforming regions in the global South, where development processes unfold in a relatively untransparent and compressed manner: post-plural knowledge and entities entangle temporally, converge partially and evolve quickly. Particularly in the context of the late-moving developing countries, although every social actors' experience is ultimately touched by global social processes, but only the social elites get well informed and entitled to act reflectively. As I have indicated in the introductory chapter, amidst the challenges of epistemic uncertainty, this research resorts to CR's meta-theoretical position to build a sound methodological pluralism approach, for studying space relationally, and context-sensitively under compressed/late/second modern conditions.

Following CR, to overcome epistemic fallacy, I see the social-spatial reality as stratified and intransitive. It entails hierarchically ordered domains of the real, actual, and empirical. Bhaskar distinguishes the "transitive" and the "intransitive objects of science" ([1975] 1978, 36–38): between categories, theories, and conceptual frameworks on the one hand, and the real entities, mechanisms, structures, and relations that make up the natural and social world on the other. In other words, CR is pluralist in terms of epistemology. One is thus disillusioned from engaging static, substantial 'transitive objects of science' to define the 'Chinese reality.' One is also freed from equalizing 'social reality' with presupposed or empirical imageries, normativity, representations of essential (political, economic, and cultural) attributes, or demarcated territorial entities. One is further disillusioned from characterizing

the mechanisms of any observable social-spatial from *either* the informants' *or* the researcher's perspectives.

CR offers no specific explanations for empirical inquiries. It requires one to resort to substantive theoretical lenses to redescribe and analyze the phenomenon of interest. I consider the phenomenon to be laden with theories, but not determined by them, in the sense that all theorizations are potentially fallible, but some may be closer to represent the structures of reality than others. I claim the reality of Beijing's artworld to be also *stratified*. In the empirical domain, it consists of the narratives, experiences, and practices I see, hear and sense during my field trips. From this fragmented information immediately gathered in the empirical domain, and epistemic forms derived from the initial theories, I manage to reveal and capture the artworld constituting events in the actual domain. These events are generated by plural mechanisms and structures with enduring properties in the real domain.

In the empirical section, the chapter five of this book, I have demonstrated the procedure and utility of such a methodological approach at a full length. I have taken three relational (social) spatial theories as initial theories, whose levels of analysis are prescribed on the level of political-economic structure, of practice and of pre-cognitive, affective sensations. The postulated causal agents are 'the law of accumulation,' 'the recursive practical structure,' and 'the relational affective and sensual structure.' I have also introduced my own hypothesis of the hierarchical sense and cognitive structure (derived from chapter 3.3) as an initial causal agent. When deploying these multi-scalar initial theories retroductively, various visual, discursive, and sensible data *become* relevant, which helps the researcher (me, in this case) to picture out the different but complementing field-constituting events.

Subsequently, more and more transitive empirical materials and intransitive notions are revealed and mobilized into redescribing an event with enough details for comprehensibility. Following the prescribed causal agents in a selected conceptualization, one can ask the "what if" questions and identify demi-regularities. For instance, while engaging with the political-economic lens (by Harvey), following the principle of accumulation based on methodological holism, one is led to picture and redescribe the occurrences of events around the material and knowledge distribution, monetization and materialization, labor division, and modes of production. I am led to ask, what if the laws underlying the production of *tizhi-nei* and *tizhi-wai*; art district, biennial, public and individual art, are accumulation of social, cultural capital, and economic capital? Can I identify the tendencies of stratified social class, labor division, and spaces of distinction?

As indicated in 5.3.4, I argue, the relation between the normative ensembles of *tizhi-nei* and *tizhi-wai*, does not reflect dialectic forces and relations of production since its inception. Moreover, as time goes by, one can identify the increasing fluidity across the previously segregated nominative artworlds, in their forms of

254 Thinking of Space Relationally

productive means (state-funding or market; domestic cultural domain or international one) and modes of production. Individual bodies come to occupy multiple positions across these normative artworlds, engage more intricately with differentiated forms of capital accumulation to maximize the sum of their own capital gain. The art district, biennials, and independent art institutions are produced by coexisting, mutually disparate modes of cultural, economic and political productions. I can identify an overarching political principle, ordering the distribution of state-assigned material and immaterial resources across these normatively distinct art fields. But to reduce the layered productive forces (especially cultural ones) in each field (e.g., the art district) to the engaging social bodies' economic/political class status obstructs the understanding of their mosaic material forms being produced.

Conversely, as I have shown in 5.4, the tendencies prescribed by the principle of repetitive social doing (by Löw) based on methodological individualism correspond closely with the formation of typical consolidated spatial forms (e.g., the loft studio, studio agglomeration in art village) in Beijing's artworld. They are constructed by art individuals or groups exhibiting similar cultural indoctrinations. However, it offers only partial explanations to spatial forms that either result from highly reflective, creative practices (e.g., artwork) or mediated interactions that occurred in obscure, provisional, and dynamic settings (e.g., Caochangdi art village).

Finally, complementary to the analytical dimensions and causal explanations offered by the first two lenses, the assemblage conceptualization from the non-representational theory (by Thrift) is built on pluralist ontology and weak epistemology. It enables me to attend to and redescribe the dynamic empirical occurrences in Beijing's artworld, capture the emergent interactions and relational features exhibited among the art community and the heterogeneous social entities in transformation and movement. In the case of Caochangdi, where art community live in close proximity with the migrant workers and local rural community, I have captured different spatial and temporal processes that drawn some of them together at particular conjunctures. A few identifiable junctures of social-material assemblages are made stable through shared weak and mediated social ties at regular times and get destabilized in the event of demolition and eviction. An emergent hierarchical sensible-cognitive structure can be identified in generating fear and conformity to political authorities.

I would not like to repeat the detailed empirical findings, as they have been presented at length in chapter 5, at the end of each sub-sections. I want to address, by deploying three theoretical lenses at distinct analytical levels, I was able to give a fuller account of Beijing's artworld's central and peripheral constituents (disparate material objects, social actors) and the plural mechanisms (normative rules, frames of meaning, habitualized practices, material affordances, and contingent perceptions and emotions), and the way in which they weld them together in generating the events observed. Such a multi-level retroductive analysis could reveal deep

causal mechanisms and their interactions, which have actually *affected* the happenings of the events we can observe in a local context. Thus, I would claim, it helps to generate context-sensitive knowledge of space production/constitution/assembling.

By redescribing the reality of the artworld in Beijing as stratified and plural, engaging systematically with this theoretical and conceptual pluralism, this research has confronted the traditionally defined social scientific rigor as a methodological-epistemological link. I admit, however, that to carry retroductive strategy to a full account – examine the powers and liabilities that infinite epistemic frames would possibly give to an empirical event – may prove extremely complex, if not impossible. Thus, a thorough elucidation of the selected theories, their epistemic forms, causal agents and levels of analysis, as presented in the first section (chapter two to four) of this book, is necessary.

6.2 Thinking of space relationally in local context

In the first section of this research, I have elucidated several forms of 'thinking of space relationally,' firstly in the domain of philosophy and then in social sciences. These elucidations serve two functions, 1) to specify the form of space and relationality embedded in various spatial conceptualization and discourses; and 2) to identify the 'initial theories' to be employed in the retroductive empirical research on the artworld in Beijing, in the second section of this book.

The metaphysical assumptions about the nature of reality and social-spatial knowledge are essential to understanding how the form of 'space' and 'relationality' are conceptualized. The social science paradigms have also imposed explicit epistemological rules on social scientists regarding what one can know, how one knows about it, and criteria for validifying the knowledge produced. Following the CR's meta-position, I have employed the sociology of knowledge approach in deconstructing the epistemic forms and rules, unraveling the core presumptions and causal mechanisms embedded in three prevailing (European) conceptualizations of relational space (chapter 2). Through a revisit to the normative discourses in traditional Chinese thoughts (chapter 3), I have made several claims about the epistemic postulations regarding 'social subject' and 'relationality,' 'things' and 'symbolic orders.' As it turns out, the shared epistemic building blocks of subject, object, relationality, and their inferential orders are divergently postulated in the European theoretical and Chinese traditional normative discourses. It leads to very different causal explanations about the form and formation of social space.

For David Harvey, the form of space (the space of the political and economic system) is produced by the political-economic structure as a whole. On the ontological level, material resources are assumed to have the intrinsic and differentiated

capacity to circulate. The political and economic structure is aligned with how these material resources are valorized, circulated and accumulated. The principle of accumulation is conceived to drive the production of economic space. As a result, social actors' knowledge, way of knowing, and productive and reproductive forces and practices are supposed to be interpreted by their relative positions in such a totality.

For Martina Löw, social space (the space of everyday life) is constituted through the repetitive social practices with regard to the social actors' habitual perceptions. On the ontological level, repetitive human doings are conceived to be real, as the generative mechanism for space constitution. Social actors are assumed to internalize and embody the social structures (symbolic rules and the distribution of material resources) prevalent in their surroundings. In the first order, relational space arises from individual social actors' synthesis (holistic habitual perception) of the symbolic meaning configuration attached to social beings and goods. It then materializes through practices, as a relational placement of social bodies, which are in constant physical movement.

Finally, Nigel Thrift's non-representational theory conceives social actors and things to be on the same ontological footing, meaning that their agencies do not lie solely in predefined or preexisting structuring attributes but rather emerge from more or fewer contingent interactions. 'Joint action,' 'affect,' 'emergence' and 'context' are deemed more real than the essential attributes of the subject, object, and their internal relations. Space (phenomenal) and the assemblage (material), thus, are conceived to emerge from the never-ending interactions between the actors and things. The former arises in the eyes of the experiencing social actors. Assemblage get territorialized in the interactions of the participating actors. Researchers are impelled to code and interpret the ways in which the social-spatial arrangements of assemblage come to be and transform without a presupposed cause.

Ontologically speaking, I claim that in the context of classic Confucian normative discourses, a two-dimensional relational sensible and cognitive structure is deemed as real, which orders the emotional, perceptual, and practical activities of the social actors. Two sets of intensive properties can be identified in the prototypical social relations prescribed in Confucianist normativity. One is *ren*-affection-intimacy, and the other is *li*-reverence-hierarchy. On the emotional and perceptual level, the social actor is assumed to be endowed with both *ren*-intimacy and *li*-hierarchy sensible and perceptual orientations. They are strengthened during primary socialization in the family environment, enable the social subjects to give meaning to extended forms of relationships. Following this logic, a broader set of horizontally (intimate-distanced) and vertically (fearful-revered) differentiated, asymmetric social relations can be identified, produced and reproduced by the participating social actors' minds and senses in the course of their encounter.

Furthermore, my analysis of the philosophical discourse about things and names in chapter 3.4 sheds light on a unique form of relational epistemology about natural objects. I have claimed that the conceptualizations and categorization of things in the traditional Daoist thoughts do not follow the subject-predicate principle nor linear causal rules. Symbols do not represent the concrete, static, singular thing, nor the general form of such things. Things are primarily conceived to be in constant motion or interaction with those that surround them. The symbols of naming things reflect the normative, correlative orders assigned by privileged authorities, usually within a political system. I have made two claims. The first claim is that thing(s) is assumed to possess emergent transformative capacities, exhibits in a relational and interactive context, than substantial attributes independent of other things and human perceivers. Names are conceived according to a correlative logic. Hence, the names of things fall between the abstract and concrete, or purely conceptual and exact representational categories. A correlative logic of ordering things is demonstrated by the normative systems of *yin-yang* and *wu-xing*. The placement of empirical things that align or misalign with such order is believed to either enhance or interrupt their mutual resonances hence the efficacy of the overall normative order, enabling the name designator to maneuver the motion of things. The second claim is that naming is deemed a privileged agency entitled to authorities. They mobilize such agency to either reproduce a normative social order or enforce the start of a new reordering process.

Having the danger of essentialism in mind, examinations of the recontextualized spatial knowledge (chapter 4) prevalent in the contemporary Chinese scientific field reveal features of spatial knowing and doing that affect the appropriation of traveling spatial theories by scholars. Most notably, scholars implicitly assign the causal primacy to vertical spatial relations when translating and adapting scale theories onto Chinese realities, which confirms my claim in chapter 3. In addition, I argue that, the communicative agency is asymmetrically distributed between actors embedded in the fields of politics and science. It reinforces the reproduction of spatial concepts and forms under the logic of centralized, top-down governance.

.

In section two, I have carried out retroductive empirical research on disparate field-constituting events of Beijing's artworld. For me, Beijing's artworld represents the emerging hyper-complex spatial phenomenon in major China cities and cities in the global South, where disparate social actors, discourses and material entities come together in close proximity, entangle under unprecedented rules. A plurality of mechanisms interacts and generates possible effects in the empirical domain, which manifests, in the eyes of the situated perceivers, as distinct mosaic social-material ensembles. To generate context-sensitive knowledge about this particular, situated phenomenon, I would argue, the researcher shall uncover the co-existing generative mechanisms at work. One shall also elucidate how certain mechanisms

co-function and affect the events' observable parts in the empirical domain. I have elaborated in depth in chapter 5, about how initial theories help to code locally observable events and grasp the demi-regular tendencies.

In my analysis, I have shown, the same mechanism (e.g., the law of accumulation) may underlie different events and generate particular social-material manifestations (e.g., the art biennial and art district). Conversely, a particular social-material phenomenon (e.g., Caochangdi village) is synthesized as a multitude of (emergent) names (the village-in-the-city, the art village, the Caochangdi art community, Cao-cun) by different actors at different times. These plural forms of Caochangdi's constitution, and the underlying generative mechanisms, may appear irrelevant to the discipline specific (e.g., art history) study of the artworld. However, if we have an action-oriented goal in mind, say, preserving the community space (in symbolic and material senses) constructed by the freelancing artists in Beijing, we have to attend to these entangled structures at work. Only by grasping the events in the actual domain, uncovering these structures and the way they interact in the real domain, can we develop local strategies for enabling, suspending, or blocking the *enactment* of them. We must always be alert about the actualization of a contingent event (e.g., the anti-demolition struggle in Caochangdi) emerge from social actors, things and their interactions (e.g., social actors resorting to principles of hierarchy) in the context of intrusive elements. These generative mechanisms revealed may play out in the re-demarcation of parts and wholes in future terms. In such cases, a method of causal disaggregation will not help.

Based on my limited theoretical elucidations and empirical demonstration, I will not make general substantive claims about what forms of social and material relationalities shall be recognized, to render the spatial analysis and interpretation valid in the local context. My manifold empirical study of the artworld in Beijing, has affirmed the possibility of uncovering several co-existing, co-articulating, and enduring necessary, contingent, and emergent relationalities on the material, normative, perceptual and affective levels. The corresponding underlying structures generate the complex phenomenon of the artworld in Beijing. For studying future complex spatial phenomena situated in urban China, in addition to the elucidated relational spatial theories traveling from Europe, I have also recognized the following structures as the initial causal agents, 1) a hierarchical sensible and perceptual structure that exist inside the individuals; 2) an asymmetrical normative structure for distributing discursive and material agency, exist inside and/or outside the individuals' cognition and senses; and 3) the emergent properties of things that exist outside the individuals' cognition.

References

Agnew, John. 1997. "The Dramaturgy of Horizons: Geographical Scale in the 'Reconstruction of Italy' by the New Italian Political Parties, 1992–1995." *Political Geography* 16 (2): 99–121.

Alvesson, M., and K. Sköldberg. 2000. *Towards a Reflexive Methodology:* London: Sage.

Anderson, Ben, and Paul Harrison. 2010. *Taking-Place: Non-Representational Theories and Geography / Edited by Ben Anderson and Paul Harrison.* Farnham: Ashgate.

Antognazza, Maria Rosa. 2018. *The Oxford Handbook of Leibniz:* Oxford University Press.

Archer, Anita. 2018. "Genesis of an Auction Sale Category: Sotheby's Inaugural Auction of 'Contemporary Chinese Art'." Journal for Art Market Studies, Vol 2, No 3 (2018). https://doi.org/10.23690/jams.v2i3.65.

Archer, Margaret, Roy Bhaskar, Andrew Collier, Tony Lawson, and Alan Norrie, eds. 1998. *Critical Realism: Essential Readings.* Critical realism. Interventions. London: Routledge.

Art Daily China. 2017, January 6. Accessed January 05, 2018. http://zhuanti.artnchina.com/llfwdt/gzld/5ffbc67c6aa247d390ef61b392a66a0a.html?wlzl.

Artron.net. 2013. ""2013 Meiyuan Biyeji Guancha Zhisi: Zhongguo 'Meiyuan Caifu Quanli Bang;" 2013 美院毕业季观察之四：中国"美院财富权力榜" [2013 Graduatotion Season, Art Academy Observer No. 4: The "Ranking of Art Academies by Finance and Power" in China].".

Asia Art Archive. n.d. "1989 China/Avant-Garde Exhibition." https://aaa.org.hk/en/ideas/ideas/1989-chinaavant-garde-exhibition.

Bach, Jonathan. 2010. ""They Come in Peasants and Leave Citizens": Urban Villages and the Making of Shenzhen, China." *Cultural Anthropology* 25 (3): 421–58.

Bao, Yaming. 2008. "Shanghai Weekly: Globalization, Consumerism, and Shanghai Popular Culture." *Inter-Asia Cultural Studies* 9 (4): 557–67. https://doi.org/10.1080/14649370802386461.

Barthes, Roland. 1967 [1964]. "Elements of Semiology." *New York: Hill & Wang.*

Basha art. 2018. ""Weihe Yishujia Bixu You Yijian Gongzuoshi, Ruguo Meiyou Ne?" 为何艺术家必须有一间工作室,如果没有呢 [Why Do Artists Need a Studio, If Not?]." https://www.94477.com/article/1959014.html.

Beck, Ulrich. 2006. *The Cosmopolitan Vision*. Cambridge: Polity.

Becker, Howard Saul. 1982. *Art Worlds*. Berkeley, Calif: University of California.

"Beijing Cultural and Creative Industries White Paper (2017)." 2018 110091/ZK-2018-000005.

Bell, Daniel A. 2010. *China's New Confucianism: Politics and Everyday Life in a Changing Society (New in Paper)*. Princeton: Princeton University Press.

Berger, Peter L. 2004. *Invitation to Sociology: A Humanistic Perspective*. [Nachdr.]. New York: Anchor Books.

Berger, Peter L., and Thomas Luckmann. 1966. *The Social Construction of Reality: A Treatise in the Sociology of Knowledge*. New York: Anchor Books.

Bhambra, Gurminder K. 2007. *Rethinking Modernity: Postcolonialism and the Sociological Imagination*. Basingstoke: Palgrave Macmillan.

Bhaskar, Roy. 2005 [1979]. *Possibility of Naturalism, a Philosophical Ritique of the Contemporary Human Sciences*. 3rd ed. Milton: Taylor & Francis.

Bhaskar, Roy. 2008 [1993]. *Dialect: The Pulse of Freedom*. 2nd ed. London and New York: Routledge.

Bhaskar, Roy. 2016. *Enlightened Common Sense: The Philosophy of Critical Realism*: Routledge.

Bodde, Derk. 1939. "Types of Chinese Categorical Thinking." *Journal of the American Oriental Society* 59 (2): 200. https://doi.org/10.2307/594062.

Boodberg, Peter A. 1953. "The Semasiology of Some Primary Confucian Concepts." *Philosophy East and West* 2 (4): 317. https://doi.org/10.2307/1397493.

Bourdieu, Pierre. 1993. *The Field of Cultural Production: Essays on Art and Literature*. European perspectives. New York: Columbia University Press.

Bourdieu, Pierre. [1995]2006. *The rules of art: Genesis and structure of the literary field*. Meridian : crossing aesthetics. Stanford, Calif. Stanford University Press.

Brenner, Neil. 2004. *New State Spaces: Urban Governance and the Rescaling of Statehood / Neil Brenner*. Oxford: Oxford University Press.

Broudehoux, Anne-Marie. 2004. *The Making and Selling of Post-Mao Beijing*. Planning, history, and the environment series. London, New York: Routledge.

C. Cindy Fan, Laurence J. C. Ma, Clifton W. Pannell, and K. C. Tan. 2008. "Geography of China." In *Geography in America at the Dawn of the 21st Century*, edited by Gary L. Gaile and Cort J. Willmott, 668–80. Oxford: Oxford University Press.

Caochangdi's village commitee. 2011. http://ccd.grwh.cn/.

Carr, Brian. 1987. *Metaphysics: An Introduction*: Springer.

Cartier, Carolyn. 2005. "City-Space: Scale Relations and China's Spatial Administrative Hierarchy." *Restructuring the Chinese City: Changing society, economy and space*.

Cartier, Carolyn Lee. 2001. *Globalizing South China*. 1. publ. RGS-IBG book series. Oxford [u.a.]: Blackwell.

Casey, Edward S. 1997. *The Fate of Place: A Philosophical History*. Berkeley: University of California Press.

Castells, Manuel. 1999. "Grassrooting the Space of Flows." *Urban Geography* 20 (4): 294–302. https://doi.org/10.2747/0272-3638.20.4.294.

Cetina, Karin Knorr. 2009 [1999]. *Epistemic Cultures: How the Sciences Make Knowledge.* Cambridge, MA: Harvard University Press.

Chai, Yanwei, Lingji Chen, and Chun Zhang. 2007. ""Danwei Zidu Bianqian" 单位制度变迁 [The Transformation of Danwei System]: "Toushi Zhongguo Chengshi Zhuanxing De Zhongyao Shijiao" 透视中国城市转型的重要视角 [The Important Lens Looking into the Chinese Urban Transformation]." *"Shijie DIli Yanjiu"* 世界地理研究 16 (4): 60–69.

Chang, Dong-Sun. 1952. "A Chinese Philosopher's Theory of Knowledge." *ETC: A Review of General Semantics* 9 (3): 203–26.

Chang, Kyung-Sup. 2010. "The Second Modern Condition? Compressed Modernity as Internalized Reflexive Cosmopolitization." *The British Journal of Sociology* 61 (3): 444–64.

Chang, Tung-Sheng. 1946. *Knowledge and the Culture* 知识与文化. Social Theory and Methodology. Shanghai: Shang wu yin shu guan.

Chaoyang News. 2018. "Cleaning up the Back Allees, Improving the Villages' Images." September 6. Accessed September 30, 2018. https://chynews.bjchy.gov.cn/sub/news/516563/12876.htm.

Chen, Kuan-Hsing. 2014. *Asia as Method*: Duke University Press Books.

Chen, Guying. 2005. ""Lun Daoyuwu Guanxi Wenti (Shang)" 论道与物关系问题 (上)[The Relation Between Dao and Wu]: "Zhongguo Zhexueshi Shang De Yitiao Zhuxian" 中国哲学史上的一条主线 [The Thread of Chinese History of Philosophy]." *Zhexue dongtai* 哲学动态 (7): 55–64.

Chen, Hon Fai. 2018. *Chinese Sociology: State-Building and the Institutionalization of Globally Circulated Knowledge.* Sociology Transformed. London: Palgrave Macmillan UK.

Chiao, Chien. 1982. "Guanxi: A Preliminary Conceptualization." *The sinicization of social and behavioral science research in China,* 345–60.

Chinanews. 2011. "Zhangjiajie's Old Name Is Called Dayong: Renaming for Integrating Tourism Resources." January 24. http://www.chinanews.com/cul/2011/01-24/2806122.shtml.

Clifford, James. 1988. *The Predicament of Culture*: Harvard University Press.

Collinge, Chris. 1999. "Self-Organisation of Society by Scale: A Spatial Reworking of Regulation Theory." *Environ Plan D* 17 (5): 557–74.

Collins, Allan, and William Ferguson. 1993. "Epistemic Forms and Epistemic Games: Structures and Strategies to Guide Inquiry." *Educational psychologist* 28 (1): 25–42.

Collins, Randall. 1984. *Three Sociological Traditions*: Oxford University Press, USA.

Confucius. 2007 [1983]. *The analects of Confucius.* Translations from the Asian classics. New York: Columbia Univ. Press.

Connell, Raewyn. 2007. *Southern Theory: The Global Dynamics of Knowledge in Social Science/ Raewyn Connell*. Cambridge: Polity.

Connolly, William E. 1987. *Politics and Ambiguity*: Univ of Wisconsin Press.

Cox, Kevin R. 1996. "The Difference That Scale Makes." *Political Geography* 8 (15): 667–69.

Crowell, Steven Galt. 2001. *Husserl, Heidegger, and the Space of Meaning: Paths Toward Transcendental Phenomenology*. Northwestern University studies in phenomenology and existential philosophy. Evanston, Illinois: Northwestern University Press.

Currier, Jennifer. 2008. "Art and Power in the New China: An Exploration of Beijing's 798 District and Its Implications for Contemporary Urbanism." *Town Planning Review* 79 (2-3): 237–65.

Danermark, Berth, Mats Ekström, and Karlsson Jan Ch. 2005 [1997]. *Explaining Society: Critical Realism in the Social Sciences*. Critical realism: interventions. London, New York: Routledge.

Danto, Arthur. 1964. "The Artworld." *The Journal of Philosophy* 61 (19): 571–84.

DeLanda, Manuel. 2006. *A New Philosophy of Society: Assemblage Theory and Social Complexity*: A&C Black.

Delaney, David, and Helga Leitner. 1997. "The Political Construction of Scale." *Political Geography* 16 (2): 93–97.

Deleuze, Gilles. 2006. *Nietzsche and Philosophy*. With the assistance of H. Tomlinson. European perspectives. New York: Columbia University Press.

Du, Weiming. 1997. *Confucian Traditions in East Asian Modernity: Moral Education and Economic Culture in Japan and the Four Mini-Dragons : [Conference of the American Academy of Arts and Sciences (AAAS), May 15-18, 1991]*. [2nd print.]. Cambridge Mass. Harvard University Press.

Durkheim, Emile. 1982. *The Rules of Sociological Method*. London: Macmillan Education UK.

Eduard, Kögel, ed. 2008. *Ai Weiwei Beijing. Fake Design in the Village*. Berlin, Germany: AedesLand.

Edward W. Soja. 2009. "Taking Space Personally." In *The Spatial Turn: Interdisciplinary Perspectives / Edited by Barney Warf and Santa Arias*, edited by Barney Warf and Santa Arias, 11–35. Routledge studies in human geography 26. London: Routledge.

EGG Gallery. 2019. ""Chuzu-Chaoyangqu Caochangdi LOFT Jiegou Gongzuo Shi" 出租-朝阳区草场地LOFT结构工作室 [Renting-the LOFT Structure Studio Space in Caochangdi, Chaoyang District]: "Shihe Hualang Huo Shejilei Gongzuoshi" 适合画廊或设计类工作室使用 [Suitable for Gallery or Design Studio]." https://www.douban.com/group/topic/132118832///.

Eisenstadt, S. N. 2003. *Comparative Civilizations and Multiple Modernities*. Leiden: Brill.

Elias, Norbert. 2001 [1987]. *The Society of Individuals*. New York: Continuum.

Emirbayer, Mustafa. 1997. "Manifesto for a Relational Sociology." *American Journal of Sociology* 103 (2): 281–317.

Fan, Ruiping. 2005. "A Reconstructionist Confucian Account of Environmentalism: Toward a Human Sagely Dominion over Nature." *J Chinese Philos* 32 (1): 105–22.

Fan, Ruiping, and Erika Yu. 2011. *The Renaissance of Confucianism in Contemporary China*. Philosophical studies in contemporary culture v. 20. Dordrecht, New York: Springer.

Fei, Hsiao-Tung. 1946. "Peasantry and Gentry: An Interpretation of Chinese Social Structure and Its Changes." *American Journal of Sociology* 52 (1): 1–17.

Fei, Xiaotong. 1992 [1947]. *From the Soil: The Foundation of Chinese Society*. Berkeley [etc.]: University of California Press.

Feng, Jian, and Yixing Zhou. 2008. ""Zhuanxingqi Beijing Shehui Kongjian Fenyi Chonggou" 转型期北京社会空间分异重构 [The Social Spatial Differentiations of Beijing in the Transitional Phase]." "*Dili Xuebao*" 地理学报 63 (8): 829–44.

Fingarette, Herbert. 2004 [1972]. *Confucius: The Secular as Sacred*. Religious traditions of the world. Pittsburgh, Pa. Association, Pleasant Hills Community Church.

Fletcher, Amber J. 2016. "Applying Critical Realism in Qualitative Research: Methodology Meets Method." *International Journal of Social Research Methodology* 20 (2): 181–94. https://doi.org/10.1080/13645579.2016.1144401.

Friedmann, John. 2006. "Four Theses in the Study of China's Urbanization." *Int J Urban & Regional Res* 30 (2): 440–51. https://doi.org/10.1111/j.1468-2427.2006.00 671.x.

From Jean-Paul Sartre to Teresa Teng: Cantonese Contemporary Art in the 1980s: Asia Art Archive, 2010. https://aaa.org.hk/en/collection/search/archive/materials-of-th e-future-documenting-contemporary-chinese-art-from-1980-1990-document ary-film/object/from-jean-paul-sartre-to-teresa-teng-cantonese-contempora ry-art-in-the-1980s-english-subtitles.

Fukuyama, Francis. 1997. "The Illusion of Exceptionalism." *Journal of Democracy* 8 (3): 146–49. https://doi.org/10.1353/jod.1997.0043.

Fung, aYu-Lan, and Derk Bodde. 1997. *A Short History of Chinese Philosophy: A Systematic Account of Chinese Thought from Its Origins to Present Day*. 2. printing. New York: Free Press.

Gaubatz, Piper. 2008. "New Public Space in Urban China. Fewer Walls, More Malls in Beijing, Shanghai and Xining." *China Perspectives* 2008 (2008/4): 72–83.

Gernet, Jacques. 2008 [1982]. *A History of Chinese Civilization*. 2nd ed. Cambridge: Cambridge University Press.

Giddens, Anthony. 1984. *The Constitution of Society: Outline of the Theory of Structure*. Berkeley: CA: University of California Press.

Giddens, Anthony. 2001. *New Rules of Sociological Method: A Positive Critique of Interpretative Sociologies*. 2., rev. ed., repr. Stanford, Calif. Stanford Univ. Press.

Giddens, Anthony. 2013. *The Consequences of Modernity*. Oxford: Wiley.

Giddens, Anthony, and David Held, eds. 1982. *Classes, Power, and Conflict: Classical and Contemporary Debates*. Berkeley: University of California Press.

Go, Julian. 2013. "For a Postcolonial Sociology." *Theory and Society* 42 (1): 25–55. https://doi.org/10.1007/s11186-012-9184-6.

Goldman, Merle, and Oufan Li, eds. 2012. *An Intellectual History of Modern China*. Second edition. Cambridge modern China series. New York, NY: Cambridge University Press.

Gottdiener, Mark, and Alexandros Ph Lagopoulos. 1986. *The City and the Sign: An Introduction to Urban Semiotics*: Columbia University Press.

Graham, A. C. 1986. *Yin-Yang and the Nature of Correlative Thinking*. Occasional paper and monograph series / Institute of East Asian Philosophies no. 6. Kent Ridge: Institute of East Asian Studies.

Gransow, Bettina. 1993. "Chinese Sociology: Sinicisation and Globalisation." *International Sociology* 8 (1): 101–12.

Gransow, Bettina. 2017. "Soziologische Chinastudien Und Chinesische Soziologie Im Globalen Kontext: Geteiltes Wissen–unterschiedliche Forschungsperspektiven?" *ASIEN* 144: 119–34.

Gransow, Bettina, and Jiangang Zhu. 2016. "Labour Rights and Beyond-How Migrant Worker NGOs Negotiate Urban Spaces in the Pearl River Delta." *Popul. Space Place* 22 (2): 185–98. https://doi.org/10.1002/psp.1894.

Groff, Ruth. 2007. *Revitalizing Causality: Realism About Causality in Philosophy and Social Science*: Routledge.

Guo, Yuanyuan, Sougeng Hu, and Gui Jin. 2012. ""Jiyu Gaijin Chengshi Ynli Moxing De Hunan Jingjiqu Kongjian Geju Yanbian Yanjiu" 基于改进城市引力模型的湖南省经济区空间格局演变研究 [Evolution of Spatial Pattern on Hunan Province's Economic Zones Based on Improved Gravitational Models of Cities]." *"Dili Xuebao"* 地理学报*[Economic Geography]*.

Guo, Yuhua, Yuan Shen, and Peng Chen. 2014. *The Politics of Dwelling "Ju Zhu De Zheng Zhi": Homeowner Advocacy and Community Construction in the Contemporary Chinese Metropolis "Dang Dai Du Shi De Ye Zhu Wei Quan He She Hui Jian She"*. 1st ed. Li xiang guo Imaginist. Guilin: Guangxi shi fan da xue chu ban she.

Guzidao. 2016. ""Wode Pengyou Zai Heiqiao (Shang) " 我的朋友在黑桥(上) [My Friends in Heiqiao (1)]." https://mp.weixin.qq.com/s/YYabG2yNCp-EZFx3AYxMxQ.

H.G. Alexander. 1956. *The Leibniz–Clarke Correspondence*. Manchester: Manchester University Press.

Habermas, Jürgen. 1979. *Communication and the evolution of society*. Boston: Beacon Press.

Hacking, Ian. 1999. *The Social Construction of What?* 1st ed. Cambridge, Massachusetts and London: Harvard University Press.

Hall, David L., and Roger T. Ames. 1987. *Thinking Through Confucius*. SUNY series in systematic philosophy. Albany: State University of New York Press.

Hammersley, Martyn. 1992. *What Is Wrong with Ethnography? Methodological Explorations/ Martyn Hammersley*. London: Routledge.

Hanquinet, Laurie, ed. 2016. *Routledge International Handbook of the Sociology of Art and Culture*. 1 edition. Routledge International Handbooks. London: Routledge.

Hansen, Chad. 1983. *Language and Logic in Ancient China*. Michigan studies on China. Ann Arbor: University of Michigan Press.

Hansen, Chad. 2000. *A Daoist Theory of Chinese Thought: A Philosophical Interpretation*: Oxford University Press on Demand.

Hansen, Chad. 2009 [1992]. *A Daoist Theory of Chinese Thought: A Philosophical Interpretation*. 1. iss. as pbk., [Nachdr.]. New York: Oxford Univ. Press.

Hansen, Mette Halskov, and Rune Svarverud, eds. 2010. *IChina: The Rise of the Individual in Modern Chinese Society*. Copenhagen: NIAS Press.

Harbsmeier, Christoph, and Joseph Needham. 1998. *Science and Civilisation in China: Volume 7, the Social Background, Part 1, Language and Logic in Traditional China*: Cambridge University Press.

Harvey, David. 1989. *The Condition of Postmodernity: An Enquiry into the Origins of Cultural Change / David Harvey*. Oxford: Basil Blackwell.

Harvey, David. 2001. *Spaces of Capital: Towards a Critical Geography / David Harvey*. Edinburgh: Edinburgh University Press.

Harvey, David. 2005. *A Brief History of Neoliberalism*. Oxford: Oxford University Press.

Harvey, David. 2006a. "Neo-Liberalism as Creative Destruction." *Geografiska Annaler: Series B, Human Geography* 88 (2): 145–58.

Harvey, David. 2006b. "Space as a Keyword." In *David Harvey*, edited by Noel Castree and Derek Gregory, 270–93. Oxford, UK: Blackwell Publishing Ltd.

Harvey, David. 2009. *Social Justice and the City*. Rev. ed. Geographies of justice and social transformation 1. Athens: University of Georgia Press.

Harvey, David. 2016 [2006]. "Neoliberalism as Creative Destruction." *The ANNALS of the American Academy of Political and Social Science* 610 (1): 21–44. https://doi.or g/10.1177/0002716206296780.

Harvey, David, and Bruce Braun. 1996. *Justice, Nature and the Geography of Difference*: Blackwell Oxford.

Harvey, David, and Nak-chung Paik. 2017. "How Capital Operates and Where the World and China Are Going: A Conversation Between David Harvey and Paik Nak-Chung." *Inter-Asia Cultural Studies* 18 (2): 251–68. https://doi.org/10.1080/1 4649373.2017.1309501.

Hershock, Peter D., and Roger T. Ames. 2006. *Confucian Cultures of Authority*. SUNY series in Asian studies development. Albany: State University of New York Press.

Ho, Loretta Wing Wah. 2011. *Gay and Lesbian Subculture in Urban China*. Milton Park, Abingdon, Oxon, New York: Routledge.

Hook, Philip. 2014. *Breakfast at Sotheby's: An a-Z of the Art World*. New York: Overlook Press.

Hsun Tzu. 1966. *The Works of Hsuntze*. With the assistance of Homer H. Dubs. Probsthain's Oriental Series XVI. Taipei: Ch'eng-Wen Publishing Company.

Hu, Heng. 2015. "*Huang Quan Bu Xia Xian?*" 皇权不下县? "*Qing Dai Xian Xia Zheng Qu Yu Ji Ceng She Hui Zhi Li*" 清代县辖政区与基层社会治理 *[The County Administration and Social Control in Qing Dynasty]*. Di 1 ban. Xin shi xue & duo yuan dui hua xi lie. Beijing Shi: "Beijing shi fan da xue chu ban she" 北京师范大学出版社.

Huang, Yasheng, Sally Stein, and Allan Sekula. 2010 [2008]. *Capitalism with Chinese Characteristics: Entrepreneurship and the State*. Cambridge, New York: Cambridge University Press.

Husserl, Edmund. 1989. *The Crisis of European Sciences and Transcendental Phenomenology: An Introduction to Phenomenological Philosophy*. 8. printing. Northwestern University studies in phenomenology and existential philosophy. Evanston, Ill. Northwestern University Press.

Ingold, Tim. 2011 [2000]. *The Perception of the Environment: Essays on Livelihood, Dwelling and Skill*. London, New York: Routledge, Taylor & Francis Group.

Jameson, Fredric. 2003 [1991]. *Postmodernism: Or, the Cultural Logic of Late Capitalism*. 10th ed. Durham: Duke University Press.

Jammer, Max. 1993 [1954]. *Concepts of Space: The History of Theories of Space in Physics*. Dover edition. Dover books on science. New York: Dover Publications.

Jessop, Bob, Neil Brenner, and Martin Jones. 2008. "Theorizing Sociospatial Relations." *Environ Plan D* 26 (3): 389–401. https://doi.org/10.1068/d9107.

Jiang, Yi. 2018. "Chinese Philosophy in the New Era from the Perspective of the Theme of the 24th World Congress of Philosophy." *Front. Philos. China* 13 (2): 182–93.

Jullien, François. 2000. *Detour and Access: Strategies of Meaning in China and Greece*. New York: Zone Books.

Kant, Immanuel. 2009 [1781]. *Critique of Pure Reason*. With the assistance of P. Guyer. 15. print. The Cambridge edition of the works. Cambridge [u.a.]: Cambridge Univ. Press.

Keith, Michael, Scott Lash, Jakob Arnoldi, and Tyler Rooker. 2014. *China Constructing Capitalism: Economic Life and Urban Change*. 1st ed. International library of sociology. London: Routledge.

Keller, Reiner. 2005. "Analysing Discourse. An Approach from the Sociology of Knowledge." *Forum: Qualitative Social Research*, no. 6. https://doi.org/10.17169/fqs-6.3.19.

Knoblauch, Hubert. 2013. "Communicative Constructivism and Mediatization." *Communication Theory* 23 (3): 297–315. https://doi.org/10.1111/comt.12018.

Kong, Jianhua. 2009. "Beijing 798 Yishuqu fazhan yanjiu"北京798艺术区发展研究 [Study on the Development of 798 Artistic Area in Beijing]. "*New Horizons*"新视野. 151 (01): 29-32.

Kuhn, Thomas. 2012 [1962]. *The Structure of Scientific Revolutions: Univ.* 4th ed. London and Chicago: The University of Chicago Press.

Langer, Susanne Katherina Knauth. 2007 [1942]. *Philosophy in a New Key: A Study in the Symbolism of Reason, Rite, and Art.* 3. ed., [repr.]. Cambridge, Mass. Harvard Univ. Press.

Lao Zi. 2001 [n.d.]. *Dao De Jing: The Book of the Way.* Berkeley: University of California Press. Translation and Commentary by Moss Roberts.

Latour, Bruno. 2005. *Reassembling the Social: An Introduction to Actor-Network-Theory.* [Online-ausg.]. Clarendon lectures in management studies. Oxford: Oxford University Press.

Lee, and Hubona. 2009. "A Scientific Basis for Rigor in Information Systems Research." *MIS Quarterly* 33 (2): 237. https://doi.org/10.2307/20650291.

Lee, Ching Kwan. 2001 [1998]. *Gender and the South China Miracle: Two Worlds of Factory Women.* [Nachdr.]. Berkeley, Calif. [u.a.]: Univ. of California Press.

Lefebvre, Henri. 1991 [1974]. *The production of space.* Oxford, OX, UK, Cambridge, Mass., USA: Blackwell.

Lewis, Mark Edward. 2006. *The Construction of Space in Early China.* SUNY series in Chinese philosophy and culture. Albany, NY: State University of New York Press.

Li, Chenyang, and Franklin Perkins, eds. 2015. *Chinese Metaphysics and Its Problems:* Cambridge University Press.

Li, Hongjin, and Shenghui Li. 2011. ""Jiyu Yinli Moxing De Chengshiqun Jingji Kongjian Lianxi Yanjiu-Zhusanjiao Chengshiqun De Shizheng Yanjiu "基于引力模型的城市群经济空间联系研究-珠三角城市群的实证研究 [Gravity Model Based on Spatial Connection of Urban Agglomeration Economies: An Empirical Study of the Pearl River Delta City Group]." "*huanan Ligong Daxue xuebao (the social science version)*" 華南理工大學學報 (社會科學版) 13 (1): 19–24.

Li, Yi, and Fulong Wu. 2018. "Understanding City-Regionalism in China: Regional Cooperation in the Yangtze River Delta." *Regional Studies* 52 (3): 313–24. https://doi.org/10.1080/00343404.2017.1307953.

Li, Zhigang, Fulong Wu, and Hanlong Lu. 2004. ""Dangdai Woguo Dadushide Shehui Fenyi- Dui Shanghai Sange Shequ De Shizheng Yanjiu" 当代我国大都市的社会空间分异——对上海三个社区的实证研究 [Socio-Spatial Differentiation and Residential Inequalities in Shanghai: A Case Study of Three Communities]." "*Chengshi Guihua*" 城市规划 28 (6): 60–67.

Lin, Yanliu, Bruno de Meulder, and Shifu Wang. 2012. "The Interplay of State, Market and Society in the Socio-Spatial Transformation of "Villages in the City" in Guangzhou." *Environment and Urbanization* 24 (1): 325–43. https://doi.org/10.1177/0956247811434362.

Liu, Qian. 2015. ""Zhongguo Shiyan Yishu Jiaoyu Cong Nalilai Dao Naliqu?" 中国实验艺术教学从哪里来到哪里去 [Where Does the Chinese Experimental Art Educatioin Come from and Where to Go?]." July 23. Accessed October 20, 2016. https://young.artron.net/exhibitions/cafa2015/news/79.

Liu, Shijin, Shouying Liu, Wei Xu, and Ting Shao. 2013. ""Sange Cunzhuang De Zizhu Chengzhenhua Xinde" 三个村庄的自主城镇化心得 [The Self-Urbanization Tragectories of Three Villages]." 东方早报 [Oriental Morning Post], December 10. Accessed October 01, 2016. http://www.bjqx.org.cn/qxweb/n101085c769.aspx.

Liu, Xiaoping, Xia Li, Yimin Chen, Tao Liu, and Shaoying Li. 2010. ""Jiyu Duozhinengti De Juzhu Quwei Kongjian Xuanze Moxing" 基于多智能体的居住区位空间选择模型 [Agent-Based Model of Residential Location—ABMRL]." *"Dili Xuebao"* 地理学报*[Economic Geography]* 65 (6): 695–707.

LIU Weidong, JIN Fengjun, ZHANG Wenzhong, HE Canfei, LIU Zhigao. 2011. "Progress in Economic Geography (2006-2011)." *"Dili kexue Jinzhan"* 地理科学进展 *[Progress in Geography]* 30 (12): 1479–87.

Löw, Martina. 2015. "Space Oddity. Raumtheorie Nach Dem Spatial Turn." *sozialraum.de* (1). https://www.sozialraum.de/space-oddity-raumtheorie-nach-dem-spatial-turn.php. Accessed August 08, 2019.

Löw, Martina. 2016 [2001]. *Sociology of Space: Materiality, Social Structures, and Action.* Cultural sociology. New York, New York: Palgrave Macmillan.

Lu, Luguang. 2004. ""Chengshi Juzhu Kongjian Fenyi Ji Pinkun Renkou Fenbu Zhuangkuang Yanjiu-Yi Hefeishi Weili" 城市居住空间分异及贫困人口分布状况研究——以合肥市为例 [Study on Spatial Differentiation and Distribution of Poverty Populatio: A Case Study of Hefei City]." *"Chengshi Guihua"* 城市规划 28 (6): 74–77.

Lu, Peng. 2015. *"Mei Shu De Gu Shi"* 美术的故事 *[The Story of Art in China]: Cong Wan Qing Dao Jin Tian.* 1st ed. Gui lin City: *"Guang xi shi fan da xue chu ban she"* 广西师范大学出版社.

Lu, Ping, and Hui Zhen. 2010. ""Jiyu GWR Moxing De Beijingshi Zhuzhai Yongdi Jiage YIngxiangyinsu Ji Kongjian Guilu" 基于GWR模型的北京市住宅用地价格影响因素及其空间规律研究 [The Research of Residential Land Price, Spatial Pattern and Its Influencing Factors Based on Geographical Weighted Regression Model]." *"Jingji Dili"* 经济地理 30 (3): 472–78.

Lyotard, Jean-François. 1984. *The Postmodern Condition: A Report on Knowledge*. Minneapolis: University of Minnesota Press.

Ma, Laurence J. C., and Fulong Wu. 2005a. "Restructuring the Chinese City." *Restructuring the Chinese City: Changing society, economy and space*, 1–18.

Ma, Laurence J.C. 2005. "Urban Administrative Restructuring, Changing Scale Relations and Local Economic Development in China." *Political Geography* 24 (4): 477–97. https://doi.org/10.1016/j.polgeo.2004.10.005.

Ma, Laurence J.C., and Fulong Wu, eds. 2005b. *Restructuring the Chinese City: Changing Society, Economy and Space* 24. New York: Routledge, Taylor & Francis Group.

Malpas, Jeff. 2012. "Putting Space in Place: Philosophical Topography and Relational Geography." *Environ Plan D* 30 (2): 226–42. https://doi.org/10.1068/d20810.

Mangurian, Robert, and Mary-Ann Ray. 2009. *Caochangdi Beijing Inside Out: Farmers, Floaters, Taxi Drivers, Artists, and the International Art Mob Challenge and Remake the City*. Hong Kong: Timezone 8.

Marilyn Strathern. 1992. "Parts and Wholes: Refiguring Relationships in a Post-Plural World." In *Conceptualizing Society*, edited by Adam Kuper, 75–106. London: Routledge.

Marston, Sallie A., John Paul Jones III, and Keith Woodward. 2005. "Human Geography Without Scale." *Transactions of the Institute of British Geographers* 30 (4): 416–32.

Massey, Doreen B. 2005. *For Space*. 1. publ. London: Sage.

McCall, George J. 1969. *Issues in Participant Observation: A Text and Reader*. Addison-Wesley series in behavioral science: quantitative methods. Reading, Mass. Addison-Wesley.

McCarthy, John, and Yan Wang. 2016. "Culture, Creativity and Commerce: Trajectories and Tensions in the Case of Beijing's 798 Art Zone." *International planning studies* 21 (1): 1–15.

Merriman, Peter, Martin Jones, Gunnar Olsson, Eric Sheppard, Nigel Thrift, and Yi-Fu Tuan. 2012. "Space and Spatiality in Theory." *Dialogues in Human Geography* 2 (1): 3–22. https://doi.org/10.1177/2043820611434864.

Mill, John Stuart. 2009 [1875]. *System of Logic Ratiocinative and Inductive*: Cosimo, Inc.

Miller, Izchak. 1984. *Husserl, Perception, and Temporal Awareness*. Cambridge, Massachusetts: Bradford: MIT Press.

Mingers, John. 2014. *Systems Thinking, Critical Realism and Philosophy: A Confluence of Ideas*. Oxford and New York: Routledge.

Mizoguchi, Yūzō. 2011 [1989]. *"Zuowei Fangfa De Zhongguo"*作为方法的中国 *[China as Methodology]*. 1st ed. Beijing: SDX Joint Publishing Company.

Morse, Janice M. 1991. "Approaches to Qualitative-Quantitative Methodological Triangulation." *Nursing research* 40 (2): 120–23.

Moscovici, Serge. 1988. "Notes Towards a Description of Social Representations." *European journal of social psychology* 18 (3): 211–50.

Muzzetto, Luigi. 2016. "Time and Meaning in Alfred Schütz." *Time & Society* 15 (1): 5–31. https://doi.org/10.1177/0961463X06061334.

Needham, Joseph. 2005 [1956]. *Science and Civilisation in China: History of Scientific Thought* 2. Cambridge: Cambridge University Press.

OECD., Publishing, and for Economic Co-operation and Development Staff Organisation. 2012. *Redefining Urban: A New Way to Measure Metropolitan Areas:* Organisation for Economic Cooperation and Development (OECD).

Oi, Jean C. 1992. "Fiscal Reform and the Economic Foundations of Local State Corporatism in China." *World politics* 45 (1): 99–126.

Olds, Kris, and Nigel Thrift. 2005. "Assembling the "Global Schoolhouse" in Pacific Asia." *Service industries and Asia-Pacific cities: New development trajectories*, 199–215.

Party Branch of Caochangdi Village. 2007. The Historical Book of Caohangdi Village.

Pasini, Enrico. 1996. "Corpo E Funzioni Cognitive in Leibniz.".

Peck, Jamie, and Adam Tickell. 1994. "Searching for a New Institutional Fix: The After-Fordist Crisis and the Global-local Disorder." *Post-Fordism: a reader*, 280–315.

Peng, Kaiping, and Richard E. Nisbett. 1999. "Culture, Dialectics, and Reasoning About Contradiction." *American psychologist* 54 (9): 741.

Peng, Xiaofei. 2011. ""Dangdai Shiyan Yishu 'Ruzhu' Meixie" 当代实验艺术"入住"美协 [The 'Inclusion' of Contemporary Experimental Art in the Art Association]: "Lv Shengzhong Bo 'Zhaoan' Shuo" 吕胜中驳"招安"说 [Lv Shengzhong Argue Against Amnesty]." April 15. Accessed April 15, 2011. http://art1.people.com.cn/GB/205643/206244/14398143.html.

People's government of cui gezhuang township, chaoyang district, Beijing. 2010. ""Caochangdi Gaikuang" 草场地概况 [The Overview of Caochangdi]: The Profille of Caochangdi Village." September 28. Accessed January 28, 2016. http://ccd.grwh.cn/2010/jinrigaikuang_0928/804.html.

Perkins, Franklin. "Metaphysics in Chinese Philosophy." In *Metaphysics Research Lab, Stanford University*. The Stanford Encyclopedia of Philosophy. https://plato.stanford.edu/archives/win2016/entries/chinese-metaphysics/.

Powell, Christopher John, and François Dépelteau. 2013. *Conceptualizing Relational Sociology: Ontological and Theoretical Issues.* New York, Basingstoke, Hants. Palgrave Macmillan.

Rapoport, Amos. 1990. *The Meaning of the Built Environment: A Nonverbal Communication Approach.* Tucson: University of Arizona Press.

Relph, Edward. 1976. *Place and Placelessness:* Pion.

Roulleau-Berger, Laurence, and Peilin Li, eds. 2016. *Post-Western Revolution in Sociology: From China to Europe.* Post-western social sciences and global knowledge. Leiden, Boston: Brill.

Russell, Bertrand. 2005 [1900]. *The Philosophy of Leibniz.* New York: Routledge.

Russell, Bertrand. 2009 [1914]. *Our Knowledge of the External World: As a Field for Scientific Method in Philosophy*. Routledge classics. London: Routledge.

Sahlins, M. 1985. "Islands of History. Chicago: University of Chicago Press.".

Savage, J. 2000. "Participative Observation: Standing in the Shoes of Others?" *Qualitative health research* 10 (3): 324–39. https://doi.org/10.1177/104973200129118471.

Sayer, Andrew. 2010 [1984]. *Method in Social Science: A Realist Approach*. 2ed. New York: Routledge.

Schemmel, Matthias. 2016. *Historical Epistemology of Space: From Primate Cognition to Spacetime Physics*. SpringerBriefs in history of science and technology. Cham, Heidelberg, New York, Dordrecht, London: Springer.

Schutz, A. 1962. *The Problem of Social Reality*. Edited by Natanson Maurice. The Hague: Nijhoff.

Schutz, Alfred. 1972. "Symbol Reality and Society." In *Collected Papers I: The Problem of Social Reality*, edited by Maurice Natanson, 287–356. Dordrecht: Springer Netherlands. https://doi.org/10.1007/978-94-010-2851-6_11.

Schutz, Alfred. 1982. *Collected Papers*. Edited by Maurice Natanson. Phaenomenologica ; 11. Dordrecht, Boston, London: Kluwer Academic Publishers.

Schutz, Alfred, and Thomas Luckmann. 1995. *The Structures of the Life-World*.

Schutz, Alfred, George Walsh, and Frederick Lehnert. 1972. *The Phenomenology of the Social World*. Northwestern University studies in phenomenology & existential philosophy. [Evanston, Illinois]: Northwestern University Press.

Schwartz, Benjamin Isadore. 1985. *The World of Thought in Ancient China*. Cambridge, Mass. Belknap Press of Harvard Univ. Press.

Shen, Jianfa. 2007. "Scale, State and the City: Urban Transformation in Post-Reform China." *Habitat International* 31 (3-4): 303–16. https://doi.org/10.1016/j.habitat t.2007.04.001.

Shih, Shou-chien. 1993. "The Orthodox and the Avant Garde: An HIstorical Examination." In *China's New Art: Post-1989*, edited by Valenrie C. Doran, 27–30. Hong Kong: Hanart T Z Gallery.

Shun, Kwong-loi. 1993. "Jen and Li in the "Analects"." *Philosophy East and West* 43 (3): 457. https://doi.org/10.2307/1399578.

sina.cn. 2016. "The International Forum of Public Art and Urban Design in CAFA." October 17. Accessed October 18, 2016. http://collection.sina.com.cn/ddys/zh/2 016-10-17/doc-ifxwvpar8236983.shtml.

Skinner et al., ed. 1995 [1977]. *The City in Late Imperial China*. Studies in Chinese society. Taipei: SMC Publishing.

Sklar, Lawrence. 1977. *Space, Time, and Spacetime*. Berkeley, London: University of California Press.

Smith, Huston. 1980. "Western and Comparative Perspectives on Truth." *Philosophy East and West* 30 (4): 425. https://doi.org/10.2307/1398969.

So, Alvin Y., Nan Lin, and Dudley L. Poston. 2001. *The Chinese Triangle of Mainland China, Taiwan, and Hong Kong: Comparative Institutional Analyses*. Contributions in sociology no. 133. Westport, Conn. Greenwood Press.

Somers, Margaret R., and Gloria D. Gibson. 1993. "Reclaiming the Epistemological Other: Narrative and the Social Constitution of Identity.".

Stallabrass, Julian. 2006. *Contemporary Art: A Very Short Introduction*: Oxford University Press.

Steyerl, Hito. 2010. "Politics of Art: Contemporary Art and the Transition to Post-Democracy." december 2010. http://worker01.e-flux.com/pdf/article_8888181.pdf.

Studtmann, Paul. 2018. "Aristotle's Categories." In *The Stanford Encyclopedia of Philosophy*. https://plato.stanford.edu/archives/fall2018/entries/aristotle-categories/

Swyngedouw, Erik. 1997. "Neither Global nor Local." *Spaces of globalization: reasserting the power of the local. Londres: Gulford*, 137–66.

Tang, Yang. 2011. "Chaoyang District Village "Establish Community, Demolish Village" Project." *Xin Jing Bao*, January 13. https://news.qq.com/a/20110113/000276.htm.

Tang, Yijie. 2015. *Confucianism, Buddhism, Daoism, Christianity and Chinese Culture*. China Academic Library. Berlin, Heidelberg: Springer Berlin Heidelberg.

Thornton, Sarah. 2012. *Seven Days in the Art World*: Granta Books.

The Beijing News. 2011. "Three Villages in Beijing Chaoyang Would Experiment "Transforming Village into (Urban) Communities" 北京朝阳3村将试"建居撤村"." January 13. Accessed August 31, 2014. http://news.sohu.com/20110113/n278833852.shtml.

Thrift, N. J. 2008. *Non-Representational Theory: Space, Politics, Affect / Nigel Thrift*. International library of sociology. London: Routledge.

Thrift, Nigel. 1996. *Spatial Formations*: Sage.

Thrift, Nigel. 2004. "Summoning Life." *Envisioning human geographies*, 81–103.

Thrift, Nigel, and John-David Dewsbury. 2000. "Dead Geographies—And How to Make Them Live." *Environ Plan D* 18 (4): 411–32. https://doi.org/10.1068/d1804ed

Tilly, Charles. 1999. *Durable Inequality*. 1st paperback printing. Berkeley, Los Angeles, London: University of California Press.

Todorov, Tzvetan. 1999 [1982]. *The conquest of America: The question of the other*. Oklahoma paperback ed. Norman: University of Oklahoma Press.

Tsai, Kellee S. 2007. *Capitalism Without Democracy: The Private Sector in Contemporary China*. Ithaca, N.Y. Cornell University Press.

Tsao, Hsingyuan, and Roger T. Ames, eds. 2011. *Xu Bing and Contemporary Chinese Art: Cultural and Philosophical Reflections*. SUNY series in Chinese philosophy and culture. Albany: SUNY Press.

Tu, Wei-Ming. 1968. "The Creative Tension Between Jen and Li." *Philosophy East and West* 18 (1/2): 29. https://doi.org/10.2307/1398034.

Tu, Wei-Ming. 1985. *Confucian Thought: Selfhood as Creative Transformation*. SUNY series in philosophy. Albany: State University of New York Press.

Urry, John. 2012. *Sociology Beyond Societies: Mobilities for the Twenty-First Century*: Routledge.

Valerie C. Doran, ed. 1993. *China's New Art: Post-1989*. With the assistance of Don J. Cohn, Zhang Jingqing and Jannie Sze. Hong Kong: Hanart T Z Gallery.

van Dijk, T. A. 2006. "Discourse, Context and Cognition." *Discourse Studies* 8 (1): 159–77. https://doi.org/10.1177/1461445606059565.

van Dijk, Teun Adrianus. 2008. *Discourse and Context: A Sociocognitive Approach*. Cambridge: Cambridge Univ. Press. http://www.loc.gov/catdir/enhancements/fy08 34/2008015449-b.html.

Vannini, Phillip, ed. 2015. *Non-Representational Methodologies: Re-Envisioning Research*. Routledge advances in research methods 12. New York: Routledge, Taylor & Francis Group.

Walder, Andrew G. 1995. "Local Governments as Industrial Firms: An Organizational Analysis of China's Transitional Economy." *American Journal of Sociology* 101 (2): 263–301.

Wallerstein, Immanuel Maurice. 2006. *European Universalism: The Rhetoric of Power*: New Press New York.

Wang, Aihe. 2000. *Cosmology and Political Culture in Early China*. Cambridge studies in Chinese history, literature, and institutions. Cambridge: Cambridge University Press. https://doi.org/10.1017/CBO9780511529221.

Wang, Aihe. 2006. *Cosmology and Political Culture in Early China*. Cambridge: Cambridge University Press.

Wang, Fenglong, and Yungang Liu. 2015. "How Unique Is 'China Model': A Review of Theoretical Perspectives on China's Urbanization in Anglophone Literature." *Chin. Geogr. Sci.* 25 (1): 98–112. https://doi.org/10.1007/s11769-014-0713-2.

Wang, Zhixing. 2012. ""Zhongguo Beijing Caochangdi Yishucunluo Kaocha" 中国北京草场地艺术村落考察 [The Reseach on the Caochangdi Art Village in Beijing China]." Master Thesis, Fine Art, "Zhongyang Meishu Xueyuan" 中央美术学院 (The Chinese Academy of Fine Art). Accessed March 01, 2014.

Warf, Barney, and Santa Arias, eds. 2009. *The Spatial Turn: Interdisciplinary Perspectives / Edited by Barney Warf and Santa Arias*. Routledge studies in human geography 26. London: Routledge.

Watsuji, Tetsuro, Yamamoto Seisaku, and Robert E. Carter. 1996. *Watsuji Tetsuro's Rinrigaku: [Ethics in Japan]*. SUNY series in modern Japanese philosophy. New york: State University of New York Press.

Watsuji, Tetsurō. 1989. *Climate and Culture: A Philosophical Study*. Documentary reference collections. New York, London: Greenwood.

Weber, Max. 1959 [1951]. *The Religion of CHina: Confucianism and Taoism.* Illinois: The free press.

Weber, Max. [1972] 2013. *Wirtschaft Und Gesellschaft: Grundriss Der Verstehenden Soziologie.* 5., revidierte Aufl., Studienausg. Edited by Johannes Winckelmann. Tübingen: Mohr.

Wittgenstein, Ludwig. 1969. *On Certainty.* Oxford: Blackwell.

Wood, Allen W. 2007. *Kantian Ethics:* Cambridge University Press.

Wu, Fulong. 2010. "Gated and Packaged Suburbia: Packaging and Branding Chinese Suburban Residential Development." *Cities* 27 (5): 385–96.

Wu, Fulong, Fangzhu Zhang, and Chris Webster. 2012. "Informality and the Development and Demolition of Urban Villages in the Chinese Peri-Urban Area." *Urban Studies* 50 (10): 1919–34. https://doi.org/10.1177/0042098012466600.

Wu, Hung. 2014. *Rong Rong's East Village: Zhong Guo Shi Yan Yi Shu De Shun Jian.* 1st ed. Shanghai: Shang hai ren min chu ban she.

Wu, Hung. 2001. "The 2000 Shanghai Biennale—The Making of a Historical Event." *ART Asia-Pacific* 31: 42–49.

Wu, Hung. 2000. "Zhang Dali's Dialogue: Conversation with a City." *Public Culture* 12(3): 749–768.

Wu, Wenguang. 1990. "Bumming in Beijing: The Last Dreamers." With the assistance of B. Gao, S. Mou, D. Zhang, M. M. C. Zhang and X. Zhang. 1990.

"Xi Ci." n.d. https://ctext.org/book-of-changes/xi-ci-shang/zh.

Xiang, Yong. 2013. ""Cong Yishuqu Dao Wenhua Chanye Yuanqu" 从艺术区到文化产业园区[From Art District to the Cultural Industrial Park]." *"Guangming wang"* 光明网, February 18. http://www.ce.cn/culture/gd/2 01302/18/t20130218_24120107.shtml.

Xinhua.cn. 2015. "The Fourth Meeting on Urban-Related Work Held in Beijing 中央城市工作会议在北京举行: Xi Jinping and Li Keqiang Make Important Talks 习近平李克强作重要讲话." http://www.xinhuanet.com/politics/2015-12 /22/c_1117545528.htm.

xinhua.net. 2017. "The Beijing City in Xi Jinping's Eyes 习近平心中的北京城." March 1. http://www.xinhuanet.com//2017-03/01/c_1120550040.htm.

Xue, Ling, and Kaizhong Yang. 2003. ""Chengshi Yanhua De Duozhuti Moxing Yanjiu" 城市演化的多主体 (Multi—Agent) 模型研究 [Researh on Urban Evolution Using Agent-Based Simulation]." *"Xitong Gongcheng Lilun yu Yanjiu"* 系统工程理论与实践 23 (12): 1–9.

Xunzi. 2016 [n.a]. *Xunzi: The complete text.* Edited by Eric L. Hutton. Princeton: Princeton University Press.

Yan, Feng. 2014. ""Meixie Weishenme Yaozuo Shiyan Yishuzhan?" 美协为什么要做实验艺术展? [Why Does the Art Association Organize Exhibitions of Experimental Art?]." *"huakan"* 画刊 (9): 12.

Yan, Xuetong, Daniel Bell, Zhe Sun, and Edmund Ryden. 2013. *Ancient Chinese Thought, Modern Chinese Power*. The Princeton-China series. Princeton: Princeton University Press.

Yang, Mayfair Mei-hui. 1994. *Gifts, Favors, and Banquets: The Art of Social Relationships in China*: Cornell University Press.

Yang, Wei, Li Di. 2015. "Ba shi nian dai"八十年代 [the Eighties]. 1st ed. Changsha: "Hunan mei shu chu ban she"湖南美术出版社.

Yang, Shangguang, and Yulan Wang. 2006. ""Shanghai Chengshi Juzhu Kongjian Fenyi De Shehuixue Yanjiu" 上海城市居住空间分异的社会学研究 [On the Differentiation of the Urban Residential Space in Shanghai]." "Shehui" 社会 26 (6): 117.

Yeung, Henry Wai-chung. 2005. "Rethinking Relational Economic Geography." *Transactions of the Institute of British Geographers* 30 (1): 37–51.

Yin, Yimei, Zhigao Liu, Michael Dunford, and Weidong Liu. 2015. "The 798 Art District: Multi-Scalar Drivers of Land Use Succession and Industrial Restructuring in Beijing." *Habitat International* 46: 147–55.

Zhang, Chaohui. 2007. *"Haishang, Shanghai: Shuangnianzhan De Ganga"* "海上,上海"—双年展的尴尬 [Haishang, Shanghai: The Dilemma of Bienial].

Zhang, Jie. 2012. *The Cultural Gene of Ancient Chinese Space: The Cultural Gene of Ancient Chinese Space*. Beijing: Qinghua daxue.

Zhang, Jinxiang, Fulong Wu, and Runchao Ma. 2008. ""Tizhi Zhuanxing Yu Zhongguo Chengshi Kongjian Chonggou: Jianli Yizhong Kongjian Yanhua De Zhidu Fenxi Kuangjia" 体制转型与中国城市空间重构 — 建立 一种空间演化的制度分析框架 [Institutional Transition and Reconstruction of China's Urban Space: Establishing a Instituional Analysis Structure for Spatial Evolution]." "Chengshi Guihua" 城市规划 (6): 55–60.

Zhang, Longxi. 1992. "Western Theory and Chinese Reality." *Critical Inquiry* 19 (1): 105–30.

Zhou, Xiaohong. 2010. ""Zhongguo Yanjiu De Guoji Shiye Yu Bentu Yiyi" 中国研究的国际视野与本土意义 [The Global Horizon and Local Meaning of China Studies]." *Academic Monthly* 学术月刊 (9): 5–13.

Zhou, Yixing. 2016. "Zhou Yixing: Figure Out the Development Status of Chinese Cities, Clarifying the Concept of City 周一星: 搞清城市发展现状 理清城市基本概念." http://www.planning.org.cn/news/view?id=3878.

Zhu, Daocai, Lin Lu, Xiulong Jin, and Shanzhu Cai. 2011. ""Jiyu Yinli Moxing De Anhui Chengshi Moxing Geju Yanjiu" 基于引力模型的安徽城市空间格局研究 [The Research on Spatial Structure of Urban Spaces Based on Gravity Model: A Case Study of Anhui Province]." "Dili Kexue" 地理科学 5: 7.

Zhu, Pingyi. 2016. *On Earth* 说地: *How Chinese Learn the Form of the Earth* 中国人认识大地形状的故事. 1st ed. Beijing: Shang wu yin shu guan.

Zhu, Yizhong, and Yu Cao. 2011. ""Jiyu PSR Moxing De Guangdong-sheng Chengshi Tudi Jiyue Liyong Kongjian Chayi Fenxi" 基于 PSR 模型的广东省城市土地集约利用空间差异分析 [ASSESSMENT of UR-BAN LAND INTENSIVE USE BASED on PSR MODEL:A CASE STUDY of GUANGDONG PROVINCE]." *"Jingji Dili"* 经济地理 31 (8): 1375–80.

Ziporyn, Brook. 2012. *Ironies of Oneness and Difference: Coherence in Early Chinese Thought : Prolegomena to the Study of Li.* SUNY series in Chinese philosophy and culture. Albany: State University of New York Press.

Anon-ymiz-ation	Profession	Time	Meeting Place	Inter-view Type	Location
ADA1W	798 Art District Administrative	2015.12	798 art district	Infor-mal	Beijing
IA7ZH-1,IA7ZH-2	Independent Artist	2015.12; 2016.01	Studio	For-mal	Beijing
IA3Yo-1, IA3Y-2	Independent Artist	2017.01	Studio	For-mal	Beijing
IA5L	Independent Artist	2016.01	Studio	For-mal	Shanghai, Berlin
IA4H-1, IA4H-2	Independent Artist	2015.11	Studio in Heiqiao	For-mal	Beijing
IA12GJ	Artist, Living in Heiqiao	2016.01	studio in Heiqiao	For-mal	Beijing
AA1ZJ	Artist Activist	2015.11	Exhibition venue	For-mal	Shanghai
IA9LB	Artist living in Beijing	2016.01	Residency Place	For-mal	Berlin
IA8G	Artist living in Heiqiao	2016.01	studio in Heiqiao	Infor-mal	Beijing
AFA1L	Artist, Founder of Independent Art Space	2016.01	Home Studio	For-mal	Beijing
IA1L	Artist, Founder of Independent Art Space	2015.10	Art Space	Infor-mal	Beijing
IA2G-1, IA2G-2	Artist, Founder of Independent Art Space	2015.10	798	Infor-mal	Beijing
IACA10L	Artist, Graduate from CAFA	2018.08	Party	For-mal	Beijing, Berlin
IA6ZR	Artist, living in Caochangdi	2019.01	Exhibition venue	Infor-mal	Berlin
IA13GY	Artist, PhD Candidate in Cultural studies	2016.01	Beijing Art Week Venue	Infor-mal	Beijing

Appendix: anonymized interview list

ID	Role	Date	Location	Type	City
IA14FJ	Artist, Private Museum Stuff	2016.10	Café	Formal	Guangzhou
IA11LZ	Artist, Transfer from Physics Major to Art	2016.01	Studio	Formal	Beijing
CA1Z	Artist/CAFA Conference attendant	2016.10	CAFA	Informal	Beijing
CVC3	Caochangdi Constructor	2013.12	Caochangdi	Informal	Beijing
CVC1	Caochangdi Villager	2013.12	Caochangdi	Informal	Beijing
CVC2	Caochangdi Villager	2014.01	Caochangdi	Informal	Beijing
CVC4	Caochangdi Villager	2014.01	Caochangdi	Informal	Beijing
CR3YM	Curator	2016.01	Studio & Art Fair	Informal	Shanghai, Berlin
CR2CJ	Curator	2016.01	Her husband's studio	Informal	Beijing
CUL1L	Curator and Public University Lecturer	2016.01	Studio in Tianjin	Formal	Tianjin
CR1LJ	Curator of NPO Art Space	2016.01	Café in Caochangdi	Formal	Beijing
CDA4C	Curator, Director of Artist Residency Place	2016.01	IFP	Formal	Beijing
CE1W-1, CE1W-2	Curator, Editor	2017.01; 2017.08	Exhibition venue	Formal	Beijing, Lion
EC2YB	Curator, Editor, University Lecturer	2016.01	Gallery in Caochangdi and 798, Party	Informal	Beijing, Berlin
CAU1	Curator, Used to Work in Auction House	2016.01	Studios in Heiqiao	Formal	Beijing
EAA1S	Editor, Artist, Activist	2016.01	His Gril friend's studio	Formal	Beijing
EC1ST	Editor, Living in Caochangdi	2016.12	Gallery Opening	Formal	Beijing
FM1W	Filmmaker	2016.01	Exhibition venue	Formal	Kassel, Cannes

LA1C	Founder of Indepen-dent Literature Asso-ciation	2016.01	Studio	For-mal	Beijing
G1MC	Gallerist	2016.01	Gallery	Infor-mal	Beijing
G2J	Gallerist @ Beijing Commute	2015.11	798	Infor-mal	Beijing
G1LC	Gallery Director	2014.06	Office	For-mal	Beijing
G3CJ	Gallery Intern @Caochangdi	2014.07	Caochangdi Café	Infor-mal	Beijing
ICC1Z	Independent curator, art critic	2016.01	Residency Place	Infor-mal	Shanghai
MR1CS	Migrant resident in Caochangdi, Cleaning Lady at the Gallery	2014.07	Caochangdi Gallery	Infor-mal	Beijing
M1G	Museum Director @ Today's Museum	2015.11	Museum Meeting Room	Infor-mal	Beijing
NMA11T	New Media Artist	2016.01	Studio	For-mal	Beijing
ODA1	Off-space director /Anthropologist	2016.01	In Lab-47	For-mal	Beijing
PRA1Z	PR of Art media	2017.01	Apartment	For-mal	Beijing, Berlin
MD1LJ	Private Museum Director	2016.01	Museum Meeting Room	For-mal	Guangzhou
PM2ZJ	Private Museum director, Artist	2016.12	Party	Infor-mal	Beijing, Berlin
PCA1W	Professor of CAFA, Artist	2016.01	Restaurant outside CAFA	Infor-mal	Beijing
PCA2Q	Professor of CAFA, Artist	2016.01	Gallery	Infor-mal	Beijing
PC3AW	Professor of CAFA, Artist	2016.01	CAFA	For-mal	Beijing
SCA1L	Students at CAFA	2016.10	Exhibition Venue	Infor-mal	Beijing

Social Sciences

kollektiv orangotango+ (ed.)
This Is Not an Atlas
A Global Collection of Counter-Cartographies

2018, 352 p., hardcover, col. ill.
34,99 € (DE), 978-3-8376-4519-4
E-Book: free available, ISBN 978-3-8394-4519-8

Gabriele Dietze, Julia Roth (eds.)
Right-Wing Populism and Gender
European Perspectives and Beyond

April 2020, 286 p., pb., ill.
35,00 € (DE), 978-3-8376-4980-2
E-Book: 34,99 € (DE), ISBN 978-3-8394-4980-6

Mozilla Foundation
Internet Health Report 2019
2019, 118 p., pb., ill.
19,99 € (DE), 978-3-8376-4946-8
E-Book: free available, ISBN 978-3-8394-4946-2

**All print, e-book and open access versions of the titles in our list
are available in our online shop www.transcript-publishing.com**

Social Sciences

James Martin
Psychopolitics of Speech
Uncivil Discourse and the Excess of Desire

2019, 186 p., hardcover
79,99 € (DE), 978-3-8376-3919-3
E-Book:
PDF: 79,99 € (DE), ISBN 978-3-8394-3919-7

Michael Bray
Powers of the Mind
Mental and Manual Labor
in the Contemporary Political Crisis

2019, 208 p., hardcover
99,99 € (DE), 978-3-8376-4147-9
E-Book:
PDF: 99,99 € (DE), ISBN 978-3-8394-4147-3

Dorothee Brantz, Avi Sharma (eds.)
Urban Resilience in a Global Context
Actors, Narratives, and Temporalities

October 2020, 224 p., pb.
30,00 € (DE), 978-3-8376-5018-1
E-Book: available as free open access publication
PDF: ISBN 978-3-8394-5018-5

**All print, e-book and open access versions of the titles in our list
are available in our online shop www.transcript-publishing.com**